C0-BVR-744

Insignificant
Things

Visual Arts of Africa and Its Diasporas

A SERIES EDITED BY KELLIE JONES AND STEVEN NELSON

Matthew Francis Rarey

Insignificant Things

Amulets and the Art of Survival

in the Early Black Atlantic

DUKE UNIVERSITY PRESS DURHAM AND LONDON 2023

© 2023 DUKE UNIVERSITY PRESS
All rights reserved
Project Editor: Jessica Ryan
Designed by Matthew Tauch
Typeset in Garamond Premier Pro by Westchester Publishing Services

Library of Congress Cataloging-in-Publication Data
Names: Rarey, Matthew Francis, author.
Title: Insignificant things : amulets and the art of survival in the early Black
Atlantic / Matthew Francis Rarey.
Other titles: Visual arts of Africa and its diasporas.
Description: Durham : Duke University Press, 2023. | Series: The visual arts of
Africa and its diasporas | Includes bibliographical references and index.
Identifiers: LCCN 2022043193 (print)
LCCN 2022043194 (ebook)
ISBN 9781478019855 (paperback)
ISBN 9781478017158 (hardcover)
ISBN 9781478024422 (ebook)
Subjects: LCSH: Amulets—Africa—History. | Art objects, African—History. |
Ceremonialobjects— Africa—History—Sources. | Black people—Material
culture—Atlantic Ocean Region. | Material culture—Africa—History—
Sources. | Material culture—Atlantic Ocean Region—History—Sources. |
African diaspora. | BISAC: ART / History / General | ART / African
Classification: LCC NK1080 .R36 2023 (print) | LCC NK1080 (ebook)
DDC 745.096—dc23/eng/20230103
LC recordavailableathttps:// lccn.loc.gov/2022043193
LC ebook recordavailableathttps:// lccn.loc.gov/2022043194

Cover art: Bolsa de mandinga attached to the Inquisition record of
Jacques Viegas, Lisbon, Portugal, 1704. Tribunal do Santo Ofício,
Inquisição de Lisboa, proc. 2355; pt/tt/tso-il/028/02355. Image courtesy
of the Arquivo Nacional da Torre do Tombo.

To Jacques and José Francisco.
To Crispina, Vicente, Lobão,
and Luis. To Torquato, João,
and José. To all those who sought
protection in their time of need,
and to all those who still seek it.

May harm never find you.

Contents

Acknowledgments

This book would not exist without the influence and contributions of countless friends, colleagues, and interlocutors. At the University of Wisconsin–Madison, Jill H. Casid played a formative role in its formation as an effort to think with and beyond the power structures of the archives of Atlantic slavery. Henry Drewal keeps showing me what it means to love and celebrate the artistic worlds of the African diaspora, and what it means to be a committed teacher and colleague. James Sweet's 2007 seminar on African diaspora history introduced me to his initial work on mandingas—to which I remain indebted here—and his investigations in Portuguese Inquisitorial archives established the ground on which this book stands. In turn, I owe continued thanks to Severino Albuquerque not only for his initial feedback on this text, but for going through the likely painful process of teaching me Brazilian Portuguese. In doing so he introduced me to a place I knew very little about, but now has become a second home.

Gathering, organizing, and interpreting the sources for this book has been a monumental task, but one made possible only through the guidance of archivists and caretakers. In Portugal: thanks to the entire staff of the Biblioteca Nacional de Portugal, especially in the rare books section. At the Torre do Tombo in Lisbon, Inês Correia, Anabela Ribeiro, and Ana Gil all proved instrumental in helping me locate critical sources, including facilitating my short but impactful time viewing Jacques Viegas's amulet. At the Arquivo Histórico Ultramarino, Carlos Almeida and Teresa Fernandes proved invaluable guides to an institution that will be home to many future research projects. At the Gabinete de Estudos Arqueológicos e da Engenharia Militar, warmest thanks to José Fontoura, José Paulo Ribeiro Berger, and First Sergeant José Rodrigues. In Lisbon, I also acknowledge the assistance of Pedro Aguiar Branco and João Simões, whose generosity

resulted in some of this text's critical visual sources. In Brazil: thanks to the staff of the Biblioteca Nacional in Rio de Janeiro, especially Alex and the staff of the special collections and manuscripts sections. At the Arquivo Histórico Municipal in Salvador, Felisberto Gomes and Adriana Pacheco spent nearly three months with me in a small room every day as I poured over decades of documents. I will never forget Adriana's genuine excitement when I finally found what I needed. Gratitude as well to the staff of the Arquivo Público do Estado da Bahia, not only for their assistance with guiding me toward sources and documents relating to the Malê Revolt, but also for their routine and welcome offers of coffee and cookies. Finally, it goes without saying that in the wake of my endless flurry of document requests, consultations, and pestering questions across all these institutions, I have forgotten many names. I hope this does not diminish the appreciation I have for your work and assistance.

I also owe gratitude to the many friends and colleagues in Brazil who made—and make—my time there possible and enjoyable. An incomplete list includes Sylvia Athayde, Erivan Andrade, Luis Nicolau Parés, João José Reis, Angela Lühning, Oacy Veronesi, and Toluaye José Antonio de Almedia, all of whom provided me instrumental connections and forms of inspiration. Special recognition goes to Dona Vivi Nabuco and the entire Nabuco family for graciously hosting me in Rio de Janeiro, and for generously funding my first research trip to Brazil. And a most special *abraço* to Gracy Mary Moreira, who helped me in so many ways both in and out of this project.

This book was born out of conversation and community at three institutions I have been lucky enough to call home over the past nine years. At the University of Wisconsin–Milwaukee, Katharine Wells, Hilary Snow, Ermitte St. Jacques, and Gladys Mitchell-Walthour all proved helpful interlocutors and friends during my brief time there, and all contributed critical suggestions to the manuscript's framing and core ideas. Since 2015, Oberlin College has proved a helpful and productive place to think through the ideas that animate this project. I was able to concretize this book's structure and historical framing through energizing conversations Tamika Nunley, Danielle Terrazas Williams, and Peter Minosh in our collective ad-hoc working group on slavery and visual culture. I thank them all for their helpful pushes and supportive criticism. In turn, I remain grateful every day to be a part of Oberlin's Department of Art History. My colleagues Erik Inglis, Bonnie Cheng, Christina Neilson, Sarah Hamill, and Jamie Jacobs have all provided helpful suggestions while remaining models

of support and intellectual rigor. Also at Oberlin, Wendy Beth Hyman, Johnny Coleman, Caroline Jackson Smith, Wendy Kozol, Ana María Díaz Burgos, and Andrea Gyorody all provided their own forms of support; I am lucky to call them friends. Finally, I completed this manuscript during a one-year residency at the Program of African Studies at Northwestern University, where I found a welcoming and peaceful intellectual community. Special thanks go to Megan Keefe, Kelly Coffey, LaRay Denzer, Tiffany Williams-Colbeigh, and Esmeralda Kale for facilitating my time and research there. I was also fortunate to have Aldair Rodrigues and Naaborko Sackeyfio-Lenoch as officemates during my time in Evanston, and this manuscript benefitted from conversations with them both.

I presented versions of this book's research at the conferences of the Brazilian Studies Association (2014), the College Art Association (2015), the African Studies Association (2016), and the Arts Council of the African Studies Association (2017). Thanks to Ana Lucia Araujo, Yaëlle Biro, Benjamin Anderson, and Yael Rice for their invitations to participate on these panels, and to my fellow panelists and audience members at these venues for their engaging questions and comments. Susan Gagliardi invited me to the ASA and ACASA panels she co-organized, and I do not think she knows the extent of the critical role she has played in this book. Thanks to her for believing so strongly in this text, and for reading over multiple sections of the manuscript.

I also delivered lectures related to this book's materials at the University of Wisconsin–Milwaukee, Amherst College, DePaul University, Northwestern University, and the Galeria Alice Floriano in Porto Alegre, Brazil; I thank Michael Amoruso, Mark DeLancey, Alice Floriano, and my colleagues at Northwestern's Program of African Studies and UW-Milwaukee's Department of African and African Diaspora Studies for these invitations and the conversations that emerged from them. Finally, chapter 3 received critical suggestions and editing from the participants at the Black Modernism Seminars held at the Center for Advanced Study in the Visual Arts in Washington, DC. I thank Steven Nelson and Huey Copeland not only for their generous invitation, but for their incisive feedback on that chapter and, in turn, the book's theoretical underpinnings and framework. I thank the other panelists and participants in this meeting—especially Kobena Mercer, Sylvester Ogbechie, Kellie Jones, Simon Gikandi, Rachel Newman, and Megan Driscoll—for their thoughts as well.

Others whose influence shines through in these pages includes dear friends and colleagues C. C. McKee, J. Lorand Matory, Niama Safia Sandy,

M. Carmen Lane, and Jessica Moore. Ana Lucia Araujo has long and generously supported this project in many ways, from providing instrumental feedback to supporting a wide intellectual community of scholars working on the history of slavery in the south Atlantic. I also wish to thank and acknowledge Cécile Fromont as we both work on descriptive and interpretive studies of mandinga pouches. Animated by a mutual desire to ask what these objects may tell us about enslavement and Black Atlantic visual culture, my research and writing critically benefited from our conversations and shared information. Finally, I thank two other anonymous reviewers for Duke University Press who helped flesh out this book's theoretical framing and provided invaluable suggestions and factual corrections. All remaining errors, of course, are my own.

Multiple institutions provided research and writing support for this project. The University of Wisconsin–Madison generously funded my initial research in Portuguese and Brazilian archives through the Brazil Initiative's Joaquim Nabuco Award and a Vilas Research Travel Grant. Welcome time to write, in turn, came in the form of a Chancellor's Fellowship, a Mellon-Wisconsin Summer Fellowship, and my time as a Dana-Allen Dissertation Fellow at the UW-Madison Institute for Research in the Humanities. The project found its initial contours and sources during the critical nine months I spent in Lisbon, Rio de Janeiro, and Salvador thanks to a 2012–2013 Mellon Dissertation Fellowship through the Council on Library and Information Resources. Other funding for research came from the James R. Scobie Memorial Award from the Conference on Latin American History; a 2014 UW-Milwaukee Center for Latin American and Caribbean Studies Faculty Research Travel Award; Oberlin College, including the Jody L. Maxmin '71 Art Department Faculty Support Fund; and a 2018–2019 fellowship from the National Endowment for the Humanities.

A core overview of the book's main arguments, mostly derived from chapters 1 and 2, appeared as "Assemblage, Occlusion, and the Art of Survival in the Black Atlantic" in *African Arts* in 2018. A shortened version of chapter 3 appears as "Leave No Mark: Blackness and Inscription in the Inquisitorial Archive," in *Black Modernisms in the Transatlantic World* (2023). Finally, a small section of chapter 4 appeared in my essay "Counterwitnessing the Visual Culture of Brazilian Slavery," in *African Heritage and Memories of Slavery in Brazil and the South Atlantic World* (2015). I thank all these publishers for their support of these previous publications.

I am so happy this book found a home at Duke University Press. My editor, Elizabeth Ault, as well as Benjamin Kossak, both deserve endless

recognition for their patience and helpful guidance as they shepherded these words from manuscript to book. I also thank Annie Lubinsky and Jessica Ryan for seeing the book through to its copyediting and production stages.

Family should be first, but it always seems fitting to thank them last. My father has always believed in me unconditionally and continues to express genuine excitement when something I write enters the real world. And it was my mother who—though she may have come to regret it later—told me as an undergraduate to change majors from anthropology to art history, because, as she said, "it's what you really love." She never knew how right she was. And to Lindsay Fullerton: my confidante, editor, travel, research, and life partner. You lived every step of this project with me, you read every word multiple times, and you held my hand during all its ups and downs. I owe you so much.

Last, I give thanks to those whose permission I could not solicit: the mandingueiros whose life stories and creations animate this book. I do not pretend to do justice to your work here, but I am grateful for the opportunity to try. I dedicate this text to you.

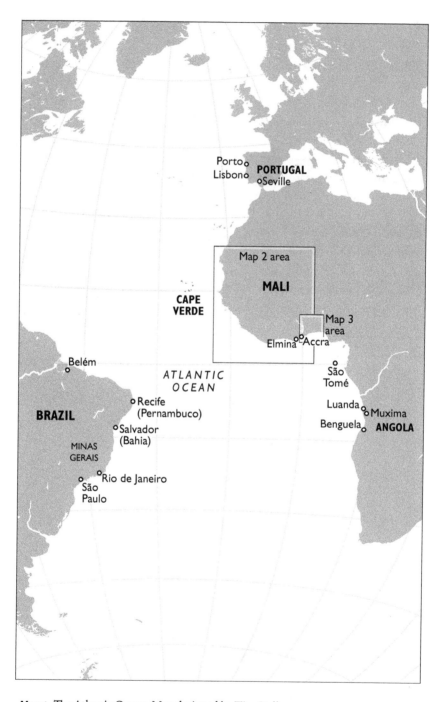

Map 1 The Atlantic Ocean. Map designed by Tim Stallman.

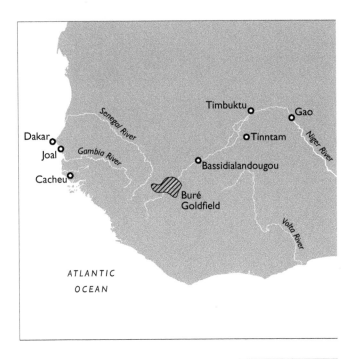

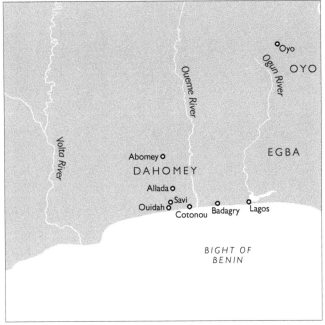

Map 2 West Africa and the Sahel. Map designed by Tim Stallman.

Map 3 The Bight of Benin. Map designed by Tim Stallman.

Significance, Survival, and Silence

If our search for the enduring and the beautiful cannot be reconciled with the ugly facts of a painful historical present, perhaps it is to the ugly, the mean, and the seemingly insignificant that we need to address our attentions.
David Doris, *Vigilant Things*

Any historical narrative is a particular bundle of silences.
Michel-Rolph Trouillot, *Silencing the Past*

Inside the pages of trial record (*processo*) 2355 of the Lisbon Inquisition, there is a curious addition, an unexpected insertion, an object seemingly out of place: a small fabric pouch, slightly more than an inch wide, sewn into its binding (figure I.1). Made of one continuous piece of textured fabric, its left side still displays its original finishing whip stitch used to seal the amulet (figure I.2). By contrast, a tear in the right side opens onto a glimpse of the pouch's contents, while the white strings at top testify to a previous, almost haphazard, repair. Its once green exterior now faded to a patchy brown and its form now flattened to near imperceptibility between the pages, for the past three centuries this object has subtly warped the fifty-one handwritten folios that surround it. This object's unassuming form, however, belies the transoceanic circulations of people, objects, and ideas that led to its creation; the awesome, dangerous forms of power and protection it provided its user; the significant, coordinated efforts to eliminate it; and the nascent system of global surveillance into which it decisively intervened.

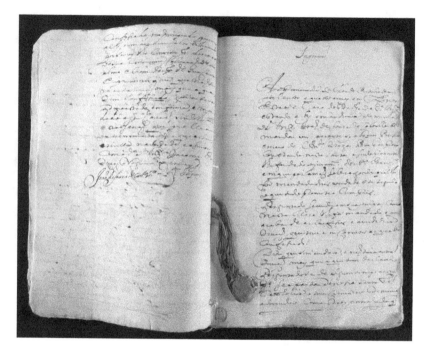

I.1 Bolsa de mandinga attached to the Inquisition record of Jacques Viegas, Lisbon, Portugal, 1704. Tribunal do Santo Ofício, Inquisição de Lisboa, proc. 2355; PT/TT/TSO-IL/028/02355. Image courtesy of the ANTT.

Between the mid-seventeenth and late eighteenth centuries, pouch-form amulets (*bolsas*) like this one—often, but not exclusively, referred to as *mandinga* in the records of the Portuguese Inquisition—found a diverse clientele in Madeira, Cape Verde, Brazil, Angola, and Portugal. The governance of the Portuguese Empire bound together these regions, as did the movements of Africans' lives and ideas during the Atlantic slave trade: a system of transcultural destructions, reciprocal flows, and reinventions scholars have come to call the Black Atlantic world.[1] Surviving testimonies describe these objects' diversity of forms and powers. Usually in the form of a fabric or leather pouch, some attracted new lovers, while others provided luck in games of chance.[2] Some bolsas used by enslaved people explicitly challenged that legal status: one turned its user invisible to escape his enslaver, and another stopped the movement of a slave ship.[3] But most commonly, users, witnesses, and inquisitors all agreed that these amulets protected individuals from intimate personal violence. Though documents suggest that people of all backgrounds and social classes used bolsas,

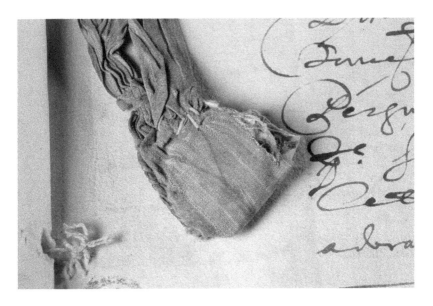

I.2 Detail of figure I.1, showing original finishing whip stitch used to seal the amulet.

a disproportionate number of trial records, including many of the most detailed, focus on enslaved Africans who had spent time in Brazil; Africans who—like the objects they made and disseminated along the way—spent their lives navigating and reinterpreting conflicting visual and ritual practices on both sides of the Atlantic Ocean.

The pouch shown here—one of only two surviving examples in the records of the Portuguese Inquisition—entered the archive in July of 1704, when authorities received it as evidence in the trial of Jacques Viegas. Jacques, an enslaved West African "native of the Mina Coast" (*natural da Mina*), was about twenty years old when he was arrested in Lisbon on charges of "witchcraft and the use of fetishes" (*bruxaria e feitiçaria*) the previous month. After his arrest, Jacques entered the Holy Office and held up this object for inquisitors to see as he made his confession. Between June and October, inquisitors interrogated Jacques about the object's origins, construction, and use. Jacques testified that he acquired it from Manuel, another Black man in Lisbon, who manufactured pouches that could protect their wearers from knife wounds, gunshots, and malevolent forces. Through the torn seam in its side one can see its empowering contents: black hairs, seeds, and cotton, all wrapped inside a folded piece of paper (figure I.3).

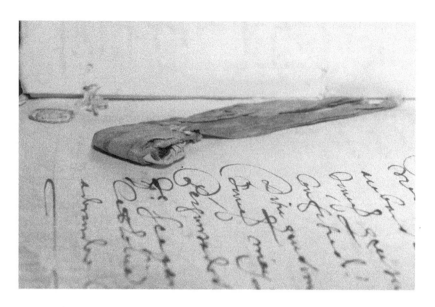

I.3 Bolsa de mandinga attached to the Inquisition record of Jacques Viegas. Its
contents are visible through the torn seam on the side. Tribunal do Santo
Ofício, Inquisição de Lisboa, proc. 2355; PT/TT/TSO-IL/028/02355. Image
courtesy of the ANTT.

The secrecy of this amulet's contents, however, contrasted with the
spectacular public performances that confirmed its efficacy. During his
May 1704 deposition, Manuel Correa, a white Christian-born man (*cristão
velho*; literally "Old Christian") testified that he had sought out Jacques in
hope he could provide protection from violence, as Manuel was engaged in
a series of quarrels.[4] Jacques obliged and gave him a small amulet whose
powers Jacques demonstrated by holding it while plunging a sword
into his own chest. Awestruck, Correa recounted that Jacques did this
"with great force; but it did not hurt him, only bending the sword."[5]
This proved that it was no ordinary object: it was *mandinga*. While for
eighteenth-century Portuguese speakers this term commonly referred
to talismanic objects with perceived African associations and other-
worldly powers, to inquisitors this term confirmed Jacques's "pact with
the Devil." And so they sentenced Jacques to a public penance of his faith
(*auto-da-fé*), a public flogging, and three years of exile to the Algarve,
in southern Portugal. It was at least the second forced migration of his
young life. But while Jacques would never return to Lisbon, his pouch re-
mains there, preserved inside the decaying pages used to imprison it and
its former owner.

<center>* * *</center>

This book is a history of this object and an exploration of the interpretive possibilities it folds into the troubled archives of Atlantic slavery. Jacques's *bolsa de mandinga* ("Mandinga pouch") exemplifies a discourse covering three centuries and four continents in which enslaved and other marginalized people turned to apotropaic objects as tactics of survival. In so doing, they created unprecedented, portable archives of their lives and milieux. Yet these objects' visually banal form, surreptitious display, and inherent mobility did more than facilitate their survival in the context of forced migration and its concomitant quotidian violence. Rather, these aesthetic strategies helped them to avoid unwelcome gazes and close visual inspection, tactics that would seem to counter their significance as protective agents and archival sources. This book, then, is an attempt to write through an irreconcilable contradiction: an art history of the Black Atlantic that centers objects designed to avoid analysis.

Insignificant Things does not approach these objects as a distinct set of works, but rather as an evolving discourse that intersects with early modern debates over race, identity, diaspora, vision, and value. The book argues, first, that the wide circulation of bolsas and the mélange of inclusions reveal the complex and mutual imbrications of cultural practices only later termed *African* and *European*. Indeed, concerns about cultural authenticity mattered little to Jacques. As an embodiment of its user's search for safety in a violent world, Jacques's object bound together a mélange of pragmatically selected materials in new and intimate configurations. In so doing, *mandingueiros* ("mandinga-makers") disavowed claims to authenticity and cultural origin. Second, the book argues that these' objects internal contents—tossed aside by inquisitors but highly valued by bolsa-users—interrogated elite assumptions about the spiritual and economic value of bodies and materials in the context of Atlantic slavery and mercantilism: a point that leads to their eventual characterization by inquisitors, in the early 1700s, as canonical objects of *feitiçaria* ("fetishism" or "sorcery"). And finally, by uniting effective, sought-after apotropaic powers with unassuming forms, mandinga amulets broke down the linkages between violence, visuality, and political power that scaffolded systems of racial and cultural hierarchy.

Exemplary of a material and discursive history of African-associated apotropaic amulets used between the sixteenth and early nineteenth centuries, the singularity of Jacques's bolsa de mandinga exists in tension

with the broad, deep contextual terrains one must cover to account for its presence in the archive. Across four chapters this book traces the circulation and use of amulets in fifteenth- and sixteenth-century West Africa before moving out to the wider Atlantic rim. While the narrative makes occasional reference to amulets in regions under Spanish and French governance—primarily Spain, Colombia, Saint-Domingue, and Louisiana—chapters 2, 3, and 4 focus on regions associated with the Portuguese Empire—the Upper Guinea Coast, the Bight of Benin, Angola, Brazil, and Portugal—between the late 1600s and 1835. Looking in and against Arabic-language narratives from the West African Sahel, sixteenth- and seventeenth-century European-language travel and merchant trader accounts along the West African coast, the archives of the Portuguese Inquisition, and the records of early nineteenth-century Brazilian police forces, the book's chapters collectively chart a history of the forms these objects took on, the Atlantic circulation of contents their makers assembled and sealed inside them, the social relationships they facilitated, the otherworldly abilities they carried, and the efforts made to alternately suppress and control them.

The objects at the core of this study reexamine long-standing questions in African diaspora art history, slavery studies, and visual culture studies. How, for example, does the use of the West African ethnonym *Mandinga* to refer generically to empowered objects reframe understandings about the emergence of ethnic identities in the wake of the internal African and Atlantic slave trades? What do the contents and construction of these amulets reveal about how those persons forcibly transported through Africa, and across the Atlantic, responded to the new conditions in which they found themselves—in particular, how they protected themselves from the new dangers they encountered? Why did they value these visually benign objects and contents that radically depart from the widely studied corpus of print culture, plastic arts, and monuments also used to represent or memorialize slavery across the Atlantic world? And how, finally, might these bolsas de mandinga pose new possibilities for those seeking traces of Black peoples' lives and livelihoods inside the archive of Atlantic slavery? If the goal of African diaspora art history, as Krista Thompson reminds us, is to "put pressure on such particularized configurations of art and art history that do not get seen as such, and which masquerade as universal," then—in their material interrogation of universalizing claims to power, and in their attempts to avoid visual surveillance in so doing—mandinga amulets are paradigmatic African diasporic objects.[6]

In so doing, *Insignificant Things* argues that mandinga pouches reveal new historical actors, new methods of constructing archives, and new models for considering how those in diaspora represented and navigated their experience in arenas meant to obscure it.

Contexts: Jacques Viegas and Mandingas in the Black Atlantic, ca. 1700

Jacques's trial resulted from seismic cultural political shifts at the turn of the eighteenth century. In the decades before 1700 a series of prominent African states collapsed or fragmented, leaving power vacuums in their wake. In central Africa, the Kingdom of Kongo's 1665 defeat by the Portuguese at the Battle of Mbwila began a period of political disintegration. In the Gold Coast the Akwamu state was supplanted by Asante, who increasingly focused on slave trading between Accra and Ouidah after 1700.[7] And in the land of Jacques's birth—referred to as the "Mina Coast" or "Slave Coast"—competition for primacy in the trade with Europeans fueled warfare among rival states. As late as the 1690s, Allada and Hueda controlled coastal trading centers, but by the early 1700s Dahomey expanded southward from its capital at Abomey and gradually cut off access to internal trade routes as the slave trade intensified.

These developments intertwined with those in the Portuguese colony of Brazil. Since the mid-sixteenth century, sugar—principally cultivated by enslaved Africans laboring in Bahia and Pernambuco—had been Brazil's dominant cash-crop. But in the 1690s sugar planters gradually abandoned their plantations as they joined a gold rush in Minas Gerais. So significant was the Minas Gerais gold rush that it had a quantifiable effect on the empire's population distribution: between three and ten thousand people left Portugal annually for Brazil in the first few decades of the eighteenth century. This emigration likely contributed to a decrease in Portugal's population between 1700 and 1732.[8] To fund expansive mining operations, Brazilian merchants traded gold for captives in West African ports like Accra, Elmina, and Ouidah and quickly dominated the slave trade there.[9] Yet they did so illicitly: since the 1690s, the Portuguese Crown had banned Brazilian merchants—most operating from Bahia—from trading on the Mina Coast.[10] Merchants ignored the order, and Portugal lost control over the colony's economy. Though in 1703 they reversed the decree, the Crown's distant location in Portugal meant that Brazilian traders feared

few repercussions if they ignored the monarchy's attempts to regulate the trade.[11] By 1725, over half of Brazil's population lived in Minas Gerais, and by the end of the eighteenth century, over half of Minas Gerais was enslaved.[12]

Capital flowing from Brazil further destabilized West African political structures. The resulting competition for prisoners of war to enslave and sell to Europeans led to an unprecedented increase in their numbers. Between 1690 and 1700, over 160,000 captive Africans found themselves on ships bound for Brazil or Portugal. Nearly double that of the previous decade, this number accounted for nearly half of all Africans similarly displaced to the Americas or Europe in those same ten years.[13] The person later named Jacques Viegas was one of these.

Jacques's trial makes no mention of his life between his departure from Africa and his arrival in Portugal. Though Brazil was the most common destination for those exiled from the Mina Coast, his trial record's absence of references to Brazil suggest that he disembarked in Portugal. In Lisbon, Jacques encountered a city with a strong African presence. Wolof Muslims enslaved in African networks had been arriving in Portugal since the 1500s, and some had studied at Qur'anic schools in Africa before finding themselves in Iberia.[14] In Spain and Portugal, they and other African Muslims (Portuguese, *mouriscos*; Spanish, *moriscos*) had reputations as healers and keepers of esoteric knowledge.[15] Converted to Christianity by choice or by force, the Inquisition later prosecuted some for using talismanic objects: a practice that preceded that of Jacques's by over a century and a half.[16] In 1556, for example, Luís Duarte, captured by the Portuguese after a battle in Morocco, was arrested by the Inquisition on charges of Islamism; a talismanic paper with Arabic writing served as evidence in his trial.[17] And in 1592, Juan Martín, a morisco living in Seville, Spain, carried Qur'anic papers "hidden on his person" that could heal illnesses and assist in escaping from captivity: an object whose form, display, and function mirrored those later labeled *mandinga*.[18]

Jacques's Lisbon was a crucial node in the Atlantic exchange of bodies, objects, and lives. Many Africans lived in the city, transported there by ships that also offloaded sugar, gold, and animals from Brazil into Lisbon's port. Missionaries and traders in Goa, Java, and Macau sent back spices, textiles, and ivory. Even a century before Jacques's arrival in Lisbon, stores on the Rua Nova das Mercadores, the city's main market street, sourced curiosities from across the globe; one could find Indian textiles and other goods at markets held every Tuesday on Rossio Square.[19] Those

who could afford them assembled ivories, curios, and other exotica in curiosity cabinets or other displays in their homes.[20]

But as one early sixteenth-century painting makes clear, these materials engendered anxieties about the religious life of a city at the crossroads of transoceanic exchange (figure I.4). Its anonymous artist depicts a group of white Europeans being boiled, stabbed, force-fed, and prodded in a vision of Hell presided over by an allegory of Portugal's overseas consumption.[21] The masked figure holds an ivory hunting horn, its form deriving from those produced by Kongo, Edo, and Sapi artisans on Portuguese commission (figure I.5), while its green feathered suit and headdress echoes those produced by Tupi (Indigenous Brazilian) artists for ritual use. One torture even depicts being force-fed a Portuguese coin minted from West African or Brazilian gold.

This punitive vision of white Europeans' lustful consumption from across the Atlantic prefaces a concern that had strengthened by the time of Jacques Viegas's trial: that the intermixture of Atlantic slavery's forced circulation of bodies and goods undermined social morality and the Church's spiritual authority. In 1728, priest and moralist Nuno Marques Pereira spoke of hell as a place filled with "serpents, scorpions, snakes, lizards, toads, and all sort of poisonous creatures," a menagerie of Brazilian-associated

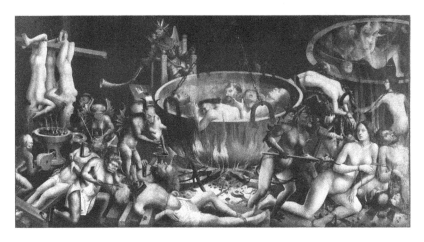

I.4 Unknown Portuguese master, *Hell*, 1505–1530. Oil on oak, 119 × 217.5 cm
 (46.9 × 85.6 inches). Museu Nacional de Arte Antiga, Lisbon, Portugal.
 Image courtesy of the Direção-Geral do Património Cultural /Arquivo e
 Documentação Fotográfica. Photograph by Luísa Oliveira and José Paulo
 Ruas, 2015.

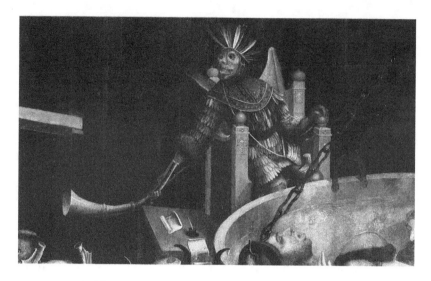

I.5 Detail of figure I.4.

fauna that made clear his perception of Brazil as a land of torments.[22] Indeed, throughout Brazil's colonial period (1500–1821), over half of the population was enslaved; Africans, both enslaved and free, participated in a diverse range of religious practices. The religious experiences of Africans arriving in Brazil included Islam, West African devotions to vodun and òrìṣà, central African forms of ancestor veneration, and Congolese Catholicism. In Brazil, these all commingled with varying forms of popular and institutionalized Catholicism and Indigenous spiritual traditions. Building on Pereira's perception, throughout Brazil's colonial period, as Laura de Mello e Souza describes it, "syncretism was one of the faces of hell," since "African and indigenous beliefs were constantly demonized by elite thought, incapable of comprehending colonial religiosity in its ever more multifaceted expressions."[23]

Portuguese and Spanish Inquisition trials of the seventeenth and eighteenth centuries, however, suggest that Africans' religiosities also thrived in the metropole. And though Inquisition records decried the increasing visibility of Africans' practices, many prominent whites in Brazil, Portugal, and even central Africa also participated in them.[24] In social contexts where one's status was based in skin color, descent, and cultural affiliations, white Portuguese clients also looked to Central African *calundu* divination ceremonies as well as to mandinga amulets, even as others decried them.[25] This cultural reality generated new discourses of power and orthodoxy, and in

response the Portuguese Catholic Church constantly moved the proverbial goalposts of permissibility. The Portuguese Inquisition emerged in this context, its existence and priorities bound with the lives of those in Portugal's far-flung empire. From its establishment at the request of King João III in 1536—shortly after the anonymous vision of *Hell*—to its disbanding in 1821, the Holy Office's authority and scope waxed and waned because of royal whims and political opportunism in a pluralistic world. The Inquisition's lifespan, in turn, almost exactly paralleled that of the rise and decline of Portugal's transatlantic slave trade and its governance of Brazil.

Of the Inquisition's three metropolitan tribunals, Coimbra and Évora processed nearly two-thirds of all cases over its three-century run, all from Portugal. And while it tried some local cases, the Lisbon tribunal processed all cases from Africa and Brazil. This distribution suggests that the Inquisition paid comparatively lesser mind to religious life in the colonies. Though by 1610 the Spanish Inquisition had established tribunals in Lima, Mexico City, and Cartagena de Indias, Portugal never established an autonomous tribunal in the Americas.[26] As a result, Brazilian cities like Pernambuco and Rio de Janeiro, or Portuguese trading centers on the African coast like Cacheu and Luanda, were imagined as potential havens for practitioners of African religions, Muslims, Jews, and "New Christians" (*cristãos novos*, those raised outside of Christianity but later baptized) escaping persecution in Portugal. Paradoxically, the Holy Office also exiled them to such locales as punishment. While in practice this resulted in fewer cases from Brazil or Africa sent for prosecution in Lisbon, the Lisbon tribunal continued its vigilance through a combination of periodic visitations conducted by the Holy Office, bishops, and other church representatives as well as through a network of commissaries (*comissários*) who identified suspects for prosecution. This nascent system of surveillance also surrogated everyday people: a church edict stated that "any person, man or woman, clergy or religious person, of whatever state, condition, dignity, or class" had a duty to denounce sins against the Church.[27] Though the Inquisition's focus was originally on religious crimes such as blasphemy and Judaism, its expanding Atlantic purview created new categories of sexual crimes, censorship, magic (*magia*), witchcraft (*bruxaria*), and *feitiçaria*, a term that encompassed a range of actions related to the expert manipulation and control of unseen forces and physical objects as well as to the acquisition of illicit knowledge necessary to carry out such spiritual labor.[28] It was under this final category Jacques Viegas was charged and convicted in 1704.

Jacques was brought before the Lisbon tribunal at the time of the Inquisition's most significant focus on Brazil. Brazil's increasing wealth from gold production had sped up the institutionalization of ecclesiastical structures and commissary networks in the colony, which led to more denunciations sent to Lisbon.[29] In turn, the significant population influx in the decades after the gold rush, especially of enslaved Africans, meant that persons of African descent appeared with increasing frequency before the Lisbon Inquisition between 1700 and 1730. This period also encompasses most trial records concerning mandingas. For this reason, both enslaved Africans and inquisitors in Portugal viewed mandingas as having a special connection to Brazil. José Francisco Pereira—an apparently prolific African-born mandingueiro then resident in Lisbon—relayed at his 1731 trial that "since he had spent some time in Brazil, many blacks hounded him to give them mandingas because [they said] he must have brought some from there."[30] The Inquisition, it seems, had already noticed the problem on both sides of the Atlantic: in 1692, in Santarém, Portugal, a Black man named Diogo was denounced for "carrying a bolsa like those dealt with" in inquisitorial decrees (*editais*).[31] And in 1693, agents of the Lisbon Inquisition sent a group of twenty-five decrees concerning the bolsas to Rio de Janeiro, presumably in response to increasing reports of their use there.[32] One of the clearest statements on the Inquisition's suspicion of Brazilian bolsas comes from the Portuguese-born Dominican priest Alberto de Santo Tomás. Working as a missionary in the Bahian countryside from 1703 to 1713, he began to adopt exorcism rituals that paralleled those he denounced, which included producing his own bolsas that his clients wore "around their neck or attached to their clothes."[33] When he denounced himself in 1713, inquisitors dismissed the case—his "exorcisms" found to be in keeping with Catholic doctrine—but they ordered he discontinue distribution of the bolsas.[34]

The story of Miguel Ferreira Pestana further shows how mandingas disavow attempts to pin down their allegiance during this period.[35] A native of Espírito Santo, Brazil, Pestana's Indigenous background contrasts to the predominance of African-born and African-descended mandingueiros who appeared before the Lisbon Inquisition. At his 1744 trial, Pestana described how some years prior he arrested a Black man while working as a *capitão-do-mato* (literally "bush captain," someone employed to find and capture people in flight from enslavement) in the parish of Inhomirim in Rio de Janeiro. After searching the man's belongings, Pestana found a bolsa. At his trial, Pestana claimed—or feigned—ignorance of this object's

form and function, instead asserting that Ventura, a Black man who accompanied Pestana on his searches for fugitives, informed Pestana of its significance. Opening the amulet, Pestana found a folded piece of paper inscribed with "various painted figures and some written letters in a great variety of inks," a description that foregrounds the critical role of written and drawn-on papers inside mandinga pouches.[36] Unable to read the paper's text or interpret its designs, Pestana showed it to Salvador Correa, a literate acquaintance of his who, ironically, would eventually denounce Pestana to the Inquisition. Correa—identified as *mulato* (someone born of one Black and one white parent) on the trial record—then informed Pestana that the paper served to grant good luck in games and "to not be injured," and so Pestana decided to keep the amulet with him, believing it would assist him in his role as a capitão-do-mato.[37]

In its movement from an object assisting someone fleeing enslavement to assisting someone charged with his capture—who, in turn, was later arrested and exiled for its use—Pestana's testimony underscores amulets' seamless movements between competing realms of power, allegiance, and hierarchy. Rather than being understood as an object restricted to a particular class or cultural sphere, bolsa-users and -makers consistently reappropriated and recontextualized them to serve competing interests in an ongoing popular search for safety and success in a dangerous world. In turn, Pestana's narrative—in which a Black man is charged with assisting the capture of fugitives—again underscores the care that must be taken to not equate assertions of Africanness with Blackness, nor either of these with enslavement or resistance, particularly in colonial Brazil. Finally, note Pestana's need to open the object and detail its contents not just to Ventura but also to his inquisitors. Before the Inquisition, he continued to deny any association the object had outside of an inquisitorial vision of Catholic orthodoxy.

Such aspects are not unique to Pestana's case, but rather inflect scores of inquisitorial and police trials associated with the amulets discussed in the pages that follow. The primacy of inquisitorial records as an archival source for bolsas, however, overemphasizes the role of the Inquisition in everyday life, even in this especially busy period. In the entirety of its purview, the Inquisition only received about 1,000 denunciations from Brazil; even then, most concerned New Christians accused of practicing Judaism.[38] Collectively, the Portuguese Inquisition's tribunals only tried 852 people for feitiçaria between 1700 and 1760, and this number included only sixty people of African descent.[39] Given that in 1725 Brazil had, by

one estimate, an African-descended population of between 100,000 and 150,000 people, the overwhelming majority of those using bolsas de mandinga not only never appeared before the Inquisition; they never feared that they would.[40] Imagine how many of these objects were produced but will never be known; consider this certainly massive and now largely disappeared archive: one we can only glimpse through the tear in the side of Jacques's amulet. But, reading the records closely, one sees how Africans knew of the proliferation and promise of these objects as singularly effective forms of personal protection, fabricated through the intertwined histories of religious transformation, material exchange, forced migration, and struggles for power that characterized the early eighteenth-century Atlantic world.

"Insignificant": The Historiography of an Odd Title

On the surface, the title of this book undermines its argument. It reproduces the words and perspectives of inquisitors who, looking into Jacques's amulet—and many others—simply dismissed the importance or meaning of what they saw. Indeed, the book's title reproduces a trial scribe's description of the contents of an amulet worn by Lobão, an enslaved man accused of participating in an African-led rebellion in Bahia in 1835. "Fragments of insignificant things," he wrote.[41] Yet they were not insignificant, for the accusers and accused in such trials had long agreed on the power of amulets used by Africans. As evidenced by Jacques's trial a century earlier, inquisitors had dedicated years to finding and suppressing these objects, and in 1835, Lobão used his in an attempt to overthrow Bahia's slavery society. At its core, then, this book asks why Jacques and Lobão, despite their different historical contexts, looked to these "insignificant" materials as manifestations of apotropaic powers and revolutionary potential.

The book's title is an effort to put into practice the same recontextualizations and against-the-grain readings of elite claims to power that mandingueiros manifested in their own practice. To this end, "insignificant" also registers authorities' anxiety about the autonomy of objects and their users in a slavery society. As will be outlined in chapter 4, in 1835 the scribe used "insignificant" to dismiss the amulet's contents as things that would "signify" to elites because of their legibility inside an agreed-upon system of economic value and power signaling. He thus unwittingly testified to a system of signification and valuation that not only operated

outside of elite understandings, but that interrogated what Martin Jay calls the "scopic regimes of modernity" by strategically recontextualizing and reevaluating its contents.[42]

Almost fittingly, these "insignificant things" have only recently begun to attract sustained analysis, particularly from Brazilian historians.[43] All recent studies of mandingas, including the present text, build on Laura de Mello e Souza's pioneering 1986 work on colonial Brazilian popular religiosities, *The Devil and the Land of the Holy Cross*, which first looked to Portuguese Inquisition records to outline mandinga amulets' wide use across Brazil's social strata. Souza placed this diverse clientele in dialogue with repeated references to the amulets' visibly Catholic inclusions of orations, altar stones, and eucharistic hosts, labeling them "the most syncretic of all magical practices" in Brazil.[44]

Following Souza, research on bolsas expanded into the wider Atlantic, focusing on the transoceanic experiences of the eighteenth-century African-born mandingueiros whose work also forms the backbone of *Insignificant Things*. Daniela Buono Calainho's 2008 book *Metrópole das mandingas*, for example, analyzed the scope and structure of Africans' diverse religious systems in eighteenth-century Portugal and their association with feitiçaria. For Calainho, the "syncretic" contents of mandingas again reflect selective choices by their makers; thus, she concludes that Africans' practices transformed in the context of Catholicism and inquisitorial repression, but retained "fundamentally African characteristics."[45] Vanicléia Silva Santos, also writing in 2008, took an Atlantic-wide perspective on mandinga-production in the late seventeenth and eighteenth centuries, concluding that mandingas were "symptomatic of the encounter between various African ethnic groups in Brazil" and that they occupied an identity "between Catholicism and Bantu and Guinean knowledges."[46]

These conclusions show that mandingas' material dimensions are critical to their interpretation, with amulets' Catholic characteristics emerging as points of focus, contention, and consternation.[47] Authors read them as difficult-to-interpret transculturations, as early articulations of contemporary Afro-Brazilian religiosities, or as efforts to mask or dialogue indigenous African beliefs with foreign influences.[48] In each case, mandingas are registered through the degrees of relationship to a kind of originating African thought system. *Insignificant Things*, by contrast, significantly expands and historicizes these objects' African context as part of scholars' continued efforts to resist what Henry John Drewal critiques as a prevailing conception of African cultures as "static, passive . . . anachronisms."[49]

Chapter 1, for example, shows how amulets of nearly identical external form and function to what are later labeled mandingas emerged in West Africa prior to the rise of the Atlantic slave trade. Initially conceived as Islamic-associated amulets to protect long-range gold traders and their caravans, they accumulated new layers of meaning with the expansion of human trafficking in the Sahara.[50] By the sixteenth century, as the transportation of captives from Senegambia to Iberia and the Americas inaugurated the discourse of mandingas in the Atlantic world, these amulets were already transcultural objects that served to protect their wearers from displacement and forced labor. Thus, this book aims to situate mandingas not as solely Luso-Brazilian artifacts associated with Catholicism, nor as purely African devices. Rather, they embody the historical grappling of Islam, Catholicism, and varied other African religions, even prior to their seeming emergence outside of Africa.

In turn, this book for the first time situates *mandinga* as a popular discourse, not as a discrete set of identifiable objects. As José Pedro Paiva notes, early eighteenth-century bolsas de mandinga did not differ substantially from amulets already widely used in Portugal.[51] Rather, these were identified as mandinga because of their new African associations—a desperate inquisitorial attempt to distinguish between mutually constituted ritual systems only later labeled "African" and "Catholic." In this way, the mandinga-as-discourse intervenes in changing understandings of the natural and cultural world, particularly in the wake of increasing material exchange, human migration, and cultural transformation brought by the expansion of empires like Mali, Dahomey, Oyo, and Portugal; the increasing power of Portugal's Inquisition; and a need to process, if not avoid, the violence of daily life. The diverse clientele of bolsas suggests that these struggles crossed lines of race and class but were particularly sensitive for those who were cast out of or displaced from their homelands and communal networks.

This discursive, as opposed to solely object-based, orientation allows the book's core framework to move far beyond studies of the religion and cultural lineage of mandingas that so far have dominated work on them. The present text develops arguments put forth by Cécile Fromont and me in earlier essays, placing mandingas not just as emblems of cultural practices from Africa or embodiments of new religious universes but as strategic responses to interpersonal violence, cultural displacement, and institutional power emerging from the intersections of slavery, commodity exchange, and religious transformation in the Black Atlantic.[52] The book thus continues work of scholars like Toby Green and Thiago Henrique Mota, who

have shown how the rise of material trade and human trafficking in West Africa impacted religious systems there.[53] *Insignificant Things* also uses mandingas to show how the rise of the African and Atlantic slave trades, and the concomitant material exchanges they led, directly impacted belief structures and the objects associated with them, but does so by expanding this argument out into the Atlantic, showing how Africans' ritual practices continued to be shaped by the realities of material exchange and slavery in and out of West Africa.

Elsewhere, scholars debate the role of these objects in reference to the social status of their makers and users, primarily enslaved Africans. James Sweet, for example, characterizes bolsas de mandinga as thoroughly transcultural objects, and yet also as singular productions of various African groups to respond to the quotidian problems faced by the enslaved.[54] While I build on this argument here, especially in chapter 2, I expand it to show how bolsa-makers intentionally interrogated wider power structures inside the amulets they produced. This argument pushes into a potential characterization of certain bolsas as a form of resistance to slavery, as has been asserted by Rachel E. Harding.[55] Roger Sansi, however, cautions against considering bolsas de mandinga as a way enslaved people resisted their legal status. Building off Souza's conclusions, he rightly noted that few of their users were African, that most contained Catholic designs or elements, and that very few, proportionally, were used by the enslaved as a means of resistance or escape.[56] Yet Sansi's structure, where resistance seems opposed to Catholic imagery, not only discounts the radically inventive ways mandingueiros recontextualized the array of ritual symbols they encountered, it also potentially obscures what I emphasize in chapters 3 and 4: Black people's attempts at survival itself as resistance and revolutionary act in a world founded on slavery.

Significance, Insignificance, and the Scraps of Black Atlantic Cultural Production

In his 1993 text *The Black Atlantic: Modernity and Double Consciousness*, Paul Gilroy uses the image of a ship in motion as a chronotope for the Black Atlantic world. A ship, he says, "focuses attention on the Middle Passage, on the various projects for a redemptive return to an African homeland, on the circulation of ideas and activists, as well as the movement of key cultural and political artefacts."[57] Building on this metaphor, American

and British writers have credited *The Black Atlantic* with demonstrating how African diaspora cultural production is not an ahistorical "survival" of static African societies—a point expanded on later—but rather is defined by a collective memory of exclusion from the promises of modern national citizenship and political equality. As such, for Gilroy, Black Atlantic cultural formations fundamentally constitute and challenge conventional meanings of vision, identity, and modernity in the so-called West.[58]

Gilroy's focus on enslavement as an organizing principle of Black cultures intersects with long-standing investigations into the role of representations of enslaved subjects and allegories of freedom. Scholars have looked to paintings, print culture, sculpture, landscapes, monuments, consumer goods, and visual technologies—as well as to the legacies and reworkings of each of these by contemporary artists and in the public imaginary—to foreground slavery as a visualized practice of power negotiation.[59] And since, as Kimberly Juanita Brown notes, "studies of the black Atlantic and its subjectivities have always been studies of visual culture(s)," scholarship on the visual culture of slavery frequently disavows the limiting frameworks of geography, nationhood, and temporality in order to tease out the circulating webs of imagery and icons that worked, and continue to work, to render visible the intertwined dynamics of racialization and subjection.[60]

Yet in his focus on English-speaking Black people in the United States, Britain, and the Caribbean, Gilroy's work elided previous scholarship that traced the Black Atlantic's discontinuous cultural flows between Brazil and West Africa and that foregrounded the study of visual culture in this nexus. From the 1940s onward, for example, the French-born, Bahia-based ethnographer Pierre Verger utilized meticulous archival research and a relentless photographic eye to trace cultural dialogues sustained by Africans and Afro-Brazilians as they traveled back and forth between Bahia and the Bight of Benin.[61] Though Verger's project was to document the culinary, artistic, architectural, and ritual resonances between present-day societies on either side of the Atlantic, in so doing, he framed Black cultural production as a product of Black peoples' forced movements and collective agency. Thus, while in Gilroy's work Africa became a kind of absented locus for the intellectual "redemptive return" of displaced Black people, for Verger, Africa was a space of cultural dynamism linked to, but not defined by, the slave trade.[62]

Building on both these threads, *Insignificant Things* looks to Africans' movements and innovations between Africa, Portugal, and Brazil to re-

cast both the materials and discourses of the visual culture of slavery. It does this in two ways. The first is embodied in another vision of a ship, specifically the one fabricated by Haitian artist Pierrot Barra the same year Gilroy published *The Black Atlantic* (figure I.6). Its sequins, fabrics, and string—media discarded, pulled, and reassembled from the Atlantic world's transcultural storehouse—here constitute the sculpture as much as they envelop it. Performing the roles of both captain and captive, the central figure seems overtaken by the beauty and weight of that which binds it to the vessel. At home in its own dislocation, the agent of its own capture, Barra's *Boat* conjures into the present those new worlds that were forged and lost in the bellies of slave ships: a vision of African cultural production in diaspora that, following the lead of J. Lorand Matory, exists because of, not in spite of, its participation—by force and by choice—in translocal and transcultural dialogues.[63] Like many artists creating work to serve the *lwa* of Haitian Vodou—in this case, Agwe, spirit of the sea and

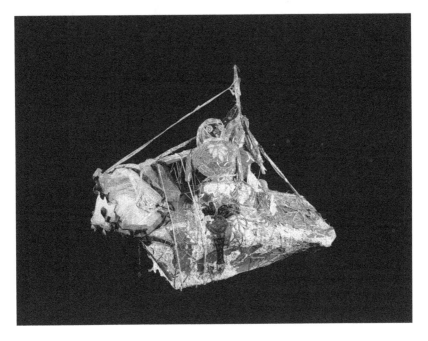

I.6 Pierrot Barra (Haitian, 1942–1999), *Boat*, 1993. Wood, satin, plastic, sequins, beads, pins, metallic ribbon, lace 86 × 45 × 94 cm (33.8 × 17.7 × 37 inches). Fowler Museum at UCLA, Los Angeles, California. Museum Purchase, Manus Fund, X94.76.7. ©Photo courtesy of the Fowler Museum at UCLA.

patron of fishermen—in the workshops of Port-au-Prince in the 1990s, Barra made new forms from inexpensive, cast-off, and recycled materials, or as Sibylle Fischer terms it, Caribbean *rasanblaj* ("reassemblage") made from "the trash in the streets."[64] In this way, Barra's vision of Black Atlantic artistic production recalls the archival methodologies of Jessica Marie Johnson, who similarly points out that any history of persons of African descent "during the period of slavery must build a narrative using fragments of sources and disparate materials," or what Saidiya Hartman calls the occluded registers and the disparate locations of the "scraps of the archive."[65] The material lives of mandinga amulets traced in this book suggest that Black artists have long created portable archives of Black Atlantic slavery and visual culture assembled from those very scraps cast off by elites.

By positioning unassuming artworks at the center of transatlantic debates over power and authority, *Insignificant Things* challenges traditional narratives about the political role of cast-off materials and ephemera, instead foregrounding them as critical interventions in the emergence of visualized racial formations. Such a framework will not be new to Africanist art historians, however. Suzanne Blier, for example, demonstrated how West African Vodun's incorporation of novel, foreign, and "detritus" materials emerged from the psychological and collective trauma of the slave trade in the Kingdom of Dahomey in the eighteenth century.[66] I also bring David Doris's idea of Yorùbá trash assemblages (*àà̀lè*) as sources of "affecting power" to bear on mandingas.[67] Paralleling their makers' experience of dislocation and recontextualization, bolsas de mandinga contained an array of items that interrogated cultural boundaries, religious orthodoxies, and artistic hierarchies, and did so from inside a small pouch engineered to facilitate transfer from person to person. In this way, the mandinga amulets of the early 1700s embody a mobile version of what Cécile Fromont has termed a "space of correlation," where their makers explored cultural transformation and sociopolitical efficacy away from the oversight of masters, inquisitors, and other elites.[68] In turn, since mandingas present one of the few cases where Europeans actively sought out objects derived from the spiritual practices of Africans, *Insignificant Things* uses the lens of accumulation aesthetics to read Portuguese Inquisition records themselves as assemblages that willingly incorporated the counterhegemonic objects they sought to suppress.

I also emphasize that mandinga amulets are not unique in their accumulative and fragmentary aesthetic principles, but rather adopted aesthetic

logics equally critical to the construction and discourse of imperial power. Consider, for example, a collage that subtly articulates the relationship between imperial visual culture and cut-and-paste aesthetics in context of the eighteenth-century south Atlantic. Produced in May 1779 by Carlos Julião, an Italian-born colonel and artist in the Portuguese army, *Elevation and façade showing in naval prospect the city of Salvador* presents a view of Bahia's capital city as its ruling classes wished it to be (figure I.7).[69] At the bottom, a row of urban types defined by racial category, social status, and cultural origin conveys the stability of social rank and structure; at the center, nine plans of Salvador's forts and garrisons collectively render the ideal of a protected and secure city; and at the top, Portuguese imperial flags fly over merchant ships crossing a panoramic vista of a bustling, productive harbor. In piecing together *Salvador*, Julião drew every fortress, ship, person, and label elsewhere, carefully cut them out, and then pasted them together on the background: a once blank slate now populated with the bricolage of empire. While these images work in concert to manifest the idealized qualities of a colonial port city, Julião's choice to bind them together in a collage highlights that dream's artificial construction. This act of assemblage

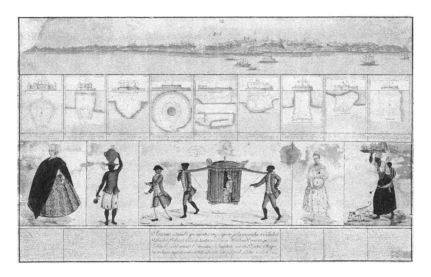

I.7 Carlos Julião, *Elevasam, Fasade, que mostra em prospeto pela marinha a Cidade de Salvador da Bahia de Todos os Santos na América Meridional . . .*, 1779. Painted collage. Gabinete de Estudos Arqueológicos e da Engenharia Militar, Lisbon. Image courtesy of the Gabinete de Estudos Arqueológicos da Engenharia Militar / Direcção de Infra-Estruturas do Exército.

calls attention to the movements and flows of cultures and identities that always link the here to the elsewhere, to that which is literally off *Salvador*'s map. The crossing of ships and bodies back and forth between Africa, the Americas, and Europe—whether entering the bay with enslaved Africans to work sugar plantations, or leaving the harbor with the refined cane sugar their labor created—was essential to Salvador's economic and political viability as a node in the Black Atlantic web.

If assembling *Salvador* from the fragmented histories and memories that circulate through the Black Atlantic constitutes the imagined colonial city, these processes of extraction, dislocation, and reassemblage also invoke its potential unsettling. Transplanting histories of enslavement and Atlantic cultural flows, as well as the ways such histories are formed through the politics of transplantation, are as much a part of *Salvador* as the military fortifications and symbolic trappings of Portuguese imperial authority: for at the bottom right, at the edge of the collage, a West African-born fruit seller carries a bolsa.[70] While this visible rendering of countercolonial aesthetics works inside *Salvador*, its piecemeal assemblage also asks us to think about what remains unseen underneath those pasted fragments, what provocations and possibilities exist along the ridges where the body, the fortress, and the flag were glued into *Salvador*.

In this sense, *Insignificant Things* foregrounds the seeming indecipherability and visual banality of bolsas not just as matters of current scholarly debate but as their core aesthetic strategies. Principles of visual indeterminacy, occlusion, and assemblage governed their production as a strategic innovation in a society marked by systemic violence and ever-shifting cultural boundaries in Africa as well as in diaspora. By hiding their internal contents, mandingueiros experimented with an ever-changing assemblage of carefully chosen activating substances; a strategy that may also explain why, as Amy J. Buono notes, art historians thus far "have largely ignored the mandinga pouches," given that "the more 'artistic' elements are hidden from view inside the pouch itself."[71] Buono's conclusion parallels that of David Doris, who in discussing Yorùbá ààlè, lightly castigates an art historical discourse that had, prior to his work, all but discounted these forms. "Some objects," he notes, "do not sit comfortably within the bounds of art history, a fact that suggests less about their inherent cultural excellence than it does about the impoverishment of an alien discourse that would seek to delimit so narrowly the possible objects of its study."[72] I cannot disagree, and indeed *Insignificant Things* represents an effort to expand how and why certain objects command the attention of scholars. But I am also

suggesting that aesthetic logic of bolsas de mandinga was intended to, in a sense, *prevent* them from being objects of study. If, as outlined in chapters 3 and 4, slavery can be understood as a set of visual practices that sought to "render black subjects transparent to a visualizing gaze" while also erasing them from public visibility, then the visually banal construction of mandingas reflects a strategic effort to reckon with the slavery's visual contradictions.[73]

Survival, Silence, and Archival Reckonings

"Survival" in this book's subtitle references two intertwined discourses in the historiography of the Black Atlantic and theorizations on the archives of Atlantic slavery. First, in the mid-twentieth century, Melville Herskovits searched for African cultural "survivals" in the context of proving the historical depth of African-descended peoples' history in the United States and the Americas more broadly.[74] Prior to Herskovits's work, most writers framed the Middle Passage, as well as the effects of plantation slavery, as ground-clearing losses from which Africans emerged devoid of cultural identity. Herskovits instead argued that an "African baseline of tradition" persisted in the societies of the Americas, and could be detected through careful analysis of Black performative, linguistic, and artistic practices.[75] The Africanist art historian Robert Farris Thompson later also sought to identify the "persisting strands of these ancestral patterns" of "African visual traditions" in the Americas as constitutive of what he coined as the "Black Atlantic visual tradition."[76]

One unfortunate legacy of Herskovits's work was a tendency in African diaspora art history to frame African societies as static, de facto antecedents to American history, as opposed to vibrant, shifting cultures that continued to evolve before, during, and after the rise of the Atlantic slave trade.[77] Indeed, one of this book's central goals is to show that the histories of mandinga amulets must be placed in dialogue with specifically historicized artistic practices on the African continent, for the collective impacts of the internal and oceanic slave trades profoundly altered cultural life there, as they did in the Americas and Europe. Interpreting amulets as a discourse of protection and survival allows for a framing of their genealogy as an ever-evolving interrogation and surreptitious appropriation of regimes of power, whether they be in the fifteenth-century West African Sahel or the halls of the Lisbon Inquisition in 1704.

As easily countered as Herskovits's work is today, his contribution was in framing African-inspired cultural practices as a counterarchive of historical evidence, an embodied record of the survival and transformation of African ideas and histories exiled from their homeland. In the words of the editors of a 2015 issue of *Social Text*, perhaps it is best to see Herskovits's work as an early challenge to "what types of evidence count when it comes to making claims about the lives of the dispossessed."[78] "Survival" in this book then also references the ongoing search for ethical engagements with the archives of Atlantic slavery. For Herskovits, slave ship registers recorded not cultural losses but important information on the origins of the enslaved, and first-person accounts from travelers in the Sea Islands and plantation owners in the US South presented incontrovertible evidence of the historical depth of African cultures in the Americas. Scholars today express new laments as they ethically approach the violence of archival production. In a 2015 essay articulating this problem, Simon Gikandi describes the archives of Atlantic slavery: "Between the dungeons on the West African coast and the shores of the Caribbean and the Americas," he wrote, "the African slave inhabits another archive, one that didn't concern itself with the unity of things that were being said or done by the European traders. In this archive, a place of pure negativity, all enslaved Africans could hope for was an occasional stammer in the cracks of European speech . . . that sought to exclude them."[79] Gikandi's summary built on arguments of the previous decade, which took the archives of Atlantic slavery as spaces strategically designed to narrate the experiences of the enslaved and dispossessed by obscuring or eliminating them. In this framework, archiving is inseparable from the production of hierarchies of power, a point that leads to ground-clearing conclusions such as those of Antoinette Burns, who argues that "*all* archives are, in the end, fundamentally unreliable" because of the power dynamics inherent to their creation.[80]

This problem has taken on a particular resonance for the critical turn in Black Studies that informs this book's methodological underpinnings. Saidiya Hartman, Christina Sharpe, and Jared Sexton, for example, have all worked to trace what they frame as the difficulties of glimpsing historical experiences of enslaved subjects through documentation intended to obscure them—an approach the 2015 *Social Text* issue editors call the transformation of "archival lack into a methodological tool. Imperial archives, these authors contend, often record blackness or black life only as an absence of human subjecthood, as when the enslaved enter the historical record as a number, a mark, or a notice of death."[81] Hortense

Spillers's landmark essay "Mama's Baby, Papa's Maybe," still fresh more than three decades after its publication, undergirds much of this thinking.[82] Implicitly defining Blackness as a series of othered subject positions that axiomatically function outside of legal orders of race and gender, Spillers argues that any effort to collectively articulate a Black identity remains haunted by what Coco Fusco terms the "originating metaphors of captivity and mutilation" that accompanied Black peoples' entrance into and formation of the modern world.[83] For Saidiya Hartman, this situation requires a kind of critical speculation that eschews citationary practices—or as Hartman terms it, "critical fabulation"—to provide an ethical engagement with the histories of those so violated.[84] *Insignificant Things* heeds these cautions, specifically Lamonte Aidoo's charge to foreground Inquisition records' "inherent silences and erasures," as the testimonies they contain were produced under the duress of harsh interrogation; where the guilt of the accused was all but presumed; and where the testimony itself was recorded by a scribe feverishly trying to keep up with the conversation unfolding in front of them.[85]

This book thus foregrounds this backdrop—a current perception of archival lack created in service of racially deterministic histories of violence; recent reckonings with modernity's continued disarticulation of Black lives; and writers' and artists' efforts to redress that disarticulation—to ask how mandinga amulets may add to or reframe it. On one level, Spillers's, Hartman's, Sharpe's, and Sexton's own archival sources, primarily from the nineteenth- and twentieth-century English-language United States, played a role in framing their own conclusions. By contrast, the records of the eighteenth-century Portuguese Inquisition veritably overflow with testimonies and personal details: Luiz Mott properly characterizes the more than 40,000 inquisitorial records held at the Torre do Tombo National Archive in Lisbon as an "inexhaustible source of information" on the lives of "Luso-Afro-Brazilians."[86] When in 2014 I first saw Jacques Viegas's amulet in this archive, its mutual entanglement with the surrounding inquisitorial trial record forced me to reckon with this scholarship that to that point undergirded most of my writing, for that amulet materializes the survival of Jacques's life in the heart of the archives of Atlantic slavery. His mandinga may well be the oldest surviving object produced by an African enslaved in the Atlantic trade whose name and biography are known with some certainty. And throughout this book we will see how mandinga amulets facilitated broad, independent, even transoceanic African-led social networks that remained largely outside the vision of inquisitorial authorities.

But recall that the central function of mandinga amulets was to protect their users from bodily violation. Hartman's writings rightfully take her readers to task in asking what would it mean to develop a critical practice of finding a means of survival in these archives, to map the quotidian, even banal work of what Christina Sharpe names "living in the push toward our death."[87] For Hartman and Sharpe, the creative labor of making and caring for Black lives in the constant wake of Black death necessitates charting paths forward through slavery's archives not as a matter of scholarly access or intellectual labor, but as an ethical imperative in order to, as Stephanie E. Smallwood summarizes, "piece together a picture of a place, a time, and an experience that does not otherwise figure in the archival record."[88] In their own ways, these authors thus collectively ask that we interrogate what goes into framing an object as archival, for the term presumes a disconnection from living communities and ancestors which—as Sharpe insists— necessitate continued care and protection. Bolsas de mandinga, at least as produced and utilized by all those who sought refuge from violence—in particular African, Black, and enslaved clients—seem to have already responded to the imperative Sharpe, Hartman, and Smallwood each outline. For as their users consistently noted, the work of mandingas was to materialize survival as an everyday activity, to pull together from the transcultural storehouse of Black Atlantic material culture to fabricate new ways of simply living and being in a violent world predicated on their subjugation.

And yet the two connotations of survival embodied in Jacques's amulet rest against the reality that in the end, Jacques's amulet did not protect him from the violence of the Inquisition, of repeated exile, or of the archival registers that remain the only evidence of his life. Indeed, the casual, matter-of-factness with which his trial record inscribes his final punishment exists in tension with the protracted and bureaucratic protocols of care that remain in place for the preservation of the amulet he used. Kept in a climate-controlled storeroom and accessible to researchers only with a series of high-level permissions, the designation of his object as archival ensures its continued survival on the precondition of its nearly sanitized disconnection from those who made and used it, or those descendants who still require its protective powers to resist ongoing threats to Black life.[89] As such, the "art of survival" deployed in this text is an effort to take up, and rest uncomfortably inside, the contradictions of finding an object charged with the preservation of Black lives inside an archive predicated on its erasure. The amulet's literal binding into the inquisitorial record materializes

Protection of objects ≥ people

their mutually dependent dialectic. As such, I consider that binding as a reflection not on the amulet's failure to protect its owner, nor on the seeming inability of the inquisitorial archive to incorporate it physically or conceptually. Rather, I see it as what Munira Khayyat, Yasmine Khayyat, and Rola Khayyat frame as a one of many "unexpected genealogical sources" of the archives of slavery, sources one should "should claim rather than disavow."[90] The bolsa and the Inquisition record mutually informed each other and coevolved by pushing and pulling against the discourses and possibilities the other embodied, sometimes literally, as we will see in chapter 3, when a particular bolsa used in Lisbon incorporated documents produced by inquisitorial authorities. In their mutual entanglements, these two necessarily incomplete archives dialectically embody the dual threads of violence and visualization.

The Chapters

The book's four chapters, placed in chronological sequence, progressively trace the history of mandinga pouches from their named emergence in sixteenth-century Senegambia through their use in the Revolt of the Malês, a major rebellion led by enslaved Africans in Bahia, Brazil in 1835. Each chapter also functions as a stand-alone analysis of a specific aspect of the pouches: the first chapter considers the objects' names, the second their form and contents, the third and fourth their use. While Jacques Viegas's story serves as the unifying opener for the book's first three chapters, each chapter also expands out to further trials, such as the case of Crispina Peres, a woman arrested in Bissau in 1656 accused of a series of religious crimes; Vicente de Morais, an Mbundu soldier at the Portuguese garrison of Muxima, in Angola, arrested in 1716; José Francisco Pereira and his partner José Francisco Pedroso, two prominent mandingueiros arrested in Lisbon in 1730; and finally José, a Yorùbá man arrested in Salvador, Bahia, in 1835. In each case, I work to flesh out the scant information in the trial record with a critical reading of its silences, but I also add to them with contemporary accounts, archival information, and religious records that illuminate both the inquisitorial and wider cultural context.

Chapter 1, "Labels," begins by noting that while the object Jacques used was called *mandinga*, at his Inquisition trial he identified himself as *Mina*. The chapter uses this point to trace the parallel emergence of *mandinga* and *Mina* as labels for peoples and circulating commodities in the Atlantic

between the sixteenth and early eighteenth centuries. Making use of extensive new analyses of travelogues, engravings, maps, dictionaries, and select inquisitorial cases, the first half of the chapter shows how and why the Portuguese rendering of the ethnonym *Mandinka* was slowly de-coupled from its West African ethnic referent, and, by 1700, emerged as a widely known synonym for *feitiço* (from which derives "fetish"), a word referring to a range of invisible malevolent forces as well as to the material objects that controlled, manipulated, or counteracted them. Principally, this occurred because of foreigners' confusion over the profusion and globally sourced variety of apotropaic objects used in Senegambia's pluralistic coastal societies (often by persons calling themselves *Mandinka*), which collectively confounded their expectations over the sartorial and material performances of religiosity. This ironic effort to define Mandinga-ness as a form of cultural ambiguity leads to the chapter's second half, which notes how the term *Mina* emerged as an ethnonym used to mark those captured and sold in the Bight of Benin. Many of the mandingueiros arrested by the Inquisition in Portugal and Brazil identified themselves using this term. Thus, Atlantic-wide cultural discourses created new labels (Mina) for those people made into objects (the enslaved) at the same time a group of objects (mandingas) radically transformed the meaning of the ethnonym that marked them. Providing new context for debates about the rise of African ethnonyms in the wake of the slave trade as well as for the continuing debates over how to label the origins of African objects, the chapter uses the framework of labeling to place African mandingueiros at the forefront of contemporary debates over the rise of classification and the role of origins.

Chapter 2, "Contents," begins by reproducing the list of the contents of Jacques Viegas's mandinga pouch written into his Inquisition trial, before reproducing and analyzing scores of ekphrastic descriptions of the contents of mandinga pouches that typically accompanied their confiscation and placement in Inquisition records. In so doing, the chapter builds on the debates about classification begun in the previous chapter to position enslaved Africans—so often reduced to passive victims in an emergent early modern system of global material circulation—at the forefront of early modern collecting practices. Pushing against previous scholarship's reliance on terms like *Catholic*, *Islamic*, and *African* to label the contents of the pouches, this chapter shows that debates over the alternately quotidian, foreign, and liminal contents of mandingas were in fact some of the first arenas in which such terms were debated, challenged, framed, and defended. Methodologically, the chapter takes stock of the

mélange of contents described inside the pouches by drawing close parallels between strategic practices of assemblage and occlusion, the rise of the Atlantic discourse of fetishism, and the rise of early modern collections to position Africans as key interpreters of objects on the move. To that end, the chapter uses against-the-grain readings of inquisitorial testimonies to re-create the circuits of material exchange and sale among and between mandinga-makers and users, even between Brazil and Portugal, thus showing how enslaved Africans managed to maintain, in some cases, transoceanic networks of commerce and exchange. The chapter's second half delves into the contents assembled by one mandingueiro, José Francisco Pereira, around 1730, to carefully trace how he created mandingas to subtly challenge Portuguese claims to authority over their empire and his life. Drawing analogies between the contents of José Francisco's pouches and materials drawn together from archives and museum collections in Africa, Europe, and Brazil, the chapter offers an analysis of José Francisco's intellectual orientations to show how the objects he made critically reframe circuits of exchange, classification, and modernity in the Black Atlantic.

Chapter 3, "Markings," begins by foregrounding two aspects of Jacques Viegas's case: first, that his pouch—like many others—contained paper as a key constitutive element; and second, that the pouch he used was meant to protect him from bodily violation. Responding to Hortense Spillers's outlining of the intimate relationship between archival writings and markings of violence against the enslaved, the chapter investigates the common incorporation of written papers in mandinga pouches as challenges and reckonings with imperial archives, inquisitorial procedure, and the expectation of enslavement as a condition defined by embodied violence. Providing a series of close analyses of unpublished handwritten papers, drawings, and orations once contained inside mandinga pouches and today sewn into inquisitorial records, the chapter first traces how the act of inscribing designs and words with ink onto paper and placing them inside the mandinga pouches emerged in conversation with wider practices of inscription in the African diaspora. Yet the papers also demonstrate how their users strategically reconceptualized, or took advantage of, fluid relationships between papers, bodies, and textual evocations in order to respond to otherwise contemporary theorizations of the simultaneous "hypervisibility" and "invisibility" of enslaved subjects and the obfuscated legibility of Black histories in the archives of slavery.

Chapter 4, "Revolts," investigates the prominent use of leather pouches containing Islamic prayers by Yorùbá participants the 1835 Revolt of the

Malês. This event, for the first time, clearly demonstrated the revolutionary possibilities contained inside these amulets, alternately labeled *mandinga* and *patuá* during in this period. Analyzing the trial records of revolt participants, the chapter ties together the discourses from each of the previous three chapters: the shifting roles of ethnic and object-labeling among the revolt's participants; the role of writing, particularly in Islamic talismanic papers; and the amulets' stated ability to protect their users from violence while attempting to overthrow Bahia's slavery society. As such, the chapter also seizes on a series of contemporary responses to the revolt, which launched a widespread fear not just over African cultural practices, but over long-hidden underground systems of material and information exchange through such pouches: a kind of "revolutionary aesthetics" dormant in unassuming objects and their contents. The book concludes with a coda considering the links between resistance and agency in African diasporic thinking, and the implications of this link for the visualization and interpretation of African-associated objects.

Labels

On July 8, 1704, as he attempted to defend himself against accusations later summarized as "the use of fetishes" (*usar de feitiçarias*), Jacques Viegas delivered his initial confession before the Holy Office's interrogators in Lisbon.[1] "A year ago, more or less," the transcription reads, Jacques sought to acquire a "mandinga" that "could free him from being hurt"; a quest undertaken after Jacques got into a physical altercation with two others near the Carmo Convent in Lisbon's Bairro Alto neighborhood.[2] Jacques's experience with this object echoed a similar accusation leveled against him four years prior, when a man named Gerónimo Vaz da Cunha testified that Jacques had a "mandinga . . . or something else that would impede peril with moderate force of a sword," because, Gerónimo reasoned, if Jacques did not have a mandinga, he would not have exposed himself to be wounded during their encounter.[3]

Why did Jacques and Gerónimo—neither of whom claimed Mandinga ethnicity—use that West African ethnonym to refer to apotropaic amulets in Lisbon? Their use of the term was not unique. In the early 1700s, people in Portugal, Brazil, Senegambia, and Angola used *mandinga* to refer to a range of amulets as well as to the otherworldly powers they contained. As the Atlantic slavery system converted human beings into objects defined by their valued labor, why did the circulations of peoples and materials it facilitated also create a new set of valued material relations—amulets—identified with an ethnonym disconnected from those from whom it originated?

This question carries implications beyond the historical particularities discussed in this chapter. Since Frantz Fanon first acknowledged that the visualized fact of his racialization and the resulting shock of his Blackness caused him to declare he was "an object in the midst of other objects,"

Black studies has sought ways to fracture the linkages between Blackness and "that crushing objecthood."[4] Taking stock of its Atlantic odyssey, however, *mandinga* slips across the space between bodies and objects in ways that interrogate Blackness' relationship to objectification. While pressuring typologies of racial classification, the discursive history of *mandinga* also questions the ethics of applying ethnic labels to those African objects which, like those persons transported across the Atlantic, find themselves outside the continent. In turn, by focusing on the discursive history of one term, this chapter foregrounds the formal promiscuity of mandinga amulets as an art historical problem and creative strategy. Typically defined by function as opposed to form, *mandinga* evolved over the course of the seventeenth and eighteenth centuries to describe the materialization of a set of interrelated apotropaic powers, that is, the ability to fend off malevolent forces. In so doing, the discourse of *mandinga* engendered debates about the very relationship between material values, spiritual power, and cultural identity.

Looking to West African ritual sculpture and amulets, European-language accounts of West African life, eighteenth- and nineteenth-century travelogues and engravings, dictionary definitions, inquisitorial testimonies, and cartography, this chapter traces the multidirectional evolution of *mandinga* as an ethnonym and a material manifestation of sorcery. It was in the thirteenth-century West African Sahel that Mande-language oral histories first referred to the territories of the Mali Empire as Manden (or Manding), while the name for its inhabitants, *manden'ka*, entered Fula languages as *Malinke*, English as *Mandingo* and *Mandinka*, and Spanish and Portuguese as *Mandinga*.[5] By the early sixteenth century, *Mandinga* also circulated as an identity moniker for Africans enslaved in, or originating from, a broad region in Mali's former western territories around the Gambia and Casamance rivers. Through the nineteenth century, Mandinka-identified Africans—enslaved and free—made lives and livelihoods in the Spanish Viceroyalties of New Spain and Peru, in colonial Brazil, in Cuba, and in British America. But in their uses of the term, Jacques Viegas, Gerónimo Vaz da Cunha, Manuel (the enslaved African who first sold a bolsa de mandinga to Jacques), and their inquisitors referred neither to the cultural origins of the amulet they used nor to the ethnic identity of those who produced it. Instead, they and many others across Brazil and Atlantic Africa used *mandinga* to refer to any object, but especially pouch-form amulets, whose complex materials (*feitiços*) manipulated unseen forces, also called feitiços, to protect those who used them:

a discourse commonly rendered in Portuguese as feitiçaria and in English as "sorcery."[6]

Mandinga, however, was but one of many labels for Africans' varied amuletic practices across the Atlantic world. A 1758 French decree passed in Saint-Domingue, for example, expressly prohibited enslaved and free persons of color "from composing, selling, distributing, or buying *garde-corps* or *makandals*"—protective talismans whose names reference, respectively, "bodyguards" and the legendary maroon leader François Makandal, who was widely claimed to have specialized in their production.[7] Other French authors writing in Brazil, West Africa, and Louisiana as early as the mid-sixteenth century referred to Africans' amulets as *gris-gris*, a term of likely transcultural derivation often rendered in English as *greegree*.[8] The term most commonly applied to objects Africans invested with otherworldly abilities, however, crossed European languages: *fetisso*, *feitiço*, or *fétiche*, from whence derives "fetish." In 1975, the "abundance of terms" applied to these works inaugurated the very study of what Arnold Rubin terms "power objects," to move past the imprecision of "charm, amulet, talisman, 'medicine,'" and the burdened colonialist mentalities of "fetish," which, for Rubin, obscured underlying African aesthetic principles.[9]

However, as William Pietz influentially argued in a series of articles attempting to historicize and revive the term's critical utility, *fetish* emerged in the context of attempts to make sense of the conflict between radically distinct, yet newly intertwined, social and cultural systems on the West African coast in the sixteenth and seventeenth centuries.[10] "A novel object not proper to any prior discrete society," Pietz argued that the "fetish"—in part defined by its "irreducible materiality"—responded to what he characterized as an "unprecedented" situation of intercultural encounter.[11] In this context, the fetish's novel conceptualization—distinct from its etymological origins as term for witchcraft in Medieval western and southern Europe—came to embody the impossibilities of cross-cultural translation by expressing the "problematic of the social value of material objects as revealed in situations formed by the encounter of radically heterogeneous social systems."[12]

By contrast, this chapter shows that encounters between systems of radically distinct social and religious values were by no means new to those living on the African continent when overseas merchants arrived. Though a term of European import developed to describe debates over the value of objects on the West African coast, *mandinga* may inaugurate and extend the discourse of the fetish back to the amulets that circulated through the

Sahel prior to the rise of the transatlantic slave trade in the early sixteenth century. While in the sixteenth and seventeenth centuries the intensification of the Atlantic slave trade led to a concomitant rise in human trafficking on African coast from Senegambia to Luanda, those who arrived there from Europe inserted themselves into centuries-old processes of sociopolitical hierarchizing, migration, and cultural change instrumental to the conceptualization of the objects termed *mandinga* at Jacques's trial. In other words, the space of intercultural encounter critical to the development of fetish, as Pietz argues, looks far less "unprecedented," far less "novel," when those cultural and material histories begin in Africa.

If inquisitorial testimonies are taken as an effective mirror of popular discourse, then the understanding of mandinga-materiality as a kind of unseen material efficacy developed in an Atlantic conversation between, among other locales, Cacheu, Angola, Pernambuco, Rio de Janeiro, and Lisbon almost simultaneously at the turn of the eighteenth century. The term's wide range suggests that captive Africans used, defined, and employed *feitiço* and *mandinga* to navigate shifting and stark power asymmetries, a fact that asks for a potential reframing of *fetish* from a discourse of European modernity to one that—as inquisitors in Lisbon implicitly acknowledged—placed a distinct set of pressures on it.

Mandinga operates distinctly from the multiple labels for African-associated amulets previously cited. While such terms often depend on their linguistic context, *mandinga* uniquely connotes both sorcery and an ethnonym. It thus stands out against recent efforts to reckon with the complexities of ethnogenesis and West and West Central Africans' communal identities in the wake of the slave trade. The system of Atlantic slavery, as Hortense Spillers reminds us, was ultimately a violent and violating discourse of classification and redefinition of those captured in it, wherein "the destruction of the African name, of kin, of linguistic and ritual connections is so obvious in the vital stats sheet that we tend to overlook it."[13] While classifying certain human bodies as objects, and in defining them through labor output and speculative capital, from this nexus also emerged new and reimagined labels for communal identities in Africa and the Americas. When Jacques Viegas used a mandinga amulet, he labeled with that object a centuries-old West African ethnonym that carried quite different connotations from the term he used to describe himself: *Mina*, a term that in this case was used by Portuguese enslavers to broadly refer to captives who embarked on ships in present-day Benin and Togo.[14] Jacques Viegas's case thus shows, on one level, how Africans in the wider

Atlantic took up, identified with, or cast off such labels in their efforts at community-building in the new worlds in which they found themselves.[15] But on another, it shows how Jacques Viegas, and other mandingueiros, used the discourse of *mandinga* to map new possibilities for self-fashioning and self-actualization in a world that defined them as objects.

Mandinga Origins: Talismans and Translation, ca. 1300–1600

A primarily savannah landscape at the southern edge of the Sahara, the Sahel (Arabic for "shore") has long acted as a crossroads of trade and migration, owing to its interstitial location between the desert and the forested tropical lowlands. In the eleventh century, as the main sources of the Saharan gold trade shifted south to Buré in the Upper Niger valley, centralized and hierarchical systems of political organization developed in the western Sahel.[16] By the end of the thirteenth century, these polities coalesced to form the Mali Empire.[17] Stretching from Gao in the east to the Atlantic coast of Senegambia in the west, the Mali Empire dominated the region which, between the twelfth and sixteenth centuries, was the world's leading supplier of gold.[18] Many traders converted to Islam during this period, as the religion's development and spread in West Africa was closely tied to the expansion of trade routes and the influx of wealth and competition they fostered. While Mali's elites tended to adopt Islam wholeheartedly, most of the trade on which their prestige depended took place in predominantly non-Muslim areas. For example, the fourteenth-century Arab historian Al-'Umarī attested that Mansa Musa, ruler of Mali, "stated that there are pagan nations . . . in his kingdom from whom he does not collect the tribute (*jizya*) but whom he simply employs in extracting the gold from its deposits."[19] As such, Mali's emperors, as Toby Green notes, "had to be able to manifest Islamic and African narratives and rituals" in their performances of authority.[20]

To be clear, Green argues not that Mali's emperors held onto a series of "Islamic" practices as distinct from "African" religiosities, but instead that what any given person defined as "Islam" in the Sahel could shift depending on their own cultural and economic priorities. The term *dyula* (or *Wangara*) perhaps best exemplifies this point. Broadly, these terms referred to an emergent class of itinerant, long-distance gold traders whose movements across Saharan trade routes embodied emergent discourses of religious

pluralism and shifting identity markers.[21] As Mande speakers familiar with Islam, the dyula embodied the cultural fluency necessary to move between the Sahel and traders in north Africa. For example, al-Hajj Sālim Suware, a scholar from central Mali, preached that dyula should practice pacific coexistence throughout their journeys.[22] Suware's arguments may have had an economic motivation. As trade routes expanded and Islam gained increasing influence among Mali's elites, dyula relayed how gold deposits often held ritual significance to those who guarded them, and that access to their precise location was restricted to elites and high-level ritual initiates. Dyula thus argued they had to respect the local practices they encountered in order to facilitate the gold trade—an argument that also conveniently positioned them as the only ones with the cultural brokering skills able to do so.[23] In the ensuing centuries, Muslims across the Sahara and the Sahel willingly adapted their religious practices to emerging class hierarchies and existing rituals, resulting in an "accommodationist" version of Islam that emerged, in Toby Green's terms, as a "necessary hallmark of West African life."[24] Suware's teachings thus preface Paulo F. de Moraes Farias's argument that Islam was actually "freely imported" across western Africa, and thus it "makes no historical sense to oppose what is West African and what is Islamic": a statement of open religious pluralism that will emerge as a theme in this book.[25]

As they developed in wider and later Atlantic networks, amulets continued to recombine and redefine the material manifestations of Catholicism, Islam, and African religions. During the rise of the Sahelian gold trade, protective amulets (Arabic: *ṭilasm*, *tamīna*, *ḥijāb*, or *ḥirz*) first took on their pivotal role as material embodiments of interreligious currency and agents of cross-cultural translation. Of a variety of forms, most Sahelian amulets were leather pouches filled with Qur'anic papers.[26] Placed on walls or doorways, worn as single amulets around the neck, or on larger necklaces or strings across the chest, their use among all peoples in areas adjacent to the Saharan trade was, and remains, common to the point of ubiquity.[27] While contemporary records rarely describe the amulets used during the Mali Empire's apogee in detail, accounts from the twentieth century testify to their later proliferation and multifariousness. For example, in the 1960s art historian René Bravmann noted the placement of a variety of Qur'anic amulets in "every conceivable portion" of the Nafana family royal compound in Banda, in west-central Ghana.[28] Often formally indistinguishable, they were primarily classified by use: anti-witchcraft amulets (*soubalakari*), amulets for protection against evil speech and thoughts

(*nedoudougoulakari*), and amulets for protection against physical dangers (*neguelakari*) all covered the paramount chief's horse's room, the walls of the washroom and the royal reception hall, and the doorway to the sleeping quarters; indeed, they were deemed "absolutely necessary" for the protection and proper functioning of the royal household.[29] This is not to suggest that only elites and royals utilized these amulets. Indeed, people across all social classes sought these amulets as forms of protection. As I will speculate, amulets gained a wide demand precisely because of—not despite— the security and power they seemed to provide elites and oppressors.

Though few of these amulets survived from before the nineteenth century, and no travel accounts prior to the nineteenth century reproduce images of them, an example today held in the collections of the Science Museum in London resonates with representations on Sahelian wooden statuary produced during the Mali Empire's height (figure 1.1). Designed as a necklace—and thus easily mobile and practical for someone who traveled long distances—it incorporates leather containers of varying sizes, each one embossed with a geometric design. A small leather-covered horn and two copper bells, one also encased in leather, complete the necklace. The designs on the leather pouches echo those inscribed on talismanic murals, papers, and objects utilized across Sahelian architecture and personal adornments.[30] In turn, the unseen contents of each likely contains papers inscribed with Qur'anic verses or further talismanic inscriptions. Most likely the papers contained in these pouches are *fawā'id* (sing. *fā'ida*): often, though not exclusively, Qur'anic texts understood to intervene in natural and human events.[31]

The talismanic use of Qur'anic writings and scripts remains widespread across all social classes throughout the Islamic world. Yet the critical, and occasionally singular, inclusion of Qur'anic papers inside amulets testifies to the close linking of economics and religion in their initial development in West Africa. During the Mali Empire's apogee, traders' novel use of written Arabic undergirded the development of a complex bureaucracy to manage the logistics of gold trading, while adherents also carried with them a strong belief in the apotropaic efficacy of the Qur'an's materiality, leading to the increasing use of written papers as an inclusion in amulets.[32] Itinerant clerics made their livelihoods selling amulets along with promises of their efficacy, while scholars debated the Qur'anic permissiveness of the magic (*siḥr*) they embodied.[33] But the very production of these amulets could call into question the Qur'an's textual authority since, as Constant Hamès has noted, "instead of taking the wording of the text [of the

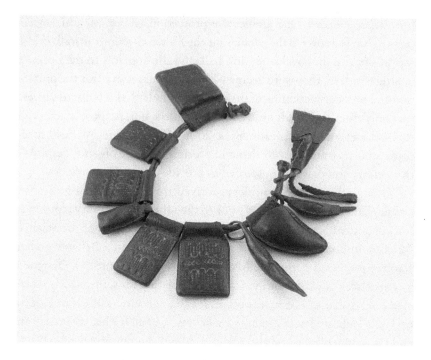

1.1 Amuletic necklace, northern Nigeria, 1880–1920. Copper, bell, and leather. Science Museum Group Collection, London, A658410. Image © The Board of Trustees of the Science Museum.

Qur'an] as it stood," talismanic papers "subjected [it] to transformational procedures."[34] By folding the paper into tight squares, and adding talismanic drawings or designs, amulet-makers "enrich[ed] the possible uses of the written word" and enacted the Qur'an's apotropaic potential beyond its text: a point to which I will return in chapters 3 and 4.[35]

By the nineteenth century some Qur'anic amulets held pride of place in elite contexts. In the 1820s, for example, British consul Joseph Dupuis described their importance in the royal regalia of the Asante state, wherein an *asantehene* (Asante monarch) donned cloth amulets and a piece of cloth covered in Arabic writing during his enstoolment ceremony, a practice that continued at least through the early twenty-first century.[36] For contemporary Sahelian elites, amulets' wide appropriation became symbolic of a regrettable dilution of their version of Islam, one made necessary by the accumulation of wealth and capital.[37] At the end of the fifteenth century, Askia Muhammad, the ruler of Songhai from 1493 to 1528, decried those who claimed "they can write [talismans] to bring good fortune, such

as material prosperity or love, and to ward off ill fortune by defeating ene-
mies, prevent steel from cutting or poison from taking effect."[38]

Askia Muhammad's observation was not strictly directed at his own
subjects. As Mande dyula used and purveyed these amulets across the Sahel,
Senegambia, and in new trading areas south toward the Gold Coast, their
use among non-Mande peoples was likely linked to the cosmopolitanism
and foreign prestige associated with dyula. In turn, the intensification of
gold trading in the Sahel also brought with it Mali's and Songhai's mil-
itarization of the region to protect and manage trading routes. A figure
dating from around the turn of the fifteenth century explores the links be-
tween Sahelian migration, wealth, and communal protection during this
period (figure 1.2). Its creator was likely part of the Soninke diaspora: trad-
ers who had migrated from the former Ghana Empire (Wagadou) in the

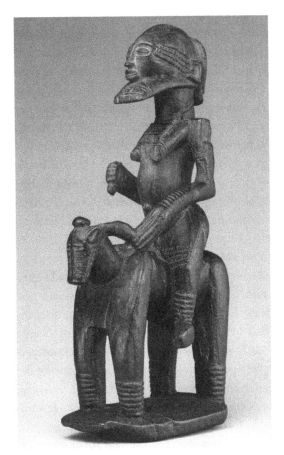

1.2
Unrecorded Son-
inke artist, Eques-
trian figure, ca. 1400.
Wood, 54.3 × 16.5 cm
(21.38 × 6.49 inches).
Private collection.

western Sahara who began speaking Mande languages as they incorporated their former trade routes into Mali's purview.[39] Its equestrian subject wears a pouch-form amulet, while anklets appear around the legs of the horse and rider. This figure was likely produced during the expansion of Mali's cavalry. Its equestrian stance and decoration echo Al-'Umarī's description of the golden bracelets, necklaces, and anklets donned by Mali's cavaliers as emblems of their bravery.[40]

This period also saw the expansion of human trafficking to supply laborers to carry gold to trading centers in the forested lowlands south of the Sahara. These areas were home to the tsetse fly, which caused sleeping sickness that was deadly to horses; through the early twenty-first century, the forest-line still largely marked the boundary between the predominantly Muslim north and predominantly Christian south. But in the Sahel, equestrians became symbolic of an increasing divide between rulers and subjects in a hierarchical society.[41] In turn, in a militarized state, equestrian soldiers also needed to outfit themselves and their animals with protective amulets. Fittingly, Mali's cavalry often brought in their retinue *nyamakalaw*: leatherworkers and blacksmiths responsible for producing not just the cases for talismanic amulets like those worn by cavalry and depicted on the figure but also likely the figures themselves.[42] The incised zigzag pattern on the figure's neck amulet—repeated on its beard and other locations across its body—was likely carved with metal tools, which further suggests this possibility (figure 1.3). Thus, rather than considering amulets as products of a singular African origin, this figure visualizes how the production, dissemination, and ownership of amulets was intimately bound to the intensification of pluralistic religious networks, militarized political expansion, and gold trading in the Sahel. A Moroccan historian writing in 1724, for example, attested that when Askia Ishaq II, ruler of Songhai, attempted to defend against the 1591 invasion by Timbuktu, he was "not satisfied with the forces he had assembled until he added to them the leaders in witchcraft . . . as well as the masters of talismans and magic."[43] And in 2013, Alamany Kané, village head of Bassidialandougou, told a team of interviewers that "war has never touched" his region because of the "great *connoisseurs*"—keepers of hidden knowledge, well-known as amulet-makers—who had always lived in his village, including during the period of Mali's bellicose expansion.[44] These talismans were, in turn, also bound to the intensification of the Saharan slave trade, as protective amulets in a sense made possible the forms of personal protection necessary for the waging of war, defense against invasion, and the capture of prisoners

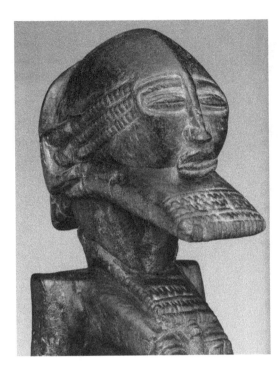

1.3
Detail of figure 1.2, showing incised neck amulet.

for enslavement.[45] In some later cases, the relationship between slave trading and amulet-acquisition was explicit: by the early nineteenth century, Asante rulers reportedly paid up to "the value of thirty slaves" for cloaks covered in leather amulets.[46]

Amulets' connotations of cosmopolitan connection and personal protection also made them a pragmatic acquisition for those fleeing or resisting the increasing violence, ritual destabilization, and internal migrations that emerged as byproducts of increased competition for gold and human laborers during Mali's expansion. Dogon peoples' migration to the relative protection of the Bandiagara escarpment in the fourteenth century, for example, was likely a response to these factors.[47] A figure dating as early as the fifteenth century, collected in the village of Tinntam in present-day Mali, shows the overlapping ways power, prestige, and protection sartorially coalesced in Dogon ritual contexts (figure 1.4). Though we lack specific historical information about this figure, its considerable weathering and libation residue suggest that it likely once played a prominent role in a local community shrine: one that, as a 2013 archaeological team in Mali has suggested through their own work around Segou, may have

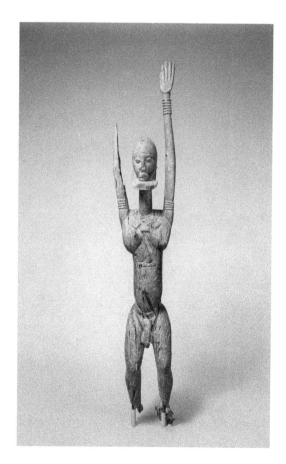

1.4

Unrecorded Dogon artist,
Male figure with raised arms,
ca. fourteenth–seventeenth
century. Wood, patina,
210.5 × 36.2 × 21.3 cm
(82.87 × 14.25 × 8.39 inches).
Metropolitan Museum of Art,
New York, 1978.412.322.

functioned to unite its village into broader political structures through a system of "shrine franchising" wherein objects and elements from pre-existing, or displaced, shrines are reassembled together to create new loci of sacred protection and collective identity.[48] Only this figure's original owners could speak to the meaning of its iconography. Its arms raised in the air, the figure's precisely carved beard suggests its subject as an elder of some political and social stature.[49] A string of pendants around the figure's neck (figure 1.5) and belt further testify to the figure's protection, while its wristlets and anklets speak to conspicuous wealth: iconography that collectively highlights the social, spiritual, and ritual authority critical to a displaced community under threat.

The preceding examples suggest that independent of the names applied to them, the rich cultural economy of talismanic objects in thirteenth- to sixteenth-century West Africa echoed, if not inaugurated, the

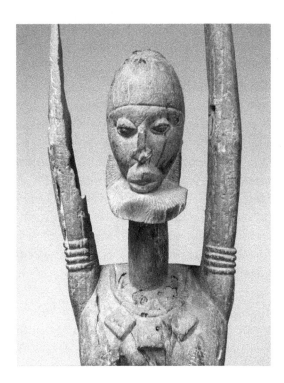

1.5
Detail of figure 1.4, show-ing neck amulets.

later discourse of *fetish* precisely by embodying the problematics of cross-cultural translation in and between, to use Pietz's words, the "radically heterogeneous social systems" that have always characterized the Sahel and, indeed, all of Africa.[50] As centralized, militarized, and trade-oriented states like Mali and Songhai rose and grappled for power in West Africa, their Muslim rulers willingly turned a blind eye to amulets' carefully se-lected and recombined sacred texts, leather, and fauna. They permitted this because the manifold iterations of amulets facilitated an intercultural economy of trade in gold and, later, human beings.[51] At the same time, their protective functions simultaneously underscored and countered the violence and internal migrations that accompanied these economic shifts as well as the persistence of older systems of social organization they had to tolerate (such as, for example, the ritual associations of Saharan gold deposits). And, as the next section outlines, while Mandinka themselves would not, at this period, have defined any of these amulets as strictly associated with their own ethnonym, the development of the discourse of the feitiço soon intersected with new forms of Mandinka identity on the West African coast.

Mandinga Identity and Religion on the Upper Guinea Coast, ca. 1500–1668

In the fifteenth century, the Mali Empire began to decline as it faced competition over trade routes. As Songhai rose in the eastern Sahel, Mali's centers of trade shifted toward formerly neglected western provinces in the Gambia and the Casamance.[52] This shift coincided with the first arrivals of Portuguese seafarers in the mid-fifteenth century, spurred by reports of gold arriving in the Upper Guinea coast between Senegal and Sierra Leone, whose merchant centers the Portuguese administered through Cape Verde.[53] Coastal towns soon saw an influx of traders formerly subject to Mali as well as Portuguese Catholic merchants.[54] Meanwhile, "New Christians" (*cristãos novos*)—mostly Judaism practitioners forced to convert to Christianity by the Portuguese king Manuel I in 1497—entered the area in order to escape the Inquisition.[55]

By the middle of the sixteenth century, the sixty miles of coastline between Dakar and Joal contained a significant Jewish population, with some settlements having a majority population of New Christians.[56] By the late 1600s, those settlers who married locally became known as *lançados*: those who had "thrown" (*lançar*) themselves into local society (or thrown themselves out of Portuguese-ness). Lançados generally lived on the outskirts of settlements, avoiding Portuguese laws and taxes. But this also meant that by marriage and social position, lançados were bound to African structures of social reciprocity and filial obligation to their African relatives; as such, they had clear stakes in local cultural practices.[57] Functioning as merchant intermediaries between traders coming from the Atlantic Ocean and those coming from the Sahara, their new social position exemplified a world impacted by the cultural flexibility underscored by Mandinka expansion.[58] Pulling from Catholicism, West African Islam, and other local practices, lançados' religion exemplified this flexibility. Jesuit missionaries in the area relied on lançados for converting the local population and engaging in local trade.[59] However, Portuguese Catholics' dependence on lançados often engendered frustration: for one sixteenth-century author, lançados cooperated "with the idolatrous heathen in the practices and sacrifices of their false religion, erect[ing] huts and build[ing] pedestals for their infernal idols. The lançados are truly 'run-aways' . . . from the Lord's grace."[60]

In the absence of Arabic-language sources for this period, historians look to Portuguese-language accounts describing the increasing Mandinka

presence in Upper Guinea. Therein, claims to Mandinka identity gain economic and cultural prestige, particularly as traders of gold, ivory, and human beings. In the early sixteenth century, the Lisbon-based printer Valentim Fernandes defined Mandinka Muslims specifically as slave traders who bring "blacks as their goods," an account no doubt informed by the recent rise in human trafficking on the coast.[61] Fifty years later, João de Barros not only termed the Mandinka as the most prominent traders in the Saharan interior and on the Gambia River, but also emphasized the merchants who went to Timbuktu on "account of all the gold that is carried there from the great province of Mandinga," even though Songhai controlled Timbuktu at the time, and Mali's power had considerably declined from its apogee.[62] By 1625, the Cape Verdean trader André Donelha simply described the Mandinka as the "greatest traders there are in Guinea."[63]

While traders formerly dependent on Mali did move into Upper Guinea, the aforementioned accounts are best read as testaments to how the adoption of Mandinka identity markers became crucial to trading in the region.[64] As Walter Rodney summarizes of this period, "one of the consequences of Mandinga supremacy was that other groups were constantly seeking to attach themselves to and 'pass' as Mandinga."[65] Indeed, in the early 1500s, the Portuguese sea captain and author Duarte Pacheco Pereira argued that peoples in Upper Guinea were actively adopting the Mandinka language and Mandinka cultural customs.[66] By the early 1600s, rulers in present-day Sierra Leone even took Mandinka eponyms.[67] Other accounts suggest that Portuguese authors unintentionally emphasized the imperial connotations of Mandinka identity claims: a point likely underscored by traders themselves.[68] In these accounts the Mandinka emerge as a culturally superior imperial people, whose distant trading empire was "like a surrounding wall" behind coastal Senegambia, and out of the reach of the foreigners on the coast.[69]

These perceptions of a singular, imperial Mandinka identity suggest an early example of Europeans' projection of what Luis Nicolau Parés calls a "parallel sense of collective identity among West African societies," despite the waves of migration and cultural change that marked this area.[70] Lusophone authors rarely interrogated the ethnic identity claims of those with whom they came into contact. Rather, as evidenced by the concern over lançados' religion, they paid more suspicion to religious orientations, particularly any occurrence of "heathen rites."[71] While the Portuguese presence had brought Catholicism and Judaism to the area, the Mandinka expansion also resulted in higher numbers of people professing Muslim

identity: a shift in keeping with the history of Islamic expansion in the Sahel and the economic access and cultural prestige associated with it.

This shifting religious discourse was often read through the amulets used and peddled in Upper Guinea. Seventeenth-century European-language descriptions of the Upper Guinea Coast strongly associated Mandinka Muslims with the use of leather amulets filled with orations written in Arabic.[72] While chroniclers often chalked the amulets up to superstition and idolatry, their writings express particular concern for the pouches' role in selling forms of religious conversion to unwitting local clients. A 1606 account authored by Jesuit priest Balthazar Barreira, for example, describes how Mandinka Muslims in Cacheu (in present-day Guinea-Bissau) placed Qur'anic papers into leather amulets and disseminated them to spread Islam.[73] In 1609, the Portuguese historian Fernão Guerreiro explicitly blamed Mandinka Muslim trader clerics (*bexerins*; today known as *serïgne* in Wolof) for the increasing use of "well-carved amulets" (*nóminas*) in Senegambia.[74] And in the early 1620s, the Englishman Richard Jobson observed that the sale and distribution of "gregories" (*gris-gris*) was one of the principal occupations of *marabouts*—a promiscuous term referring to Islamic teachers, scholars, and diviners—around the Gambia River.[75] By the middle of the seventeenth century, foreign authors routinely labeled these amulets as not the carriers but the causes of the unclassifiable, and thus objectionable, religious practices they viewed. Nicolas Villaut, a French traveler along the Guinea Coast in 1666 and 1667, cogently summarized his confusion over local religion and the role of amulets in that nexus, relating that "their religion is very intermixed" between Catholicism, Judaism, Islam, and "Idolaters" whom he identified by "small leather bags hung around their necks."[76] And in Gambia in 1695, the French author Francois Froger described Upper Guinean Islam as "very much corrupted" because of the "abominable superstition" of people placing "little heathen bags" containing Qur'anic verses on their bodies and their horses.[77]

What kind of amulets were circulating at that time? One of the few descriptions comes from André Donelha, who in 1625 blamed bexerins for spreading "the cursed sect of Mohammed" in Guinean seaports by selling "*feitiços* in the form of ram's horns and amulets and sheets of paper with writing on them."[78] Donelha's use of the term *feitiço* here seems to distinguish between a ram's horn—an empowered object used outside of Islamic contexts—and the other amulets and pieces of paper whose forms echoed those of talismans then circulating in southern Europe. Indeed, as Don C.

Skemer's work has outlined, southern and western European Christians engendered the chagrin of church elites and authorities between the thirteenth and sixteenth centuries for employing a range of handwritten and mechanically produced textual amulets, all of which they popularly understood to carry apotropaic and luck-bringing powers identical to later mandingas.[79] Other popular amulets, as well as the clairvoyants or society-supported sorcerers who authorized them, also circulated in Iberia at this time.[80] Critically, not all of these amulets were defined as "Christian." Between the late fifteenth and early seventeenth century, Spanish inquisitors strongly prosecuted the use of handwritten Arabic and Hebrew amulets and texts while comparatively ignoring Christians' employment of the same objects.[81]

Understood in this context, Donelha's fetish accusation is best read as a manifestation of an already-evolving discourse around amuletic permissiveness in Iberia. Donelha already possessed an idea of what constituted acceptable forms of Christian amulet-making, but what he saw in Africa pushed him to extend this discourse in ways that likely allowed him to reframe how he understood the practice back in Europe. As Donelha concretely applied feitiço to the ram's horn, he also—depending on how one interprets the sentence's syntax—potentially did so to the paper amulet. Here, African fetishism, through its inclusion of new materials, emerges as an even more nefarious manifestation of amuletic production that was already prosecuted in Spain and Portugal.

It was not simply the kinds of materials Africans employed in their amulets but the volume of them that commanded the attention of foreigners. A confluence of the pouch-amulets, horns, and local talismans Donelha describes plays out on the bodies of subjects depicted in Amédée Tardieu's 1847 engraving, "Peoples of Senegambia" (figure 1.6). Tardieu visually emphasizes the sheer number of such amulets, echoing Richard Jobson's 1620s description that apparel around the Gambia River was "bedecked or hang'd over" with amulets, "as [if they] were laden, and carrying an outward burthen of religious blessings."[82] Jobson's point was echoed by Claude Jannequin, a French traveler who in 1637 described the amulets carried "on all parts of the body" in Senegambia.[83] Indeed, foreigners seemed consistently fascinated and distressed by the almost ostentatious number of amulets worn in Upper Guinea, particularly given what they viewed as multiple, competing lines of cultural influence embodied in them. In Tardieu's engraving, the pouches' capacity for cross-cultural translation cuts both

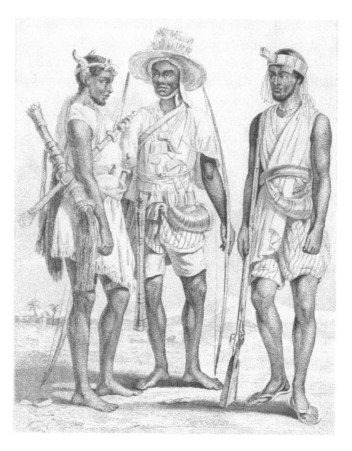

1.6 Plate 4, "Peuples de la Sénégambie: 1. Mandingue du Wolli, 2. Bambara, 3. Yoloff du pays de Wallo" (detail), 1847. Published in Tardieu, *Sénégambie et Guinée*. Engraving. Source: gallica.bnf.fr / Bibliothèque nationale de France.

ways, just as they had in the Sahel, by spreading Islam in ways that transformed it in new locales, here incorporating ram's horns from established local spiritual practices in the process.

One amulet, today held in the collections of the Sierra Leone National Museum in Freetown, brings together the contents described by Donelha (figure 1.7). Consisting of a ram's horn covered in a sheet of paper with Arabic writing and talismanic designs, it also contains other activating substances, likely herbs or other organic matter. Collectively, this object's construction demonstrates not just the itinerant nature of amuletic objects in Upper Guinea since the 1600s, but the primacy its makers gave to the

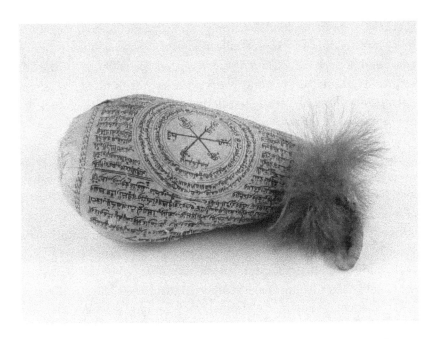

1.7 Unrecorded makers, amulet. Paper, vegetable, organic fibre, feather, fur, hair, horn. Sierra Leone National Museum, Freetown, SLNM.1967.10.02. Photograph courtesy of Sierra Leone National Museum / www .sierraleoneheritage.org.

apotropaic efficacy of objects, as opposed to concerns about its cultural origins or religious orthodoxy. More importantly, this object also speaks to a historically shifting conception of amuletic efficacy informed by the influx of new and foreign trade goods brought by those from across the desert and the ocean.

The ease and volume of the integration of previously foreign practices baffled Lusophone authors, particularly when they viewed West Africans utilizing what they defined as Christian symbols, such as crucifixes or rosaries.[84] Responding to this problem around 1615, Manuel Álvares decried the selective appropriation of Christianity in Senegambia, saying, "All of them practiced, and had always practiced, a form of Christianity which concealed pagan ceremonies, for they only showed themselves Christian when in the sight of the padre, while in the Lord's sight they were worse than heathen."[85] On one level, Álvares's observation thus employs a kind of Christian versus pagan classification that would have made little sense in a fluid and plural West African ritual universe. But more importantly, it also

speaks to a commonly held assumption on the part of foreign observers: that West Africans were strategically obscuring certain religious forms to gain cultural or political favor. Álvares's implicit demand to know the full scope of local ritual life not only prefaces the later demands of inquisitors opening mandinga amulets to see all their contents, but also ignores the importance of the strategic seclusion of certain objects and rituals in West African contexts, whereby the lack of access that persons have to something accentuates its spiritual authority. Thus, the "concealing" Álvares notes may have simply been a signal of his own distance from the spiritual worlds he attempts to describe, in addition to locals' own savvy negotiation of onlookers like Álvares. But in his telling, locals' selective revelation of their ritual lives makes them "worse" than others for its upending of his vision of Christianity.

In another telling example from Casão, a port on the north bank of the Gambia River, André Donelha reported that he was "distressed" to see his acquaintance Gaspar Vaz "dressed in a Mandinga smock, with amulets of his fetishes" (*nóminas dos seus feitiços*) hanging "around his neck."[86] Sensing Donelha's worry over his outward sartorial rejection of Christianity, Vaz explained that his dress was simply a strategy to win favor with his Muslim uncle, whose goods he was set to inherit. Lifting his smock, Donelha saw Vaz wearing "a doublet and shirt in our fashion and from around his neck drew out a rosary of Our Lady."[87] While Gaspar's explanation satisfied Donelha, his sartorial practice can also be understood as an adept manipulation of symbols to strategically appeal to different religious sensibilities.[88] By literally peeling away a layer of clothing to display the identity most effective in preserving his relationship with Donelha, Vaz exemplified the strategic shifts in clothing, religion, and language that were a defining feature of life in cosmopolitan Upper Guinean seaports.[89] The historian José da Silva Horta goes so far to identify Gaspar Vaz as a *grumete* (Portuguese for "cabin boy"), many of whom assisted lançados and other foreign traders along the rivers in Upper Guinea.[90] These grumetes adopted Portuguese names, became conversant in Christianity, and communicated in Kriol, a Portuguese-based lingua franca still spoken in the area.[91] Critically, Donelha identified Vaz as a Mandinka himself. Formerly enslaved on the island of Santiago in Cape Verde but with newly acquired social status in Gambia; conversant in Kriol, Portuguese, and other African languages; able to demonstrate affiliations with the shifting contours of Upper Guinean Islam and Catholicism; and having moved geographically and culturally between Luso–Cape Verdean and Upper Guinean

worlds, Vaz exemplified the pragmatic performativity of Mandinka identity in seventeenth-century Upper Guinea.

One 1668 Portuguese Inquisition case explores the role that Mandinka identity claims and Mandinka-associated feitiçaria came to materialize in the divergent worldviews of peninsular Catholics and residents of Upper Guinean port cities. Crispina Peres, a Banhu woman from Cacheu, was charged with, and eventually convicted of, a range of religious crimes including consulting Mandinka ritual specialists, undertaking "heathen" rituals, and of "carrying the cords that the Mandingas" customarily used.[92] Peres, who identified as *parda*, argued at her trial that her ritual life was commonplace and widely accepted in mid-seventeenth-century Cacheu, then a transitioning cosmopolitan merchant center largely outside of the Inquisition's purview.[93] A Portuguese settlement on the south bank of the river of the same name, Cacheu had a significant lançado population. But in the early 1650s, Cacheu also counted among its residents a small group of Jesuits and Franciscans charged with overseeing inquisitorial charges; the Franciscan order had also recently established a Catholic hospice in the settlement.[94] Peres's eventual denunciation was likely linked to her social prominence, as she was the only woman among the five residents of Cacheu put on trial by the Inquisition during its nearly three-century run.[95] The accusations of feitiçaria leveled against her, however, were atypical; the other four Cacheu residents were accused of practicing Judaism.[96]

Testimony from witnesses in Cacheu spoke to Peres's status as one of the most sought-after healers and spiritual leaders in the city. Peres was accused of employing the services of a diverse range of itinerant African-identified healers, including Banhu *djambakós* (rendered by the trial scribe as *jacabousses* or *jambacosses*), as well as Mandinka women and bexerins.[97] Sebastião Vaz, a boat captain in Cacheu, was one of a series of witnesses to accuse Peres of keeping altars (*chinas*) in her home, which were attended "in the company of heathen who are called in for that purpose, pouring palm wine and the blood of sacrificed bulls, cows, and chickens over them."[98] This description, though vague, will be familiar to any student or practitioner of West African religions. Across this region of the continent, the spiritual forces housed and grounded in altars require continued attention and sustenance, commonly provided in through nourishment through blood from animal sacrifices and libations including palm oil. But for decades prior to her trial, these accumulative and ephemeral altars had caught the eye of Catholic elites. Bemoaning the difficulty of efforts at "converting" the local population in Serra Leoa, in 1607 Balthazar Barreira

decried the presence of "Christian Blacks who . . . by contact with the heathen had so forgotten the obligations of our holy faith that either they possessed chinas themselves or they allowed their slaves to do so and they had dealings with these chinas and made them offerings."[99] In an earlier 1606 letter, Barreira also expressed frustration at efforts to labeling symbols he held sacred through ritual lenses he considered foreign: Bijogos Islanders, he declared, took "images of Christ or of Our Lady" to be the "'white man's china" or "Christians' china."[100]

Barreira's concern with the intellectual veracity of West Africans' conversion to Christianity speaks to inquisitors' search for ways to reconcile the diverse populations of the colonies with the pragmatic adoption of spiritual practices they displayed. Simultaneously dismayed and fascinated by the utilization of "heathen" rites across the population, these practical realities of everyday life in Upper Guinea also served as a potential defense for Peres, since—as even Sebastião Vaz testified—"all or most of the black and some of the white women of this settlement" used chinas.[101] Indeed, the "mandinga cords" inquisitors accused Peres of using were given to her by a prominent white man. Peres testified that in the mid-1650s, in Cacheu, she learned from her friend Maria Mendes that Ambrósio Gomes, a wealthy and socially prominent Cacheu-based lançado trader married to a Bijago woman, could provide Crispina a remedy to the childbearing difficulties she was having.[102] Gomes himself had, in 1663, been accused of working with Mandinka healers to cure his own illnesses and using Mandinka-associated talismans.[103] In Peres's telling, Gomes arrived at her home, took out two black-and-white cotton cords, and dipped them in a mixture of water and powders. Tying them around her arms and waist, he instructed Peres to drink the waters, which, according to her testimony, eased her pains and allowed her to give birth. Peres also asked Gomes to use the cords on her son until he learned to walk, to which he assented, and later collected a goat as payment for the healing service.[104]

About a year after her encounter with Gomes, Peres testified, Maria Mendes returned to Peres's house with an unnamed "black heathen Mandinga" to cure Peres's young daughter Leonor, who had fallen ill. This person tied similar cords around Leonor's arm, saying that these cords had worked for Maria Mendes's own daughter when she had fallen ill.[105] This healer tied cords around Peres's arms as well, asserting that they were also necessary to cure her daughter.[106] But the cords did not have the same effect for Leonor, who passed away.[107]

That these Mandinka-associated healing practices came from Gomes, "who was Catholic," formed a critical part of Peres's defense.[108] Her argument hinged on a series of explanations meant to pry apart any association between Mandinka ethnicity and talismanic practices. Fittingly, Peres identified the cords, presumably from Gomes's identification, as those that "black Mandingas commonly use, and which they have for their relics"; concluding with a term likely intended to further convince inquisitors of the cords' acceptability, given the importance of saintly relics in southern European Catholicism.[109] In turn, Peres testified that Gomes "always carried the cords with him" in Portugal, as did "almost all natural [born] Christians in [Cacheu], especially men who went to war and women who gave birth."[110] While Peres's point could have been a defense of her own use of the cords in front of an inquisitorial tribunal, historical evidence from the region underscores her point, as "bodyguard" amulets (Kriol: *guarda di kurpu*) had widespread use among Upper Guinea's diverse residents.[111]

Inquisitors, meanwhile, worked to sort out the boundary lines between their perception of permissible and impermissible religiosities. During Peres's interrogations in Lisbon in September of 1667, Fernão Correa de Lacerda, the head inquisitor, asked her "if she believes, or at any time believed, that animals, sticks, stones, or other material objects were indeed . . . gods," whether she thought "each nation has a different god," and "if she holds, or at one time had held, that it was permissible to attend sacrifices that the heathen make to their idols . . . or to order [Catholics] to make them in some form."[112] Peres answered "no" to each question, but her unsurprisingly defensive responses are less instructive to the present analysis than the questions the inquisitor asked. His line of questioning not only conveyed an inquisitorial suspicion in the efficacy of material objects, but continued the discourse exemplified in Gaspar Vaz's dress and Peres's wide spiritual repertoire: that in general, religious practices in West Africa were defined less by adherence to particular belief systems than by a pragmatic, presentist logic focused on whether or not they were effective to certain ends. "How is it possible," Correa de Lacerda finally asked Peres about the cords, "that she carried them without having the same faith in them that the Mandingas do?"[113] Peres's careful response both redirected the question and drew a distinction her interrogator did not seem to process: she simply said that "she did not hold the same faith in the cords that the Mandingas did, and she carried them because everyone carried them."[114]

Peres's critical final point seems to be the genesis of the discourse of *mandinga* as it emerged in Portugal, Brazil, and elsewhere in Atlantic

Africa in the decades after her trial. As a defense, Peres insisted that one could use empowered objects derived from foreign belief systems without adhering to those worldviews, irrespective of whether such objects were effective to certain ends. But inquisitors argued the opposite, namely, that material objects functioned as carriers of a distinct and definable belief system and, as such, to use them was to claim those views as one's own. Unsurprisingly, inquisitors declared they won the debate, and convicted Peres for carrying "the cords which the Mandingas have for Divine causes because she had the same faith in them."[115]

The inquisitors' declaration seems to have set a precedent over the ensuing century. In inquisitorial contexts, objects became understood not only as the manifestations of circumscribed religiosities, but also as a kind of identity-marker for their user. Similar exchanges and conclusions are repeated in Inquisition records for the next century or so following this trial, but such ubiquity suggests that inquisitorial suspicion over the unseen efficacy of material objects across unstable cultural spaces was one of the main preoccupations of their questioning, especially as such practices continued to evolve in the Black Atlantic world. Yet in so arguing, inquisitors had to eschew assumptions of bounded cultural practices. If *mandinga* was defined as a material embodiment of an unseen spiritual efficacy, then what was the function of ethnonyms or identity markers? As we have seen, travelers and merchants on the West African coast seemed unconcerned with statements of ethnic identity. In turn, *Mandinga* itself was not only a contingent identity strategically deployed, but one of many ethnonyms that emerged as critical to the development and function of a transatlantic slaving economy. As new bodies (defined as objects of labor and capital) began to circulate alongside new commodities and objects, the desire to classify objects emerged in parallel with and in contrast to the desire to classify people: two trends intimately connected to the emergent discourse of mandinga-as-feitiçaria.

Mandingas and the Sorcerous Work of Classification

One etymology of the word *sorcery* traces its English genesis to the early fourteenth century, from Old French *sorcerie*, in turn from the Latin *sortis*, to "sort."[116] Read in the context of this lineage, sorcery refers to one's ability to influence the outcome of future events through the manipulation of unseen forces. The sorcerer's powers derive from an expertise in the classification and

interpretation (read: sorting) of materials with an eye toward their other-worldly or seemingly unnatural powers. Sorcery also depends on nonsorcer-ers, defined as those who believe in the power of unseen forces to influence human life but who lack the expertise to identify and work with sorcerous objects. Thus, while the practice of sorcery depends on the sorcerer's dis-cerning ability to classify and interpret, it also renders visible the distinction between those who possess esoteric forms of knowledge and those who do not. As Crispina Peres's trial shows, the emergent discourse of feitiçaria was intimately connected to the practice of applying African ethnonyms to specific objects, and it coevolved with the practice of redefining and creating new forms of ethnic identification for enslaved Africans.

One case study through which to map these linkages is the trial of Vicente de Morais, who in 1715 appeared before the Holy Office in Lisbon charged with the "crime of being a mandingueiro."[117] Morais had spent his entire life near Muxima, a Portuguese garrison (*presídio*) in present-day Angola, and where he was employed as a soldier at the time of his trial. On the south bank of the Kwanza River, Muxima was one of a series of military forts responsible for protecting borders and trade routes of the Kingdom of An-gola (*Reino de Angola*), a Portuguese captaincy administered from Luanda, some eighty miles to its northwest. Morais's Mbundu ancestry would not have been uncommon among soldiers stationed at Portuguese presídios in Angola. As Linda Heywood outlines, thousands of Mbundu peoples took refuge near forts like Muxima after the Dutch capture of Luanda in 1641; in turn, Mbundu soldiers (*kilambas*) had, since the early seventeenth century, played a key role in Portuguese military victories in Angola.[118]

At his trial, Morais testified that António Dias, a white Portuguese sol-dier also stationed at Muxima, had given him a pouch to wear that would "protect him from dangers."[119] Morais defended his own actions by assert-ing that every soldier at the garrison wore one, suggesting their particular utility for those involved in warfare—a critical point to which I will return in chapter 4.[120] Initially suspicious of Dias's amulet's efficacy, Morais testi-fied that he put the pouch around a dog's neck, took out his gun, and shot it. The dog survived unharmed. Morais then classified it as many others would have: "the pouch" he said, "was mandinga."[121]

Morais's trial illuminates the shifting racial and cultural dynamics of mandinga use in eighteenth-century Angola. On one level, the use of mand-inga amulets by both white Portuguese and Mbundu men further speaks to their popularity across racial and cultural lines, even in Angola. In turn, while scholars such as Laura de Mello e Souza have rightly pointed out that

most African-born mandingueiros appearing before the Lisbon Inquisi-
tion in the early eighteenth century lived in Lisbon and had often spent
some time in Brazil, there is no evidence that Morais ever left Angola prior
to his arrest.[122] This suggests that that the fame of mandinga amulets—or,
more specifically, the popular associations of apoptropaic objects with this
term—took hold in Angola alongside, or shortly thereafter, its increas-
ing use in Portugal, Brazil, and parts of West Africa. The shipping routes
that connected Luanda, Lisbon, and Brazil also functioned as conduits of
popular discourse, and Morais saw his amulets as intertwined with wider
Atlantic networks. In addition to the mandinga, he was accused of carry-
ing "three little [talismanic] stones" labeled, respectively, as "Sallamanca,"
"Cabo Verde," and "Paulista" (a reference to São Paulo, Brazil)—terms that
linked their powers to Iberia, the islands of the African Atlantic, and the
Americas.[123] In his own reading of Morais's trial, Roger Sansi argues that
this terminology indicates that the stones' powers derived "from some
strange and special place that, like the contents of the [mandinga] bag, is
exceptional": a reading supported by the fact that Morais had never visited
the locations with which he labeled the stones.[124]

While Sansi's reading suggests that Morais associated objects and ideas
foreign to Angola with powerful forms of protective efficacy, visible forms
of cultural and religious reinvention were de rigeur throughout Angola, in-
cluding Muxima, Luanda, and Benguela.[125] As central Africans—especially
those living near the coast—were converted to Catholicism through the
efforts of Italian and Portuguese missionaries, they reimagined Catholi-
cism through local lenses.[126] They participated in Catholic masses and were
often the artisans responsible for producing the sacred objects needed for
their execution. In turn, free Blacks and mulatos were counted among
church personnel.[127] And as Mariana Candido outlines, in Benguela—and
indeed, throughout Portuguese Angola—Portuguese administrators of all
racial backgrounds came to rely on local healers, and these close interac-
tions drew the suspicion and occasional ire of other officials.[128] In a 1736
letter to Lisbon, Angola's captain-general complained that it was "not only
the pagans of the interior, but also the whites, who use superstitions and di-
abolical rites, and because they are not punished, their excesses continue"
(*continuão com excesso nelles*).[129]

Though inquisitorial records do not suggest that mandinga amulets
were widespread in Angola, the variety of protective objects Morais used
speaks to the dynamics that so frustrated the captain-general.[130] Morais re-
called using a prayer card taken from the altar of Muxima's church as well

as a bolsa made of damask or *chita* (a kind of color-stamped cotton) and containing a piece of altar stone that, Morais asserted, protected himself during fights with some of the white Portuguese soldiers at Muxima.[131] This reference continued in Angola after Morais's trial. Kalle Kananoja presents an analysis of a 1750 trial, for example, in which Felipe Dias Chaves, a man living in Ambaca, another fort in Angola, confessed to owning a series of small pouches alternately containing black, brown, and red powders; one in particular contained black powder, two small horns, three iron rings, and two bones—all objects he labeled as mandingas.[132] Chaves also stated that all these mandinga objects were consecrated to Muta Kalombo, a spirit "venerated in the interior of Angola as a personal spirit related to hunting, warfare, and fire."[133] Danla á Tango, one of the healers who shared a space with Chaves, described further objects—animal horns and skins—also consecrated to Muta Kalombo, and that Danla á Tango also referred to as mandinga.[134] Clearly, Chaves and Tango had found in *mandinga* a term that could translate Muta Kalombo's objects to a wider context.

These trials demonstrate the speed with which the term *mandinga* became identified with an unexpectedly wide range of apotropaic objects across the Atlantic world. Employed by white and Black soldiers in central Africa and in Portugal; by enslaved Africans and Indigenous persons in Brazil; by Muslims, Jews, and Catholic inquisitors; *mandinga* emerged above all as a term of translation. It functioned to make widely diverse ritual materials intelligible—and thus transferrable—across practices increasingly in conversation and conflict from across the Atlantic. *Mandinga* provided specialists and their clients a term to bring together diverse uses of varied empowered objects in the radically shifting ritual economies of seventeenth- and early eighteenth-century Brazil and Angola; why else, as we have just seen, would it be used to mark animal horns consecrated to Angolan spirits at the same time it labeled altar stones in Catholic churches?

This is particularly noteworthy given that inquisitorial documents prior to Gerónimo Vaz's 1700 denunciation of Jacques Viegas, discussed at the opening of this chapter, employed only generic formal descriptors to objects of similar function, regardless of the racial or social status of their users. In a 1689 trial from Lisbon, for example, the soldier André da Silva was found to be carrying a pouch that could protect him from guns and iron weapons—powers that seem decidedly *mandinga* from the perspective of Jacques's 1704 trial—but was referred to simply as a *bolsa*.[135] And in 1690, the free Black man Patrício de Andrade, a native of Cape Verde, was accused of carrying a "small blue pouch" (*bolsinha azul*) with similar

powers.[136] Andrade later marched in an auto-da-fé for the crime of "having a pact with the Devil, carrying with him certain things in a pouch so that he would not be hurt with arms, and having experienced on his body to demonstrate the said effect," but the word *mandinga* never appeared in the documents associated with his trial.[137]

What had changed in this short period? One explanation comes from Vicente de Morais's trial, where an emphasis on the "African" origin and nature of the bolsas coincides with the increasing perception that bolsas were crossing racial and geographic lines not only in their use, but also in their construction.[138] *Mandinga* came to be commonly accepted as a label for bolsas only at the moment they took on a non-African clientele and as they began to widely incorporate objects and substances into their contents that were already in use inside popular Catholic amulets. As will be explored in further detail in chapter 2, early eighteenth-century inquisitorial records document pieces of altar stone, papers inscribed with sacred Catholic prayers and images, bird feathers, rocks, sticks, powders, roots, hair, and human bones among the contents of mandinga pouches confiscated in Portugal. Given that sorcery itself derives its power from those who possess the esoteric knowledge to properly utilize objects from unknown or ambiguous origins, it is no surprise that those accused of being mandingueiros utilized objects that, to inquisitors, defied classification. When Morais first opened the pouch that he had been given by Dias, he discovered "some orations [written in] Latin," "a piece of Agnus Dei, and a green thing that he did not recognize."[139] These inclusions were doubly concerning to inquisitors. On one level, the Latin orations Morais saw could not only speak to his proper Catholicism—a question of key focus to his inquisitors—but also project into Catholic objects an unseen ritual efficacy that questioned inquisitorial authority. In turn, questions of religious affiliation obscured the importance of the "green thing he did not recognize," an object that— fittingly for a feitiço—was likely chosen for its illegibility, not despite it.

Inquisitors often voiced either confusion or disinterest over the meaning of this litany of polyphonic spiritual materials. Some trials make little mention of the pouches' contents, while others declare them either insignificant detritus or uninformed manipulations of proper Catholic practice. Presented with the physical evidence of that which they sought to denounce, inquisitors were often faced not with an identifiable African sorcery, but with a distorted mirror of religious values reframed. Inside the pouches, proper Catholic imagery was redeployed in new contexts, and other substances simply could not be classified. I forward, then, that

in a sense *mandinga* really classified that which inquisitors, and indeed many mandinga users and makers, found noteworthy precisely because it exceeded extant definitional boundaries. Yet because inquisitors dedicated transoceanic efforts to seeking out sorcerous objects, *mandinga* also marked that in which they believed: a circulation that likely reinforced the amulets' widely accepted powers.

Such inquisitorial efforts to define and suppress mandingas and their users coalesce in the term *feitiçaria*, the accusation most often leveled against mandingueiros. Feitiçaria broadly defined the goal-oriented invocation and manipulation of feitiços, both material and immaterial. While often translated into English as "sorcery," in the Inquisition's records the term is often analogized to, or even substituted for, *bruxaria* (witchcraft), *sacrilégio* (sacrilege), or *magia* (magic). Yet feitiçaria connoted a special knowledge of unseen or hidden things, a kind of esoteric expertise that remained both elusive and feared.[140] As such, feitiçaria was ambiguously defined as that which it was not, and throughout the first half of the eighteenth century it was usually deployed as an accusation as opposed to a self-description. In this way, as Luis Nicolau Parés notes, "the threat, real or imagined, of feitiçaria . . . played an important role in the relationship between masters and slaves," to which I would add the power dynamics that shaped a climate of suspicion and fear across territories under the Portuguese Inquisition's purview.[141] In response, in the decades after 1700, as the Inquisition received word of practices of which they were previously ignorant or ignored, their equation of mandinga with feitiçaria reflected a nascent intellectual investment in the idea of a definable, and distinct, African religiosity that would only concretize in the nineteenth century as well as its inherent opposition to sanctioned Catholic practice. The first Portuguese-language dictionary, published by Raphael Bluteau in 1716, makes clear the initially dual definition of mandinga as both ethnic group and feitiçaria:

> Mandinga: Kingdom and people of Africa, in the lands of the Blacks of Guinea, along the Gambia River . . . the blacks of Mandinga are great *feiticeiros* [practitioners of feitiçaria]. . . . It appears that some pouches have taken [this] name . . . with which [their users] make themselves impenetrable to knives, and with which they have experimented in this court and Kingdom of Portugal on various occasions.[142]

While here Bluteau laments the influx of mandingas into the imperial metropole, he also seems to confirm their efficacy. In his writing, mandingas

really do work to protect their wearers from harm, an opinion that speaks to their popularity across a broad spectrum of people living on the edges of the Atlantic rim. However, the Portuguese themselves facilitated the spread of mandinga pouches across the Atlantic. In another point that explains the proliferation of mandinga accusations around 1700, between 1694 and 1698, the annual arrivals of enslaved Africans into Brazil nearly quadrupled.[143] While mandingueiros during this period came from all racial backgrounds, mandinga clients seemed to prefer pouches from enslaved Africans who had spent at least some time in Brazil.

No extant Inquisition record that discusses mandingas lists a defendant who identifies as Mandinka.[144] In other words, by the turn of the eighteenth century, Brazil's growing role in these cross-cultural exchanges meant that *mandinga* was not only de-coupled from an identifiable ethnic origin but was also applied to objects and people whose biographies crossed Africa, Brazil, and Europe. The conflation continued in later dictionaries and language guides: "Mandinga, are two kingdoms of Africa," wrote João de Morais Madureira Feijó in 1734, "and of the second is, [that] the blacks are great feiticeiros, and use some bolsas, which are called *Mandinga*, so that swords will not pass [through] them."[145] The 1789 edition of Bluteau's dictionary definition makes this explicit: it reads simply "Mandinga: African. Feitiçaria."[146]

The term's gradual redefinition as a fetish object of unclassifiable or syncretic confusion, however, stands in contrast to the efforts to define *Mandinga* as an ethnonym on contemporary maps. William Berry's 1680 map *Africa: Divided according to the extent of its principall parts*, for example, labels both the lower-case ethnonym and upper-case "Kingdom" of "Mandinga" (figures 1.8 and 1.9). Echoing the imperial perceptions of Mandinka identity that carried through the seventeenth century, a small castle visually reinforces the kingdom designation, while a dotted line delimits its geographic boundaries. But given the discourses of feitiçaria then attached to *Mandinga*, I also suggest that this map makes visible a belief in definable and classifiable African ethnonyms that can be sorted by foreign viewers. Its title actively "divide[s] [Africa] into parts" "distinguished from one another," while that classifying action is underscored by the colored dotted lines that surround a dizzying array of "empires, monarchies, kingdoms, states, and peoples." Yet the map's unusually wide frame allows into view to other areas that, as mandingueiros would acknowledge and inquisitors knew, were instrumental to the construction of mandinga amulets' seeming African-ness: Portugal and its Brazilian colony.

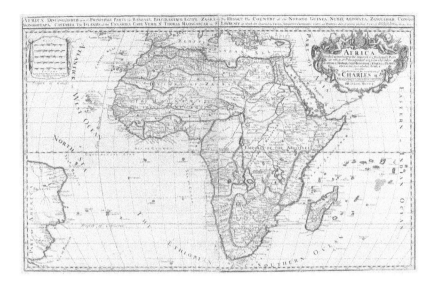

1.8 William Berry, *Africa: Divided according to the extent of its principall parts in which are distinguished one from the other the empires, monarchies, kingdoms, states and peoples, which at this time inhabite Africa.* (London, 1680). Engraving with hand coloring; 57 × 88 cm (22.4 × 34.6 inches). Photo courtesy of Northwestern University Libraries.

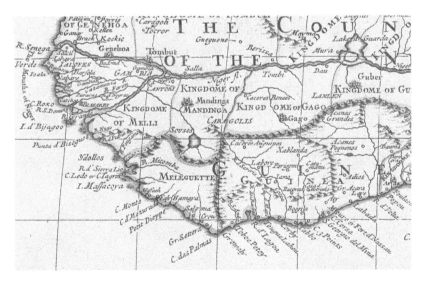

1.9 Detail of figure 1.8, depicting Senegambia, Guinea, and the "Kingdome of Mandinga."

How, then, does the conception of *mandinga* as a materialized feitiço intersect with the evolution of *Mandinga* as an ethnonym in the wake of the slave trade? Or, to restate the question posed at the beginning of this chapter, what might *mandinga* contribute to the discourse on the relationship between Blackness and objecthood? To answer that question, we must first consider the role and evolution of ethnic designations in the contexts of not just Atlantic slavery, but the African-inspired spiritual practices developed from that nexus.

Minas, Mandingas, and the Labor of Classification

Written in the elaborate cursive of contemporary elites, the cover page of Jacques Viegas's Inquisition trial record identifies its contents. "Trial of Jacques Viegas," it reads, "black slave of Antonio Viegas Pato, *natural* of Mina, and resident in this city of Lisbon" (figure 1.10).[147] Consider the subtle and strategic ways this piece of paper labels and classifies the accused. First, in naming its subject as "Jacques Viegas"—a combination of his baptismal name and the surname of his enslaver—it ties Jacques's identity to his legal status while masquerading it as kin. And second, it identifies him as a *natural* of the Mina Coast, and in so doing names his origin with the label applied to a broad swath of the West African coast by enslavers. Trial choreography required Jacques to repeat the exact phrasing of this cover page back to inquisitors.[148] In so doing, Jacques displayed his knowledge of the labels applied to him and the spaces in which he had to deploy them, while also confirming, even naturalizing, them in front of officials.

How did Jacques become "Mina"? Some clues come from his genealogy interrogation, which took place on July 10, 1704. Inquisitors intended this set of questions, usually the first after the accused's initial confession, to establish whether the accused was a good Christian based on their upbringing and thus subject to Church teachings and doctrine. In genealogy testimonies, inquisitorial scribes rarely wrote down questions asked of the accused; so, as is typical, Jacques's responses are in the third person. Jacques stated that

of his parents and grandparents he has no recollection, because he was of young age . . . when he came to this Kingdom. And that he was baptized Christian on the island of São Tomé in the Church of São João Baptista . . . and that his *padrinho* [godfather] was a black man whose name he does not know.[149]

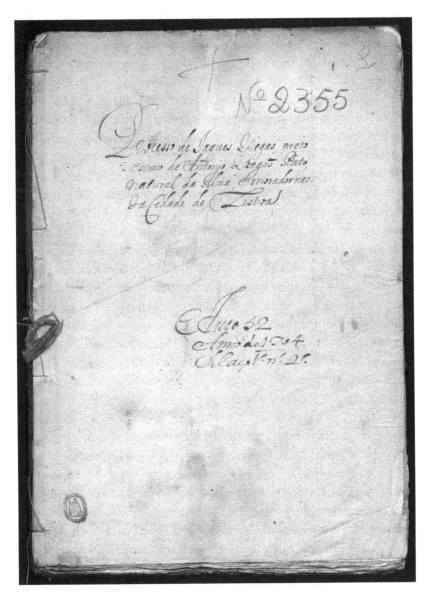

1.10 Cover page of the Inquisition trial record of Jacques Viegas. Lisbon, Portugal, 1704. Tribunal do Santo Ofício, Inquisição de Lisboa, proc. 2355; PT/TT/TSO-IL/028/02355. Image courtesy of the ANTT.

Though these answers provide few clues about Jacques's early life, the year, terms, and scope of his responses allow for informed speculation. Jacques stated at his trial that he was "twenty years of age," suggesting he was born in 1683 or 1684.[150] Jacques also recounted that it had been "twelve years, more or less, since he left Mina," making him only eight years old when he left the African mainland, around 1692.[151] Even if asked explicitly, one wonders how many details Jacques would have been able to recall about his life in Africa from such a young age.

Historian I. A. Akinjogbin effectively characterized the 1690s as one of "social insecurity" and "chaos" in this region, wrought by the dramatic intensification of European commerce and the efforts of local institutions to manage it.[152] Specifically, Jacques's designation as a natural of Mina suggests he was enslaved through Ouidah, then the principal trading center between Lagos and the Volta River. Ouidah's prominence was recent, as it was only in 1671 that the French transferred their main factory there from Offra.[153] In the 1680s, the ruling Kingdom of Allada had collapsed after invasions by the Kingdom of Oyo, and subsequent wars among states like Akwamu and Whydah (namesake of the city of Ouidah) created, according to Akinjogbin, "a power vacuum, which in turn brought lawlessness," wherein "Slave raids, sanctioned by authorities, became the new fashionable occupation. Everyone sought slaves and no one seems to have questioned any slave owner how he got them."[154] The 1690s thus saw not only an increase in banditry and slave trading as a profitable byproduct of these wars—and also made the wars more profitable—but also saw a marked increase in the use of imported European firearms for the purpose.[155] Between 1681 and 1685, embarkations of enslaved persons in the Bight of Benin more than doubled from the previous five-year period (from over 19,000 to over 40,000); by the 1690s, nearly 10,000 people per year were being placed on European slaving vessels through Ouidah.[156] Summarizing the experience of life near Ouidah after the wars of the 1690s, Thomas Phillips simply stated that "all the plunder is men and women to sell for slaves."[157]

Jacques's trial provides few details about his crossing of the Atlantic. In response to the sole question posed to him on the topic, he stated that he was taken from Mina to the island of São Tomé, where he spent a month before being taken to Portugal.[158] Between 1685 and 1700, the Trans-Atlantic Slave Trade Database provides twenty-three surviving records for about twenty ships that purchased human beings through Ouidah and stopped at São Tomé, where crews commonly purchased or offloaded cargo before crossing the Atlantic. In 1692, for example, the *São Jorge* arrived at

São Tomé from the Mina Coast, where its crew had purchased four hundred and six captives; the Lisbon-based ship then headed to Bahia.[159] In turn, the *Fredrik Wilhelm*, operated by the Brandenburg Africa Company and sailing under the Hanseatic League, arrived at Ouidah in January 1693, where they purchased seven hundred and thirty-eight captives for enslavement. The ship then sailed for São Tomé, where it stayed before arriving in the Caribbean, at the island of St. Thomas, in July.[160]

The Church of São João Batista, where Jacques was baptized, still stands on São Tomé (figure 1.11). Built in 1562, it was one of the main churches of the São Tomé diocese, which at the time of Jacques's arrival had recently split from Lisbon to join the archdiocese of Bahia; a shift necessitated by the development of direct nautical traffic between Brazil and West Africa.[161] Jacques's attestation of a Black *padrinho* would also have been in keeping with the city's religious landscape. Johann Oettinger, a crewmember on the *Fredrik Wilhelm* during its 1693 stopover, noted that the "town and its environs swarmed with black men and women in European costume, many of whom had joined the Catholic church," many of whom, he stated, "have even dedicated themselves to the priesthood."[162]

1.11 Church of São João Batista, São Tomé, São Tomé and Princípe. Photograph by Aaron Mertz, 2019.

The ethnonym of *Mina* Jacques used to identify himself at his Lisbon trial was not utilized by any local groups along the West African coast. It functioned, instead, principally as a label applied by slave traders and the slavery bureaucracy to certain Africans in Brazil and Portugal. Though it descends from Elmina Castle, a trading outpost founded by the Portuguese Crown in the Kingdom of Fetu, in present-day Ghana, in 1482, it is famously imprecise as a marker of geographic or cultural origin. The castle eventually gave its name to the so-called Mina Coast (Portuguese: *Costa da Mina*): a broad, politically contested stretch that did not actually include the Castle. As Pierre Verger notes, *Mina* eventually encompassed the area between the Volta River and the present-day city of Cotonou, Benin, a region that historians today term the "Slave Coast" and that included all peoples from there, whether speakers of Gbe, Ga, or Yorùbá, and regardless of political background.[163] In turn, *Mina* designations shifted depending on the areas and times in which Africans found themselves. As Mariza de Carvalho Soares first pointed out, while in nineteenth-century Rio de Janeiro *Mina* referred to all Africans with origins in the Mina Coast, in Bahia this same group was divided between Minas, Jejes, and Nagôs (Yorùbá-speakers), and others, resulting in the not-uncommon situation where an African's ethnic identity could change if they moved between Portuguese captaincies in Brazil.[164]

On the surface, *Mandinga* functioned similarly. Beginning in the late sixteenth century, many of those enslaved in or around Upper Guinea also began to strategically claim Mandinka identity in the Americas. In a testament to the perceived cultural dominance of the Mandinka in Upper Guinea, once "a subject or a victim of Mandinga hegemony had been shipped by Europeans under the mistaken impression that the captive was Mandinga," Walter Rodney observed, "then the mistake might well have been carried through as a positive deception on the part of the enslaved individuals."[165] While varying widely across the Americas, in many cases *Mandinga* could express a diversity of cultural affiliations, or even as a meta-ethnic umbrella term that encompassed otherwise distinct backgrounds. For example, a 1738 court case between two Cuban *cabildos de nación*—Africans' Catholic-associated mutual aid organizations—saw the opposing cabildos of the *nación mandinga soso* (Susu) and the *nación mandinga yolofe* (Wolof), which, as Stephane Palmié notes, are "bynames clearly indicating anything but Malinke origins."[166] As if paralleling inquisitors' confusion over the shifting materials that characterized mandinga amulets, by the nineteenth century in Cuba, as Rosanne Marion Adderley

notes, "Imprecision seems to be an inevitable feature of this ethnic term [Mandinga], even more so than others."[167]

Of what utility to enslavers, and to the Inquisition, was this imprecise, if persistent, bureaucratic penchant to classify enslaved Africans? The Italian Jesuit priest Giovanni Antônio Andreoni—writing under the pseudonym André João Antonil—provides one answer in his late seventeenth-century writings describing the inner workings of Brazil's sugar industry. Andreoni's observations, primarily based on his experiences at Jesuit-run *engenhos* (sugar mills) in Bahia, argued for the importance of classifying enslaved Africans based on ethnicity. Echoing widely shared contemporary sentiments among enslavers, Andreoni implied that meta-ethnic monikers effectively corresponded to Africans' suitability for specific kinds of labor. Of those "who come to Brazil," he wrote, the "Ardas and Minas are robust. The ones from Cape Verde and S. Tomé are weaker. Those from Angola, raised in Luanda, are better able to learn mechanical tasks than the others already named. Among the Congos there are also some quite industrious ones, good not only for working sugarcane, but also for workshops and in the house."[168] Like Jacques's Mina designation, the ethnonyms Andreoni used each developed over the course of the eighteenth century through a combination of the slave trade's bureaucracies and Africans' investment of these terms with communal significance. Such ethnonyms, as Andreoni asserts, served originally to assist enslavers in maximizing and streamlining labor output and capital production in the colonies.

Though generic stereotypes, these ethnic denominations continued to persist in the Americas long after they ceased to be useful to the ruling classes; they were transformed by Africans into networks of filial solidarity and ritual life. Black Catholic confraternities in Brazil and Cuba, for example, organized their memberships with these meta-ethnic designators. They formed new communities and mutual aid networks and, in turn, perceived rivalries or contrasts with other brotherhoods from different nations. This system persisted in nominally Catholic institutions, such as Cuban cabildos de nación, through the late nineteenth century, when the numbers of African-born persons in the Americas declined after the cessation of transatlantic traffic. And through the first decades of the twenty-first century, Brazilian Candomblé still organized itself into nations like Nagô and Jeje, while some of the principal lwa of Haitian Vodou belong to the Rada nation, whose name descended from the Kingdom of Allada, and, in turn, the Arda designation cited by Andreoni.

While the names of these spiritual nations owe specific debts to African regions or meta-ethnic designations, they are not necessarily culturally linked to them. In Haitian Vodou, the lwa of the Rada nation are defined not by cultural origin in or near Dahomey, but (closer to what Andreoni described) by the applicability of their abilities and labor-energies to specific realms of spiritual action. In contrast to the hot-tempered and unpredictable Petwo spirits, for example, those who serve the lwa know those of the Rada nation to be calm and even-keeled, and thus more suitable for spiritual labors that require long, sustained, and unhurried attention. Consequently, Rada altars feature soft color palettes of blues and greens, and their sacred percussion rhythms convey a strong but stable energy suitable to their temperament. These "American" characterizations of "African" spirits gradually evolved from earlier cultural essentialisms derived from enslavers' perceptions of the productive fitness of those they enslaved. In the lives of Africans, the institutions they founded, and the spiritual worlds they made, meta-ethnic designations stand in for the presumption of the quantity and quality of physical labor Africans could perform.

The contemporary labor values of Afro-Atlantic spirits testify to Atlantic slavery's historical reliance on a system of classification and labeling through which to identify the productive value of objects. Critical to that process was the role of applying ethnic labels as a mode of control, efficiency, and organization of the system. When Jacques declared himself Mina before the Inquisition, he was strategically redeploying elites' commonly held ideas about the inherent qualities of human laborers-as-objects to perform certain kinds of work for them. In this way, those who benefited from a transatlantic slaving economy were not unlike those mandingueiros and feiticeiros who sought to identify and manipulate the physical world for their benefit. In pulling together and transporting the enslaved to new locales for new forms of labor, enslavers also identified and organized the physical world in ways meant to serve their own purposes for the accumulation of power and capital. But as African-inspired spiritual practices continued to turn over and think through this history, consider the role of mandingas inside this nexus. For across Brazil, Portugal, and Atlantic Africa, *mandinga*, too, served to define a materialized set of objects that performed apotropaic spiritual labor for those who made, sold, and used them; yet mandinga used an intimate assemblage of objects and contents whose organizing principles seemed consistently unavailable, even illogical, to those lacking the esoteric knowledge to produce them.

Consider a Brazilian case from 1740, in which three residents of the village of Vigia, in Pará, testified that Lino—identified as Indigenous (*mameluco*) in the records—was, in the words of denunciate José Inácio Furtado, *mandingado* ("mandinga-ed") because Furtado said that he witnessed Lino emerged unharmed despite multiple scattered blows and attempted stabbings.[169] Does Furtado's label mirror the aforementioned discourse of lançado by suggesting that Lino participated in a politics of identity outside of settler-colonial mentalities that otherwise labeled him? Does it suggest that Lino possessed, or at least had connections to, esoteric knowledge others did not? And, if so, does this explain why inquisitors transported him to Lisbon to interrogate the knowledge unavailable to them? Jacques Viegas was never asked these questions. But as he sat before the Inquisition, one wonders if he felt he had lost the moment of possibility and self-protection afforded by this new label of *mandinga* attached to his person, one supplied by another enslaved African who was able to interpret and manipulate the physical world in ways not just distinct from his enslaver, but in ways that supplied him with the protection from the violence inherent to his other label of *Mina*.

Conclusion: The Violence of Ethnogenesis

Transatlantic slavery was a discourse that was founded on the idea that individuals could not have agency precisely because of their material conversion into objects. At stake in mapping the genealogy of *mandinga* has been, I argue, another ethics of ethnic labeling; a new way of reflecting on how scholars of African art history and the African diaspora classify the objects and lives in their care. As Susan Gagliardi and Yaëlle Biro noted in a 2019 essay, "for almost as long as they have used cultural or ethnic group names to categorize and study arts, art historians and other scholars have questioned the validity of the approach."[170] Indeed, since at least the 1980s, Africanist art historians have sought to find ways to work past what Sidney Kasfir influentially termed the "one tribe-one style" model of African art history.[171] Kasfir's work called attention to the ease with which art historians and anthropologists label specific types of objects with seemingly static and bounded ethnic monikers. These implied a kind of cultural homogeneity and ahistorical stasis and failed to account for the fluid crossings of identity, style, and dynamic historical change that have always defined

Africans' arts. Indeed, such a discourse even continues to impact the study of mandinga amulets because of the common presumption that they were made or brought to the Americas by Mandinka peoples.[172]

In turn, Gagliardi and others have built upon the work of anthropologist Jean-Loup Amselle, who argued that many of the ethnic terminologies used for African identities—and thus objects—are, themselves, "the invention of . . . colonial administrators, professional ethnologists, and those who combine both qualifications."[173] Amselle's work forced Africanists to reckon with the legacies of colonial violence inherent to the classification of African lives and works, though, as Bruce S. Hall points out, Amselle often leaves little room for the role of "African ideas in the formation of colonial categories," thus, scholars must be vigilant in their prioritization of Africans' agency in accounting for the intersecting identities they used both in and out of the continent.[174]

In one sense, then, I am reading mandingas as a dynamic example of strategic African cultural invention in the transcultural spaces of the early modern Black Atlantic world. But to stop there would be to overlook the other central role of mandingas: as a desperate response to systemic violence faced by those who used and made them. Often, such violence was the product of the social upheaval that accompanied the formation of new ethnic identities in the wake of the transatlantic slave trade. Indeed, Jacques Viegas's continued presence in the archive belies what James Sweet has called the "quiet violence" of ethnogenesis, here defined as the process by which a select group of people come to define themselves as sharing a common culture.[175] Those prisoners of war who did not die en route to slave garrisons at Elmina or Ouidah had the opportunity to forge Mina kinship networks in Brazil only if they survived the Middle Passage. In the bowels of slave ships, on Brazilian sugar plantations, and in Portuguese cities, enslaved Africans encountered new identities that they not only had to navigate, but often had to take up and make their own to survive. The creation and definition of Mina, then, partially involved the violent erasure of previous understandings of communal belonging, brought about by radical disruptions, interethnic conflicts, forced migrations, and population loss. In this world, a small, portable, transcultural pouch meant to protect its wearer from the violence of others may have been the only tool at Jacques's disposal: one small tool by which, as Stephanie Smallwood notes, "African captives guard[ed] against the disintegration of self in diaspora, following the implosion of the categories by which they had understood themselves and their world."[176] Others, however, did not survive as

long as Jacques did, and their names never appeared in the Inquisition's records. They were never able to make the choice to take up a new ethnonym, or to protect themselves with a small pouch. For those who did not survive the Atlantic slave trade—and for many of those who did—the formation of terms like *Mandinga* and *Mina* necessarily involved violent processes of migration and social rupture. These identities, in turn, came to mark their bodies as commodities and to project presumptions onto them that later became lived realities. In this way, the ethnic label existed prior to its expression: a sorcerous classification that profoundly influenced the fate of enslaved captives.

Contents

Throughout Africa, [the natives] are in general extremely superstitious . . .
they entertain an assemblage of indistinct ideas, of which it is impossible to
give any clear description.

Joseph Corry, *Observations Upon the Windward Coast*, 1807

Break a vase, and the love that reassembles the fragments is stronger than that
love which took its symmetry for granted when it was whole.

Derek Walcott, "The Antilles," 1992

The first handwritten folio of Jacques Viegas's trial record contains a
summary of the two testimonies against him. In it, João Nunes, the inquis-
itorial scribe, summarized the deposition of Manuel Correa, a Christian-
born man (*cristão velho*) whose testimony in May of 1704 ultimately led to
Jacques's arrest. It reads, in part, as follows:

> According to the second testimony of Manoel Correa . . . the accused took
> from the roll of his pants a paper wrapped in cotton, inside of which were
> three things, which looked like very small stones; and in the middle a small
> pin [*alfinete pequeno*]. . . . And because the ingredients inside the bolsa
> naturally do not have the stated effects [to protect from knife wounds];
> and because these facts constituted magical and diabolical operations; it is
> presumed that the accused made an explicit pact and friendship with the
> Devil.[1]

Correa's short but precise visual description of the form and contents of
Jacques's mandinga pouch was not unprompted or incidental, for inquisi-

torial trials concerning bolsas consistently incorporate onlookers' or authorities' descriptions. Ranging from a quick inventory to an extended ekphrasis, their ubiquity suggests that accusations of feitiçaria all but required inquisitors to open these amulets and record their contents. Jacques's own amulet even bears the scars of this event. A small tear in the side opens to reveal some of what Correa described, while its top seam has been resewn with untarnished white string matching that used in the binding of Jacques's trial record. These tears and repairs suggest that Jacques's amulet was opened for examination after its arrival at the Holy Office (figure 2.1).

Why did inquisitors inventory this object's contents only to dismiss the importance of what they saw; in particular, to define it as evidence of his "pact . . . with the Devil"? In this chapter, I argue that inquisitors' seemingly contradictory response to mandinga amulets reveals the substance of their efficacy: an interrogation of, and reckoning with, elite hierarchies of religious practice and material value in the early eighteenth-century Atlantic world. Inside mandinga pouches, inquisitors not only viewed mandingueiros' special knowledge of materials elites otherwise deemed as

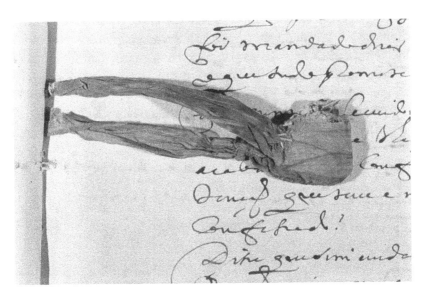

2.1 Bolsa de mandinga attached to the Inquisition record of Jacques Viegas, Lisbon, Portugal, 1704. Detail showing white string repairing a tear. Tribunal do Santo Ofício, Inquisição de Lisboa, proc. 2355; PT/TT/TSO-IL/028/02355. Image courtesy of the ANTT.

unconventional or insignificant; they also saw objects that questioned the apotropaic efficacy of materials already sanctioned by the Church.

In deploying the term *feitiço* for these amulets, inquisitors and users alike also spoke to their power as originating from what William Pietz, as discussed in the previous chapter, defines as the material reality of the fetish: "the fixation or inscription of a unique originating event that has brought together previously heterogeneous elements into a novel identity."[2] As amulets and talismans serve as exemplary manifestations of this emergent discourse—at least as interpreted by European traders on the West African coast—Pietz thus raises a series of points relevant to consideration of mandinga pouches moving forward: first, that their constituent material elements derive from—and implicitly accentuate—their heterogeneous origins; second, that mandingas materialized debates about the constructedness of aesthetic and material forms of social values; and third, that *feitiço* was not simply a European mischaracterization of African religiosity, but rather a theory of material relations that evolved and expanded as the Atlantic commerce intensified. Inquisitors thus feared what they saw inside mandinga amulets: unsettling proof that, as J. Lorand Matory notes, the "fetishist is [not] blind to the source of the fetish's value" since "Afro-Atlantic priests typically know that it is people who make gods."[3] A mandinga amulet, I argue, accrued its power by revealing the intentional assembly of the religious and economic systems its contents indexed.[4] In this way, bolsas de mandinga desublimate extant structures of power as a method of healing and protection from the personal and social ills they perpetrated.

Critically, inquisitors regarded the supernatural powers of bolsas not as fantasies but as evidence of pacts with the Devil. By acknowledging the efficacy of mandingas, inquisitors could only find mandingueiros guilty of sorcery by first asserting they had misunderstood these materials' natural function. If, as Michael Taussig argued in his trenchant study of laborers in 1970s South America, an invocation of the Devil becomes "an indictment of an economic system which forces men to barter their souls for the destructive powers of commodities," then inquisitors' invocation of that same name—and the discourse of feitiçaria with which they equated it—served as an effort to unsee what they saw inside mandinga amulets: a series of attempts by those experiencing forced labor or migration, or violence, to assert control over the systems of valuation and political and religious power that shaped their lives.[5]

This chapter foregrounds how the contents of mandingas worked in tandem with the external form that contained them. In the context of a slavery society, mandinga pouches visually alluded to secretive activating contents but never granted their revelation. This tension is critical to understanding the discourse of feitiçaria as a visually restricted set of material and immaterial relations made manifest in the form of bolsas de mandinga. As amulets circulated through their makers' broad social networks, markets, and inquisitorial tribunals, what I term the "strategic occlusion" of their internal contents allowed mandingueiros independent spaces of world-making and knowledge-exchange. At the same time, these hidden contents engendered the desire and jealousy of any onlooker—inquisitors included—who sought to access to these occluded forms of knowledge.

At stake inside mandinga pouches, then, is the authority to valuate materials and lives in the context of an Atlantic trade system dependent on the conversion of human bodies into capital. This argument moves Pietz's original from the context of mercantile trade on the West African coast to inquisitorial encounters in the Portuguese metropole. How and why, then, did those who used bolsas consider, collect, and interpret the mélange of images and objects they encountered on both sides of the ocean to intervene in debates over the boundaries of identity, religion, and value? How might we look to them to make sense of the intimate and contrasting ways these mandingueiros brought together these in-clusions out of sight, and in so doing consider them not just as an index of their world, nor as an effort to control it, but as a model for imagining it anew?

This chapter delves into these questions in three parts. It first traces the political role of visual description in Atlantic Africa and mandinga trials broadly as it relates to protective objects that contain, yet occlude, their activating contents. This tension, key to understanding the discourse of feitiçaria, also served as an aesthetic response to increasing political and so-cial destabilization in the wake of the slave trade. The chapter then moves to Brazil and Portugal, outlining how the Atlantic market in mandinga-production and sale challenged elite valuations of religious objects and cultural hierarchies. It concludes with an analysis of the mandinga practice of José Francisco Pereira. Arrested by the Lisbon Inquisition in 1730, his amulets materialize an effort to reckon with the diverse economic, politi-cal, and religious forces that shaped his life.

The Visual Politics of Occlusion,
or, How to Not Describe a Fetish

Surviving records vividly describe bolsas' diverse array of animating contents. A 1692 Portuguese case cites an amulet containing a piece of paper with some "badly written" (*mal escritas*) words, some realgar (a bright red mineral historically used as pigment and poison), and floral remnants: seven pepper seeds, "a root that appeared to be of celery," and some other unidentifiable "little bits of herbs."[6] Collectively, these contents testify to long-standing investments in the healing nature of flora and other natural materials as well as in paper orations in European popular Catholicism. Other amulets, though, mirrored a fragmented and pluralistic universe, incorporating perceived exotica, empowered media, and the ephemeral debris of Atlantic slavery and capitalism. In a representative case from 1732, the enslaved African António de Sousa was accused of using a bolsa in Lisbon that contained "some red feathers of a Brazilian bird, a piece of bull's horn, and some small stones wrapped in paper," contents that encapsulated the contemporary cultural flows of the Black Atlantic.[7] The bull's horn potentially referenced a range of West African amulets discussed in chapter 1. Especially when identified as Brazilian, red bird feathers embodied material and ritual transformations between Portugal and Brazil. While the Tupi—seminomadic Indigenous peoples inhabiting Brazil's coastal forests—had long used brilliant scarlet feathered capes in ritual contexts and as markers of social status, by the seventeenth century an international group of Jesuit missionaries in Brazil were incorporating Tupi featherwork into their presentation of the sacraments; Europeans also increasingly sought Tupi feathered clothing for use in collections and public performances.[8] The small stones in António de Sousa's bolsa, meanwhile, were likely ground altar stone (*pedra d'ara*) taken from a Catholic church, while paper was the backing material of Catholic orations, inquisitorial archiving, and the bureaucracy of global trade. Even this small description reveals the worlds of ritual transformation, material circulation, and transcultural movement that this mandingueiro's work encapsulated.

Since these descriptions were produced in the context of inquisitorial searches for feitiçaria, they often give primacy to references from Iberian Catholicism. When underscoring the false values mandingueiros placed in amulets' other contents, inquisitors often either dismissed them as unimportant detritus or carefully detailed them to highlight their sacrilege. On his arrest in Belém, Grão-Pará, Brazil, in 1668, Manuel João,

a sixteen-year-old barber, was discovered to be wearing a "small pouch" (*bolsinha*) on his chest which, according to the Holy Office's auditor (*ouvidor*), contained an "oration of Our Lady of Montserrat" from Jerusalem with "four marked rules" on it that could "free [one] from many dangers" (*livrava de muitos perigos*); a torn piece of paper; another piece of paper containing pieces of Agnus Dei; a bit of garlic; two stalks of rue; and a bone the size of a fingertip, also wrapped in paper, which appeared "to belong to some dead man" for the bone appeared to still be fresh when it was wrapped.[9] In other cases, descriptions trail off once the overtly Catholic objects were recorded. In a 1727 testimony from Pernambuco, the white man João de Siqueira Castelo Branco was accused of using a bolsa recorded as containing "Communion cloths and purificators"—two types of objects distributed during Catholic masses—but his accusers described the other contents only as "other little things": a turn of phrase representative of inquisitors' disbelief in the apotropaic value of much of bolsas' contents.[10]

Descriptions could be obsessively detailed. Consider the following, recorded by Spanish inquisitors inside a large pouch confiscated from António de Salinas, a sixty-six-year-old fisherman and ritual healer who claimed descent from the "blacks from Guinea" and was arrested in Cartagena de Indias (present-day Colombia) in 1666:[11]

> Some white powders wrapped in two small papers . . . a wooden stick apparently from a relic that looked like a cross, a stamp of Saint [Adelelmus] of Burgos placed in a piece of red cloth, and with it a little piece of linen—I did not know if it was *corporal* or not—all wrapped in a piece of blue satin.[12] And in another piece of paper there was a stick which protected against snake bites; a corn kernel; ten little pieces that looked like splinters of wood; leaves of some tree or plant; and a little bag or coarse cloth which had inside it a small printed image of Our Lady of Soledad. And in another paper there were two, and perhaps more, pieces of Saint Nicholas bread;[13] an old papal *bulla* which both inside and outside lacked the name of the person to whom it belonged; a handwritten, very miraculous prayer very beneficial to the body and soul which ended with "Amen, Jesus"; and another handwritten prayer which was to avoid being drowned, hurt, imprisoned, or other things, which begins by commending the just Jesus and his mother whose son he is: and ends "Amen, Jesus."[14]

This ekphrastic description speaks to the activating power of the written word, of printed images, and of Catholic ritual objects. It implies an

interest in various kinds of cloth or textiles, in tandem with the healing efficacy of natural flora. The "little pieces" and "splinters" of certain contents reference larger objects from which they derive and illustrates the critical role of breakage, fragmentation, and debris inside many bolsas. The veritable mélange it reproduces charts new and intimate relations between contents that collectively disavow easy assumptions about cultural origin, religious affiliation, or artistic hierarchy. Collectively this amalgamation, as Pablo F. Gómez notes in his own analysis of Salinas's case, provides an "inventory of . . . material culture . . . gathered from communities spanning the entire Atlantic"; in so doing, the bag "indexed and contained an entire world."[15]

Gómez's poetic conclusion rightly alludes to the size and sophistication of African healers' knowledge networks, ones largely obscured by Inquisition records. But it is not my only goal here to read inquisitorial descriptions against the grain to understand what mandingueiros worked to achieve inside their amulets. For as Delinda Collier also recognizes in these descriptions, many early twenty-first-century art historians should see a kind of "inappropriate" decontextualized formalism; a failure on the part of inquisitors to connect their subject of analysis to the sociocultural worlds in which they circulated.[16] This formalism is intentional, for it allowed inquisitors to presuppose their own conclusions, mainly, that they were describing feitiços, or materializations of feitiçaria. For Pietz, the questions asked of Jacques's object reproduce the "fundamental question" of the "problem of the fetish," principally "how material objects as such could embody . . . any value not expressing the material object's 'real' instrumental and market values."[17] In Jacques's case, the inquisitors' conclusion—that its materials "did not have the stated effects"—functioned as proof of his feitiçaria. But Collier pushes further, seeing in such encounters not only the clear connection that Pietz leaves unstated—that the fetishization of objects had already transformed into the fetishization of Africans' bodies—but also what I elaborate on in the following section: the "beginnings [of art history] as a pidgin language in the theater of conquest," which will later morph into the "racializing mechanism of art history."[18]

Returning to Gómez's statement about the selective, indexical nature of António de Salinas's work—and, by extension, that of many other African-born bolsa-makers—we can elaborate on Collier's point. Bolsas de mandinga garnered attention during a broad seventeenth-century cultural trend in western and southern Europe to discount metaphysical interpretations of globally sourced objects held inside of what is variously called the "cab-

inet of curiosities," or the *Wunderkammer* or *Kunstkammer*: cabinets or physical rooms assembled by elites in which to display large collections.[19] These collections, as Isabel Yaya notes, shared a common goal: "to assemble a 'microcosm' of the known world," and "control and frame the unfamiliar" it contained.[20] The sense of control and ostentatious display the cabinets embodied, however, teetered against what James Delbourgo describes as the nonfixity of their meaning, as stark and unexpected juxtapositions in display invited speculative conversations on travel, exchange, and shifting relationships.[21]

The contents of the amulets described so far, of course, similarly archived and processed long-distance Atlantic trade: the common source from which the kunstkammer and mandingas emerged. But their divergent receptions—one a commonly cited source point for the creation of speculative visual analysis and the origins of art history, the other institutionally denigrated—pose a distinct set of questions around the then-emergent racializing schema mapped onto the relation between enslaver and enslaved. For as agents of Atlantic mercantile exchange converted Africans' lives into capital commodities, they "fabricated"—to use Collier's carefully chosen pun on the etymology of "fetish"—the capital Europeans used to acquire and consume the materials filling their cabinets.[22]

This is one way of saying that inquisitorial encounters over bolsas de mandinga served as theaters in which to process the contingency of Atlantic-wide debates over value and meaning that otherwise largely excluded African actors. The amulets easily demonstrate that rather than passive victims in this process, those forcibly transported across the Atlantic were also key agents and interpreters of this new global circulation of material objects. But it also suggests that, uncharacteristically for his careful analysis, Pietz may have spoken too quickly when he wrote that his genealogy of the "fetish" was "not concerned . . . with the relation of the fetish idea to the actual conceptions of West African culture."[23] For though he is right to situate the discourse of the fetish as a novel discourse emerging from mercantile and religious exchange in the cross-cultural spaces of the West African coast in the sixteenth and seventeenth centuries, West Africans themselves also actively took up and reframed this discourse not just on their home continent, but in the cross-cultural centers of Europe and the Americas.[24] In Pietz's telling, the geographic distance of European travelers from their home continent allowed for conception of African religiosities as a kind of distant fetishism of a "baffling diversity" of objects: "a function of the infinite diversity of the human imagination unrestrained by reason."[25] But

foregrounding the forced movement of Africans outside of the continent to locales like Portugal and Brazil allows for both an examination of the religious and valuation practices of Europeans and the concomitant redefinition of feitiço that Africans employed.

We can now return to Gómez's observation of Salinas's bag as both index and container of its maker's world, for these two roles acted in orchestrated tension through the framework of what I refer to as strategic occlusion, wherein makers actively selected the form of a bolsa to hide its contents from view and thus simultaneously control and flaunt the esoteric knowledge it contained.[26] This framework dialogues with an important discursive thread in Africanist art history, which foregrounds how certain African objects' spiritual powers derive, as Mary Nooter describes it, from "the deliberate obstruction, obscuring, or withholding" of their contents.[27] Framed as a kind of visual principle, art historians have explored and defined certain works as "power objects" that manifest effective powers through their material contents as opposed to the visual force they outwardly convey.[28]

As an example from the Mande cultural sphere discussed in the previous chapter, the shirts worn by members of Mande hunters' associations (donso) are commonly covered with a protective layer of West African Islamic-associated talismans (figures 2.2 and 2.3).[29] The example shown here displays shells, animal claws, horns, and a plethora of leather amulets containing Qur'anic papers: a collective assembly of objects pulled together from the crossroads of trans-Saharan exchange and warfare. Research conducted conducted by Lorenzo Ferrarini in Burkina Faso in 2011 and 2012 suggests that hunters and the ritual specialists responsible for the shirts' creation chose amulets not for their outward visual appearance, but rather as functions of efficacy, in that they were understood to harness the same apotropaic abilities regardless of their materials or their visibility.[30] This was a visual argument: since onlookers were not privy to Mande hunters' knowledge about the contents of their amulets on their shirts, then the accumulative, almost ostentatious display of amulets on shirts flaunted the "restricted access knowledge" hunters possessed.[31]

Asking a Mande hunter to detail an amulet's contents would descriptively disentangle it, and thus unmake its power. More broadly, to enumerate and classify contents runs counter to the animating logic of spiritually empowered objects in a range of Afro-Atlantic religions that developed during and after the period of the slave trade. For example, in his discussion of West African Yorùbá sacred altars—assemblages privileging container-

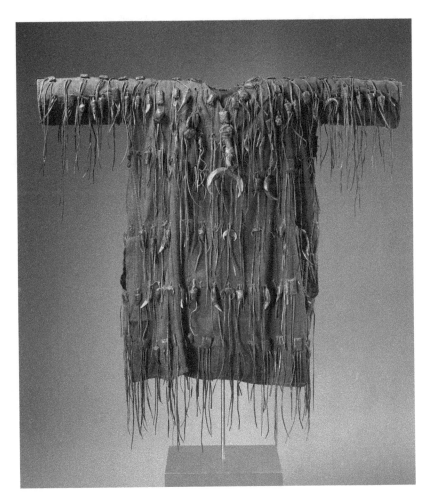

2.2 Hunter's Shirt, Donson Dlokiw. Mali. Malinke. Late nineteenth–early twentieth century. Cloth, leather, shells, animal claws, horns. Ex coll. William S. Arnett, 1994.4.111. © Michael C. Carlos Museum, Emory University. Photo by Bruce M. White, 2008.

form objects housing empowered contents—J. Lorand Matory notes that priests are often "unwilling to give that distinct item in the assemblage a discrete and particular noun. . . . If forced to itemize, they name a few things and quickly put a stop to it," instead concluding, "The god is the entirety of those things together."[32] Like Matory, I can recount numerous occasions on both sides of the ocean when ritual specialists have politely redirected my questions about the contents of a hidden room, or have demurred to more polite topics when I ask about the origin of the contents of

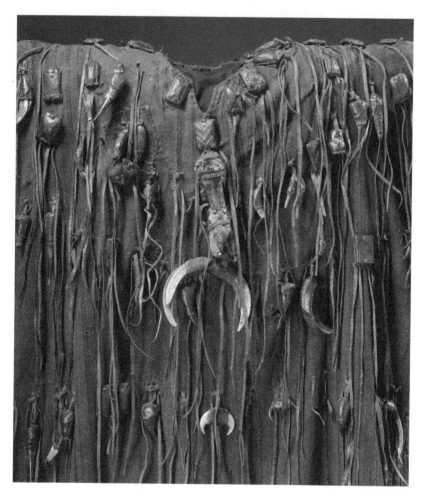

2.3 Detail of figure 2.2, showing leather amulets and those of other materials.

an altar. The subtext is clear: not only were my questions misplaced, but as a noninitiate, I was not privy to the knowledge contained in these spaces.

One could note the priests' reticence as simply a point of cultural difference, and thus characterize Portuguese Inquisition trials as clashes between differing epistemological frames: an African penchant for visually occluding esoteric ritual knowledge—as embodied in Jacques's amulet—struggling against the ocularcentrism and classificatory impulses of Western modernity. But to do so would belie the common historical genesis of both strategies: the social instability and pervasive climate of fear that

accompanied the intensification of slave raiding and trading in Atlantic Africa after the sixteenth century—for peoples across this world sought out the protection of unseen forces manifested in material objects.[33] In the wake of this history, the Portuguese Inquisition occupied a strange legal space, for they tried to suppress feitiçaria in colonial contexts even as "Portuguese and other European settlers in Atlantic Africa commonly shared a belief in magic and sorcery," including the efficacy of spells, and the power of feiticeiros.[34] And this Atlantic universe of charms, amulets, talismans, and what Africanists will later call "power objects" were, in contrast to this final term, used to cure, to harm, and to protect, and they often did so through a strategy of flaunted visual containment to harness forms of materialized power. One could thus define the term *feiticeiro*—a term for operators of power objects or feitiços—as a gloss for someone who actively mediates between systems of classification, cultivating a correspondence between preexisting materials and social and personal ills to provide cures for them.[35]

This partly explains why the act of opening amulets and describing their contents was such a critical part of transforming them from mandinga to feitiçaria: inquisitors had to make their materiality "irreducible," as Pietz frames it, through their destruction and conversion into evidence.[36] This served as an attempt to push through the performative discourse of sorcery, whose fully revealed truth, as Roger Sansi describes it, "can be revealed only in part, precisely because it is occultation which makes sorcery powerful."[37] Indeed, according to Raphael Bluteau's 1713 dictionary, a feiticeira is one possessed of knowledge of "hidden things," while a feiticeiro is one who "does or makes things of supernatural forces."[38] Francisco Bethencourt notes this second level of "hidden" implicit in Bluteau's definition, "for it refers not just to special knowledge, but a special form itself of seeing unavailable to others"; in this case, a careful itemization of the causes of systemic violence and social ills, and a careful attendance to their potential cures.[39]

How might we characterize the social ills to which mandingas responded? From what did these protective objects protect? In Sierra Leone, around the Bight of Benin, and in West Central Africa—homes to societies that long held that personal and communal misfortune resulted from malevolent forces and those who manipulated them—the slave trade extracted human beings and material resources, leading to the restructuring of the spiritual worlds those persons and objects supported. This generated interpersonal suspicion and fear of elites who allowed such losses. John Thornton notes, for example, that people in the lower Congo in the late seventeenth and early eighteenth centuries began to perceive

themselves as "exploited victims of greed and evil," and so turned "all forms of exploitation into manifestations of witchcraft."[40] And in the late sixteenth century, André Almada asserted that those found guilty by divination of what he termed "witchcraft" across West Africa were "taken into captivity, including their entire family. For chiefs, this was obviously a very economical method of obtaining slaves."[41]

The discourse of witchcraft Almada cites here reflects his attempt to name a notion shared across Africa and Europe: processes used to identify and cast out those perceived responsible for social disintegration. In Atlantic Africa, such accusations carried punishments of social ostracization, death, or sale into wider Atlantic networks: a point that Cécile Fromont discusses as a potential motivation for the later production of mandinga amulets by those so enslaved.[42] Accusations of witchcraft thus concentrated wealth and social power by exchanging the socially outcast for economic gain. This created a runaway cycle: the slave trade developed in concert with antisocial spiritual forces responsible for its effects, and in turn generated more accusations and persons exiled across the ocean. One traveler summarized this situation in the nineteenth century, declaring that "the slave trade owed many of its victims" to witchcraft accusations, "which the wicked men who traded in human flesh took care to foster by every means in their power."[43]

By what techniques could one respond to this climate? Power associations—a social fixture from Senegambia to the Bight of Biafra— trained initiates to preserve ritual knowledge and protect communal harmony, while also identifying antisocial actors and the malevolent spirits with which they communed. Performative manifestations of their authority largely parallel the visual discourse of seclusion discussed earlier, as they "employ signs, symbols, and forms of knowledge which are withheld from noninitiates, but these things are regarded as a special source of power through being kept private."[44] The Poro of the Upper Guinea coast—a diverse series of manifestations of quasi-governmental initiatory societies historically responsible for the training of warriors—remains well known for its "control over states of Darkness through its medicines and practices of verbal and ritual secrecy."[45] Dating back to the earliest European interactions in Upper Guinea, Poro initiates have also played key roles in resisting and mediating the slave trade as well as adjudicating witchcraft trials that resulted in the expulsion of the convicted into Atlantic slavery.[46] Oral histories from Mande hunters' associations also suggest their emergence during a historical period when antisocial actors and spirits roamed the

landscape.[47] A shirt's dense coat of talismans, then, not only shields the wearer from socially disruptive unseen forces. It suggests that power associations' focus on secrecy and strategic occlusion emerged out of a climate of mutual fear in the wake of human and material losses. In this context, strict protection of spiritual knowledge emerged as a top priority, to the point where spiritual vessels, rather than containing information accessible to initiates, served as repositories of esoteric knowledge untranslatable to humans. Fittingly, as some Mande hunters added amulets to their shirts in the early twenty-first century—a practice that also accumulated their spiritual power (*nyama*)—they described the shirt's appearance as approaching "the Mande concept of *dibi*, meaning obscurity, ambiguity, and potentially devastating strength."[48]

This may explain why early European accounts from the West African coast consistently speculate about the contents and exchange values of Africans' amulets. Writing on the Gold Coast in between 1601 and 1602, the Dutch trader Pieter de Marees expressed a kind of illicit desire, even suspicion, over the unseen contents of African traders' amulets. Observing that outwardly they wore "beads and other things which we bring to them," he noted what is inside their "leather bags is unknown to me, for they do not allow me to look at them."[49] Marees's lingering confusion suggests his desire to gain access to the knowledge he was denied as well as his feelings of jealousy over Africans' revaluation of European trade goods. This point became more explicit in the ensuing decades: on the Gold Coast in 1666, the French author Nicolas Villaut bemoaned Africans' amulets as "bits of horn filled with garbage" and "a hundred other infamies"; Villaut also perceived that amulet-wearers were clearly duped into acquiring things of little value, since it was "their Prestres" that sold them the objects.[50]

This implicit connection between visual description, occlusion, and fetishism was made clear following the mandinga trials of the 1700s–1730s. In his 1760 essay inaugurating the use of the term in the Europe, Charles de Brosses uses "fetishism" to define the worldviews of Black Africans as a "confused assemblage" and "indecipherable chaos" of myths and mythmakings; alongside a defined tendency to "appropriate everything that was foreign."[51] Tellingly, de Brosses names "amulets" and "protective talismans" as its material exemplars:[52]

> These divine Fetishes are nothing other than the first material object that each nation or individual has seen fit to have ceremonially consecrated by its Priests: a tree, a mountain, the sea, a piece of wood, a lion's tail, a stone,

a shell, salt, a fish, a plant, a flower, an animal of a certain species, such as a cow, goat, elephant, or sheep; in short, anything of this sort that one could possibly imagine. They are so many Gods, sacred objects, and also talismans for the Negroes, who worship them in an exact and respectful manner, address their wishes to them, offer them sacrifices, carry them in procession if it is possible, or wear them on their persons with great marks of veneration, and consult them on any significant occasion.[53]

Here, the "problem of the fetish," as Pietz terms it, is a problem of visual description understood as a method of categorization attached to accepted hierarchies of value. Making this point explicit in 1807, the British mercantilist Joseph Corry derisively stated the relationship between the difficulty of visual description and its relation to the fetish. The term is "an expression of compound meaning," he wrote, "forming an arrangement of various figures, which constitute the objects of adoration . . . it is an incongruous composition of any thing dedicated to the purpose [of adoration or devotion]."[54] Some, he noted, were "composed of distorted images" and "bedaubed with other preposterous applications," including blood, palm oil, or feathers, which, it seemed, were problematic not only in the sense of their misplaced value vis-à-vis worship, but also because they prevented him from seeing the forms underneath.[55]

A 1732 engraving visualizes this problem as one of key consequence to the interpretation of material objects in the Black Atlantic world (figure 2.4). It was published to accompany the first English edition of Jean Barbot's 1688 travelogue, written as a series of observations made during the author's time in West Africa as an agent of the French Compagnie du Sénégal between 1678 and 1682. A seemingly haphazardly strewn collection of pots, blade weapons, leaves, feathered objects, a small bell, and a beaded necklace occupy a featureless landscape. Filling the entire spatial depth of the picture plane—one square object in the background even seems to lean over the horizon line—the engraver reckons with the series of contrasting values and forms brought together in this assemblage, collectively labeled as "other Sorts of Fetissos." Barbot's engraving, in his words, shows the "cult" herein depicted as defined by a mysterious combination of "trash" from which Africans read prophecies.[56] In tandem, it also alludes to the *fetisso* as a slippery or even promiscuous term that could mark almost any object: "they have so many things they call *Fatishes*," wrote the English traveler Thomas Phillips in the 1690s, "that I could never understand the true meaning of the word."[57] Thus, the engraving opens for visual

2.4 "Other Sorts of Fetissos," 1732. Published in Barbot, *A Description of the Coasts of North and South-Guinea*. Photo courtesy of the Newberry Library, Chicago.

inspection objects well-known to his audience and those that even Barbot could not define; it brings together a range of floral, faunal, and manmade items that as a result of their labeling as *fetisso*, an audience knew could be utilized by Africans to control, manipulate, or counteract a wide range of unseen forces. As Gabriele Genge has noted, the existence of materials that could embody fetissos posed less of a problem in this system of asymmetric value exchanges than the powers they could produce once brought into close proximity to those persons who possessed the esoteric knowledge required for their identification and use.[58] By placing them in an uninhabited landscape, Barbot strategically divorces the sorted fetissos from their makers and users and the potential threat they posed.[59]

What Barbot and his contemporaries did not explicitly account for, however, were the dramatic transformations in the material economy of religious practices along the West African coast at this moment. As new imports made their ways into local markets to be traded for human beings—beads, cloths, guns, munitions—Africans increasingly expanded the material universe of their rituals, and the spirits they served, to incorporate these items.[60] Luís Antônio de Oliveira Mendes, a Bahian-born sugar planter, outlined this point in an 1806 speech to the Royal Acad-

emy of Sciences in Lisbon on the cultural customs of the Kingdom of Dahomey.[61] His knowledge informed by Bahia and Dahomey's economic ties as a result of their trade in gold, arms, and enslaved captives, one section of Oliveira Mendes's speech concerned the "many feitiços" used by Dahomeans, specifically how they

> make a bolsa as an imitation of a *breve* (a popular Catholic written oration), which they carry with them and in which they deposit certain things of their own invention as well as some relics in which they believe. . . . To this end they make use of . . . all that comes to their imagination: in them they put many kinds of hair, certain teeth and beaks of animals and birds, pins, lancet tips, feathers and dried entrails of those same birds, and their nails, the skin and the rattle of different kinds of snakes and many other things, giving to all of this a value which it certainly does not have.[62]

Reconfiguring the relations between exchange objects of European import, Catholic ritual, and local flora and fauna, Oliveira Mendes seems in awe and suspicion of how to classify the material universe he encountered. In this way, the intensification of the slave trade on the West African coast fundamentally shifted the types of materials Europeans labeled as fetishes. As items of cosmopolitan manufacture, their utility and value inside local cosmologies was almost inherent. Their ritual value was largely inseparable from their economic utility at this point, a standard function of a cultural economy based on exchange and material accrual. But, like Barbot and de Brosses, Europeans often disparagingly claimed Africans misplaced, or did not understand, the value—whether culturally or economically—of these objects. But as Africans increasingly found themselves in the Americas, they encountered new social ills to which to respond, and new systems of power from which to protect themselves. In turn, they continued to revaluate the materials of new ritual universes in ways that profoundly impacted the structure of popular religiosities and thus garnered increasing attention from onlookers.

Amulets, Altar Stones, and the Debate over Value

J. Lorand Matory argues that the spirited creations of Afro-Atlantic religious practitioners were called fetishes "precisely because Africans, Europeans, and their descendants have looked at them and intensely disagreed

about the value and agency that can be legitimately attributed to them and their makers."[63] Indeed, we have seen this discourse play out already through aforementioned examples in West Africa, as well as in chapter 1, where the circulation of newly imported objects generated fierce debates and suspicions over the economic and spiritual values embodied in them. But mandingueiros in Brazil and Portugal added a second level to this discourse: they strongly *agreed* with white elites about the religious values embedded inside the new objects they found. This turn of events alternately surprised and confounded inquisitors as they saw the core symbols of their personal religious systems adopted and adapted not only inside of the structures created to preserve them, but also on the bodies of those persons they sought to convert.

Throughout eighteenth- and early nineteenth-century Brazil, Africans utilized a mélange of tattoos, scarifications, jewelry, beads, amulets, and medals that collectively formed an apotropaic "second skin."[64] Peoples across the Atlantic world in the early eighteenth century broadly conceived of human bodies as permeable containers potentially subject to manifold outside influences: a perspective closely related to systemically high mortality rates and short life expectancies. In Portugal, one in four children died before seeing their first birthday.[65] Amulets thus provided a bodily seal from interpersonal violence such as knives, guns, and other weapons; malevolent spirits; sicknesses and curses.[66] In so doing, amulets collapsed distinctions between the physical and the spiritual by protecting bodily autonomy from outside dangers. A late eighteenth-century watercolor by Carlos Julião visualizes amuletic pouches' role in this practice (figure 2.5).[67] The untitled image, though devoid of labels by the artist, likely depicts a Black street vendor in northeastern Brazil.[68] Framed against a sparse landscape, she balances a tray of fruit on her head while carrying a child on her back: two cues Julião uses to mark her as fertile for the production of food and enslaved laborers. In his rendering, Julião turns her left hip and chest toward the viewer to call attention to the talismans displayed on her body. Around her neck hangs a devotional scapular, rendered as a black square on a red string, which in practice would have been marked with images or prayers to a Catholic saint. Other objects also speak to Catholic affiliations. The yellow and red circles at her waist represent common brass and bronze medallions with images of saints and Christ. One is identifiable: a silver heart-shaped medal, at the far right, reproduces the Sacred Heart of Jesus, which by the early eighteenth century was well-established as a popular Catholic devotional symbol.[69] In the seventeenth

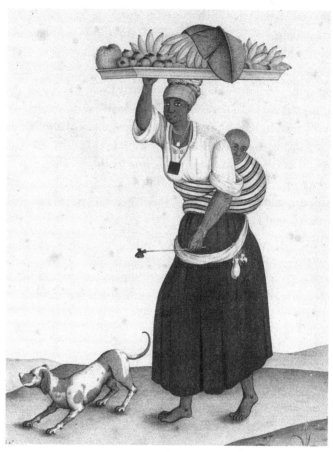

2.5 Carlos Julião, *Untitled ("Black street vendors")*, detail. From *Notícia summaria do gentilismo da Asia: Com dez riscos illuminados*. Brazil, last quarter of the eighteenth century. Watercolor on paper, 45.5 × 35cm (18 × 14 inches). Acervo Fundação Biblioteca Nacional, Rio de Janeiro, Iconografia C.1.2.8, folio 43. Photo courtesy of the Fundação Biblioteca Nacional.

2.6 Detail of figure 2.5.

and eighteenth centuries, both scapulars and medals like these were popular among "new Christians" who were those most often denounced to the Inquisition. Such denunciations were occasionally the result of what Julião displays here: the close intermingling of orthodox objects like scapulars and medals along with other, sacrilegious amulets and apotropaic symbols on their bodies. A tattoo or drawing of a pentagram—a common occult and talismanic symbol—marks the back of the woman's left hand, while two pouches hang from strings attached to the white cloth encircling her waist (figure 2.6).

With precise attention to detail and a lack of individualizing features, Julião's figures serve as generic types for viewers to closely inspect clothing, amulets, and physiognomies. These choices imply that the talismans Julião renders are closely linked to popular forms of Africans' religiosities, in contrast to the orthodox Catholicism of Iberian elites. But a 1602 portrait by the Spanish court painter Juan Pantoja de la Cruz testifies to the popularity of apotropaic amulets even among Iberian royalty (figure 2.7). In it, Ana Mauricia, daughter of Philip III and Margaret of Austria, wears multiple embellished crosses, a heart-shaped medallion, and a *figa*, a fist-shaped protective amulet known from Etruscan and Roman sources that today is commonly associated with African-inspired religions in Brazil. Appropriately for an infant, she also holds a red piece of coral, intended as a teething device. Collectively, the objects she holds underscore how the proliferation of amulets was important for children, as their new bodies were considered particularly vulnerable to spiritual or physical damage.[70] Julião's watercolor, then, attests to how a wide-ranging corpus of apotropaic amulets became popular among a diverse group of users in between the early seventeenth and late eighteenth centuries.[71] In Brazilian urban centers specifically, vendors readily sold such amulets to an eager public: historian Mariza de Carvalho Soares notes that amulets were among the goods directly imported from Africa and sold by free Black women at their market stalls in Rio de Janeiro.[72]

As a result of this expanded clientele, Inquisition records suggest that by the early eighteenth century, elites came to regard these amulets with curious visual speculation and potential fear, especially given the bodily autonomy and religious experimentation they afforded their users. Fittingly, the pouches Julião depicts around the woman's waist stand out in this diverse range of talismanic media for their seeming visual banality and ambiguity, key factors to the subtle power of mandingas. As the term *mandinga* described the function of an amulet, not its form, the display of amulets

2.7 Juan Pantoja de la Cruz, *La Infanta Ana Mauricia de Austria*, 1602. Oil on canvas, 86 × 76 cm (33.8 × 22.9 inches). Convent of Las Descalzas Reales, Madrid, Spain.

and apotropaic symbols on one's body immediately invited speculation about their potential powers. In turn, pouches could serve other talismanic or even practical functions distinct from mandingas. Perhaps most nefariously for inquisitors, the scapular rendered on both of Julião's portraits could also be mandinga, and may only be distinguished from the pouches around his subjects' waists by an unseen ritual efficacy manifested through contents that remain invisible even as these objects are proudly displayed. The Portuguese Bishopric of Lamego responded to this problem in its 1683 constitutions by making a distinction not only between the types of things Catholic devotees carried, but also the effectiveness they manifested

for their wearers. Asserting that "it is not a vain thing, but holy, to carry Relics with devotion and decency, and without superstition, nor to believe in some definite effect that undoubtedly should proceed from them," they cited proper things to carry as "blessed Beads, Crosses, Agnus Dei, and Images of our Lord, or of our Lady, or of the Saints" and censured all those who "carry amulets, orations or written words around the neck, believing that by their virtue nothing will hurt them in war, or in a fight, or they will not die in fire nor drown, nor die suddenly; and that everything will prosperously succeed for them."[73]

The Lamego bishopric's efforts speak to a latent fear over the proper interpretation and use of amulets and relics, a fear likely stemming from a concern about how to maintain religious and political authority through Catholic orthodoxy in an increasingly pluralistic society. Indeed, the trial records of many African-born mandingueiros show how deftly they reimagined the proscribed uses of otherwise sanctioned objects. The Lamego bishopric's censuring of "orations or written words" in this context is particularly telling. In 1730 the West African-born José Francisco Pereira, whose case is discussed in detail later in this chapter, testified that the first mandingas he made in Lisbon were breves (also called bulas)—a type of written oration sold by the Roman Curia to confer indulgences to their faithful—and that were also regularly used to wrap relics. He claimed he purchased the breves specifically "to give them the title of mandinga" and thus fulfill his enslaved clients' demands for the talismans.[74] Similarly, in 1729, Luis de Lima, an African then enslaved in Porto, also confessed to having purchased an oration that "served as mandinga" from a mandingueiro named Francisco in Pernambuco three years prior.[75] According to Luis, specific Catholic orations served as critical inclusions inside many of the pouches Francisco made and sold.[76] At his trial, Luis— either to salvage a truthful excuse or feign ignorance—played up this discourse of permissiveness. Echoing a similar point made by Crispina Peres at her trial, Luis stated that he was unaware that in Pernambuco the amulets he used were a "prohibited thing," and did not learn so until early in 1729.[77] Luis told a similar story about Manuel Purieiro, a mandingueiro he knew in Pernambuco and met again in Portugal, saying that Manuel had once gifted a divination object to an enslaved Black man in Brazil with the understanding that since such a thing was "very prohibited" in Portugal, Luis could not bring it across the Atlantic.[78] Luis, however, claimed that he transported the mandinga he acquired from Francisco to Porto from Pernambuco.[79]

While Luis likely stated this information to avoid punishment, his explanation speaks to inquisitors' other concern: Africans' illicit transatlantic mandinga-object market economy. Pietz notes that the discourse of feitiçaria and feitiço during the early eighteenth century was primarily framed as a debate over the perceived efficacy and exchange value of objects on the West African coast. But Luis suggested that Africans maintained a strong economy that acquired, exchanged, and marketed the spirited objects of European orthodox and popular Catholicism alongside a diverse range of flora, fauna, and ephemera, and even did so in metropolitan Portugal. A significant portion of Luis's confession is dedicated to the names and biographical details of dozens of African-born mandingueiros in Brazil and Portugal, some of whom were later put on trial and punished: a fact that speaks to this network's actual historical existence.[80]

Inquisitors expressed a combination of bafflement and curiosity at the range of materials that entered Luis's pouches. In one situation, he stated that he was given a series of ingredients from an enslaved man named José Luis, who sought to escape his English enslaver in Porto.[81] To this end, José Luis gave him a tooth, some ground pepper, and some garlic.[82] In another story, Luis stated that in Porto in 1727 he had sold "as mandinga" a silver-plated jaguar claw (hanha) to someone enslaved to a Brazilian man.[83] Though pepper and garlic surely commanded significantly lower prices than the claw, the implied debate at Luis's trial was about how these ingredients matched with the spiritual powers of the amulets, as this was the source of their economic value. At the same time, Luis understood the protective value afforded by his own mandinga pouch as secondary to its economic one: a point that undercuts assumptions of African mandingueiros as simply reproducing forms of proto- or precapitalist African religiosities. Indeed, upon arriving in Portugal with the amulet he brought from Brazil, Luis claimed he opened and divided it into smaller parts, added a piece of a dead man's bone to each, and then sold them for a profit.[84]

Luis's buying and selling of objects as mandinga suggests that their apotropaic properties were intimately tied to the economic value. Luis even stated that the main reason he produced mandinga amulets in pouch form was "so he could sell" them, and inquisitors followed up with questions about the prices his creations demanded. In one case, Luis sold a mandinga he received from another enslaved Black man named Damião, who had come from Brazil, for one quarter moeda de ouro (a Portuguese gold coin) to a cloth-seller in Portugal.[85] Other cases reveal similar concerns with the market prices of amulets. José Francisco Pereira's prices oscillated

depending on time and location in Lisbon or Rio de Janeiro, but included one half of a moeda de ouro; two or three *cruzados novos*, one *quartinho*, or sixteen *tostões*: numbers that suggest that an enslaved African's market cost for an effective bolsa de mandinga in Lisbon at least doubled between 1700 and 1730.[86] This means that the Inquisition's period of greatest interest in mandingas exactly coincided with a significant rise in their demand. One may rightly ask, then, whether the Inquisition's public suppression of mandinga networks bolstered the market for them.[87]

These examples show how mandingueiros intentionally manipulated material objects' proscribed meanings to suit the needs of their clientele. At the same time, José Francisco Pereira and Luis de Lima's assertions that their breves or orations were, and could be, mandinga alluded to a potential defense at their own trial: far from being deviations from proper practice, the objects they used were actually produced and distributed by the Church. Nowhere did this fact come through more strongly than in the repeated use and circulation of pedras d'ara inside mandingueiro networks. Commonly called altar stones, these objects were some of the most sought-after ingredients inside bolsas de mandinga.[88] Hollow-centered pieces of marble filled with saints' relics, they served as sanctifying additions to church altars and tables used by itinerant priests. Eucharistic hosts, in turn, could only be consecrated when placed over a pedra d'ara. At his 1730 trial, José Francisco Pereira repeatedly attested to placing orations later inserted inside bolsas underneath pedras d'ara in churches in Portugal and Minas Gerais while "two or three masses" were said over them.[89] The Angolan-born António Mascarenhas, then enslaved in Funchal, made a similar pronouncement at his 1744 trial: "For the mandinga to be really powerful," he argued, "you have to put it between the altar stone and the altar cloth so that Mass would be said over it."[90]

James Sweet speculates that the form of the pedra d'ara resonated with Africans because their home continent widely recognized the magical properties of hollowed out objects filled with activating substances.[91] While previously I traced a different genealogy for these types of empowered containers than Sweet does—the fact that Africans only included small pieces of these objects in bolsas suggests they were not taken for their visual properties—the number of Africans who sought out pedras d'ara for their pouches speaks to the reverence in which they were held. However, pedras d'ara may be overrepresented in inquisitorial records, as those accused may have referenced the objects as an attempt to foreground mandingas' incorporation of proper Catholic practice, or because those

denouncing mandingueiros focused on the use—and often theft—of the pedra d'ara as especially sacrilegious. Regardless, the usefulness of the pedra d'ara inside bolsas de mandinga most clearly derived from the importance mandingueiros and inquisitors alike placed on it during Catholic liturgy in Portugal and Brazil, and so its adoption inside mandingas can be read as an attempt to incorporate the primacy of its ritual significance inside the Catholic world.

Given the preponderance of altar stones inside mandinga pouches, one can assume these are the small pieces of stone inside Jacques Viegas's example. Indeed, the only other surviving bolsa—today attached to the 1749 denunciation of Dona Francisca Maria de Menezes, a widow from Funchal who used it to find a new husband—incorporates small pieces of stone (figures 2.8 and 2.9).[92] Still attached to her Inquisition record, the red-and-blue cloth pouch contains a single folded piece of paper displaying a set of Latin prayer phrases interspersed with crosses and headed by an encircled cross. Scribbled letters complete a design evidently inspired by religious medals in general and possibly *vintém* coins which—as will be

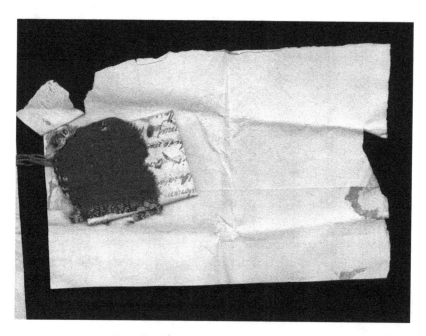

2.8 Red cloth mandinga pouch attached to the Inquisition record of Dona Francisca Maria de Menezes, Lisbon, Portugal, 1749. Arquivo Nacional da Torre do Tombo, Lisbon, Portugal. Tribunal do Santo Ofício, Inquisição de Lisboa, liv. 300; PT/TT/TSO-IL/030/0300. Image courtesy of the ANTT.

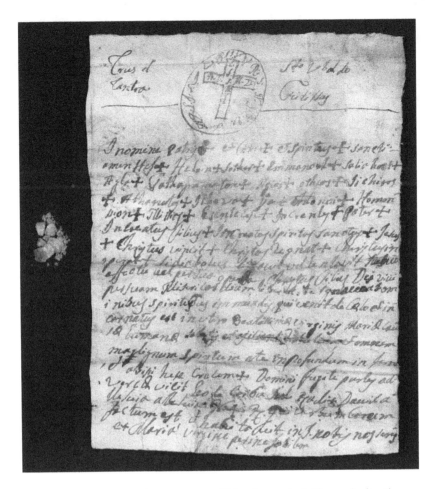

2.9 Paper oration used to wrap ground bits of stone (at left); attached to the Inquisition record of Dona Francisca Maria de Menezes, Lisbon, Portugal, 1749. Arquivo Nacional da Torre do Tombo, Lisbon, Portugal. Tribunal do Santo Ofício, Inquisição de Lisboa, liv. 300; PT/TT/TSO-IL/030/0300. Image courtesy of the ANTT.

discussed later—were broadly used in Portugal as amulets. This paper, in turn, surrounds some small stones; likely bits of altar stone given that the denunciation attests to their use in the bolsa.

As Menezes's denunciation attests, bolsa-makers worked hard to incorporate pedras d'ara inside their pouches. A series of testimonies recount the dangerous lengths to which mandingueiros went to acquire them. In his 1729 confession in Porto, Luis de Lima testified that a Black man named José, the son of a cleric living in Porto, gave him some "pieces of

pedra d'ara" that he said he had stolen from a church altar as mandinga, but that they did not appear to actually protect from knife wounds after trying them out to this end.[93] While we can never know if José indeed removed those bits of altar stone, the story demonstrates the prominence the stones carried in emergent debates over ritual validity and religious power. A 1764 case from Grão-Pará continues this point. Anselmo da Costa, identified as Indigenous (*índio*) and aged fourteen, was denounced for selling mandinga pouches in the main square (*lugar*) of his hometown of Benfica, some twenty miles northeast of the captaincy's capital of Belém. In April of that same year, in Belém, Friar Antônio Tavares reported that he suspected the theft of ritual objects from the sacristy of his church, Nossa Senhora do Carmo. He later noted on Good Friday that he found the pedra d'ara in the Church out of place, almost broken in half, and missing bits from one side. After admonishing his parishioners at Sunday mass, Tavares received news that Cyprian, his ten-year-old servant, saw Anselmo da Costa with "two pieces of the pedra d'ara," saying that with them "neither knives, swords, nor clubs could do evil to him."[94] Cyprian warned Anselmo that for the theft of this thing he would be excommunicated. Anselmo responded that "having mandinga was preservative medicine. And that excommunication did him no harm."[95]

The accusations leveled against Anselmo emphasize the transformative powers of Catholic materials, but also their potential redirection. Collectively, the circulation and revaluation of altar stones as mandinga, even prior to their removal by mandingueiros, indicates the power the Church's objects held for them. As Anselmo's response suggests, at least some mandingueiros in Brazil did not fear the church's institutional structures. Instead, they pulled together materials from new contexts, particularly when those objects exerted widely accepted spiritual or institutional powers. In this context of material-spiritual warfare, one had to gain the knowledge to manipulate empowered materials, or to seek out those who did. And all these threads coalesce in the case of José Francisco Pereira.

José Francisco Pereira: A Case Study

At the time of his arrest on charges of feitiçaria in the summer of 1730, José Francisco Pereira was likely one of the most prolific mandingueiros in Lisbon. Born near the Bight of Benin, he first spent "nine or ten years" laboring in Pernambuco after his enslavement in Africa and exile from Ouidah.[96] He was later sent to Minas Gerais for three years and then to

Rio de Janeiro for one year, before being transported to Lisbon late in 1728.[97] In all the locations in Brazil in which he found himself, he claimed, people discussed and used feitiços; indeed, José Francisco testified that a free, Black, Brazilian-born man named Zamita first taught him about feitiços when he was in Pernambuco.[98] In Lisbon he encountered a community of enslaved Africans eager for bolsas who also who felt his time in Brazil gave him a special knowledge of mandinga-production. In response, he began a mandinga-making business with his friend and confidant José Francisco Pedroso.[99] As two of the six enslaved African-born mandingueiros who appeared before the Lisbon Inquisition between 1729 and 1737, José Francisco Pereira's and José Francisco Pedroso's trial records contain the most detailed record of mandinga production in eighteenth-century Portugal. José Francisco Pedroso's trial record, in fact, contains a series of seven drawings that José Francisco Pereira intended for inclusion inside his mandinga pouches. From these, as well as from the pair's descriptions of their own work, we can trace how José Francisco Pereira's practice not only confounded an emergent distinction between feitiços-as-African and Catholic iconography, but also served as a space to forge the dynamic reinvention of his own experiences as reckonings with the daily realities of enslavement and displacement. In turn, José Francisco's work presents a critical reflection on the Atlantic market economies in objects and persons, including himself.

At first glance, José Francisco's designs collectively display what inquisitors could identify as permissible Catholic iconography. In three nearly identical images he produced, José Francisco renders at center a cross, accented with a spear and staff topped with a sponge (figure 2.10). The repetition of this image across his designs suggests that it formed a standard part of his mandinga production, and I speculate each copy was destined for a different client. At top, a heart symbol is pierced by two arrows, an image likely derived from the Sacred Heart of Jesus symbols discussed earlier. Meanwhile, the circular symbol at center derives from the wide range of devotional medals and coins-turned-amulets that circulated on the bodies of people across the African-Portuguese world.[100] The two lines crossing on top of it represent the spear and sponge used during Christ's crucifixion, but here they are converted to feathered lines that evoke the feathered quill pens José Francisco would have used to create the designs: a moment of self-reflexivity, where the contents of mandingas reflect on their own production.[101] Another image, drawn in black ink and red blood, depicts the *Arma Christi*, a collection of objects and references to events related to Christ's crucifixion (figure 2.11). This visual grouping

2.10 Paper once contained inside a bolsa de mandinga made by José Francisco Pereira, Lisbon, Portugal, 1730. Ink on paper, 33 × 30 cm (13 × 9 inches). Arquivo Nacional da Torre do Tombo, Lisbon, Portugal. Tribunal do Santo Ofício, Inquisição de Lisboa, proc. 11774; PT/TT/TSO-IL/028/11774. Image courtesy of the ANTT.

2.11 Paper once contained inside a bolsa de mandinga made by José Francisco Pereira, Lisbon, Portugal, 1730. Ink and blood on paper, 33 × 30 cm (13 × 9 inches). Arquivo Nacional da Torre do Tombo, Lisbon, Portugal. Tribunal do Santo Ofício, Inquisição de Lisboa, proc. 11774; PT/TT/ TSO-IL/028/11774. Image courtesy of the ANTT.

print + examine evidence of religious transformation

was used across southern Europe as early as the ninth century.[102] A cross, topped with the letters INRI, is flanked, on the left, by Christ's flagellation pillar topped with the rooster that crowed upon Peter's third denial of Jesus. A ladder, on the right, was used for the deposition of Jesus's body from the cross, while the skull and crossbones below the cross reference the grave of Adam.

How might we interpret José Francisco's Arma Christi? Taking José Francisco's work as a kind of representative case study, many recent authors see in his practice—and in mandingas generally—a kind of strategic religious syncretism, particularly owing to the overtly Catholic character of images like this. In her analysis of mandinga amulets, Daniela Buono Calainho foregrounds the difficulty in "uncover[ing] what is originally African" in mandingas broadly, since the ritual practices of Africans and mulatos in eighteenth-century Portugal "maintained a fluid and uncertain boundary" with European practices.[103] Didier Lahon, noting José Francisco's youth in West Africa, looked to rituals associated with contemporary West African Vodun and Yorùbá deities to argue that his bolsas contained a "double meaning" hidden behind their seemingly Catholic veneer.[104] In turn, Vaniclèia Silva Santos has suggested that José Francisco's work acts at the intersection of "manifestations of Kongo and Catholic religiosities," specifically that the "pieces of drawn paper" in his amulets "express a special form of relationship with the death of Christ and the world of the dead, characteristic of the Bantu thought system" learned from central Africans in Brazil, who would have been familiar with distinctly Kongo understandings of Catholicism prior to their enslavement.[105] The strong establishment of central African ritual communities in early eighteenth-century Pernambuco and Rio de Janeiro—two regions where José Francisco was enslaved while in Brazil—seems to support Santos's thesis.[106]

But, as Carolyn Dean and Dana Leibsohn outline, considering José Francisco's works as representative of cultural hybridity or syncretism effectively "homogenizes things European and sets them in opposition to similarly homogenized non-European conventions. In short, hybridity is not so much the natural by-product of an 'us' meeting a 'them', but rather the recognition—or creation—of an 'us' and a 'them.'"[107] This plays out on a chromolithograph of the Arma Christi, an image commonly used the Afro-Cuban-identified religion Regla Ocha, or Santería, in the early twenty-first century to represent the creator-being Olofi on devotional candles honoring a group of seven *orichas* (figure 2.12). But rather than seeing

2.12

195: Pasión de Cristo. Image printed and distributed by Cromos y Novedades de Mexico, Sa de Cv, Mexico City, Mexico. Purchased at Original Products Botánica, The Bronx, New York, May 2015. Inkjet print, 21.5 × 28 cm (8.5 × 11 inches). Collection of the author.

a direct lineage between José Francisco's Lisbon image and santeros' use of the Arma Christi, the long-standing identification of seemingly Catholic iconography with African religiosities asks us to trace the genesis of that distinction, particularly as it plays out inside mandinga pouches and in the pages of Inquisition records. Importantly, inquisitors in the early 1700s did not utilize an epistemic category into which something called African religion could fit, nor for them did there exist a category by which Africans self-defined their practices as such. While it is true that many Africans appearing before the Inquisition were charged with feitiçaria, this category was by no means exclusive to them.[108] Rather than combining a series of distinct epistemologies, José Francisco's work challenged the "presumptive norms" of inquisitorial analysis that only later necessitated a distinction between African and European thought systems.[109]

José Francisco was born in or around 1704, but his testimony does not describe his place of birth or upbringing. Most of those trafficked at Ouidah were speakers of Gbe languages, including Fon, who came from present-day southern Benin and Togo, or eastern Ghana. But some at Ouidah would have also come from northern areas adjacent to the Sahel, or were Yorùbás trafficked by the Kingdom of Oyo in present-day Nigeria.

Irrespective of his exact place of upbringing, his early life saw political changes that resulted in his exile from West Africa. A series of smallpox outbreaks, the first when he was four years old, forced internal migrations across the region. Then, in 1716, Agaja rose to the Dahomean throne and launched a campaign to consolidate his kingdom's power and access lucrative trade centers on the Atlantic coast.[110] In commemoration of his 1727 victory over Hueda and its port city Glenhue (Ouidah), Agaja took the surname "Hunyito"—"taker of ships"—and adopted a European caravel as his personal emblem. Appearing also as an appliqué design on cloth and as a carving in the walls of the royal palace at Abomey, a staff finial depicting this ship—graphically rendered with three oversized flags and two anchors—is currently held in the collections of the Musée Africain in Lyon, France (figure 2.13).[111] Those fleeing or captured in Dahomey's wars likely made up majority of those forced onto ships represented here, many bound for Brazil.[112] Caught up in these changes around 1718, José Francisco was enslaved and sold out of Ouidah.

We can only speculate about José Francisco's early religious life around the Bight of Benin. But the political instability, famine, and disease that

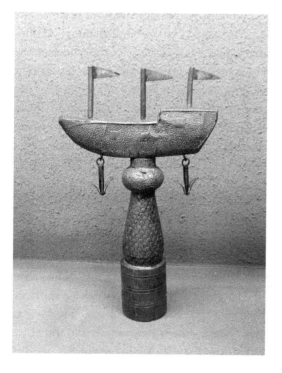

2.13
Unrecorded artist, Kingdom of Dahomey (Republic of Benin), Staff finial depicting a caravel, emblem of King Agaja, ca. 1730–1740. Wood and silver, 23 cm (9 inches) in height. Musée Africain de Lyon, Lyon, France.

characterized this period all contributed to the migration and formation of ritual communities and their associated spirits. As Edna G. Bay outlines, the deities honored by Gbe-speaking vodun devotees and Yorùbá-speaking òrìṣà devotees, "like people trading and warring," consistently "flow back and forth" across West Africa between political centers and cultural arenas, "are captured and resettled, take new names in different locations, and retain traditions of their places of origin."[113] Indeed, the majority of those he would have encountered at Ouidah were raised in a spiritual landscape that paralleled their personal experiences of forced migration.

When José Francisco was in Ouidah, Vodun—the term for any number of spiritual forces and the diverse practices used to honor them—counted many Gbe-language speakers, including the courts of Hueda and Dahomey, among its practitioners. And for many art historians, this history of spiritual migration is a defining feature of the religion.[114] This is reinforced by the physical engagement practitioners have with Vodun objects, summarized as what Suzanne Blier defines as "assemblage": altars must constantly be attended to with new offerings to replace the old; ephemeral assemblages must be destroyed to explode their activating potential; and each privileges the inclusion of visibly foreign objects as new additions to Vodun's aesthetic that keep the religion vibrant and powerful.[115]

Vodun's aesthetics shaped—and were shaped by—the economic and political contours of Dahomean processes of enslavement and the rise of European slave trading at Ouidah. Specifically, Dahomey's voduns even sanctioned the arrival and commerce of European slavers.[116] Multiple oral traditions and histories attest to Dahomey's rulers incorporating foreign voduns into the royal pantheon at Abomey, including spiritual forces held in esteem by conquered peoples, or broadly popular voduns whose independent priesthoods posed a political challenge to Dahomey's predominance.[117] Agaja himself attested that his 1727 victory over Hueda was spurred by his adoption of their serpent voduns, Da and Dangbe.[118] Dahomean rulers did not incorporate foreign voduns only to embolden them: some they neglected so that "their strength would be diminished."[119] Thus, Dahomean Vodun's incorporation of "foreign" influences can be read as strategic spiritual conquest where the active incorporation, valorizing, or diminishing of spiritual forces reflects and maintains political power.

Cécile Fromont, Didier Lahon, and I have all previously suggested that José Francisco's mandinga amulets display a wide incorporation of disparate influences and ritual references that potentially derive from his Vodun upbringing.[120] Fromont's convincing analysis of evidence from José Francisco's

trial suggests he was initiated into Vodun during his youth.[121] Here, though, I argue that the key issue is not whether José Francisco grew up with Vodun's facility for incorporating new spiritual frameworks in his ritual arsenal. Rather, José Francisco incorporated new worlds into his amulets because he spent his first years, and indeed his life, in a world that demonstrated the efficacy of claiming, controlling, or casting off spiritual and material forces to ensure personal survival or political gain.

In the Fon language spoken at Ouidah, the closest translation for the English word "slave" is *kannumon*, literally, "the person in cords" or "the one who remains in cords."[122] Carrying historical connotations of a prisoner of war, this metaphor has sculptural corollaries in a class of objects called *bocio* figures, the "empowered cadavers" that serve as sculptural intermediaries onto which their human partners dump the debris and weight of their psychological ills.[123] One oral history suggests that these figures' name and function originated during the intense social upheaval of Agaja's reign, when a healer known as "Bo" carved anthropomorphic representations of the sick as a method of treating ailments.[124] A bocio collected in Benin in 1975 is one of the rare examples that retains its original additions (figure 2.14).[125] It displays an aesthetic effect Suzanne Blier might summarize as "a range of emotions [that] seem to explode from within, the sculpture almost outgrowing itself and transgressing its own limits."[126] These include "empowered" assemblages called *bo* that have long held a range of protective and interventionist abilities. An early twentieth-century photograph from the then French colony of Dahomey depicts an unnamed hunter in a forest grove wearing one of these large bo around his neck as he stands next to an *asen*, a metal sculpture meant to honor the dead as well as facilitate interaction between physical and spiritual worlds (figure 2.15).[127] Intriguingly, bo come in a variety of forms with corollaries to contemporary mandinga pouches, such as substances from the natural world tied in bundles and hung from the body, as displayed on the bocio (figure 2.16).[128]

Suzanne Blier suggests that at one time, someone may have found a moment of relief in the techniques of suturing and binding that formed the bo and secured them to the bocio.[129] Yet as Edna G. Bay cautions, the historical "centrality" of bo in eighteenth-century Dahomey—and Fon society broadly prior to the early 1700s—suggests that captives, commoners, and political elites all utilized these objects to newly prescient ends during the period of the slave trade: as antidotes the violence perpetrated through Agaja's conflicts; as protection from being captured in war; or as weapons

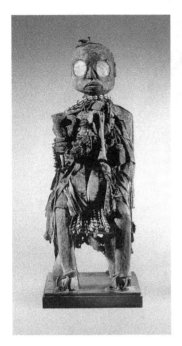

2.14 Unrecorded artist(s), likely Fon, Republic of Benin. *Bocio* figure. Wood, bones, shell, fabric, metal, and patina. Acquired 1975. Private collection. Image courtesy of Sotheby's.

2.15 "Chasseur dahoméen" (Dahomean Hunter), 1911. Plate 6 (after page 64), in Le Herissé, *L'ancien royaume du Dahomey*. Image courtesy of the American Geographical Society Library, University of Wisconsin–Milwaukee.

to gain and protect political power.[130] Thus, one may view the sutures of bolsas as a pragmatic technique to capture or contain their internal contents, especially the orations and spoken words activated in them. Indeed, Afro-Atlantic ritual specialists, as Kyrah Malika Daniels notes, continually "take great care to secure the tightly bound fabric" of sacred bundles used in the context of communal healing in Haiti and Congo, lest the spiritual forces inside escape.[131] In turn, recall that Jacques Viegas's mandinga contained a single pin. Pins remain vital inclusions in bo and bocio-derived forms, for the act of piercing, argues Blier, is one of "striking psychological power" related to the fear of corporeal transgression: concerns at the core of mandingas' efforts to seal the body from external dangers.[132] Finally, the shackles around the figure's legs allude to slavery as a social condition and psychological barrier (figure 2.17). Burdened by weights, shackles, and

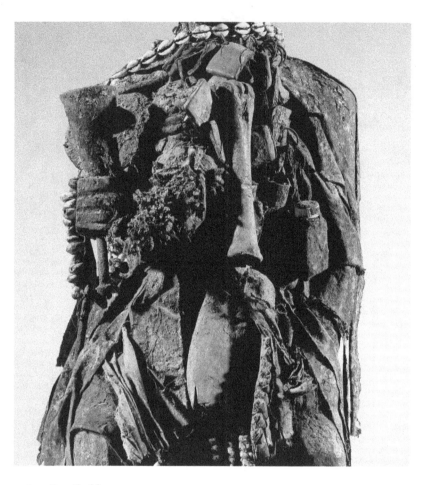

2.16 Detail of figure 2.14.

assembled matter, sutured together from the detritus of cultural trauma, this bocio gives material form to Frantz Fanon's characterization of political instability as a psychological condition in that they served as both projection and catharsis of the upheaval wrought by the internal and transoceanic slave trades.[133]

Bocio and mandinga amulets emerged simultaneously as aesthetic responses to forced migration and labor, and their makers filled them with the detritus of cultural traumas they sought to overcome. But while bocio are sedentary objects, José Francisco faced a key problem: he had to carry his burdens with him, across the Atlantic. James Sweet describes the similar predicament of Domingos Álvares, a healer enslaved and forced on

2.17 Detail of figure 2.14.

board a slave ship out of Ouidah only a few years after José Francisco, as "doubly frustrating" for this reason: "Not only was he rendered incapable of producing a response to the suffering of slavery," Sweet writes, "but he was the object of someone else's tying and binding, as Europeans co-opted his corporeal power."[134] This problem commonly informs the construction of bocio and bolsas de mandinga. While in one sense they worked to protect their makers from further violence and trauma, as well as to claim a bit of the sociopolitical power denied to their enslaved makers, to do so the pouches necessarily had to incorporate the material and psychological burdens José Francisco yearned to cast off or redeploy, even as these were distributed to his clients. We can only speculate as to what this may have meant when José Francisco arrived in Brazil and was baptized a Christian.[135] There he entered another religiously fluid world, where Africans incorporated Catholic rituals and iconographies into their varied worldviews because they functioned as indexes of cultural authority. In this way, José Francisco—like many Africans and their descendants in the Americas, as Erin Rowe notes—actively participated in the "co-creation" of early modern global Catholicism by investing this new ritual world with efficacy necessary to his personal and communal practice.[136]

The transmedia aesthetics that governed José Francisco's mandingas contrasted with inquisitors' goal to delineate orthodoxy and sacrilege. This plays out in his Arma Christi. In Brazil and Portugal, José Francisco could have encountered the Arma Christi in a range of guises: as an image on

devotional manuscripts, as a pendant worn on the body, or as a figural assemblage carried during Holy Week celebrations. Surviving medallions from Iberia testify to its devotion across social classes. Carefully carved crystal pendants showcase the Arma Christi's importance to persons of means, while widely produced metal examples—especially in bronze—evoke its wider popular devotion. Displaying a deep patina and wear associated with extended use, the reverse design on one eighteenth-century Spanish example largely reproduces the key elements of José Francisco's Arma Christi, including central cross, the two spears, and Jesus's crown of thorns (figure 2.18). In turn, a cross contemporary to José Francisco, carved by the artist Francisco António Gijón around 1716 in Seville, Spain, depicts the symbols of the Arma Christi and remains in use in public processions staged by Catholic brotherhoods (figure 2.19). While both depict the same referents as José Francisco's Arma Christi—the ladder, the spears, and the rooster, for example—a key distinction is that José Francisco's removes the bodily figure of Jesus, also reproduced on the contemporary lithograph discussed earlier, in favor of depicting the two Roman soldiers at his sides: a visual emphasis on the violators, as opposed to the violated, that I will explore further. The Arma Christi's multimedia promiscuity accentuated its transformative power, as it recast the instruments of Christ's torture as tools of personal protection and redemption. As José Francisco saw similar pendants circulating through Brazil and Portugal, carried on the bodies of "new Christians" in conversation with other mandingas and scapulars, he adopted this apoptropaic symbol into his talismanic toolkit.

Jose Francisco saw the Arma Christi manifested as medals and public processions and converted these into paper inside his mandingas. His work also resonates with contemporary descriptions of other papers included inside bolsas in Portugal and Brazil. In 1717, a man named Francisco da Silva relayed the story of a Portuguese sailor who came to the home of his employer in Bahia. The sailor conversed with Francisco about mandingas used by Black people, later showing Francisco two papers: "one for games and the other for women, with figures in the margins and on the back, and with idols and characters." The sailor allowed Francisco to copy the papers in his own handwriting, and afterward he placed them in a bolsa that he always carried with him.[137] When he was arrested in Rio de Janeiro in 1738, authorities found on the person of mandingueiro Miguel Ferreira Pestana "some pieces of imperial paper" drawn on with a Sign of Solomon and other lines and circles; as well as a bolsa containing a paper with various figures, including "hanged men, poles, and demons pulling other people,

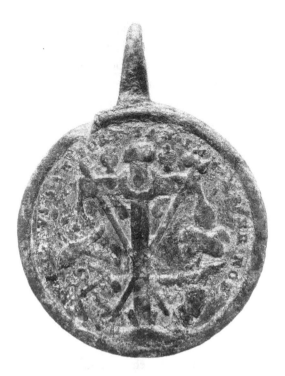

2.18
Pendant depicting the
Arma Christi. Spain,
eighteenth century.
Bronze, 3.7 × 2.8 × 1.4 cm
(1.5 × 1.1 inches). Private
collection.

2.19
Francisco António Gijón,
Cruz de la Guia (Guild
Cross) of the Hermandad
del Gran Poder de Sevilla,
Seville, Spain, ca. 1716.
Photograph of the cross
in procession by Miguel
Ángel Osuna, 2015. Image
owned and reproduced
with kind permission of
the Archivo de la Her-
mandad del Gran Poder
de Sevilla, Seville, Spain.

as well as other gallantries with red letters and black ink."[138] Perhaps the most dramatic description of a bolsa paper comes from 1743 as inquisitors interrogated António Mascarenhas, the aforementioned enslaved man from Angola, who claimed to have learned the art of bolsas from Ventura, another enslaved man. Mascarenhas described his encounter with Ventura in Rio de Janeiro "eight or nine years" prior, during which he saw his first mandinga, which he described as "a paper . . . with various designs painted in red ink, among which were an image of Christ Our Lord crucified, and a mask in the form of a person's face, and many other things like trivets and grates, and other designs."[139]

José Francisco's Arma Christi design dialogues with the preceding examples, in which drawing, tracing, and copying of designs in ink and blood emerged as powerful aspects of mandingas' affective power: aspects investigated further in chapter 3.[140] For the present argument, these images indicate that we should not mistake mandinga papers' imagery as evidence of their makers' "conversion" to Catholicism, especially since many Africans who found themselves in Brazil generally had only marginal dealings with the Church.[141] José Francisco Pedroso testified that he was baptized at age thirteen, around 1724 or 1725, at the Church of Candelaria in Rio de Janeiro.[142] Though this church's baptismal records for between 1718 and 1750 have been lost, a total of 561 enslaved persons had been baptized at nearby Sé Church in 1724 and 1725.[143] His baptism was likely short and concise: Mariza de Carvalho Soares notes that between 1745 and 1761, baptismal records of enslaved Minas—a category that would have included José Francisco Pedroso—simply listed "I baptized and placed holy waters on . . ."; a contrast to the more involved rituals for central Africans who likely had exposure to missionary activity prior to their arrival in Brazil.[144]

Most Catholic education of Africans in urban settings occurred through interpersonal interactions and teachings to each other, as opposed to more formal instruction by the Church.[145] In José Francisco Pereira's time in Brazil, institutional Catholic instruction also bent to Africans' cultural necessities, with multiple Church and governmental decrees requiring clergy to learn African languages.[146] Though the Inquisition maintained a strong presence in Brazil, researchers likely overestimate the extent to which the church generally impacted the daily lives of Africans there.[147] Most sources on African lives in Brazil are church, parish, and Inquisition records, which feeds this presumption. As a result, most work on African Catholicism in Brazil has focused on institutional devotion in Catholic brotherhoods, for which there are substantial surviving records.[148]

Less clear, however, has been the role of Catholic symbolism among the itinerant enslaved and their own adoption of seemingly Catholic symbols. José Francisco claimed that his enslaver did not want "his slaves to use any orations" because "he feared they would [use them] to make mandingas."[149] Regardless of the claim's truth, his exchange with inquisitors hinges on a fear that permissible Catholic objects could become mandinga. Here we see the implications of placing Africans at the center of debates over fetishism in Europe, for as Pietz notes, when Portuguese missionaries and merchants first encountered West African societies, the "practices labeled by the Portuguese *feitiços* were treated as the heathen equivalents of the little sacramental objects common among pious Christians. Crosses for idols, and crucifixes and images of saints for *feitiços*, was the proposal of the crusading Portuguese."[150] But in Lisbon the two mandingueiros brought this full circle. While he used the term *bolsa de mandinga*, José Francisco Pedroso noted that "the blacks call them 'relic pouches'" (*bolsa de relíquia*), a term that analogizes his amulets to the popularly venerated remains of Catholic saints preserved inside elaborate devotional containers.[151] José Francisco Pereira also testified that he "understood the mandinga as a Godly thing" because "he saw black men go to Mass with mandingas."[152] While one should note the distinction in explanations given between the interrogators and the accused, and the resulting assertions of orthodoxy and sacrilege accompanying those positions, overall these objects demonstrate the ways in which religious conversion was never a one-way process, but rather that their material transformations paralleled the process of religious recontextualizations between the foreign and the familiar.

On July 10, 1730, José Francisco Pereira provided a detailed description of how he produced his amulets. His mandingas, he claimed, consisted only of Catholic orations wrapped around a silver vintém, which were then placed under a church altar for two or three masses before being buried in a churchyard at midnight for twenty-four hours.[153] But after spending the night in the inquisitorial prisons, José Francisco returned on July 11 and immediately expanded on the previous day's recipe: his amulets included *pedra de corisco* (flint, or thunderstone), sulfur, gunpowder, a lead bullet, and a bit of a plant called *abutua*. Finally, he sought out a silver vintém and a dead person's bone and placed all these ingredients inside the paper on which he had drawn designs using blood from his own left arm. The resulting package he placed underneath the pedra d'ara to ensure that "two or three" masses were said over it. After this, he retrieved the mandinga ingredients and then buried them in a churchyard at midnight,

leaving them for twenty-four hours. Then he took all the ingredients and placed them inside a bolsa of white cloth and sold them to clients.

One wonders what happened to José Francisco on the evening of July 10 that caused him to suddenly describe these other, sacrilegious inclusions, given how carefully he must have protected this information. Perhaps another prisoner told him of the punishments he faced if he did not fully confess—a fear likely heightened without his amulets to protect him. And so perhaps it is fitting that peering inside José Francisco's description of his own mandinga, we see a pulling together of the threads of this chapter: a carefully selected inventory of references to the dangers José Francisco encountered in his multiple forced migrations and a microcosm of the power structures that violated those caught in the Atlantic exchange of commodities and lives.

The striking inclusion of flint, gunpowder, and a lead bullet were clearly intended to provide specific protection from ballistic weapons. But here I contextualize this near-literal mandinga-as-firearm through José Francisco's enslavement in Ouidah. Alongside alcohol and tobacco, gunpowder was a crucial commodity during the early eighteenth-century slave trade in the Bight of Benin, as Brazilian merchants and enslavers sold large quantities of guns and gunpowder alongside Brazilian-mined gold there.[154] By the 1690s—two decades before José Francisco's enslavement—traders in Whydah imported more than one thousand firearms annually, a scale that historian Ray A. Kea calls "almost insatiable."[155] And in a 1727 letter to King George I of England, Agaja called himself a "great admirer of fire armes" and noted that Dahomey's troops had all but abandoned other weapons.[156] One may speculate not only about the extent to which gunpowder partially facilitated the conflicts that resulted in José Francisco's enslavement, but also about whether it was one of the commodities for which his life was exchanged in Ouidah.[157] A 1730 engraving of the European fort at Savi—the main trading depot of the Kingdom of Hueda—speaks to this potential (figure 2.20). The view peers over walls into idyllic depictions of French, British, and Dutch posts, some attended by European traders in elite dress. Outside, at bottom, a French slave trader arrives with a military escort and carried on a palanquin.[158] His entrance into Savi is signaled by a group of Africans holding rifles, firing them indiscriminately amongst other soldiers holding long spears: the two kinds of weaponry that predominated in Hueda's military at this time (figure 2.21). Less obvious to inquisitors, but possessed of an equal potency to the firearm, was José Francisco's inclusion of abutua. Likely an ingredient learned from his time in Brazil,

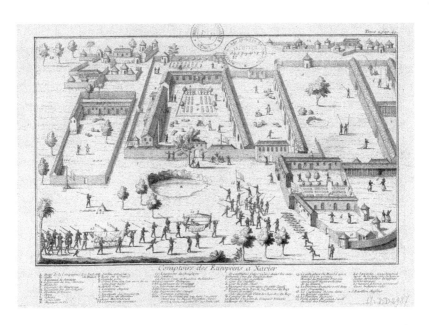

2.20 "Comptoirs des Européens a Xavier," 1730. After page 48, in Labat, *Voyage du chevalier*. Source: gallica.bnf.fr / Bibliothèque nationale de France.

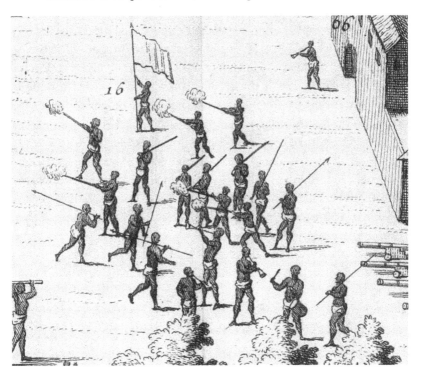

2.21 Detail of figure 2.20.

abutua is the Tupi name for a flowering plant genus whose leaves and roots were commonly used in colonial Brazil and Angola for their healing and harming properties.[159] One species holds the critical ingredient for the poison used in arrow darts.

José Francisco's mandinga thus assembles a diverse protective arsenal, one that understands the mutual imbrications of interpersonal violence, ritual authority, and his own commodification. This asks for a reconsideration of José Francisco's Arma Christi. While the symbols rendered in black ink seem to be general symbols of protection, such as the Arma Christi itself, those rendered in red—specifically, in the blood from a chicken or José Francisco's arm—seem to be those José Francisco tries to inoculate against: soldiers holding swords, a skull and crossbones, and, strikingly, the crest of the Portuguese Empire (figure 2.22). This crest followed José Francisco everywhere in his life. If José Francisco was in Ouidah in 1721, it would have welcomed him into the Portuguese slaving depot there. A contemporary aerial plan of the fort emphasizes its thick, grey walls but leaves a blank background to highlight an almost comically oversized white flag emblazoned with the imperial crest (figure 2.23). This design, in turn, likely adorned the ship that transported him to Brazil. It also could have been found on the Igreja de Corpo Santo in Recife—the church in which he was baptized—or on the public whipping post (*pelourinho*) that the Portuguese installed directly in front of it in 1711, or on any number of public buildings in Pernambuco, Minas Gerais, Rio de Janeiro, and Lisbon. And inside his mandingas, he chose to include it not once but twice: first on the Arma Christi, and second on the reverse of the small silver coin (figure 2.24).

This silver vintém bears dates from the reign of João V (1706–1750), during which José Francisco was enslaved in Africa, taken to Brazil, and put on trial in Lisbon. A small hole at top center indicates this example was once used as a medallion like those José Francisco transferred into ink and paper inside his bolsas. Made of silver likely mined in the Americas, sent across the ocean, and transformed into a new object that was exchanged for Africans' lives and circulated among the bodies and institutions José Francisco navigated throughout his life, such an inclusion was not just a reproduction of popular apotropaic practices. Instead, as a man enslaved and put on trial by Portuguese authorities, José Francisco may have redirected and reimagined the forces behind this symbol as he did for bullets and orations.

If these assembled personal goods respond to the market and religious violence of the slave trade, perhaps his mandinga practice may be taken

2.22 Detail of figure 2.11. Paper once contained inside a bolsa de mandinga made by José Francisco Pereira, Lisbon, Portugal, 1730.

2.23 *Planta da Fortaleza q fez o cap.tam de mar, e guerra Joseph. de Torres por ordem do Exm.° S.or Vasco Frz Cezar de Menezes, na Costa da Mina, no porto de Judá,* ca. 1722. Ink and pigment on paper, 41 × 32.3 cm (16.14 × 12.72 inches). Arquivo Histórico Ultramarino, Lisbon, Portugal. Cartografia Manuscrita, São João Baptista de Ajuda, doc. 167; PT/AHU/CARTM/090/00167. Image courtesy of the Arquivo Histórico Ultramarino.

2.24 Portuguese 3 vinténs coin. Undated; struck in Lisbon during the reign of João V (1706–1750). Silver. Collection of the author. Photograph by Heath Patten, 2017.

as a microcosm of the trade relations that facilitated it. At the time José Francisco was enslaved, French traders in the Bight of Benin circumvented royal and company prohibitions against utilizing their personal goods, referred to as *pacotille*, to purchase captives for enslavement.[160] Many definitions of this term equate pacotille to objects with little monetary exchange value outside Africa, but still readily exchanged for human beings.[161] But *pacotille* is an imprecise term, broadly referring to all personal effects European traders brought to the African coast to sell of their own accord, including "small bundles" that represented "the market value of a slave corresponding to a set of products, in particular alcohol, arms, tobacco, fabrics, [and] cowries."[162]

As I argued earlier in this chapter, though, questions about the global exchange value of pacotille may miss the critical point. While Europeans assembled materials with an eye toward maximizing their return for captives' lives and labors, one cannot easily disentangle economic and spiritual values of commodities as they mattered to African merchants and middlemen; for it is those objects that Africans valued spiritually, but which held a lower global monetary exchange value, that Europeans would later label as feitiços and fetishes. José Francisco understood this exchange: a pouch of goods—whether pacotille or mandinga—was valued simultaneously at a monetary price and a human life. Like French traders in Ouidah, José Francisco in Lisbon also sold pouches of "insignificant things" for human lives. And his clients were willing to pay his prices to protect themselves

from the manifold dangers and powers that José Francisco, a skilled feiticeiro with firsthand experience, could diagnose: the ills wrought by nascent global capitalism and institutionalized religious power.

Conclusion: Navigating the Black Atlantic

Looking into the contents of José Francisco's amulets is, to paraphrase Serge Gruzinski, to confront "the challenge of mélange": to ask how a seemingly heterogeneous assemblage forces a reckoning with the very concept of cultural purity or orthodoxy.[163] Such a challenge was a persistent one for those persons displaced to the alien worlds of the Atlantic rim. José Francisco's work navigated this by remixing, reinterpreting, and repurposing newly encountered images and objects as a means of survival. In this context, the inquisitors receiving his works tried to parse out a distinction between the forms of Catholicism they found acceptable and those they did not. But peering into José Francisco's creative and appropriative vision of protection, they found what Stephan Palmié calls a "vexing indeterminacy."[164]

Paraphrasing Palmié, might such a perception of José Francisco's work actually result "from a vision that rips apart conceptually what is, in fact, a seamless historical reality?"[165] He is correct to underline what has been elaborated earlier in this chapter: the insufficiency of terminologies like "hybrid" or "syncretic" to describe the accumulation of empowering materials José Francisco assembled during his life, for he likely understood these all as part and parcel of an experience that was, for him, continuous. But I linger on Palmié's term "seamless" and the term "continuous," in thinking through one final reference to an inclusion in a mandinga pouch, recorded in a testimony leveled against the mandingueiro Miguel Ferreira Pestana during his 1744 Inquisition trial. The testimony asserts this pouch contained "a large, thick piece of paper on which were painted crosses, designs, gallows, snakes, lizards, and various letters," some of which were written in blood.[166] The description echoes the designs of similar papers like those produced by José Francisco Pereira in 1730, or described by António Mascarenhas in 1743: works that embodied the spectacular transformation of popular and elite Atlantic religiosities in the hands of those African-born mandingueiros. But the testimony adds a second detail about Pestana's paper distinct from the two aforementioned: "the said paper," it reads, "had some paintings in the manner of a nautical chart" (*carta de marear*).[167]

I am hesitant to reconstruct Pestana's work or intended meaning from this description, for a term as precise as "nautical chart" may have simply been the first visual reference Pestana's accuser had to describe what they saw. But the characterization remains suggestive. Cartas de marear—grid-lined navigational charts—served as materializations of a critical scientific shift in the decades prior to Pestana's use of this piece of paper, as the Portuguese "art of navigation" transformed from the realm of speculation and inference to a regulated, scientific pursuit.[168] A proliferation of early eighteenth-century scientific guides made clear that the reason for the relatively sudden mechanization of global shipping and navigation was because of the intensification of the slave trade around the turn of the eighteenth century. For example, Manoel Pimentel's 1699 text on the art of navigation, *Arte Practica de Navegar*, contains detailed descriptions of how to navigate voyages across the triangular route, beginning with major slaving ports of call, enumerated as "the Guinea Coast of Malagueta, Mina, São Tomé, and Angola," then down the coast of Brazil from Pernambuco to Rio de Janeiro, and then, finally, to Lisbon.[169] Cartas de marear, one of the critical tools in this process, provided enslavers a mechanism by which to navigate, and to transport—and thus transform—bodies from humans into capital. As such, they necessarily developed in tandem with the dispersal of mandingueiros and mandinga pouches across the Black Atlantic.

What can we read from Pestana's potential intervention to redesign this navigational symbol that, counterintuitively, also facilitated dislocation and displacement? Cartas de marear typically presented clear, unobscured, gridded navigational views meant to allude to seamless wayfinding across the oceans. Indeed, early in the text of *Arte Practica de Navegar*, M. Pimentel foregrounded this vision by including an elaborate compass rose (figure 2.25). The Portuguese *nau* (a three- or four-masted ship) at the rose's center—its two main masts topped by Portuguese imperial flags—sails toward the horizon atop choppy waters. But Pestana's work added a series of charged references that testify to this ocean as also a place of looming dangers and precarious obstacles.

José Francisco's work stops short of an explicit vision of cultural trauma. But in so doing, it also suggests that it may not matter whether one identifies Pestana's paper as a carta de marear. For the amulets they produced already contained a set of navigational tools for the worlds in which they found themselves—tools that marked and referenced the dangers they would encounter as well as ways to move past them while never ignoring their presence. In this sense, efforts to delimit or define the contents of

2.25 Untitled engraving of a compass rose, 1699. Published in M. Pimentel, *Arte Practica de Navegar*, 10. Image courtesy of the Biblioteca Nacional de Portugal, Lisbon, Portugal.

mandingas seem insufficient to grasp what Alessandra Russo called "the absolute originality of images and objects" created in the wake of unprecedented cultural upheaval.[170] For Russo, the chaos and shock generated on all sides in the wake of the conquest of Mexico and the establishment of New Spain meant that artists had to make sense of an unprecedented new reality: to visually translate that which was untranslatable, to make work that could, as their makers and users did, "pass constantly from one world to another."[171] Art in this sense is a process by which one tries to reckon with, survive, and intervene in, this new reality. Their task was at once a "concrete impossibility" that also allowed for "infinite possibilities" that explode the boundaries of cultural production and previously established "frontiers of art histories."[172] In this sense, in front of inquisitors, the mandinga "was untranslatable to the accuser because it was, essentially, irrational and thus had no comparison in the world of objects of the rational viewer."[173] Fittingly, José Francisco recast his own need for protection as an effort to make sense of, to process, the religious pluralism and quotidian violence that Atlantic slavery and the Portuguese Empire had wrought.

Markings

For Hortense Spillers and a series of theorists writing in her wake, the corporeal violence enacted on, and constitutive of, Black people's presence in the modern world finds a kind of symbolic substitution in the archive, where it takes on the form of laboratory prose and calculated, facile regulation. This inherited "hieroglyphics of the flesh," as Spillers terms it, remains for her the locus of racial inscription and subjectivity.[1] Sherwin Bryant, in turn, fittingly characterizes the status of enslaved people in the Americas as itself "an act of archival inscription" in that the "practice of subjecting the bodies of enslaved African captives to inspection, documenting their 'marks,' including scarification, wounds received in the transatlantic passage, smallpox marks, brands of the licensed trading companies, and their overall physical conditions were more than acts of power, these were ways of forming, expanding, and legitimating the race relation of governance that slavery installed."[2] For Spillers and Bryant, one cannot separate the endless shelves of imperial decrees, slave registers, property deeds, and trial records that form the archival accumulations of Church and Empire from the "marking and branding" of enslaved bodies.[3]

The archival documents analyzed in this chapter build on this argument in two ways. First, I argue that some mandingueiros utilized papers and the act of writing to consciously respond to the connections between archival production and corporeal violence that undergird Spillers's framework. Second, I show how this concern animated the construction and public visibility of mandingas. Though this chapter analyzes a series of case studies, its argument is best exemplified by a document that serves as the linchpin of this chapter: a three-centuries-old written account of a Black person publicly performing their own body's inviolacy. On June 11, 1700,

João de São Boaventura—a missionary then stationed in Sintra, about seventeen miles from central Lisbon—sent a letter to the comissários of the Lisbon Inquisition denouncing a Black man he knew.[4] In the text, São Boaventura attests that this man wore an object described as a bolsa that functioned as a spectacularly effective shield against physical violence. On one particularly memorable occasion, São Boaventura recounted, this man took a dagger to his own neck "with such force, but the dagger bent back as if it had struck stone, without leaving any mark."[5]

São Boaventura's letter is one of scores of similar surviving inquisitorial attestations sent to Lisbon in the first half of the eighteenth century. Their existence speaks not just to the increasing use of bolsas in the Portuguese metropole, but also to the simultaneously widening visibility they occupied in public spaces and public consciousness: "many people use them" in Lisbon, São Boaventura wrote.[6] Indeed, within only a few years of São Boaventura's letter, the comissários received at least five similar denunciations, each attesting that these amulets protected their users from intimate personal violence, a function proved through public demonstrations of their efficacy. In April of 1700, two white men in Lisbon denounced Francisco, an enslaved Black Cape Verdean man for selling them bolsas; their complaint was lodged because the bolsas did not work as described.[7] In August of 1700, Gerónimo Vaz da Cunha, an enslaved Black man, attested that Jacques Viegas, then fifteen or sixteen years old, boasted that he could not be harmed. When Jacques tried to enter the house where Gerónimo lived, Gerónimo took up the challenge and ran at Jacques with a sword, but he could not penetrate Jacques's exposed skin. Gerónimo asserted that Jacques must have had a mandinga, "or something else that would impede peril with moderate force of a sword," otherwise he would not have exposed himself to be wounded.[8] In January of 1702, a carpenter testified that his friend put the base of a sword in the floor and fell on it, but survived unharmed because of the mandinga he had.[9] In September of 1702, a priest in Portugal denounced "a black man who carried a mandinga with him," its effectiveness proved when he stabbed himself in the arm.[10] And in June of 1704, Gerónimo Vaz da Cunha's suspicion was proven correct when Jacques Viegas appeared before the Inquisition, charged with using the mandinga pouch that protected him during knife-fights in a local church.[11] This is the pouch that remains attached to his Inquisition file at Portugal's National Archive. "He who has a mandinga," asserted the mandingueiro Luis de Lima in 1729, "always believes they will not be hurt with iron in fights. Those who do not have experience with

mandingas are always afraid of entering into fights . . . but [not when] carrying a mandinga with them on their chest."[12]

The volume of eyewitness testimonies, personal attestations, and interrogation records collected and created by the Lisbon Inquisition exist because of its goal to suppress the existence and use of bolsas beginning in the final years of the seventeenth century. Inquisitorial editais (decrees) were the primary means through which the Inquisition extended its own reach in this manner. Printed on paper, distributed across Portugal and select colonies, and read aloud from church pulpits, editais served to inform imperial subjects of new practices deemed heretical by the Inquisition. As noted in this book's introduction, in the late seventeenth century, select editais clearly responded to a growing inquisitorial concern over African-used bolsas in the Portugal and Brazil. João de São Boaventura in fact noted that his own letter was written in response to an inquisitorial decree that required all the empire's subjects to denounce anyone using such a bolsa.[13]

Though few of these decrees survive, the extant examples demonstrate how inquisitorial authorities carefully considered their text, distribution, and placement. A 1653 edital that outlined inquisitorial crimes through the end of the eighteenth century asserted it was to be preserved in a Church sacristy where it would be read aloud annually during Mass on the first Sunday of Lent.[14] The Holy Office distributed editais regarding more specific crimes—including those aimed at the bolsas—through a hierarchical bureaucratic network. In south-central Brazil, for example, they first sent editais to the diocese in Rio de Janeiro, who in turn distributed them to smaller ecclesiastical districts, and then to local parishes.[15] A 1763 decree in Grão-Pará provided guidelines for the placement of inquisitorial editais: they had to be published and put up in a commonly accessed and visible place, preferably the principal interior door (*guarda-vento*) of the city's cathedral for thirty days. The decree clarified that no person could remove the editais without being explicitly ordered to do so, under penalty of major excommunication from the Church.[16] A 1792 decree concerning the placement of editais in Rio de Janeiro made a similar pronouncement.[17] Church representatives could level punishments if new inquisitorial editais were not visible, and local chaplains had to sign papers asserting the date— and occasionally time—they read the document aloud to their congregations.[18] The Inquisition's strategic manufacture and distribution of print media like these editais testifies to an eighteenth-century transition in which the Inquisition made increasingly sophisticated use of printed documentation to communicate their message and transform imperial subjects

into inquisitorial agents. The prominent public display and oral recitation of decrees encouraged ambivalent onlookers, acquaintances, neighbors, friends, and even trusted confidants to send in letters from across the empire denouncing those suspected of crimes against the Church, including the use of bolsas.

I reproduce São Boaventura's letter here to call attention to its letterness, to emphasize the way that the creation, circulation, transit, and filing of written denunciations and orders like this sustained the Inquisition's fledgling global surveillance system (figure 3.1). By reproducing first-person testimonies of assumed crimes and the biographical information of those who committed them, such papers provided the medium through which imperial subjects defined one another as witnesses, suspects, and heretics. In turn, they also converted bolsas into inquisitorial evidence. As detailed in the previous chapter, a key ritual of the suppression of amulets was the conversion of their contents into paper in the inquisition file. When they could obtain mandinga pouches from their makers or users, inquisitors often feverishly opened them to reveal their contents, writing ekphrastic descriptions of the veritable transcultural mélange inside. Recall from previous chapters the following list of contents reproduced from Inquisition trials: hair, sticks, cotton, sulfur, gunpowder, a piece of lead, a bullet, a silver coin, "some red feathers from a Brazilian bird,"[19] "a green thing that the accused did not recognize,"[20] "some human fingernails and pieces of flesh, which appear to be from a dead man,"[21] and "other little things."[22] Despite the attention paid to them, inquisitors typically discarded most of the amulets' contents. But they kept the papers, orations, and drawings that were common, and sometimes singular, inclusions inside of the pouches, incorporating them into the Inquisition files.

The talismanic papers that survive inside of the Lisbon Inquisition's archives remain some of the only extant texts authored by enslaved Africans in the Portuguese Empire prior to the mid-1800s. As such, one would be right to consider them as singular archives to see how enslaved people responded to, and interpreted, their own subjectivities outside of the archives of Atlantic slavery produced to suppress them while also imagining new strategies of fugitivity and freedom. And while this chapter does so, it also considers these papers as another archival register that helps to constitute, and respond to, the thousands of surviving inquisitorial decrees, denunciations, and trials that make up the paper accumulations of Church and Empire. Each of the papers analyzed was once contained inside a bolsa eventually confiscated and sent to the Inquisition, and now remains

378

Senhor

[handwritten letter in Portuguese cursive, 1700]

3.1 Letter by João de São Boaventura denouncing an unnamed man to the
Lisbon Inquisition, 1700. Arquivo Nacional da Torre do Tombo, Lisbon,
Portugal. Tribunal do Santo Ofício, Inquisição de Lisboa, Correspondência
Recebida de Comissários, liv. 922; PT/TT/TSO-IL/009/0922. Image cour-
tesy of the ANTT.

attached to the trial record of the person who made or used them. In turn, each demonstrates how enslaved Black subjects, even in the eighteenth century, responded to that intimate transfer between archival and corporeal markings, and in turn shows how Black subjects themselves responded to the problem of archival visibility and recovery that so often undergirds contemporary scholarship on slavery in the archive.

In some cases, it seems the act of inscribing designs and words with ink onto paper and placing them inside bolsas emerged in conversation with wider practices of inscription in the African diaspora, which include graphic writing systems, scarification, and a fluid relationship between writing and orality. Yet the papers also demonstrate how their users strategically reconceptualized, or took advantage of, fluid relationships between papers, bodies, and textual evocations: a utilization of paper that ties it to Spillers's elaboration on the mutual constitution of archival papers and human flesh. Taking seriously the provocation that the "where" and "when" of modernity and modernism are neither closed off nor finalized, I argue that these papers suggest mandinga-makers and users knew of the transformative role papers played for officials and elites, and that already in the early eighteenth century, they understood and strategically responded to contemporary arguments about the intimate relationships between racialized and othered corporeality and spectacular violence, the simultaneous "hypervisibility" and "invisibility" of enslaved subjects, and the obfuscated legibility of Black histories in Atlantic slavery's archives. As persons possessed of bodies and intellects continually under surveillance, enslaved mandinga-makers used the strategic in-between space of pouches neither to confuse nor force clarity, but rather to avoid both in a deliberate attempt to represent that which must escape systematization. However, one's ability to even interpret the alternately obfuscating and media-challenging aesthetics of the mandinga papers depends, once again, on the subjugation of their owners. As such, the chapter concludes with a meditation on the possibility of archival recovery to which they allude.

Archives of Intimacy and Violation:
Cartas de tocar, 1710–1765

On October 22, 1729, Luis de Lima, aged twenty-six, watched as a scribe recorded his testimony before the Inquisition's tribunal in Coimbra, Portugal. Identifying himself as a Mina *natural*, Luis testified that he was a

major player in a transatlantic network of enslaved Africans who procured, produced, and sold mandingas of varying forms and powers in and between Pernambuco and Portugal in the 1720s.[23] Perhaps more than that of any other mandingueiro appearing before the Portuguese Inquisition in the first four decades of the eighteenth century, Luis's trial record explores the complex ways amulet-makers manipulated and reinterpreted the material word in service of the goals of physical protection and prowess. In general, and for Luis specifically, inscribed papers often played a key role in this regard. For Luis, papers functioned both as independent talismans and as animating inclusions inside the bolsas he made, distributed, and saw used by others who moved in his social and trading circles.

Luis discussed one of these papers at his own trial, when he testified that a man named Ignácio, who was then enslaved to a Brazilian assistant (*familiar*) of the Holy Office, carried what Luis termed a "card for touching women" (*carta de tocar mulheres*) in Porto.[24] Inquisitors would have already been familiar with the "touch card" (*carta de tocar*) Luis described. As the name implies, when someone touched one of these cards to the exposed skin of another person, it caused immediate changes in that person's self-control. In some cases, users asserted that touch cards transferred protective abilities, essentially "sealing" the subject's body from future violation. But most often, touch cards forced others to submit to their user's will. Descriptions of them and their use appeared with increasing frequency in inquisitorial testimonies during the first decades of the eighteenth century, a trend that attests to their widespread use as a popular religious practice across colonial Brazil and Portugal as well as their repression by the Inquisition.[25] Like mandinga pouches in this regard, touch cards commanded a wide, and often overlapping, clientele across racial and cultural lines. But Luis's repeated discussion of cartas de tocar at his own trial also implies their importance in the thriving marketplace for apotropaic objects among Africans in Porto and Pernambuco in the 1720s. As such, they present a fruitful case study to consider how nonelites generally, and Africans in particular, strategically reimagined the possibilities of paper and writing to simultaneously interrogate and participate in wider power structures in the Portuguese colonial slavery regime.

In both their form and use, touch cards navigated conceptions of racialized identity and domination formed by elites' use of paper orations, decrees, and trial records. Though exceptions abound, in general touch cards had a standardized form: a single sheet of paper with written words or markings. Spanish historian Fernando Bouza takes cartas de tocar as

evidence of the significance of writing for people in a majority illiterate society in sixteenth- and seventeenth-century Iberia.[26] Indeed, Bouza is right to note that considered alongside the other forms of writing detailed in this chapter, touch cards effectively explored new forms of written expression in a society where literacy provided social capital.

But cartas de tocar also necessarily and continually reimagined the relationships between form, text, and meaning in ways that expose the inherent porousness and indeterminacy of all archival materials. Testimonials suggest that the content of touch cards had an often unclear or ambiguous relationship to their stated powers. Occasionally they contained words, symbols, and designs that referred to the paper's specific supernatural properties or were created specifically for their stated purpose. A Portuguese woman named Damiana Micaela attested that in 1722 she received from Maria Andresa, a *cabra* (Indigenous Brazilian) woman she knew, a "paper with the power to make any person who touched it . . . do whatever she [Damiana] wanted."[27] Though nervous to test the card's powers, Damiana eventually opened it and described it as "half a sheet of paper, cut in [the shape of] a heart with several crosses, and letters in black ink, which she could not read, [and] written below the name of the said Maria Andresa in letters of blood."[28] Maria Andresa's active manipulation of the paper parallels the production of bolsas de mandinga discussed in the previous chapter: its cutting into a desired shape, the addition of ink and blood texts, and the strategic obfuscation of its written text—a point to be further discussed as critical to the production of cartas de tocar and mandinga amulets.

But, in other scenarios, cartas de tocar could be materially and textually indistinguishable from the otherwise permissible paper, Catholic orations that also found their way inside bolsas de mandinga during the same period. In this sense, though the stated powers of the touch cards depended on having a series of symbols or orations drawn on them, the actual textual content of the cards mattered much less than the desires of their users and their interpersonal activation. Once acquired—licitly or illicitly—their new users recontextualized them as cartas de tocar. Such contextual transformations demonstrate how a diverse group of mandinga-users in Portugal and Brazil strategically reimagined the role of papers, and the markings on them, to intervene in overlapping discourses of textual inscription, bodily autonomy, and spectacular forms of racialized violence.

As Luis's testimony about Ignácio indicates, cartas de tocar discussed in Inquisition trials were often used by men seeking to sexually dominate

women.[29] Luis attested that in the late 1720s he gave a copies of orations to Saint Mark and Saint Cyprian to an enslaved man named Domingos, in Coimbra, to fulfill his request for "an oration or carta de tocar" to attract women.[30] Luis instructed Domingos to place the orations underneath the pedra d'ara of a local church, noting that they could only be consecrated once the Catholic Mass was said over them. But according to Luis, a year passed without Domingos attracting anyone with the orations, or cartas de tocar. Luis attempted to remedy the situation by instructing Domingos to place the orations under his right knee and attend three masses on Saint Bartholomew's Day.[31] The trial record does not state the outcome of this attempt. Luis also testified that on one occasion he had promised to make for José, a man enslaved to a local cleric, "something" to "obtain women" (alcançar mulheres), but did not say what it was.[32] In other cases, women did use the cards explicitly for their sexual pursuits: in eighteenth-century Minas Gerais, a woman named Agueda Maria "had a paper with some words and crosses that she said was for touching men so that they would have illicit dealings with her."[33]

Though the artist did not state the image's meaning, Carlos Julião potentially alludes to the sexual-physical power of the carta de tocar through the twenty-third plate in *Figurinhos Illuminados* (figure 3.2). A mulata woman, wearing a scapular around her neck identical to that worn by the fruit vendor discussed in chapter 2 (figure 2.5), coyly turns her head away as she is approached by an elderly, bespeckled man. Leaning into her, he pushes forth a letter, a visual and linguistic play on a carta ("letter") de tocar. It is addressed "Á Sra. Joanna Rosa" (To Mrs. Joanna Rosa). While the name of the woman at left is not known, it would seem not to matter: the man's eyeglasses and quizzical look suggests that he cannot "see" or "read" the letter's contents, implying that the woman would need to touch it to activate its words as visible—and thus activate the potential relationship the man seems to desire. Ironically, it is another set of invisible papers that could work to protect the woman from the man's advances: the amulet around her neck, whose function to close her body from physical, spiritual, and sexual incursions is activated by the very invisibility, and thus illegibility, of the contents within it.

The interplay of personal violation and protection that subtly plays out between cartas de tocar and other amulets in Julião's image points to an intriguing intersectional power of certain cartas de tocar: to sexually attract or dominate others while also helping to protect its own user from bodily violation. In other words, touch cards allowed their users to close off

3.2 Carlos Julião, *Untitled ("Romantic Scene: Old man in 18th century dress hands over to a young woman a letter which reads 'To Sra. Joanna Rosa'")*, detail. From *Notícia summaria do gentilismo da Asia: Com dez riscos illuminados*. Brazil, last quarter of the eighteenth century. Watercolor on paper, 45.5 × 35 cm (18 × 14 inches). Acervo Fundação Biblioteca Nacional, Rio de Janeiro, Iconografia C.1.2.8, folio 33. Photo courtesy of the Fundação Biblioteca Nacional.

their own bodies to unwanted external influences, but only at the expense of others' bodily autonomy, primarily women's. As José Pedro Paiva first observed, while the cartas de tocar were often used in what he terms "amorous magic," many were used for protection, and occasionally for both ends at once. In one case from 1690, a young man from Montemor-o-Novo in central Portugal confessed to using a carta de tocar that had the ability to "obtain women" as well as to prevent him from being hurt.[34] Indeed, some apotropaic mandinga pouches also had the ability to forcibly attract members of the opposite sex, a power facilitated by the occasional inclusion of touch cards inside the pouches. In Recife in 1727, for example, António José Barreto was accused of owning of a piece of paper that worked not only to ensure he would "not be hurt" (*não ser ferido*)—as mandinga pouches did—but also to guarantee that "any woman that touched it

would subject herself to his will" (*qualquer mulher que tocasse a sujeitar a vontade*).[35] In 1747 in Mato Grosso, Manuel Taveira denounced a mulato man named Francisco Bahia for using a pouch that contained, in addition to some roots or grass, a carta de tocar: contents that Taveira collectively took to be mandinga. According to Taveira, Francisco Bahia mixed the grass with a kind of Portuguese brandy to cure his "impotence for venereal acts," a procedure that appears to have worked. The paper itself was clearly related to these properties: Francisco Bahia informed Taveira that it helped him to sexually attract women while also making his body impenetrable to violence, just as mandinga pouches did.[36]

In their users' hands, cartas de tocar explored a series of notions of touch—cultural, interpersonal, and sexual—while simultaneously creating new avenues for assertions of power and domination in an already highly asymmetrical colonial society. On one level, touch cards' interplay of protection and violation materially manifested contemporary collective anxieties around interpersonal contact. By the late sixteenth century, general attitudes in Europe understood the body's "fleshy envelope," as Margaret Healy terms it, to provide little protection against a litany of unseen supernatural agents; in this context, touch was "undoubtedly experienced as the most hazardous of the senses and was the source of considerable individual and collective anxiety."[37] While Healy attributes this novel conception of touch's dangers to an upsurge in European Neoplatonic and alchemical theories, one could equally attribute it to the increasing intensity of circulations of bodies, pathogens, and supernatural forces in and through the Atlantic rim.

As inhabitants of a pluralistic society constantly experimenting with the cultural and social ramifications of ongoing transcultural contact and transformation, enslaved and free Black people in Brazil acutely experienced these conflicting anxieties over personal and sexual violation. Enslaved Africans arriving in Brazil always displayed an elevated ratio of adult men, a fact that—combined with low life expectancy—resulted in "a negative growth rate of the slave population resident in Brazil."[38] In some areas, sex ratios among enslaved Africans were as high as ten men for every woman.[39] While James Sweet uses this data to explain why enslaved men in some cases sought out other men for sexual gratification and emotional sustenance, it may also suggest that cartas de tocar provided their users a mechanism for redressing the colony's racial-sexual imbalances.[40]

But, as Lamonte Aidoo has outlined, colonial Brazil's slavery regime operated through tight control of Black women's reproductive and romantic relationships.[41] Such control ensured that enslavers could track not just the physical supply of enslaved people, but the economies they labored to create. Enslaved Africans thus faced extreme competition for emotional and physical intimacy outside of the context of forced sexual relations controlled by their enslavers. While touch cards can be read as one mechanism through which their users imagined new forms of autonomy, they can equally be understood as their attempt to gain a piece of the colony's underlying systems of racialized power that ultimately relied on the sexual domination of Black women combined with personal impenetrability. The powers of touch cards thus parallel Aidoo's summary of Brazil's slavery system as a whole, which operated "around power and control: the determination of the white elite, and even free blacks and mulattos, to maintain their base of power and wealth and unfettered domination over the black body."[42] In this context, he notes, sex was not just a system of reproduction, but a "violent mechanism" of asserting power relationships.[43] By conflating sexual assault with intimacy, and by tying personal inviolacy to the performance of sexual domination, touch cards once again suggest how nonelites trafficked in amulets that relied on individuals' presumed consent to bodily exploitation. Such a logic necessarily emerged from the asymmetry of Brazil and Portugal's slavery society, but the wide clientele of touch cards demonstrates just how pervasive the desire to establish a position of dominance inside that system had become.

Unsurprisingly, stories of the use of touch cards to sexually dominate others and protect oneself occur, like the mandinga pouches, across racial lines. Their frequency also suggests that this type of touch card was commonplace and highly desirable. On October 3, 1763, in the city of Belém, Crescencio de Escobar presented himself to Giraldo José de Abrantes of the Portuguese Inquisition's visitation to the captaincy of Grão-Pará, Brazil.[44] Identifying himself as a *mameluco*—a man born of one Indigenous and one white European parent—Escobar recounted a story of some years prior when he was alone with Adrião Pereira de Faria, also identified by Escobar as mameluco. In the town of Vigia, Escobar claimed, Pereira pulled out from a bolsa he owned "a very old paper with a great deal of ripping at the edges" and then stated it was "a letter to touch women."[45] According to Escobar's testimony, Pereira claimed this paper was so potent that "anyone who touched it would infallibly obey" him.[46]

Pereira's reputation preceded him to the tribunal. Nine years prior, in 1754, Pereira, then a resident of the engenho of Tapariuaussú in Grão-Pará, had confessed to enlisting an old acquaintance to help him procure something to attract women to him. To this end, the acquaintance gave him "an oration." But some days later, this person offered Pereira another option: a "written paper" that was not just good for sexual attraction but would protect him from "being hurt with iron, lead, or bullet from his enemies" while also ensuring that it would not harm him nor ever lead to his arrest.[47] Pereira testified that he accepted the paper without reading it, keeping it with him.[48] This was the same paper, presumably, that he used in 1763. Intriguingly, Pereira seems to have derived the paper's sorcerous powers from its inscription, not its material form, believing that making a copy of it would yield the same results. As such, Escobar attested that Pereira asked him to transcribe it for a payment of three milréis. At his denunciation, Escobar recalled the paper's contents: Latin text that he claimed not to understand save for a "repetition of the word 'Devil'" (*demonio*) as well as "various crosses drawn on it."[49] After Escobar completed the transcription and received his payment, Pereira took the pen Escobar had been using and drew on the paper two figures of men, a knife, and a pistol before signing his name.[50]

Pereira's addition of these final symbols belies his earlier assertion of the paper's sole use to attract women. If we are to believe Escobar's account, Pereira's first description of the card's power may have been a cover for its true role to protect from violence, or this may be another example of a card that does both. Either way, Escobar's story illuminates the strategic systems of manufacture and belief in the carta de tocar. Pereira was clearly desperate, as he sought out someone with knowledge of written language to copy the letter's contents. That Pereira did not do this himself suggests the value he placed in the copying being done by someone intimately familiar with the written word—an especially dangerous desire, given that his eventual inquisitorial denunciation was from the mouth of the very person he asked to do the copying. In turn, the contents of Escobar's paper suggest that at least in some cases, users of touch cards strategically added designs or symbols to clarify the paper's desired powers. Pereira's addition of the pistol, two men, and knife suggests an adaptation of the paper to protect from knives, physical confrontations, and bullets. In another case from 1765, Pascual José de Moura, a painter and sculptor who lived in the Araritaguaba parish of São Paulo, was accused of practicing feitiçaria after he sold cartas de tocar that contained various orations, symbols, and designs that

were used to guarantee protection against enemies, clubs (*porretes*), knives, and blunderbusses (*bacamartes*).[51] Meanwhile, Escobar's assertion that Pereira added the word *Devil* seems unlikely. All extant cartas de tocar in Inquisition records make use of Catholic symbolism and quotidian designs referencing protection or violence; in turn, inscriptions tend to be either esoteric or Biblical. Escobar's insistence on the word *Devil* seems to have been an addition to please inquisitors' thirst for reference to it.

Pereira's oration does not survive. But the one that the cristão-novo Francisco de Campos da Silva had in his possession when he was arrested in Rio de Janeiro, accused of Judaism, in April 1710, does (figure 3.3).[52] Carried in his *algibeira*—a small bag attached to one's clothing—the paper presents a litany of empowered images and harbingers of violence from which the paper presumably protected its owner. A hanged man, two men fighting with swords, a pair of shackles, a pair of swords and a pair of pistols surrounding the Sacred Heart of Jesus, a fortress outfitted with a series of cannons, and a public flogging post (*pelourinho*)—here identical to the one constructed in Rio de Janeiro at this period, and so likely a copy of it—fill out this assemblage of violating objects and symbols in colonial Brazilian popular life. Their close integration with objects from Catholic altars, musical instruments, and even quotidian objects like a hair comb make this carta an uncommonly universal and uniquely empowered piece of paper, one that provides a rare glimpse into independently created cartas de tocar and personal designs that animated other amulets, including bolsas de mandinga.

Touch cards emerged as a direct response to the proliferation of paper with powerful associations in a highly asymmetrical society. Indeed, cartas de tocar illustrate a dual performative and materialist logic that necessarily reconsidered established relationshps between text and the effect it produces. This circulation of paper orations testifies not just to the centrality of paper and ink as inclusions inside mandinga pouches, but also, as will be discussed, to the circulation of papers passed through the various social hierarchies of popular Catholicism in a search for pragamatic solutions to problems and fights over violence, sexuality, and belonging. At the same time, the touch cards discussed here relied on a perception of the human body as a porous crossing of outside forces that could easily construct it as the target of jealousy, rape, and domination. For enslaved African men like Ignácio, touch cards provided them an opportunity to claim a bit of power in a society dependent on the sexual violation of its Black subjects. The reliance of touch cards on corporal intimacy and bodily coercion only

3.3 "Paper with figures" confiscated from Francisco de Campos da Silva in Rio de Janeiro, 1710. Arquivo Nacional da Torre do Tombo, Lisbon, Portugal. Tribunal do Santo Ofício, Inquisição de Lisboa, proc. 9352; PT/TT/TSO-IL/028/09352. Image courtesy of the ANTT.

underscored this power, paralleling the conceptions of presumed consent and intimate bodily surveillance that were part and parcel of slavery's corporeal logics. It is thus unsurprising that almost all recorded users of cartas de tocar identified as heterosexual men, for the cards allowed them to participate in a particular performance of masculinity tied to racial-sexual dominance.[53] While Spillers defines Blackness as a series of othered subject positions that function outside of legal orders of race and gender, the "marks" on cartas de tocar provided one of the few mechanisms through which the enslaved could attempt to create a position as a gendered subject: a temporary masculinity dependent on the ability to intimately dominate others while preventing domination of one's own body. It is this racial and gendered performance of Black masculinity suggested by the cartas de tocar that we will see adapted, expanded, and challenged by other mandingueiros as they strategically integrated paper inclusions inside the bolsas that protected them from the violence of slavery and the archive.

Harnessing the Word: José Francisco Pereira, 1730–1731

In the summer of 1731, agents of the Portuguese Inquisition confiscated a series of mandinga pouches from José Francisco Pereira. As discussed in chapter 2, at the time of his arrest, José Francisco was likely one of the most prolific and sought-after mandingueiros in Lisbon. One of José Francisco's surviving papers stands out for its intriguing incorporation of word and image (figure 3.4). The paper's top third, covered with fifteen lines of handwritten text, visually alludes to the paper orations and Catholic prayers—and thus possibly cartas de tocar—commonly included inside mandinga pouches. But while eighteenth-century Portuguese writing often lacks strict structure and grammar, the inventive spellings that compose this single run-on sentence make translation particularly difficult, even given its uncommonly legible penmanship. One can only draw speculative conclusions: "Brazil," for example, appears around terms suggesting that José Francisco's life had become worse once leaving there (*mau fora della*—"bad away from there"). In another section, José Francisco potentially reveals his lack of knowledge of the origin of "Feistisos" (feitiços)—*não saiba donde vem* ("One does not know where they come from")—but he requests, reiterating the key function of this paper, that the feitiços free him from danger (*lavra me do prigo*). Yet only slight shifts in how one analyzes the grammatical structure can dramatically change these sentences' meaning.

3.4 Paper once contained inside a mandinga pouch made by José Francisco Pereira, 1730. Ink on paper, 33 × 30 cm (13 × 9 inches). Arquivo Nacional da Torre do Tombo, Lisbon, Portugal. Tribunal do Santo Ofício, Inquisição de Lisboa, proc. 11774; PT/TT/TSO-IL/028/11774. Image courtesy of the ANTT.

José Francisco's paper seems an early exemplar of what Jean-Francois Lyotard called the "figural," markings whose not-yet-fully formedness is strategically rich in their semiotic pluripotential.[54]

By their own testimony, neither José Francisco Pereira nor his partner José Francisco Pedroso knew "how to read nor write."[55] When questioning enslaved Africans who had spent time in Brazil, inquisitors could all but assume such a response. For centuries, the overseas export of the country's economic output prohibited the development of a vibrant settler population with the means to invest in local formal education. At the same time, the Portuguese Crown feared that the circulation of ideas could stir up animosity against the Church or the Monarchy. As such, they prohibited production of printed materials in colonial Brazil, and tightly controlled the distribution of books there.[56] While the United States often had local laws preventing enslaved people from learning to read or write—typically because both abolitionists and pro-slavery activists presumed literacy could afford power and social prestige to those enslaved—such laws were never necessary in Brazil, where only a small minority of the general population had access to literacy training.[57] As late as 1872, less than one in every thousand enslaved people in Brazil registered as literate, compared to one in twenty in the United States in the previous decade.[58]

Given these data, one could presume the syntactical obscurity of José Francisco's papers as evidence of his own lack of formal education. But such a conclusion does not tell us why he would seek out writing as a constitutive element of his mandinga pouches at all. As Christopher Hager has noted regarding the nineteenth-century United States, many "scholars today esteem slaves' literacy as a form of resistance and a means of escape but neglect the ordinary acts of writing—often faltering and agonized— that were part of life in slavery."[59] One must first, then, consider the ways that the act of writing factored into José Francisco's everyday life. Only after this can one analyze how and why he prioritized it in his own work.

In 1730, José Francisco recruited twenty-year-old António Guedes to transcribe the necessary orations for him.[60] Thus, it is likely António's handwriting that remains preserved on José Francisco's papers. Born into a Catholic family and then working as a servant at a local church (moço de servir), Guedes was likely well-acquainted with the work of copying orations and prayers. In turn, his low position in the church hierarchy made him the safest person for José Francisco to approach.[61] Even so, using mandinga pouches in proximity of Catholic priests seems risky given that inquisitorial suspicion of the practice reached a fever pitch in the 1730s.

But consider how José Francisco's conception of the power of writing and script was closely intertwined with the pomp and transformative power of Catholic ceremony. José Francisco's own baptism, which took place in at the Igreja do Corpo Santo in Recife, Pernambuco, was likely his first exposure to the written word in general, but especially to the mutually dependent relationship between writing and orality.[62] James Sweet, in his own analysis of José Francisco's baptism, has imagined José Francisco's experience as akin to wonder as the priest read from the Bible, as he saw these elusive, magical markings from the ancestors directly speak through a spirit medium. Though José Francisco did not present an account of this ceremony at his Inquisition trial, Sweet considers James Albert Ukawsaw Gronniosaw's 1772 narrative as a kind of interpretive substitute, wherein Gronniosaw describes his early life in Borno (present-day northeastern Nigeria), his enslavement by the Dutch, and his first encounter with the written word:[63]

> [My master] used to read prayers in public to the ship's crew every Sabbath day, and when I first saw him read, I was never so surprised in my life, as when I saw the book talk to my master, for I thought it did, as I observed him to look upon it, and move his lips. I wished it would do so with me. As soon as my master had done reading, I followed him to the place where he put the book, being mightily delighted with it, and when nobody saw me, I opened it, and put my ear down close upon it, in great hopes that it would say something to me; but I was very sorry, and greatly disappointed, when I found that it would not speak.[64]

On one level, Gronniosaw describes the ephemeral power of written pages to bring forth empowering words to the select few who could engage them. In this sense, José Francisco's orations may have acted to ensnare language's ephemerality by transforming it into ink and paper, particularly as it played out on Catholic altars and during the liturgy. The rest of the design fleshes out this point. At bottom, José Francisco renders the Caravaca Cross, surrounding it with a wavy accent as if to extend its space and give it a sense of movement or spiritual effect. The original, housed in a church in Spain, had in the seventeenth century developed a new origin story that recounted how its miraculous appearance in 1231 immediately persuaded Zayd abu Zayd, the last Almohad governor of Valencia, to convert to Christianity.[65] The new associations of crosses with religious conversion, particularly in post-Reformation Iberia, made it a popular fixture on Catholic altars across the peninsula. Its powers were also ephemeral and

dependent on ritual knowledge: as José Francisco likely knew, during mass priests often carried these crosses over pedras d'ara, the specially prepared stones placed in the middle of Catholic altars whose presence sanctified that which was placed on it. It is not a coincidence that José Francisco also placed pieces of altar stone inside his mandingas, for in Catholic thought they played a key role in converting seemingly quotidian materials into powerful intercessors in human life.

José Francisco renders another of these seemingly quotidian materials at center. A circular design with a small cross likely represents a Eucharistic host, whose spiritual properties were also transformed by passing over an altar stone. Used during the most sacred moment of the Mass, the Catholic doctrine of transubstantiation—codified and widely upheld during this period—declares that this small wafer invisibly transforms into the body of Jesus Christ. For the Inquisition in particular, hosts were thus profoundly sacred and inviolable objects, and protected to the extent that stealing or breaking one was severely punished. While it is not clear if José Francisco's own mandingas contained Eucharistic hosts—they are not listed in the contents recorded by the scribe at his trial—Inquisition trials and denunciations mention their use in bolsas with what inquisitors perceived as an alarming frequency in the eighteenth century, particularly in Brazil. In the late 1730s, Pedro Gonçalves Pereira—a shoemaker from Cachoeira, in Bahia—partnered with an enslaved man named Francisco in their repeated theft of hosts from a local church.[66] In Minas Gerais in 1757, the free pardo António Carvalho Serra and his brother Salvador were accused of stealing hosts to place inside of mandinga pouches they made—a likely false accusation that resulted in António's imprisonment and untimely death in a Lisbon hospital in 1762.[67] In 1764 Joaquim Pedro, an índio in Grão-Pará, was accused of stealing altar stones and hosts that he used to make the mandinga pouches he sold around town.[68] The same accusation was leveled in 1792 against Francisco Alvares de Brito, in Cachoeira.[69] In 1798, Antónia Maria, a parda woman in Minas Gerais, was caught removing Eucharistic hosts from her mouth during Mass for the purpose of placing them inside bolsas for "witchcraft purposes."[70] Indeed, the illicit connection between bolsas and consecrated hosts was so strong in some areas that Catholic priests even facilitated their use in this manner. In 1714, a group denunciation in Pernambuco attested that a Catholic priest, Father Joseph Maurício, authorized the distribution of "consecrated hosts" (particulas consagradas) to residents in Serinhaém, to carry in their bolsas.[71]

Like altar stones, consecrated hosts evoked the transformative power of Catholic ritual and materialized the desired effect of bolsas to cross human and spiritual realms in their affective work. Such an ability may have been particularly important to the enslaved. Crossing boundaries between bodies and banality, as Christina Sharpe asserts, hosts conceptually operate as a reverse-parallel to a common experience of the enslaved by "making of bodies into flesh and then into fungible commodities."[72] José Francisco's depiction of this image, then, likely sought to reappropriate the host's powers inside of the charge of mandingas to protect their users from human violence and to invoke the invisible transformations of its other empowering contents while pointing to the potentially transgressive dangers of Portugal's most sacred objects.

Yet despite his close ties to a local church through António Guedes, we should interrogate José Francisco's decision to depict, rather than incorporate, a consecrated host in his bolsas. As Cécile Fromont has convincingly argued, José Francisco's depiction of four feathered quills emanating from the host design also point to a longer history of Afro-Atlantic religious practice understood to cleanse and temporarily protect the body.[73] Fromont points to a 1728 report published in Lisbon wherein the Brazilian-born Catholic priest Nuno Marques Pereira described his admonition of central African religious practitioners in northeastern Brazil. In his sermons, Pereira noted the role of "Geomancy, which uses certain drawings, circles, and spots formed on the ground," stressing how "this [geomancy] still today is observed" among Africans in Brazil.[74] Similar markings called *pontos riscados* ("scratched points") remain in use in the contemporary African- and Spiritist-inspired Brazilian religion of Umbanda, where they call to specific spirits and ritually cleanse practitioners. Made of chalk, sulfur, or gunpowder—substances included inside José Francisco's mandinga pouches—they are occasionally lit on fire to purify celebrants. An early nineteenth-century watercolor by French artist Jean-Baptiste Debret accents Pereira's observations (figure 3.5). It depicts what Debret labeled a "black sorcerer" as he traces a circular design on the ground. His elite garb may speak to his role as a spiritual medium or high priest, a position confirmed by his placement inside the circle, while the staff he uses to trace a circular design evokes the same design at the center of José Francisco's paper.

Taken as a whole, we can understand José Francisco's choice of paper and ink as a medium not as a mode of record-keeping. Instead, it operated on two seemingly opposed but intertwined levels: first, as a kind of reproduction of the proliferation of written orations and papers circulating in

3.5

Jean-Baptiste Debret, *Untitled (Black Sorcerer)*, 1828. Watercolor on paper, 10.5 × 6.5 cm (4.1 × 2.5 inches). Acervo Fundação Biblioteca Nacional, Rio de Janeiro, Iconografia ARC.30. Photo courtesy of the Fundação Biblioteca Nacional.

predominantly Catholic Portugal; and second, as his effort to reckon with the spectacular transformation and harnessing of the awe-inspiring forces he encountered. As such, José Francisco's creations necessarily expand definitions of literacy to account for how he understood the acts of inscription and orality that played broad roles in his own spiritual life and those of other Africans similarly displaced. Indeed, Antonio Viñao Frago calls for "a broader conception of literacy [that] should also include the ability to decipher/decode other signs than alphabetic, especially in the world of images [and] of numbers"; an especially prudent point given the revelatory ways José Francisco combined images with syntactically inventive texts in the papers António Guedes helped him to create.[75] Yet writing, José Francisco knew, had other powers. In the hands of elites, writing served as proof of his enslavement; writing authorized punishments against him; writing confirmed his legal status as property; and writing—in the form of the manumission letter—was the sole object in colonial Brazil that could distinguish between enslaved and free.[76] And it is this reckoning that comes through in the mandinga pouch used by António de Sousa.

Appropriating the Spectacle of Subjugation:
António de Sousa, 1732–1733

On January 6, 1733, two white men denounced António de Sousa, who was enslaved to a fabric merchant in Lisbon. The previous month, they attested, António nearly got into a fight with a group of people in his neighborhood. He boasted to them that "he did not fear anyone" and that "even if twelve people came at him they could not do anything bad to him," while one of the denouncers also recalled António previously claiming he "did not fear the sword."[77] At the same time, António was careful not to let information about his ownership of a mandinga pouch get back to the wrong people. When one of the white men learned of the existence of the pouch, António told him "Not to say anything to anyone."[78] But on Christmas day, the men attested, António's enslaver's brother punished him harshly by whipping him on his hands, a beating to which António reacted with some surprise, given the bolsa he owned.

António de Sousa's story walks a line common in bolsa denunciations. On one hand, the scribe's words depict António as cocky and confident, routinely boasting of his possession and the protections it granted him. At the same time, António also took pains to keep the amulet's existence and contents secret, lest the information get to the wrong ears. António's concerns parallel Laura de Mello e Souza's observations on mandinga pouches generally in her pioneering study of popular religiosity in colonial Brazil. For Souza, these objects' illicit and spectacular apotropaic powers—couched as "sorcery"—were a necessity across colonial power structures. Sorcery "not only furnished weapons with which slaves could wage a silent battle against their masters (quite often the only battle possible)," she writes, but "it also legitimized repression of and violence against these captives."[79] Indeed, multiple enslaved people specifically utilized mandingas to protect themselves from the punishment of their enslavers. In 1729, Luis de Lima testified that an enslaved Black man named Nicolau, who "knew much about feitiçarias, but whom he did not hear speak with respect to mandingas," requested Luis to make a remedy to "soften his master's beatings."[80] Luis declined to make it. That same year, Manuel da Piedade, who had run away from his enslaver in northern Portugal, confessed that he carried with him a written Catholic prayer, which "afforded protection against the dangers of the sea and beatings." Manuel likely needed much protection from the sea: he had survived two forced migrations across the Atlantic, and his apparently quick-tempered enslaver

was a sea captain.[81] These amulet-users also likely believed that their eventual subjection to punishment by inquisitors was made possible not by the lack of power in their bolsas, but by their confiscation and the desecration of their contents; in this way, the suppression of their ritual practice only worked to confirm its power, not deny it.

The double-edged ability of bolsas to repel violence but attract suspicion plays out in other inquisitorial denunciations that describe their users' spectacular public performances of self-violation, performances that consciously upended typical expectations of Black people's servitude and capacity for pain. In May of 1673, the cleric Miguel Gomes da Rama testified that on the island of Madeira, an enslaved man named Manuel was renowned for putting his sword on the ground with the blade facing upward. With the point of the sword against his chest, Manuel would throw himself on top of the sword, but it would bend without entering his body.[82] In Évora, in 1716, twenty-seven-year-old Francisco Fernandes, a pardo man, was convicted of "the crime of feitiçaria" on "presumption of having made a pact with the Devil, having laid his bare breast upon the point of a naked sword, and thrusting himself upon it, without injuring himself; [and] by doing other vain and superstitious ceremonies, lest he should be offended with iron or bullets."[83] In 1744, testimony invoked against Miguel Ferreira Pestana, the Indigenous resident of Rio de Janeiro who asserted his status as a mandingueiro, claimed that he once boasted to anyone who could hear that iron "could not enter, nor has entered" his body. Pestana later verified what he said by shattering a knife against his chest, which neither hurt him nor left any wound.[84] And in the first half of the eighteenth century in Pernambuco, a rather bombastic white man named João de Siqueira proclaimed, in the home of an acquaintance, that "nothing of iron could enter him" and showed as proof the mandinga that hung around his neck. Putting the pouch around the neck of a man enslaved to Siqueira's acquaintance, Siqueira ordered a sword to be pushed into his body. Siqueira's friend, fearing the loss of his property, pleaded with him to stop. Instead, Siqueira then put the pouch back around his own neck and pushed the sword into his own chest. He, too, emerged unharmed.[85]

I have argued elsewhere that colonial Brazilian authorities defined Africans through their bodies' capacity to endure physical pain.[86] Striking in these denunciations, then, is how such performances axiomatically situate enslaved bodies as the fitting test subject for the ability of bolsas to protect from bodily penetration. Manuel, for example, used his own body as a public

test subject, whereby the confirmation of the amulet's effectiveness lay in its capacity to stop the routinized violence that enslaved Africans feared daily. But in so doing, he had to confirm the expectation that enslaved bodies like his were *meant* to be receptors of such violence. Similarly, Siqueira called for "a slave," a move that emphasized his own power to call forth others' bodies for violent uses but also spoke to his seeming lack of confidence in the ability of the mandinga to protect him. Black peoples' use of bolsas, then, confounded and questioned the relations between embodiment, racial inscription, and violence in slavery-era Brazil and Portugal. On one hand, bolsa demonstrations relied on, and even confirmed, the perceived capacity of the enslaved body to tolerate violence and pain. In turn, by demonstrating the effectiveness of the bolsa, enslaved persons could overcome the systematic violence of enslaved life in Portugal and its colonies. But these performances also attracted the attention of onlookers who could turn them in to the Inquisition. As such, these performances not only tested the bolsa; they demonstrated the precariousness of enslavement and imperial authority.

Those who publicly demonstrated bolsas occasionally sought to use their presentations to enter the amulet-making business by attracting would-be clients. The location of the performances was thus strategic to not just attract attention but also temporarily occupy public space as a gesture of intervention against the architecture of authority and its role in constructing power relations. At his May 1673 denunciation of Manuel, who after living in Madeira moved to Lisbon, Miguel Gomes da Rama testified that one year prior he witnessed an incident involving Manuel and a soldier at the Chafariz d'El-Rey, the public "King's Fountain" at the north edge of a public *praça* (plaza) in Lisbon's Alfama neighborhood. Gomes da Rama stated that Manuel, while collecting water from the fountain, had gotten into a fight with a soldier on guard. The soldier tried to stab Manuel, but Manuel dodged the thrust. Manuel then taunted the soldier, telling him that he should go ahead and stab him, but the soldier refused. Gomes da Rama then went up to Manuel to ask him what he would have done if the soldier had stabbed him. Manuel responded that if he were stabbed, the dagger "would not do any damage because the dagger would bend and would not enter"—a statement clearly mimicking the same performances Gomes da Rama asserted Manuel did in Madeira. Gomes da Rama asked how this could be, and Manuel held up one of his arms. Tied to his wrist was what Gomes da Rama described as "a sewn piece that appeared . . . to have something inside of it." Manuel said that

the pouch protected him from harm, and that if Gomes da Rama wanted to bet on its effectiveness, he would gladly bet "five or six tostões" that no knife could penetrate him.[87] Gomes da Rama declined the offer, concluding that Manuel must be a feiticeiro.[88]

A celebrated late sixteenth-century painting of the Chafariz d'El-Rey illustrates why this location was so important for Manuel's performance (figure 3.6). An unidentified Flemish painter depicts a bustling, cosmopolitan scene filled with merchants hawking trade goods from Asia, the Americas, and Africa. People from all walks of life congregated there daily to collect water from one of the fountain's six spouts which, since 1551, had their use segregated by race, sex, and social status.[89] This was, in other words, a place to see and be seen, a place of forming new social bonds, and a place to take in the city's population. With nearly two hundred thousand residents around the middle of the eighteenth century, Lisbon was one of Europe's largest cities. A paucity of archival records and dedicated analyses make it difficult to estimate Lisbon's Black population during Manuel's life. Speculative estimates place it around one in five people, with twice as many free Blacks as enslaved, in addition to a large population of mulatos and other persons of color.[90] Though completed well over a century earlier than Manuel's public display, the artist depicts the diversity of social statuses occupied by Lisbon's African and African-descended population. In the center of the plaza, the artist depicts a Black man clad in street clothes almost comically covered in a can of fish or waste, his performance seemingly attracting attention from the onlookers. But the artist also takes care to show the higher social possibilities potentially afforded to Black men of means. In the foreground, for example, we see the figure of an African man on horseback wearing the heraldry of the Order of Santiago. Some scholars identify him as João de Sá Panasco, an African man in the employ of King João III who was eventually elevated to courtier of the Royal Household. For Manuel, then, the Chafariz d'El-Rey would have been a logical location to show off the bolsa's powers to outwit an onlooker suspicious of the amulet's apotropaic abilities. For such a performance it was necessary that he, in a sense, risk his life, although he had confidence in the ability of the bolsa to protect him.

After his punishment, António de Sousa's accusers searched his bed. Inside it, they found a bolsa made of blue cloth, which they later presented to inquisitors in order to "clear their conscience."[91] The denunciation indicates that the bolsa contained "some red feathers of a Brazilian bird, a piece of bull's horn, and some small pieces of white paper, and other pieces

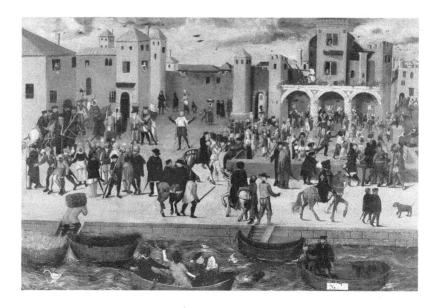

3.6 Anonymous Flemish painter, *Chafariz d'El-Rey (The King's Fountain)*, ca. 1570–1580. Oli on wood, 93 × 163 cm (36.6 × 64.2 inches). Coleção Berardo / The Berardo Collection, Lisbon, Portugal.

of the Auto-da-Fé list, all of which is suspected to be Mandinga."[92] While it is unclear who made the mandinga pouch for António de Sousa and from whence he acquired it, the contents speak to a creator who had a keen interest in redeploying the power of Atlantic objects-on-the-move, the papers of empire, and Catholic Church's public spectacles of authority.

Of this pouch's contents, "pieces of the Auto-da-Fé list" stand out for closer consideration. An auto-da-fé, literally an "act of faith," was a lavish, all-day ritual procession during which convicted heretics were marched through Lisbon's central public squares as their crimes were read aloud to assembled audiences. The Inquisition also built collective anticipation for the event by printing and distributing auto-da-fé lists across Lisbon. Typically released a few weeks ahead of the ceremony, these paper notices listed the names, ages, crimes, and punishments of those accused. In 1728, the Inquisition limited the printing of these lists to ten thousand copies, or one for more than twenty of Lisbon's residents.[93] Most of the convicted had been charged with practicing Judaism, but a litany of other crimes—particularly sorcery and "recourse to fetishes"—occurred with greater frequency in the first decades of the eighteenth century. Led by friars carrying a flag with the Inquisition's seal, the assembled prisoners walked barefoot,

carried candles, and donned robes designed to convey their wearer's punishment. Prisoners were ordered according to the gravity of their offenses. Those condemned to death by burning, for example, had flames on their clothes, while others contained other designs or colors typical of their specific crimes. Confessors and lead inquisitors on horseback rounded out the procession.[94]

In the 1730s, the procession departed from the Church of São Domingos, on the north end of Rossio Square in downtown Lisbon. An anonymous painting completed prior to the city's devastating 1755 earthquake frames the square and the church, at left, against the backdrop of the Castelo São Jorge, a Muslim-built fortress sacked by Christians during the siege of Lisbon in 1147, and a then still-potent symbol of Christian victory over apostates (figure 3.7). Framed thus as a geography of Christian victory, the artist depicts the square as a space for the public performance of Christian salvation. At the far right, for example, an accused man hangs from a high

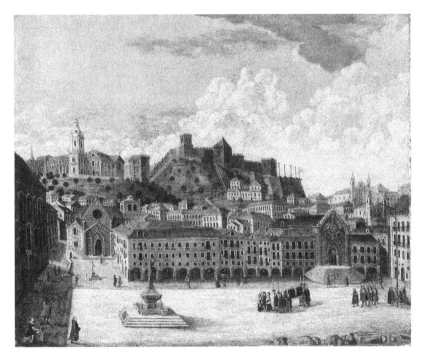

3.7 Anonymous Portuguese artist, *Hospital Real de Todos os Santos*, first half of the eighteenth century. Oil on canvas, 39 × 59 cm (15.4 × 23.2 inches). Private collection. Image courtesy of PAB / Aguiar-Branco Antiques, Lisbon, Portugal.

post for his crimes. In front of him passes the funeral procession for a good Christian, the deceased's status marked by the sumptuous gold cross on the coffin's black cloth cover. Both groups face left toward the Estaus Palace, the home of the Holy Office and seat of the Lisbon Inquisition.

The Holy Office carefully chose this starting point and subsequent route of the auto-da-fé to mirror the location and pageantry of royal entries and civic celebrations. This ensured a double occupation of this public space and its associated pageantry, blending the Inquisition's lavish ceremony with a collective ritual of belonging and authority. An "all-consuming diversion," as António José Saraiva described it, the auto-da-fé afforded the Holy Office the opportunity "to show off its ghastly supremacy."[95] Indeed, inquisitors intentionally delayed autos-da-fé to maximize their size and impact. Inquisitorial jailers would stockpile convicted heretics until they held enough people—usually a few hundred—to create "an adequate scenography [that] made evident the reality and persistence of the danger combated by the inquisitors."[96] The ceremony's pomp implicitly directed assembled crowds to assert their belonging as Christians in a Christian society, while also performatively expunging their otherness through a kind of ritualized sacrifice.[97] Few eyewitness accounts of Lisbon's autos-da-fé survive, but one account of the October 13, 1726 ceremony, published in the *New York Gazette* the following February, remains our best approximation of its choreography during this period. According to the account, the Bahian priest Manuel Lopes de Carvalho, donning a habit "all Painted with Flames" as he was given the opportunity to renounce his sins, steadfastly persisted in his opinions and at one point declared that "The Inquisition were not Christians, but Idolaters," before being burned alive.[98]

In Lisbon, a metropole whose population drew significantly from overseas, such a ritual took on the added significance of justifying Portuguese colonial interventions. "The underlying message of the theatrical public roles plated by Africans and Indians in the Auto da Fé," James Sweet argues, "was that colonized subjects needed redemption from heathenism, anarchy, and violence. The Crown and Church presented themselves as benevolent caretakers of their less fortunate subjects, taming the natural instincts of Indians and Africans through pious Christian charity."[99] The relationship between Portugal's overseas merchant empire and the auto-da-fé's paternalistic-redemptive scenography comes through in Bernard Picart's 1722 engraving of the auto-da-fé's concluding execution ceremonies in the Terreiro do Paço (Palace Yard) in Lisbon (figure 3.8).[100] The image is one of hundreds produced by Picart and eventually published in

3.8 Bernard Picart (engraver), "Suplice des Condamnez," 1722. Published in
Bernard, *Cérémonies et coutumes religieuses*. Image courtesy of the Getty Re-
search Institute, Los Angeles.

Cérémonies et coutumes religieuses de tous les peuples du monde, a lavishly
illustrated multivolume tome intended to supply an encyclopedic com-
parative record of global religious practices.[101] Published in the second
volume, which focused on European Catholicism, Picart presents a wide
view of the Terreiro do Paço facing west. At right, a massive crowd looks
on the executions by burning. Though such executions were in fact quite
rare—typically, those convicted to be burned recanted and confessed prior
to being executed—Picart's focus on this scene can be read as an attempt to
highlight Catholicism's brutality, particularly considering that Jean Fred-
eric Bernard, the book's publisher, was a Protestant living in Amsterdam to
escape persecution by Catholics in his home country of France. At the same
time, the image's wide framing also brings into view, at left, seven large
galleons in the Tagus River. Though the specific use of the ships in Picart's
engraving remains unclear, they connoted Portugal's dependence on, and
exploitation of, its overseas connections and territories. These ships trans-
ported trade goods and commodities from Brazil, carried inquisitorial
convicts to the metropole, and ferried the enslaved. Between 1725 and
1735, nearly two thousand Africans arrived in Lisbon's port, carried on

ships designated specifically for the slave trade.[102] The docks on which they disembarked were shared with ships that transported goods from the colonies alongside those set to be placed on trial by the Lisbon Inquisition for their assumed crimes in Brazil.[103]

Given the date of António de Sousa's denunciation, it is likely that the "pieces of the Auto-da-Fé list" inside his mandinga were taken from the list of June 17, 1731 (figure 3.9). It lists a total of eighty-six people: thirty-eight men and thirty-four women, plus twelve persons to be executed, and two others who had died in their jail cells while awaiting the auto-da-fé.[104] Some of these had been transported from Brazil in ships like those Picart depicts. They included the forty-three-year-old Domingos Luis Leme, a resident of Nossa Senhora do Bom Sucesso in the Rio de Janeiro bishopric, accused of marrying for the second time while his first wife still lived; and a series of Brazilian residents accused of practicing Judaism: Luis Vaz de Oliveira, a twenty-four-year-old in the Minas do Ribeirão, in Rio de Janeiro; Manoel Henriques da Fonseca, a fifty-three-year-old in Paraiba, Pernambuco; and the sixty-one-year-old Belchior Mendes Correa in Salvador, Bahia. The names of the convicted that day also included four people associated with making mandingas already discussed in this chapter. Second in line was António Guedes, the twenty-one-year-old church-hand who had assisted José Francisco Pereira in copying orations and was convicted for "cooperating in the use of mandingas." José Francisco Pereira and José Francisco Pedroso are listed at numbers 33 and 34, respectively, while two spots behind them in line, at number 36, was Manuel da Piedade, the mandinga-maker from Bahia who used his bolsa to escape beatings from his enslaver the sea captain (figure 3.10).

For the many people who used mandinga pouches made by these men in Lisbon, seeing them march in an auto-da-fé, or at least hearing of their punishment, must have been a sobering event. Though each of these men gained fame for their production of objects that could protect from public violations, the confiscation of their bolsas and their empowering contents was likely tragic for them and the clientele who depended on them. In turn, their public punishments sent a clear message to mandinga-users: these objects would not be tolerated. And yet it seems the Inquisition's public parading of the power of mandingas created new forms of engagement and empowerment for the amulets. By incorporating a piece of the auto-da-fé list, the maker of António de Sousa's bolsa deftly seized a bit of the Inquisition's authority to engage in these grand public spectacles of violation while also, potentially, preserving some of the authority that those

3.9 Front page of the Lisbon auto-da-fé list of June 17, 1731. Arquivo Nacional da Torre do Tombo, Lisbon, Portugal. Tribunal do Santo Ofício, Conselho Geral, liv. 435; PT/TT/TSO-CG/002/0435. Image courtesy of the ANTT.

QUARTA ABJURAÇAM EM FÓRMA POR FEITIÇARIA, E JUDAISMO.

33 26 JOzeph Francisco Percyra homem preto, solteyro, escravo de João Francisco Pedrozo, natural de Judà Costa da Mina, e morador nesta cidade de Lisboa occidental, por culpas de feytiçaria, e ter pacto com o demonio, a quem reconhecia, e adorava por Deos.

34 19 Joseph Francisco homem preto, solteyro, escravo de Domingos Francisco Pedrozo homem de negocio, natural de Judà Costa da Mina, e morador nesta cidade de Lisboa occidental, pelas mesmas culpas.

35 42 Manoel Delgado homem preto, escravo do Capitaõ Jozeph Rodrigues de Oliveyra, natural da Ilha de S. Thomé, e morador nesta cidade de Lisboa occidental, pelas mesmas culpas.

36 27 Manoel da Piedade homem preto, solteyro, escravo do Capitaõ Gaspar de Valladares, natural da cidade da Bahia, e morador na de Lisboa oriental, pelas mesmas culpas.

3.10 Second page of the Lisbon auto-da-fé list of June 17, 1731; detail showing the names of José Francisco Pereira, José Francisco Pedroso, and Manuel da Piedade. Arquivo Nacional da Torre do Tombo, Lisbon, Portugal. Tribunal do Santo Ofício, Conselho Geral, liv. 435; PT/TT/TSO-CG/002/0435. Image courtesy of the ANTT.

three prolific mandinga-makers possessed. Those people who found themselves enslaved used these antimodels of the object to challenge and reframe the common linkage between optic-spectacular ways of seeing and the performance of imperial claims to authority.

Fleeing the Archive: Manuel de Barros and João da Silva, 1742

Accused of "sorcery and recourse to fetishes" as he sat on trial before the Lisbon Inquisition in 1752, João da Silva, an enslaved *"natural* of Angola," testified how he came to possess the mandinga pouch that resulted in his arrest.[105] Ten years prior, while enslaved on a plantation at Olho de Peixe, in rural Bahia, João encountered Manuel de Barros, an African-born man on a journey toward the capital city of Salvador. Manuel had to travel under the radar, for he had fled his enslavement somewhere in the country's interior. João provided Manuel with food and assistance for his journey. As a token of thanks, João asserted, Manuel gave him a leather amulet, which Manuel said had the power to free João from enslavement, just as it had done for him. After Manuel continued his journey, however, João held the object in suspicion. He showed it to several white people, asking them if it was permissible to wear it around his neck. None seemed to have an opinion, save a young woman named Teresa. Teresa, aware of the decrees against these objects, immediately informed the local Vicar that João was in possession of a mandinga. Soon after, the Vicar confiscated João's amulet and tore it open, revealing its assembled contents, which included: "a square-shaped rock, a piece of garlic, two pieces of lead, a piece of consecrated host," and the paper reproduced here (figure 3.11).[106]

While the earlier analyses in this chapter discussed how the abilities of bolsas and touch cards to protect from general violence or to attract sexual partners implicitly relate to enslaved and Black peoples' efforts to contest and accommodate overarching structures of imperial power, the amulet João claimed he received from Manuel is one of the few bolsas explicitly linked by its users to enslaved people's efforts at resistance or fugitivity. Recall from chapter 2 Luis de Lima's account of being asked to produce a bolsa so José Luis could escape his English enslaver in Porto.[107] In another case from 1741, two people testified that Domingos Álvares, an enslaved native of Mahi, north of Dahomey, used bolsas to stop wind, thus inhibiting the movement of the ship transporting him between Pernambuco and

3.11 Paper once contained inside a pouch used by João da Silva in Bahia, Brazil, before 1742. Arquivo Nacional da Torre do Tombo, Lisbon, Portugal. Tribunal do Santo Ofício, Inquisição de Lisboa, proc. 502; PT/TT/TSO-IL/028/00502. Image courtesy of the ANTT.

Rio de Janeiro. The witness Manuel da Costa Soares testified that as the ship sat in the water, he had "come to know that Domingos Álvares was a feiticeiro." Ordering Domingos undressed, Soares uncovered "some bolsas . . . in which he placed some feitiçaria things." He ordered the objects burned, and after this the wind picked up and the ship went on its way.[108] While we do not have Domingos's testimony about this event, Soares's denunciation shows how even those who did not use bolsas occasionally attributed to them the power to flee, or at least interrupt, the forced transport and enslavement of Africans in Brazil—an attribution that speaks to, as previously outlined, a deep suspicion of the counterimperial possibilities of these seemingly benign objects.

Other bolsas, however, were used to not just escape slavery, but escape it as a visual condition defined by surveillance. Another trial attests that in the early months of 1737, in Lisbon, an enslaved man named Domingos received from another enslaved man named João Angola an object that allowed its owner to "not be hurt, and to be able to open [locked] doors without being detected . . . in order to run away from the house of his master."[109] Note how Domingos defined this object's powers not just as a way to escape enslavement, but to escape enslavement as a visual condition that recast Africans' bodies as objects for others' pain and pleasure.[110] In turn, note that the mandingas under discussion in both trials lack a known maker or origin: they were, instead, traded between enslaved people in mutual acknowledgment of their common predicament.

The extent to which one can and should characterize bolsas de mandinga as an anti- or counterslavery practice remains a salient topic of debate. Some historians closely link the use and production of the bolsas to resistance against enslavement,[111] while for others, the sheer number of non-Africans, specifically whites, using bolsas de mandinga in Portugal in the early eighteenth century makes it "a bit reductive to explain sorcery discourse just as a function of slave resistance or African cultural resistance in general."[112] But the aforementioned bolsas, in allowing their enslaved users to escape surveillance and violence, prefaced a key thread in contemporary theorizations of the visual culture of slavery. Recent work by Saidiya Hartman and Krista Thompson, for example, defines slavery as a contradictory visual condition, caught between the "hypervisibility" of enslaved persons always under surveillance, and the social—and thus archival—"invisibility" of slave status.[113] "Everywhere haunted by the gaze," in this sense, Huey Copeland notes, "African diasporic cultural practitioners have time and again turned to the word in posing alternative articulations of the

self."[114] Indeed, the paper contained inside João's mandinga may perform similar work. Orations like these follow a structure relatively unchanged even in contemporary Brazil: the paper's top half, punctuated with small Latin crosses, reproduces the text of a prayer to Saint Mark, while the bottom half—the space typically reserved for personal petitions—refers to the Ave Maria and the Our Father, two other standard Catholic orations. But by the end, the writer asks for "sacred medicine," to "not have a sword enter into my body" and to be able to "walk day and night."

These requests for freedom from violence and spectacular visibility continue through the paper's design. At bottom right, a wide, shaded base of a cross and dotted accents suggest it represents an architectural feature (figure 3.12). Many Portuguese-founded cities, both in the colonies and in the metropole, featured large stone crosses like these at the center of public plazas or cemeteries where they functioned as markers of the Church's authority and as a locus of public devotions and petitions. One nearly identical to that rendered on the paper was a prominent feature of the Largo de São Domingos, the first place passed by accused heretics during their autos-da-fé, and a location depicted on the previously discussed painting of Rossio Square in Lisbon (figure 3.13). The owner of this amulet likely sought escape from the structures of subjugation tied to imperial plaza architecture referenced here. They did so by making themselves invisible to onlookers and the archive. In this way, the text simultaneously collapses the act of its inscription, the new voices it granted its author, and the violence inherent to its production. The effect renders its creator as a kind of fugitive from the visual; a ghostly apparition outside of the grip of both language and image that stages an ongoing flight from the surveillance of his own body. In so doing, his body, now made text, itself becomes both the attempted apparatus of enslavement and the means of escape.

To this end, consider how enslaved persons in Brazil had to navigate not only a litany of new cultural possibilities and conventions, but also the

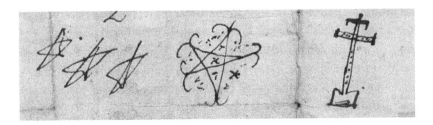

3.12 Detail of figure 3.11.

3.13 Detail of figure 3.7 showing the São Domingos Church and the two crosses fronting it.

burdens of a social condition defined by their bodies and their skin. Recent excavations of an early nineteenth-century African burial ground in Rio de Janeiro attests to what one group of scholars characterizes as Africans' "intensity of strategies for covering the skin"—the organ responsible for absorbing brutalities, for deflecting evils, and most closely tied to racial subjectivity.[115] In this context, African' frequent goal was to "seal the body" from physical violence and malevolent spirits by using anything and everything at their disposal: scarifications, jewelry, beads, medals, and mandinga amulets. Occasionally, such protections took the form of tattoos. A sparse but rich visual record left by eighteenth century observers testifies to the use of the Star of Solomon as an apotropaic symbol when drawn on the skin. This star, a common talismanic and occult symbol used across

Europe and West Africa for centuries, appears repeatedly on João's paper. A series of four stars separate the text of Saint Mark's prayer from the personal petitions, while these symbols reemerge at the foot of the page: a group of three stars at left; at center, another five-pointed star, this time accented and embellished.

The importance and role of Solomon's Star comes through in a bolsa case from the 1760s in far southern Brazil. In 1767, witnesses denounced Silvestre de Pinho, a sixteen-year-old Black *crioulo* (creole) employed as a soldier at the Fort of Santa Rosa, for carrying a consecrated host inside an oration paper with the power to "free him from bullets and enemies" (figure 3.14).[116] Creased from being folded, one can clearly see the symbols that transformed the paper into an empowered object. A pentagram like that on the hand of the woman in Carlos Julião's depiction of the African fruit seller, discussed in chapter 2, appears once more, inked into paper just as it had been inked into skin—here again paired with a series of crosses. Each symbol intermingles with short orations and signatures, each accented with a small cross, placed randomly, even feverishly, across the paper, which seem as apotropaic punctuation marks. Terms lifted from the Bible, prayers, or the Liturgy—*Christo* (Christ), *emdeospadre* (In [the name of] God the Father), *noso* ("our," usually a reference to *nosso senhor*, "our father"), *direita* ("right" for "the right hand of the father")—intermingle with other words employed, perhaps, because of the ease with which they could be copied by whomever produced this oration: *esta* (this), *todo* (all), *morto* (dead). What does it mean that *criado*, the term for an enslaved domestic worker, appears inside the Star of Solomon, here punctuated with two crosses? Why does *donde* (where) appear disconnected at top left? Why does the oration's creator—assumed at trial to be Silvestre himself—take such pains to ensure the words follow no clear order of top, bottom, or proper direction? The words' multidirectionality and dynamic relationship to each other teases with meanings, as if pulled from a series of orations but rearranged in a radically new method to upend hierarchies of speech and language. Christina Sharpe's beautiful meditation on the structure of M. NourbeSe Philip's *Zong!* poems equally applies: "The tongue struggles to form the new language," Sharpe notes. "The consonants, vowels, and syllables spread across the page. The black letters float like those Africans thrown, jumped overboard, and lost in the archives and in the sea."[117]

The addition of such empowering symbols like the Star of Solomon to one's body was particularly charged and dangerous for fugitive Africans, as they likely tried to avoid any distinguishing characteristics during their

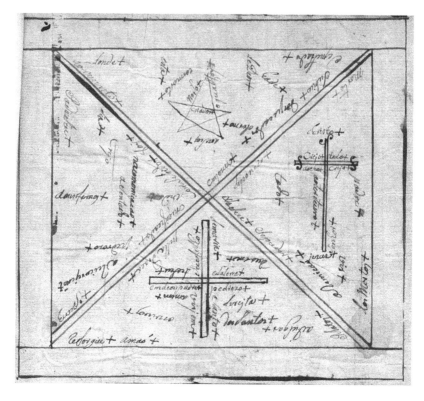

3.14 Paper used by Silvestre de Pinho at the Fort of Santa Rosa, Brazil, 1767. Arquivo Nacional da Torre do Tombo, Lisbon, Portugal. Tribunal do Santo Ofício, Inquisição de Lisboa, proc. 224; PT/TT/TSO-IL/028/00224. Image courtesy of the ANTT.

ongoing flight from the oversight of enslavers and *capitães-do-mato* (mercenaries working to capture those fleeing enslavement). Research by Aldair Rodrigues has located a series of descriptions of Savalou peoples (present-day Republic of Benin) enslaved in Minas Gerais in the 1740s and 1750s.[118] Descriptions of their heights, weights, facial features, and scarifications across their faces and bodies survive in local tax documents produced so their owners could claim property. Many of those described had fled into the mountains of Minas Gerais, and their descriptions of scarifications were used to confirm their sale as well as alert capitães-do-mato to their appearance.

European observers in the early nineteenth century produced multiple engravings of these African scarifications, reflecting an interest in the relationship between body modification, racialization, and enslavement. In an

engraving from his 1835 illustrated travelogue *Malerische Reise in Brasilien*, German artist Johann Moritz Rugendas depicts two women whose portraits stand in for wider African ethnicities developed during the era of the transatlantic slave trade (figure 3.15). The engraving made from Rugendas's drawings created during his time in Brazil depicts, on the right, a woman with scarifications commonly associated with the Mina nation. Her exposed chest and uncovered head provide an unimpeded view of the markings that in an African context, transformed her into an empowered spiritual vessel. Rugendas contrasts this with a Rebolo woman; her lack of identifiable scarifications implied by her fully clothed body and covered head. As discussed in the first chapter, *Rebolo* and *Mina* are ethnonyms used originally by Portuguese slave traders to define enslaved Africans. Mina marked those, like José Francisco, who departed through ports on the Bight of Benin. It had little to no currency in Africa as an identity marker, though it did become one point of community-building for Africans in Brazil.

One wonders how João da Silva would have understood the practice of iron branding, which marked him as property of a particular enslaver or plantation. Between 1742 and 1862, the Santa Casa de Misericórdia of Bahia—the Catholic organization responsible for the burial of enslaved Africans in Salvador—recorded thousands of names and branding marks in a multi-

3.15 Pierre Roche Vigneron (engraver), "Cabinda, Quiloa, Rebolla, Mina," 1835 (detail). Section 2, Plate 10, in Rugendas, *Voyage pittoresque dans le Brésil*. Acervo Fundação Biblioteca Nacional, Rio de Janeiro, Brazil. Image courtesy of the Fundação Biblioteca Nacional.

volume register of *bangué* burials, so named for a type of second-class coffin consisting of a net with two sticks to carry the body, used for burying those who could otherwise not afford funerals, such as the enslaved or indigent. A page from one of the archive's registry books shows how the transformative properties of fire, iron, skin, and text previously referenced in Umbanda pontos riscados and inside mandingas emerge here once again, but to quite different ends (figure 3.16). Many of the book's entries give the name of the dead in the left-hand margin; here, in an entry from March of 1771, the names of Anna, Mariana, and António, among others, record their death dates and circumstances of their burials. The archive's many entries involving enslaved persons, however, are often identified by drawings of the iron branding marks visible on the bodies of the dead. While many of these markings reproduced the initials of enslavers, note that this page's seventh entry—which records a branding marking an African man (*gentio da Costa*) on the right side of his chest—uses the same Catholic sacred heart symbol discussed in the previous chapter that appeared on medallions and inside José Francisco's mandingas. The design all but stands in for the dead's name, which is not recorded. This symbol, then, may critically respond to Hortense Spillers's description of the blurred boundaries between, on one hand, the "marking and branding" of Black flesh that confirmed it as an owned commodity and, on the other, the thousands of pages of imperial records that codified the legal and cultural frameworks that violated Black lives. On this page and in Rugendas's illustrated travelogue, the written markings on papers are not easily separable from the markings and brandings on enslaved bodies: a dual-edged power that played out on fugitive Africans' bodies and the amulets they carried with them.

The papers contained inside João da Silva's mandinga respond to the contested and competing roles of inscription in the early modern Black Atlantic world. This pouch's maker, like the others outlined earlier, sought to harness not only the spectacular power of the written word, but also an empowered range of corollary practices. Papers allowed mandinga-makers to transform and transport graphic writing systems, bodily scarifications, Catholic amulets, and the ephemerality of incantation. At the same time, writing inside mandingas may have also been a desperate effort to stave off the other, more malevolent uses of its power: to enslave and control Africans' bodies, to ensure their complicity inside wider systems of surveillance, to regulate and define criminality, and to punish, often violently. With this perspective in mind, I conclude with some thoughts on the slavery archive that mandingas both depart from and help to constitute.

3.16 Page from the sixth Livro do Bangué, recording the names or markings of those buried by the Santa Casa de Misericórdia da Bahia in Salvador, Bahia, Brazil, March 1771. Acervo da Santa Casa de Misericórdia da Bahia–scMBA, Salvador, Bahia, Brazil.

Conclusion: Archival Silences

A close colleague of mine once expressed to me their jealousy at the richness of the archival materials that form the basis of this project. My colleague is not incorrect. The amount of information we have, for example, about Jacques Viegas's mandinga pouch remains, to my knowledge, unprecedented among extant objects produced by enslaved Africans anywhere in the world prior to the nineteenth century. We know his name, his birthplace, and extensive biographical details regarding his life in Portugal. We have his own testimony as to the reasons he used this object, the general logic behind its construction, and its relationship to similar works at the time. But I wonder, looking at Jacques's amulet once again, what he, Luis de Lima, José Francisco Pereira, António de Sousa, and João da Silva would think of the depth of information we have on their lives. Their presences in the archive are intimately connected to the fact that while the mandingas they used may have granted them momentary command over the spectacular systemic violence to which their lives and bodies were subjected, they also attracted attention of onlookers that subjected them to inquisitorial violence. For Jacques's possession of that amulet and that paper, he was forced to perform a public penance of his faith, publicly flogged, and exiled. The Inquisition trial record that surrounds that pouch remains the only extant record of his life. It is a record produced under the duress of harsh interrogation, where Jacques's guilt was all but assumed; all of which was recorded by a scribe trying to keep up with the conversation in front of him.

Returning to São Boaventura's letter, the one that opened this chapter, note that it contains precious little information on the man denounced. São Boaventura even apologizes for the letter's sparse contents. The unidentified Black man "said things to me daily," he wrote, but much of what he said "I poorly understood, because he did not speak clearly. . . . I do not now remember [the details of our conversations] in a form in which I can write them."[119] Note how the letter thus not only attests to the inviolability of the unnamed man's body because of the bolsa, but also renders his subject effectively inviolable by the Inquisition due to the confusion of his speech and his name. Indeed, I can find no record of this man ever being brought to trial. In a sense, he escaped the Inquisition's suppression as well as that of the archive. Even his speech, as São Boaventura alludes, was as difficult to interpret and impossible to summarize as the unclear syntax used to empower mandinga pouches.

Manuel de Barros, meanwhile, used his own mandinga not simply to escape slavery, but to escape from the archive. He entered it as quickly as he left; a ghostly specter that rushed in and out simply to deposit a fragment of history before once again disappearing. João da Silva was not so lucky. His presence in the archive is intimately connected to the fact that he did not flee, he did not manage to escape. Indeed, I was unable to locate any other historical evidence that Manuel de Barros existed. João may have invented him during interrogations as a kind of justification or explanation for how he came to possess the amulet in question. As such, Manuel de Barros—much like the unnamed man in São Boventura's letter—not only performs a fugitive escape from archival violence but enters into a different kind of archival register that leaves no mark.

The archive, Saidiya Hartman argues, "is a tomb."[120] "The raw numbers of the mortality account," she writes, "the strategic evasion and indirection of the captain's log, the florid and sentimental letters dispatched from slave ports by homesick merchants, the incantatory stories of *shocking* violence penned by abolitionists, the fascinated eyewitness reports of mercenary soldiers eager to divulge 'what decency forbids [them] to disclose,' and the rituals of torture, the beatings, hangings, and amputations enshrined as law" all inundate the archive of slavery with scandal and excess.[121] Yet in this context, she implores, narrating a counterhistory of slavery necessitates we meditate on "the incomplete project of freedom" that continues through our work as scholars, a kind of reckoning with, and acknowledgment of "the precarious life of the ex-slave, a condition defined by the vulnerability to premature death and to gratuitous acts of violence."[122] Indeed, the pages that surround Jacques Viegas's mandinga, José Francisco's drawings, and João da Silva's prayer petitions—the objects they may have trusted to protect them—are those that violate them once again. Inside mandinga pouches, certain enslaved Africans desperately sought immediate responses to the violence around them, in some cases choosing to escape from the regulatory systems that sought to control them.

In this framework, Portugal's inquisitorial archive does not seem to erase the subjectivity and experience of those it interrogates. Rather, its existence depends on its own ongoing disarticulation and rearticulation by actively incorporating its assumed, but ultimately mutually constituted, oppositions. In turn, mandinga pouches also had to play this game, actively seizing alternately empowered, unseen, ephemeral, and potentially transgressive contents through the papers that constituted them. Perhaps, then, what is often framed as a form of silence of Black lives in

3.17 Paper once contained inside a mandinga pouch made by José Francisco Pereira, Lisbon, Portugal, ca. 1730. Arquivo Nacional da Torre do Tombo, Lisbon, Portugal. Tribunal do Santo Ofício, Inquisição de Lisboa, proc. 11774; PT/TT/TSO-IL/028/11774. Image courtesy of the ANTT.

the archive itself might in fact be the object of, rather than an obstacle to, a project of archival recovery. Mandinga-papers produced by enslaved subjects during this period alternate between obscure syntax and divine referents, gesturing toward—as Lyotard suggests—what cannot and could not be articulated or represented. Thus, the active creation and incorporation of mandingas into the "archive of slavery" frame it not categorically as a site of erasure or deprivation, but rather what remains secret, hidden, or intentionally obscured; a practice derived at the complex intersections of inscription's role of empowerment and subjection.

One of the surviving papers from José Francisco's mandingas stands out for its extensive text (figure 3.17). Like his other orations, this paper is likely António Guedes's transcription of José Francisco's own words, making it one of the few surviving texts known from an enslaved African of this period that was created solely for them. Repeated crosses, the common additions to the Christian orations with which José Francisco was so familiar, punctuate roughly written letters in the oration's top half, which reproduces a common prayer. In the bottom half, through the inventive spellings and occasionally obscure syntax that characterize his other writings, in brief moments of clarity, José Francisco's wishes shine through. He implores God to let him do what he wants, to make what he wants, to have what he wants, to overcome any impediment, to open any door without anyone detecting him, and, in the final lines, to return to Brazil.

On June 18, 1731, the day after his public auto-da-fé, José Francisco sat before a document outlining the "secrecy terms" of his Inquisition trial (figure 3.18). As he could not read it, he must have listened as printed words once again came alive before him. Ironically, they declared his silence. He "was to be very secret regarding everything seen, and heard" in his jail cell and during his trial, under penalty of "gratuitous punishment." After this was read, the presiding scribe wrote José Francisco's name at the bottom of the page. In between "José" and "Francisco," he traced the quill across the paper, using the same motion with which he had seen others empower Latin orations many times before: a shaky cross that sealed his fate (figure 3.19).

TERMO DE SEGREDO.

AOS *Aezoito* dias do mes de *Junho* — de mil & seiscentos & *toi ta e hum* — annos em Lisboa nos Estaos, & caza do despacho da santa Inquisiçaõ, estando ahi em audiencia da *[...]* — os senhores Inquisidores, mandaraõ vir perante sy, do carcere da penitencia a *[...]* R. pres. contheud neste processo, & sendo presente lhe foy dádo juramento dos santos Euangelhos, em que poz a mão, & sob cargo delle lhe foy mandado, que tenha muito segredo em tudo o que vio, & ouvio nestes carceres, & com ella se passou acerca de seu processo, & nem por palavra, nem escrito o descubra, nem por outra qualquer via que seja, sobpena de ser gravemente castigado o que tudo elle prometteo cuprir, & sob cargo do ditto juramento, de que se fez este termo de mandado dos dittos senhores, que *assinou Manoel de [...]*

3.18
Page outlining the "secrecy terms" of the Lisbon Inquisition trial of José Francisco Pereira, 1731. Arquivo Nacional da Torre do Tombo, Lisbon, Portugal. Tribunal do Santo Ofício, Inquisição de Lisboa, proc. 11767; PT/TT/TSO-IL/028/11767. Image courtesy of the ANTT.

3.19 Detail of figure 3.18, showing José Francisco Pereira's "+" signature. Arquivo Nacional da Torre do Tombo, Lisbon, Portugal. Tribunal do Santo Ofício, Inquisição de Lisboa, proc. 11767; PT/TT/TSO-IL/028/11767. Image courtesy of the ANTT.

Revolts

On February 9, 1835, an enslaved African man named José found himself on trial in the house of Felix Garcia de Andrade Silveira Cavaleiro, Justice of the Peace for the first district of the Freguesia of São Pedro Velho in Salvador, Bahia, Brazil.[1] Identified as *Nagô*—a term for Yorùbás in Brazil—José had been arrested two weeks prior on suspicion of participating in, or at least having advance knowledge of, an insurrection on the night of January 24–25.[2] On that evening, a group of nearly six hundred people, almost all *Malês* (a Brazilian term for African-born Muslims), directly confronted Salvador's authorities with clubs and knives in an attempt to overcome the city's security forces, head to the sugar plantations outside the city to liberate and recruit more of the enslaved, and finally lay siege to Salvador.[3] The Revolt of the Malês provoked a fierce backlash from the municipal government. Immediately following the rebellion, Francisco de Souza Martins, President of Bahia province, ordered Francisco Gonçalves Martins, Salvador's chief of police, to round up the revolt's conspirators and leaders and collect all necessary evidence for their trials.[4] The searches of Africans' homes came quickly, aided by locals: residents denounced enslaved Africans they knew and joined inspectors on house raids.[5]

While some circumstantial evidence implicated José as a participant in the rebellion—he had known relationships with two other Nagô participants in the revolt, Francisco and Carlos, and José was seen leaving the house of his enslaver the night of the rebellion to meet up with them—one of the pieces of evidence used to prove his guilt and eventually justify his punishment of eight hundred lashes was a listing of the objects found in his possession when he was arrested on January 27. These included:

A sheet of paper with writing; on the top half of the front of the page, and on the reverse, were written Arabic characters. [We also found] a rope of ninety-eight coconut beads on what looked like a cotton cord with three tassels but one cannot tell of what color, and at the end of the rope a finial made of the same coconut; seven rings of white metal spun on a white rag with blue markings, a small bundle with blue markings and white lines, inside of which found a half sheet of paper, written with those same Arabic letters, folded into small folds. These objects are worthy of our distrust, and very much indicate that the African José knew of the disastrous insurrection that unfortunately took place on the night of January 24 to 25, and as such was imprisoned by the National Guard.[6]

It is not clear from José's trial record whether he owned this piece of paper, nor is it apparent whether he could read or write Arabic. When questioned on his ownership and use of the paper, the cord, the rings, and the packet (*patuá*), José described each in turn. The patuá, he said, "is good for the wind," an explanation that was met with little interest or understanding by his interrogator but that likely referred to the patuá's function to protect the wearer from *anjonu* or *alijano*: potentially wrathful spirits known in Yorùbáland as born from a union of air and fire.[7] The beads, described by José as "for prayer," were a *tessubá* used for the daily recitation of Islamic prayers, while the rings, purchased for "his fingers," served as a popular fashion item among Malês specifically and Africans generally in Bahia.[8] And the piece of paper? José said simply that it "was not his."[9]

José's explicit denial of his ownership of the paper may have been a way to work around what his accusers presumed and what this chapter analyzes: the presumed rebelliousness of the objects used by Africans in early nineteenth-century Brazil. Such perception was by no means unique to José's case. Indeed, the religious objects of Africans served as the motivation for President Martins's ordered searches of their homes following the revolt; they constituted the very evidence he sought. Martins commanded Salvador's justices of the peace to have their block inspectors "enter every house . . . belonging to black Africans and search them rigorously for men, arms, and 'written papers.'"[10] Martins's order made no distinction between presumed participation in the rebellion and ownership of these written papers: "Africans who taught Arabic and distributed Islamic literature were turned in," João José Reis notes in his foundational history of the revolt, as were "those who simply received friends at home to talk."[11]

In the ensuing trials, interrogators focused on the ownership and significance of a range of religious objects: prayer beads, writing tablets, books of Qur'anic prayers, and fabric or leather amulets like the one possessed by José.[12] Torquato, another enslaved Nagô man arrested in the aftermath of the insurrection, also was brought to trial for his ownership of Arabic papers and the patuás that housed them. During a search of the house of Torquato's enslaver, José Pinto Novais, police found a box belonging to Torquato containing a string of glass prayer beads and some patuás, one of which "contained cotton soaked with unknown potions" and others containing folded pieces of paper.[13] One of these papers still survives, held at the State of Bahia's Public Archive in Salvador (figure 4.1). Six lines of text, reading from right to left, reproduce *al-Fātiḥah*, known in English as "The Exordium," or "The Opener," the first sura of the holy Qur'an.[14]

In the name of God compassionate and most merciful. Praise to God, Lord of the Worlds. Merciful, Compassionate. Ruler of the day of Judgment. It is you we worship and you we [ask for] help. Guide us on the straight path. The path of those upon whom you give blessings. Those who are not the object of your wrath, and are not those who went astray. Amen.[15]

While the Exordium's references to the "Day of Judgment" and assistance in guiding Muslims "on the straight path" carry potent relevance for participants in a revolt with religious underpinnings, equally important are the ways Torquato activated the power of these words. Or rather, how Torquato activated these lines of ink *as* words, in making lines of ink into aesthetic and sacred invocations with ritual and political power beyond their formal structure. Cutting across these six handwritten lines, two vertical and four horizontal creases mark where Torquato carefully folded the paper over and into itself, a sacred act that worked to hide his calligraphy from human view before placing it inside the leather pouch, where it could be seen only by God or other spiritual forces known to West African Muslims.[16] Yet while cutting open these protective amulets, in smoothing out the sacred order of creases and folds, in revealing to human eyes a text meant as a holy request between a deity and their adherents, this page—like those belonging to José—was not translated by officials. Instead,

4.1 Document found inside of a patuá belonging to Torquato; seized by police on February 5, 1835. Arquivo Público do Estado da Bahia, Salvador, Bahia, Brazil; Documentos Malês, Maço 2848. Image courtesy of the Arquivo Público do Estado da Bahia.

It is found that the writing on the said pages is the same as the correspondences found on the insurgents, and it is inferred that the accused [Torquato] had relationships with them, and without a doubt contributed to the mentioned insurrection. In these Terms and conforming to the Law, it should be that the Accused be punished with the penalties decreed in article one hundred thirteen of the Penal Code.[17]

What is clear is that José and Torquato's interrogators did not, or could not, translate the very text they decreed as evidence of complicity in the Malês' plot to overthrow Salvador's slavocracy. Officials did not recognize on these papers the distinctive horizontality and rounded letterforms of West African Maghribi script, long utilized in the West African Sahel for transcribing Arabic, and then-favored by early nineteenth-century Bahia's West African Muslims to reproduce Arabic and Hausa-language prayers and invocations.[18] Yet even so, the description of José's paper as Arabic is more exacting than in the trial records of others accused of participating in the rebellion. On January 28, during a search of the houses of seven other enslaved and free Africans, police found papers, tablets, and writing supplies for a language described as either "Arabic or Persian."[19] And on January 30, Maria Clara da Costa Pinto denounced the free Nagôs Aprígio and Belchior for "making writings that appeared [like those found] on the insurgents, with entirely strange letters and characters."[20] Even in José's own trial, the adjective *Arabic* became synonymous for the unknown and indecipherable, at least from the perspective of his accusers: José was eventually found guilty of "having participated in the insurrection, seeing that he had a paper written with unknown characters . . . similar to those found on other insurgents."[21] If, as shown in chapter 3, mandingueiros' textual and syntactical experimentations in paper created spaces through which to process the contested roles of writing and inscription in the context of their enslavement and forced migrations across the Atlantic, in 1830s Bahia, those charged with confiscating and opening Africans' amulets now viewed corollary experimentations, and the figural spaces they created, as inherently acts of revolt.

* * *

How was it that such seemingly innocuous objects and texts came to be so concretely linked with a violent insurrection? As we have already seen, for over a century before the Revolt of the Malês, Africans' amulets, broadly referred to as mandingas, framed and reflected debates over ethnicity and race

and struggles for power and self-preservation across the Black Atlantic. But the events in Bahia in late January and early February of 1835 represent a new level of political intensity and revolutionary vision, in which revolt participants utilized talismanic pouches as a key part of their armor. Such a move was not unique to the 1835 revolt, for it also occurred in a series of rebellions in northeastern Brazil in the first decades of the nineteenth century. In an 1807 letter, for example, João da Gama Melo, Count of Ponte and Governor of Bahia, cited "certain superstitious compositions which are called mandingas" found on the bodies of participants in a revolt that year, for the objects supposedly made them "invulnerable and protected from any pain or offense."[22] Collectively, these African-led revolts convinced authorities of the implicit rebelliousness of these "insignificant things," as one official termed it, to the extent that—as José's trial record makes clear—simply owning one was perceived as a revolutionary act.

This chapter, in part, traces the historical trajectory of how what had been known as *bolsas de mandinga* up to the early nineteenth century, and largely known in Brazil by the Tupi-derived term *patuá* after this point, developed through cultural and political contexts in West Africa and Brazil in the early nineteenth century, and finally came to be utilized by revolt participants in Bahia.[23] As such, a perceived link between African-led insurrections and the content of patuás was not necessarily an unfounded overreaction in the minds of Salvador's ruling classes. While Salvador's police force put many Africans on trial following the Malê Revolt solely because of their ownership of religious objects commonly used by African Muslims in Brazil, at the same time, many of the rebellion's participants believed in the power of patuás, and the writings contained inside them, to ensure their own bodily protection as well as the success of the rebellion. As such, patuás provided political and religious efficacy for their owners precisely because their contents were not, and are not, indecipherable; not "entirely unknown," as Torquato's accusers would have it. Indeed, the apotropaic aesthetics they utilized remained relatively unchanged from their initial development in the context of trans-Saharan trade, migration, and military expansion outlined in the first chapter. But their utility in Bahia was not only a fact of cultural transfer. Rather, it occurred in a wider late eighteenth and early nineteenth century Atlantic context wherein white authorities and enslavers in Senegal, Haiti (formerly Saint-Domingue), Cuba, and Louisiana, among other locales to be discussed, reported their distress at the existence of objects they felt animated the rebellious agency of the enslaved.[24] From this perspective, I view the 1835 Revolt of the Malês

as the culmination of a series of political arguments about the material-ization of freedom, animated and supported by the spectacularly effective protective powers embodied in material talismans around the turn of the nineteenth century.

Locating Agency and Rebellion in the Amulets of the Black Atlantic

The debate over the meaning and agency of objects at José's trial was the culmination of two intersecting discourses that developed over the previous half-century throughout the Atlantic world: first, the planter and colonial ruling classes' increasing worry about, and collective responses to, African-led uprisings in the wake of wider revolutionary politics and the increasing volume and bureaucratic efficiency of the Atlantic slave trade; and second, the diverse types of amulets and objects Africans employed in the context of insurrectionary movements. For ruling classes generally, these threads generated a range of concerns over where, exactly, one located the agency—and thus suppression—of the enslaved. Writing from Senegal in 1789, the French merchant and slave trader Dominique Lamiral specifically linked *gris-gris*—the term Lamiral used for leather pouch amulets with Qur'anic papers—to the possibilities of violent uprisings among those he enslaved. "All the Negros that we buy have Grisgris on them," he stated; as such, "the first care is to take them away from them."[25] Implying personal experience in the matter, Lamiral argued that if one did not remove such amulets, then "they are sure of experiencing some seditions or revolts, they always promise them that they will defeat the whites, and that is why care is taken to remove all these Grisgris from them."[26]

Lamiral's warning marks a critical transition in enslavers' perception of the amulets used by Africans. Though bolsas de mandinga and other amulet-forms that circulated in West Africa had long embodied apotropaic functions, rarely did users deploy their powers for physical attacks. Though in the early 1700s Jacques Viegas used his bolsas de mandinga to escape violence during physical altercations, this ability also generated an aggressive confidence rendered in inquisitorial records as a performance of unrestrained Black masculinity. Other cases in the eighteenth century testify to the increasing use of talismans to commit violence against others in power or, more specifically, surveilling control. In one 1773 case from New Orleans, an enslaved Louisiana-born man named Francisco was put on

trial for asking Carlos—self-identified as a "Mandingo" from "Guinea"—
to prepare for him a "gri-gri" that could kill an overseer on the plantation
where they labored.[27] But for Lamiral's experience in Senegal, personal
choice no longer factored into the equation. Instead, the presence of gris-
gris on Africans' bodies simply meant there was "sure" to be a rebellion.
Lamiral thus did more than confirm the efficacy of amulets, for he read
them as the critical factor in a redefinition of Blackness as either revolting
or docile. This dialectic required him to accept that gris-gris possessed an
agency with determinative effects on those possessed by them.

In this framework, then, these revolting objects raise a second issue;
or rather an objection of sorts to an argument Lamiral made implicitly
in 1789 but elucidated most clearly only two years after the Revolt of the
Malês: G. W. F. Hegel's attempt to justify Africans' enslavement by dismiss-
ing their consciousness, agency, and value. "For it is the essential principle
of slavery," he wrote in *The Philosophy of History* in 1837, "that man has
not yet attained a consciousness of his freedom, and consequently sinks
down to a mere Thing—an object of no value.'"[28] In the opening chapter
of his seminal *In the Break: The Aesthetics of the Black Radical Tradition*,
Fred Moten reframes Hegel's foundational paradigm on the structure of
slavery: mainly, wherein dominant white-coded subjects possess, control,
and violate Black-coded objects. Pressing on Hegel's equation between en-
slavement and objecthood, Moten turns to what he calls the "dispossessive
force" of the object, wherein "the subject seems to be possessed—infused, de-
formed—by the object it possesses."[29] If Hegel axiomatically defined enslave-
ment, and thus Blackness, as an absence of consciousness and value, Moten
instead points to Hegel's objectification of Blackness as a form of objection
to hierarchies of value and protocols of decorum: "The history of black-
ness," Moten cogently summarizes, "is testament to the fact that objects
can and do resist."[30] Lamiral avoids this realization by displacing the issue
onto the physical objects carried by those enslaved, thus generating a strug-
gle for the control of Africans' bodies and lives between white enslavers
and amuletic objects.[31] Moving forward, how then might we understand
the role of African's amulets as materializing active movements across that
boundary that "separates slavery and 'freedom,'" and in so doing consider
the multiple possibilities in the phrase "revolting objects"?

I do not mean here to simply reproduce a "dubious personification of
inanimate objects," as W. J. T. Mitchell cautioned in considering the possi-
bility of the wants and desires of images.[32] Rather, in a point now intensi-
fied from those outlined in chapters 2 and 3, I am suggesting that Atlantic

slavery's wide disavowal, or at least ignorance, of the individual or collective agency of those it enslaved generated new and pervasive concerns about the effective power of the material world in ways that questioned the location not just of agency, but of control. Africans' use of amuletic objects was the critical factor in this discourse, wherein the seeming magic of bodily contact imbued objects with a kind of unseen efficacy that had the power to incite rebellion. Tellingly, though the Portuguese Inquisition had broadly suppressed the use of bolsas de mandinga across racial lines, whites' perception of the danger of amulets by the late eighteenth century seems increasingly tied to Africans' racial identity. Though whites at this time also wore amulets, they were rarely, if ever, participating in rebellions.

While Lamiral felt he could easily eliminate gris-gris because of his ability to recognize their form and function, others expressed a series of anxieties over the invisible transformation of a range of visual and material practices when utilized by Black people in the context of violent struggles for freedom. Such was the case in late eighteenth-century Saint-Domingue, wherein a report on the execution of an enslaved man accused of participating in the revolts later collectively termed the Haitian Revolution stated that they found on his person "pamphlets printed in France [claiming] the Rights of Man" and on "his chest he had a little sack full of hair, herbs, bits of bone, which they call a fetish . . . and it was, no doubt, because of this amulet that our man had the intrepidity which the philosophers call Stoicism."[33]

As Stephan Palmié notes in his own analysis of this excerpt, the methodological problems involved in analyzing this assemblage are not limited to simply granting equal "ideological force" to the pamphlet and the pouch, for—in an argument that parallels the previous analyses of mandinga contents in this book—to do so artificially separates out those aspects as symbols of Western modernity and African tradition, a move tantamount to a "denigration of the . . . historical subjectivity" of the dead.[34] But Palmié also somewhat sidesteps how the original statement insists that the materials inside the pouch, as opposed to the pamphlet, was the animating force of this man's desire to reclaim his own body from the structures that claimed it by in turn giving himself over to the effective force of the objects he carried. France's 1789 Declaration of the Rights of Man did of course trigger a protracted power struggle between the National and Colonial Assemblies on the rights of Saint-Domingue's free Black residents, and such debates likely factored into enslaved Africans' resistance to the white planter class on the island; as such, it can be read as motivator and antagonism

for the ensuing rebellions.[35] And perhaps it is precisely this ambiguity the execution report attempted to avoid. By once again locating rebelliousness in the unclassifiable and indecipherable, the authorities described Africans' political background and cultural contexts in the same manner, and carefully avoided any questions of the role of those papers in undermining the slavery regime. What the Saint-Domingue case signals, then, is an effort to not simply ignore Africans' political motivations, but to limit them to efficacious materials deemed overtly outside of the genealogies of Western rational modernity. Hence, echoing Palmié's caution, one could argue that the statement's intent was to parse out the pamphlet and the pouch as distinct fragments with the intent of denigrating his body once again.

But that separation and classification of animating contents prefaces another interpretive problem. The aesthetic strategy of assemblage that animated the contents of amulets encompassed images and objects that prevented facile parsing and interpretation by those who confiscated them. This fact led to wide-ranging accusations of rebelliousness leveled at the collective dynamism of Atlantic visual culture that Black people reformed and remixed during this period. Such was the case in 1812, when José Antonio Aponte y Ulabarra, a free Black artist and retired member of a free Black militia in Cuba, was accused of spearheading a potential revolt in Havana. In a response paralleling that of Bahian officials in 1835, upon receiving word of the conspiracy, the Captain General ordered the searches of Black people's homes and the confiscation of evidence related to the potential revolt. Aponte's home did serve as one of the key conspiratorial centers for planning and organizing the attempted rebellion that bears his name.[36] And in his home they found, and confiscated, a now-lost work commonly known as his *libro de pinturas*: seventy-two pages containing a range of drawings, paintings, collages, montages, and pastiches depicting, among other things, portraits of George Washington, Jean-Jacques Dessalines, and Henri Christophe; maps of Havana; images from Greek mythology; a range of flora and fauna; landscape views; and a self-portrait.

Aponte's accusers found this artwork so critical to their investigation that three of the four day-long sessions that constituted his trial covered only the "meaning of his pinturas."[37] But Aponte's answers to his interrogators' questions, far from drawing a clear line between his aesthetics and his revolt, instead relied on a mix of creative expression, diverse aesthetics, historical references, and his personal background as artist and soldier. Aponte also spent time discussing the material choices in his works, referencing "figures and scenes 'placed on top' of others, so that one page

might feature a breadth of media types, including fragments from a print or decorative fan with painted figures," as such, "colonial authorities had no other word [than *pinturas*] to describe a completely new collaged mixture of media types."[38] These interpretively and intellectually rich readings of his own creations nevertheless confounded and dissatisfied his interrogators, who desired to "relate the ambiguous symbolism" of Aponte's works to "conspiratorial motives."[39]

I avoid interpreting Aponte's work here to instead consider how accusers suddenly defined the animating objects of rebellion by creative strategies of remixed imagery, collage, and assemblage that, at least for white elites, could not be classified and analyzed as models for further identifying other such works. Aponte's *libro de pinturas* thus seems representative of what Kobena Mercer labels as the "surprising ways in which blackness travels" as manifested through the "call-and-response dialogue of visual culture" and the "creative energies of such cut-and-mix aesthetics."[40] The multidirectional traveling circuits of Black Atlantic visual expression Aponte worked through not only reimagined his own life experiences and creative energies, but in so doing, also carefully worked to "tame and appease the predatory force of the master gaze."[41] Thus, Aponte's interrogators struggled to materially or visually pin down his "revolutionary" aesthetics as such.

In the wake of the Revolt of the Malês, questions of material efficacy and aesthetic visibility continued to inflect arguments about the objects that seemingly empowered the revolt's participants. On February 7, 1835, Albino, an enslaved Hausa man, sat and translated the Arabic texts of some of the papers confiscated in the raids. Albino testified that these contained a series of writings directly applicable to the cause of overthrowing Salvador's slavery regime: orations to protect the body from weapons, a road map showing safe routes to take during the rebellion, and a "proclamation" to assemble the revolt's participants, in addition to a calendar for Muslims to track fasting days.[42] Albino was asked to interpret the importance of two wooden tablets, one covered in writing and one without. These both were likely *allo* (from the Arabic *al-lawh*, "tablet"): Qur'anic writing boards commonly used across West Africa (figure 4.2). The mid-twentieth-century Hausa example shown here, from northern Nigeria, displays a decorative leather-covered wooden handle and curved base to ensure its comfortable use. It displays angular script in dark-brown ink the first twenty-three lines of text from the seventy-fourth sura of the Qur'an called *al-muddaththir*, "The One Wrapped Up."

4.2 Hausa artists, northern Nigeria, *Allo* (Writing board), ca. 1930–1940.
Wood, ink, nails, and leather; 47.9 × 19.7 × 1.3 cm (18.86 × 7.76 × 0.51 inches).
Allen Memorial Art Museum, Oberlin College, Oberlin, Ohio.

Students of the Qur'an in West Africa have long used allo like this to practice writing verses, as well as for a second reason that Albino elaborated: "the blank one," Albino noted "had already been washed . . . so that the water could be drunk as mandinga."[43] Throughout nineteenth-century West Africa, writing tablets would be washed with ink and the resulting mixture drunk as a talisman.[44] Though it is not known if Albino would have used the term *mandinga* this way outside of the context of the trial, he implies its use here marks what was previously labeled as a feitiço: any sort of efficacious material or action. This was likely a concerning development in the context of police raids focused on the confiscation of material objects. If, in 1789, Lamiral felt it easy to identify, and thus eliminate, the amulets that animated rebellion; and if, in Cuba in 1812, Aponte's revolutionary objects embodied the diverse expressive possibilities of Black Atlantic visual and material culture; what did it mean when, in 1835, as police searched for "written papers," the writing they sought was not just ephemeral, but invisible? How might that fact throw into question the techniques of visual surveillance and control that undergirded the logics of police searches for objects, and, indeed, the very structure of a slavery society? These questions run underneath José's own aesthetic practices as informed by his background in West Africa and the new circumstances in which he found himself in Brazil.

Revolting Objects between Oyo and Bahia

José's papers, and the amulet he carried, derived from his formative cultural and political contexts in West Africa. Though at the time his trial he had been in Brazil for ten years, José still exactingly identified himself as *Nagô-Ebá*, a designation referring to his origins in Egba, a federation of Yorùbá kingdoms in present-day southwestern Nigeria. In the late eighteenth century, Egba had been a subject state of the Kingdom of Oyo. Occupying the critical savannah areas between the deserts to the north and the forests to the south, Oyo made key use of Hausa veterinarians from the north to maintain a cavalry in southern areas where, previously, horses would easily succumb to sleeping sickness.[45] By the mid-eighteenth century, Oyo used this cavalry to dominate a series of polities south of the forest-line, including Egba.[46] This expansion was closely linked to the increased numbers of captives being sold out of the Bight of Benin during the 1700s.[47] In 1796, Egba rebelled against Oyo, a move that—when combined with other

critical defeats and rebellions—increasingly destabilized Oyo.[48] Between 1804 and 1808, the *jihad* that created the Sokoto Caliphate in the north put increasing pressure on Oyo's armies, which in turn led to an influx of enslaved Muslims into Oyo. Many of these later joined the cavalry that rebelled against Oyo's aristocracy in 1817.[49] The reemergence of the Kingdom of Dahomey further strained Oyo's dominance in the 1810s.

Just as in the rise of the Mali Empire in the 1300s and 1400s outlined in chapter 1, and the rise of Dahomey in the early 1700s outlined in chapter 2, systemic wars in Yorùbáland served as the means to subjugate and remove political enemies, while also supplying prisoners of war as human capital to convert into labor and resources through either local or foreign sale.[50] As Oyo collapsed in the 1820s and 1830s, its armies morphed into smaller independent bands that led raids on southern provinces, including Egba, leading to a marked increase in the number of captives sold at Badagry and Lagos.[51] As such, José's enslavement in Africa and his eventual transport to Brazil was likely a result of the warfare that plagued Egbaland during this period.[52] And once again, in this context, leather amulets filled with Qur'anic papers became the critical currency of self-protection that allowed their users to engage in, and escape from, violence—uses that continued among enslaved Africans displaced to Brazil in the wake of Oyo's collapse. The Yorùbá historian Samuel Johnson, for example, described Yorùbá war staffs in the nineteenth century as "encased in leather" and "wrapped all over with charms and amulets," no doubt of the kind produced by Muslim priests.[53] Johnson further describes the scene in December of 1830 when in the city of Ilorin—then under invasion by armies loyal to Oyo—Muslim priests "were very busy making amulets not only for individual self-protection, but also in order to defeat the enemy completely."[54] In one striking example of the primacy given to amulets in the wars of this period, armies from Ibadan—knowing full well the importance of Oyo's cavalry to its former dominance—captured scores of horses from armies loyal to Oyo not in order to form their own cavalry, but to use as sources of horsetails on which to tie leather amulets as "preventives against bullets in war."[55] The confiscation of defeated enemies' amulets was a key performance of victory in later wars in Yorùbáland as well: in 1860, when forces from Ibadan captured the famous Ijesha warrior Ogedengbe, one of their first tasks was to confiscate all of his amulets.[56]

In continuing to foreground his Egba origins during his trial, José testified to the long reaches of this political history in 1830s Bahia. Regardless of whether he physically participated in the revolt, the amulets he used

held strong currency in his homeland as conduits of power and protection against the warfare and slave trading instigated by those loyal to Oyo. In this sense, as with the capture of Ogedengbe two decades after José's own trial in Bahia, Yorùbá defendants likely understood Bahian authorities' campaign to arrest owners of patuás and detail their contents, in the context of West African warfare, as a confirmation of the objects' revolutionary power, as a desecration of their sanctity, and as the police's attempt to coopt the amulets for their own use.

But Salvador's distinct cultural landscape also likely reframed why and how José utilized and interpreted the objects he carried. In 1835, over one third of the city's estimated sixty-five thousand residents had been born in Africa, and nearly four-fifths of Africans in Salvador were enslaved.[57] Those who served Yorùbá òrìṣà, Aja-Fon vodun, Hausa isköki (wind spirits closely related to the aforementioned anjonu), and central Africa's many minkisi all held strong presences in Bahia's African society.[58] While these spirits tended to carry associations with specific African cultural regions, Islam had a more ethnically diverse following. *Malê*, rather than referring to a specific ethnic group, was used by all segments of the population to refer to Muslims born anywhere in Africa.[59] In addition, and in keeping with histories of African Catholicism in Angola, Portugal, and colonial Brazil discussed in previous chapters, many Africans in postindependence Bahia continued to practice forms of Catholicism at all social levels at the same time they participated in other African religious practices.[60]

In this context, Marcos de Noronha e Brito, Count of Arcos and Governor of Bahia from 1810 to 1818, espoused a policy of encouraging African cultural expression as a means of concretizing Africans' ethnic divisions.[61] The Count "believed Africans should be permitted to practice their religions, play and sing their musics, and dance traditional dances from Africa, since the free expression of these cultural practices would exacerbate ethnic differences," and thus lessen the chance for the formation of a pan-African ethnic identity in Salvador that could coalesce into an organized revolt like that which had occurred in Saint-Domingue only a decade prior.[62] Yet Arcos's policy seems to have failed: the four major revolts in Bahia during his tenure led Bahia's military commander, Felisberto Caldeira Brant Pontes, to write to the imperial court in Rio de Janeiro to denounce the governor and his policy of allowing Africans free cultural expression.[63]

Arcos and Brant Pontes seemed to agree that Africans' religious practices—especially Islam—were in some way related to rebellion. Whether free religious practice exacerbated rebellions by the enslaved or

prevented them, both seemed to implicitly tie African religions to both Africans and the enslaved. At the same time, what Arcos and Brant Pontes perceived as African religious practices were by no means confined to enslaved or free Africans and Brazilian-born Black crioulos. Indeed, it is the very ability of Afro-Atlantic religions to move across seeming boundaries of race, ethnic affiliation, and class in nineteenth-century Bahian society that make it difficult to discuss how, if at all, African religions contributed to Africans' resistance to enslavement on a quotidian level, or were linked to violent rebellion, as they was so explicitly were in 1835. Patuás like those belonging to José, for example, were widely used by both Muslims and non-Muslims in the city. The rapid spread of these amulets through Bahia's African, crioulo, and white populations was possible because, as pragmatic solutions to real-world problems, they both posed no threat to, and could be easily incorporated into, the worldviews of the other African religious systems.

This point is illustrated by Lisa Earl Castillo and Luis Nicolau Parés's research on the case of Iyá Nassô, a free Nagô woman also known by her Catholic name of Francisca da Silva. As Castillo and Parés note, on February 5, 1835 police searched Iyá Nassô's home, a Candomblé temple where she served as head priestess.[64] This search was based on accusations by the tailor Martinho Ferreira de Souza and his wife, Mônica Maria de São José, against Francisca da Silva's two sons by birth and by Candomblé initiation: Domingos da Silva and Thomé José Alves.[65] Martinho and Mônica reported to the police that they suspected that living in Francisca's home were "blacks who were accomplices to the insurrection."[66] Martinho said that Thomé and Domingos "held in their house large gatherings of blacks, who were constantly coming and going, and that this had been going on for quite some time."[67] Mônica also noted these large gatherings of Africans at Thomé and Domingos's residence, which were "attended by both men and women, dancing and singing in their language."[68]

As we have seen, the recording of the objects used in these Candomblé rituals was of primary importance to their accusers. Martinho testified that during these gatherings Thomé wore "a white shirt . . . with a scooped neck like a woman's blouse, decorated with a red cloth."[69] Mônica mentioned Domingos's attire, noting that he wore garments similar to Thomé as well as "large quantities of beaded necklaces."[70] Confirming their suspicions, inside the home police discovered a patuá, described as a "sewn leather pouch measuring an inch and a half" containing "a piece of paper with Arabic characters."[71] For this pouch, and paper inside it, the police

arrested Thomé.[72] Domingos's arrest followed in late March, as the result of subsequent accusations leveled by Martino and Mônica. Further raising their suspicion, in the days following the rebellion—during the witch-hunt for African religious objects in the city—Martinho claimed he had seen Thomé and Domingos "appearing furtively at the window, as though they wanted no one to see them . . . they seemed frightened and . . . no longer went out of the house."[73]

Martinho and Mônica's accusation derived from a seemingly malicious understanding of the particularities of Africans' religious practices in Bahia, despite their proximity to them in their daily lives. The red and white clothing worn by the brothers, and their use of beaded necklaces, suggests they were both initiated to Xangô, the orixá of thunder, lightning, and drumming who is the deified manifestation of the legendary fourth king of Oyo. As Thomé, like his mother, was identified as being from Oyo, this association makes sense on both a biographical and religious level. At the same time, the use of white clothing and African-language chants was all the evidence Martinho and Mônica needed. The Malês participating in the rebellion also donned all white clothing, and white remains the clothing color of choice in Yorùbá-inspired Candomblé houses to this day. Thus, in the aftermath of the rebellion, this visual association of white clothing and African bodies worked to generalize African religious practice in the minds of outsiders and implicitly link it to rebellion and resistance. Yet even as a Candomblé practitioner, it seems that Thomé was not a cultural separatist. His use of a patuá, with its Arabic writings, resonates not only with what were likely his formative experiences in Oyo, but also his ongoing choice to incorporate wider Afro-Atlantic ritual practices into his own religious universe. At the same time, Bahian authorities after the rebellion marked patuás as clear manifestations of African religion, and thus held them in distinct opposition to the status quo.

The patuás José knew in Egba and used in Bahia, however, also circulated in a wider amuletic economy wherein other types used by enslaved and free Africans and Black crioulos gained widespread recognition and acceptance in the decades prior to the rebellion. Yet these other forms did not factor into police searches after the 1835 revolt. In a description equally at home in Salvador, the British traveler Thomas Ewbank's description of mid-nineteenth-century Rio de Janeiro noted the commonality of "ancient charms and amulets, including the *figa*," in the city, and described his wonder looking through the windows of silver shops to see a proliferation of "crosses, crucifixes, crowns, palms, glories, and other little sacer-

dotal bijouterie" for sale on the Rua dos Ourives, a street well-known for its many metalworkers and jewelers.[74] Ewbank's accompanying engraving graphically displays these amulet types, laying them out for the viewer's easy classification and categorization (figure 4.3). In two tightly written pages following this engraving, Ewbank elaborates on the use, meaning, and associations of each of the objects depicted. These include a Sign of Solomon, a figa, a piece of coral, a pair of keys, and crescents, in addition to an animal tooth or claw that resonates with the silver-encased jaguar claw sold by the mandingueiro Luis de Lima in Portugal in the 1720s, as referenced in chapter 2. In addition, heart-shaped amulets also appear, apparently still popular a century after they appeared in Carlos Julião's watercolors and José Francisco Pereira's mandinga-papers. But beyond serving as a record of amulet types, Ewbank seemed equally concerned with mapping the intersecting racial, gendered, and class associations of amulets. While "Mina and Mozambique women" and the majority of "fashionable white ladies" in Rio de Janeiro wore heart-shaped amulets, he perceived the tooth or claw as specifically associated with a criminalized vision of African reli-

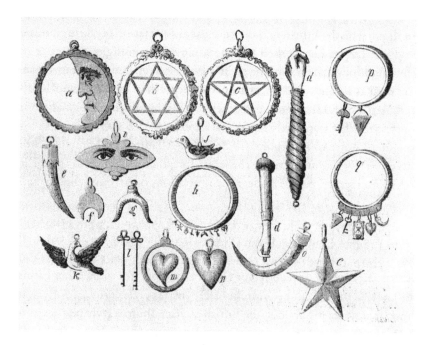

4.3 Untitled engraving ("Charms and Amulets"), 1856. Published in Ewbank, *Life in Brazil*, 131. Terrell Special Collections, Oberlin College Libraries, Oberlin, Ohio. Photograph provided by Oberlin College Libraries.

gions: "one precisely like it was taken by the police," he noted, along with "other paraphernalia, from an African conjuror."[75]

In its quasi-democratic characterization of the wide clientele of amulets, Ewbank's writing belies the racial and class hierarchies that regulated Black people's access to amulets and bejeweled finery in the early Brazilian Empire. An 1827 watercolor by Jean-Baptiste Debret, the French court painter who traveled in Brazil between 1816 and 1831, provides an opening to explore those dynamics (figure 4.4). A Black woman, whose tattoos indicate she is African-born, sits on the landing of a public staircase overlooking Guanabara Bay in Rio de Janeiro. The platter of cashew fruits for sale in front of her and her dress—a lace blouse, a cloth headwrap, and blue and white beaded necklaces—signify her as an *escrava de ganho*. These wage-earning enslaved women dominated Brazilian urban alimentary economies through the nineteenth century. Through a contract guaranteeing their enslavers a portion of their income, usually a set weekly fee, they sold goods or foods and kept the rest of the earnings for themselves. Enslavers also occasionally rented out the skilled labors of *escravos de ganho* for set

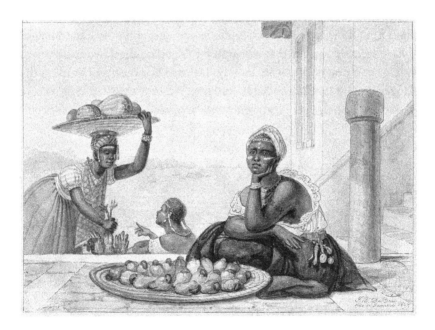

4.4 Jean-Baptiste Debret, *Nègresse Tatouée vendant des fruits de cajous (Tattooed Black Woman Selling Cashew Fruit)*, 1827. Watercolor on paper, 15.7 × 21.6 cm (6.2 × 8.5 inches). Museus Castro Maya / IBRAM, Rio de Janeiro, Brazil, N° 1572858, 2022.

rates.[76] Often, those enslaved tried to use their earnings from this system to purchase their own freedom.[77]

But Debret's image suggests an observation that Ewbank shared: that before purchasing their freedom, amulets—specifically figas—were common purchases for enslaved women.[78] Indeed, Debret clearly depicts a gold figa hanging from the woman's waist, alongside an animal tooth, and a series of smaller circular amulets (figure 4.5). These perhaps represent the fruits she sold or the coins used to purchase them, and the respective connotations of fecundity and wealth each likely carried. Collectively, this assemblage of hanging metal amulets was called a *penca de balangandãs* (literally a "bouquet of things that clang"): a common and broadly accepted amuletic assemblage for enslaved and free Black women in nineteenth-century Bahia.[79] Often described as having an apotropaic function related to bolsas de mandinga, balangandãs also visibly incorporated objects onlookers associated with European Catholicism, such as crosses; European mysticism, like the figa; and African religiosities in Brazil.[80] Yet they were distinguished by their materials—typically gold, silver, or brass—and the three-dimensional open visibility of their attachments. Black women's outward display of these luxurious objects also challenged the racial order. As Silvia Hunold Lara notes, a series of laws and decrees in the second half of the eighteenth century that attempted to regulate Black women's access to gold and fine fabrics were largely "justified as a means of evading the danger of confounding social hierarchies."[81] For example, a 1709 decree passed by the Salvador city council was amended by the King to specifi-

4.5 Detail of figure 4.4.

cally "penalize . . . 'female slaves' who used silks and adornments of gold."[82] A 1749 law emanating from the Portuguese Crown, in turn, forbade Black persons—regardless of legal status—"to adorn themselves with jewels, or silver or gold" due to how "offensive" Black people's "freedom . . . to dress themselves" was to the racial-legal hierarchy.[83] The law, Lara argues, reflects a shift in public perception of Black women, as they no longer functioned as "one more among the many 'show-ornaments' displayed by their masters; they themselves had become the targets of the legal orders."[84]

Such laws, however, were not always applied or enforced equally; indeed, a royal decree suspended the 1749 law after only four months. Part of the reason was that in Bahia, "daily life . . . brought legal norms into confrontation with social practices," particularly in a context where the sartorial luxury and finery of enslaved women often functioned as proxies for their enslaver's status.[85] Indeed, enslaved women could receive balangandãs as loans or gifts from their enslavers, as the artistry and precious metal publicly testified to an enslaving family's wealth.[86] For Debret in particular, a staunch defender of Brazil's slavery system during a time of abolitionist sentiment across the Atlantic, the clear marking of an enslaved woman's body through connotations of economic and culinary production was not incidental, for it embodied his own neoclassicizing aesthetics and routine idealizing of Black women.[87] To mark their escape from this form of objectification, free Black women often also added a small canister to their balangandãs representative of their manumission.[88] One surviving penca de balangandãs from nineteenth-century Bahia—its gold base metal speaking to its owner's accrued wealth—incorporates a number of gold coins as well as a miniature sculpture of a cashew fruit like those sold by Debret's subject (figure 4.6). It also, importantly, includes two small manumission cylinders, the lack of which in Debret's painting confirms the enslaved status of his subject.

Balangandãs signified manumitted women's entryway into an emergent Black middle class in Bahia. But although conspicuous displays of wealth could transform Black women's social status, balangandãs also subtly suggest a more fraught relationship between Black people and object-commodities. By prioritizing the use of metals with widely traded and widely accepted exchange value, they also spoke to histories of consumption and wealth accrual that scaffolded an economy based on slavery. And in their overt display and incorporation of a range of amuletic inclusions, balangandãs invited surveillance, close inspection, and easy categorization by onlookers, thus diffusing any potential threat they posed—even, as

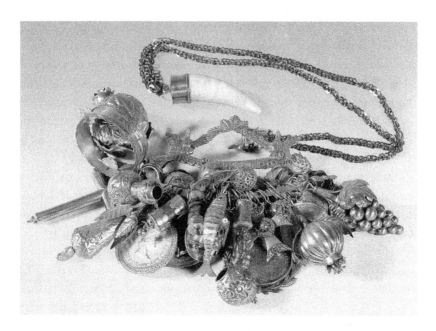

4.6 Penca de balangandãs, nineteenth century. Gold and other materials, 41.7 × 7 cm (18.8 × 2.8 inches). Fundação Museu Carlos Costa Pinto, Salvador, Bahia, Brazil.

Silvia Hunold Lara notes, their "amulets and charms . . . held meanings not always easily decipherable by the masters."[89] As suggested in their onomatopoetic name, even their noisiness alerted others to their presence. In this light, Ewbank's engraving and accompanying text seems designed to function as a guidebook through which onlookers could interpret this small section of Black Brazilian visual culture.

It is perhaps for these reasons, as art historian Amy Buono alluded to in a 2015 article, that pencas de balangandãs have been the subject of a number of exhibitions and are strongly represented in museum collections in Brazil, the United States, and Europe, for they were designed for wider acceptance and visual attention in a racially hierarchical see-and-be-seen prestige economy.[90] Yet the functionally related but materially distinct mandinga amulets and patuás rarely have commanded the attention of curators or museum-goers. Not only were they designed to escape visual attention for the exact reasons balangandãs attracted it, but their forms were also often unmade through the destructive effects of classification. Making no sound to signal their presence, and inviting no easy analysis from onlookers, those amulets created independent spaces of possibility outside the surveillance

of slavery and in turn carried none of the hierarchical material associations of value and wealth that undergirded the slavery economy. As such, when linked to an African-led rebellion, they engendered a drastically different, even repressive, response in the nineteenth century.

Surveillance: Blackness, the Patuá, and the Portrait

In her 2015 book *Dark Matters: On the Surveillance of Blackness*, Simone Browne frames Blackness and enslavement as key sites through which surveillance, as a set of visual technologies and practices, was first codified and executed.[91] Browne's argument builds upon that of Nicholas Mirzoeff, who cites plantation slavery as the generative environment of what he terms "oversight," defined as "the regime of taxonomy, observation, and enforcement needed to sustain a visualized domain of the social and the political."[92] For Mirzoeff, slavery necessitated a system of control and regulation, and what developed was a process of "ordering" the world's contents by separating and categorizing its aspects into distinct and manageable groupings like "the slave," and "the plantation," with the visualized enforcement of surveillance and violence as the discursive framework that policed these categories. Critically, for Mirzoeff, these techniques of visual oversight appear in arenas meant to seem aesthetic, and hence natural and apolitical. Mirzoeff thus looks anew at the aerial view perspective on maps of colonial territories, the guiding text legends at the base of schematics in travelogues, and at registers and balance sheets recording the contents of slave ships as embodiments of this classificatory and regulating tendency that undergirded the production and maintenance of racial hierarchy and colonial authority. Ewbank's rendering of the amulets he saw in Rio de Janeiro appears as a classic example of these techniques, as its aerial perspective, its clear delineation of its contents, and its guiding text legend was a hallmark of the colonial nomination of the visible, surveyed and enforced through unrestricted vision: whether of the sovereign; the sovereign's surrogate, a plantation overseer; a tailor in Bahia reporting the religious crimes of an enslaved African man to the Lisbon Inquisition; or an English author walking Rio's streets in order to write a travelogue of the curiosities he encountered.

The urban landscape of colonial and early imperial Brazilian cities provide further case studies for considering the visualized operations of oversight, beyond the contexts of Caribbean plantation slavery that largely undergird Mirzoeff's framework. While multiple laws regulated

the movement, dress, and actions of enslaved subjects, and while—as the reaction to the Malê Revolt makes clear—persons across the social spectrum acted as surrogates for surveillance of the enslaved, Brazilian cities also materialized, even monumentalized, the figure of the overseer in the forms of *pelourinhos*, stone columns symbolic of imperial secular authority that doubled as public whipping posts.[93] Nearly every colonial Brazilian city displayed one, typically in large public plazas adjacent to major churches.[94] In January of 1835, Salvador's pelourinho stood at the highest point of an open square then known as the Largo do Pelourinho, and today officially named Praça José de Alencar (figure 4.7).[95] Both location and symbolism bound these columns to the maintenance of social order, just as they served to anchor the chains that bound criminals during their public whippings.[96] By the late 1700s, floggings of criminals—typically free commoners—were frequent events in Bahia, Rio de Janeiro, Pará, and Minas Gerais.[97] Subjects were led to the pelourinhos as their crimes were read aloud and as assembled audiences looked on. The design of pelourinhos was tied to their function; those in wealthy cities were decorated in

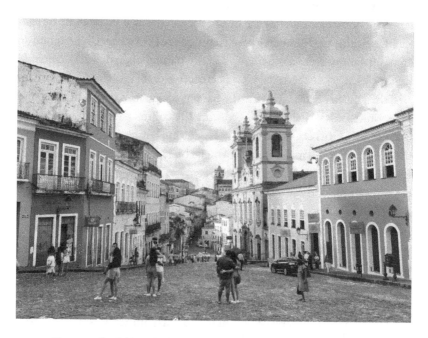

4.7 Photograph of the Praça José de Alencar in Salvador, Bahia, Brazil taken from near the former location of the city pelourinho. Photograph by Matthew Francis Rarey, 2022.

4.8 Pelourinho of Mariana, Minas Gerais, Brazil. Photograph by Raul Lisboa,
2007.

elaborate stone and metalwork. The pelourinho of Mariana, Minas Gerais, is one of the few extant examples (figure 4.8). Erected in 1750, dismantled in 1871, and reconstructed again from original plans in 1970, it features a multitiered stone base and intricate ironwork decked in the iconography of global empire, local justice, and benevolent violence. At its top, an imperial crown rests on an open globe, a symbol of Portuguese maritime global sovereignty used on the Brazilian flag through the end of the imperial period. The main column of the pelourinho is anthropomorphically outfitted as an imperial jurist, its iron arms balancing the scales of justice against a skyward-pointing sword, symbolic of the forceful hand of violence necessary to maintain social order. At its center, a Portuguese coat of arms doubles as the pelourinho's pectoral, maintaining the balance between the objects in its arms. At the pelourinho's base are two shackles to which prisoners would have been bound.

As I have explored elsewhere, the architecture of pelourinhos in the context of Brazilian urban centers created what Silvia Hunold Lara calls "theaters of power" that trafficked in public, violating displays of convicted subjects.[98] Such punishments were not only routine for enslaved Africans convicted of crimes prior to the revolt, but were also leveled against many of the revolt's participants.[99] But my argument here takes a different turn, in order to ask how routinized and aestheticized images of Black life in nineteenth-century Brazil can be understood as part of a larger system of maintaining the power structures Lara outlines. With this idea in mind, one can return to Debret's seemingly aesthetic rendering of an escrava de ganho, which I have already partially read in the context of racialized surveillance. For as Agnes Lugo-Ortiz and Angela Rosenthal have outlined, the common depiction of "servants and pages of African descent" during the rise of Atlantic slavery empires serves to call attention to the aesthetic conditions of enslavement: while portraiture is a self-affirming and even humanizing genre of aesthetic practice, a portrait of the enslaved would seem to belie the dehumanizing logic at the center of slavery discourse.[100] At the same time, though the enslaved were in most cases socially and politically invisible, their existence in portraiture serves to call attention to how they were also, to return to Saidiya Hartman's productive theorization alluded to in chapter 3, "hypervisible."[101] For Lugo-Ortiz and Rosenthal, the "slave," as a visualized concept, was defined by an "existence . . . permanently subject (at least theoretically within the logic of chattel slavery) to the surveilling gaze of the master and/or its surrogate figure, the overseer."[102] The seemingly relaxed nonchalance of Debret's subject

belies the careful attention he gives to her appearance, his close recording of the tattoos and markings on her face and arms, in an effort to create a visualized typology of the escrava de ganho not as an individual, but as a regulated and defined type.

As such, while the evidence of José's guilt was materially manifest in unfolding and recording the objects in his possession, equally important was the recording of José's visual appearance: an act that worked to re-establish the aesthetic conditions of slavery that José's rebellious objects attempted to undo. Thus, I do not find it a coincidence that Francisco José dos Santos Morici, the scribe at José's trial, was also responsible for describing José:

José, of the Nagô nation, is 24 years of age, more or less, with a little facial hair and small eyes, round face, [and] symbols of his nation; [he is] small, [of] tall stature, accented being dressed in white trousers, attached with suspenders, [and a] shirt decorated with small blue markings, down to the knees.[103]

Morici's description, while emphasizing José's identifiable physical features, glosses over the visual specifics of the "symbols of his nation." Called *abaja*, Nagôs received these facial scarification marks at a young age, reflecting their affiliation to specific Yorùbá ethnic groups.[104] An 1864 albumen studio portrait by the Portuguese-born photographer Christiano Júnior, then active in Rio de Janeiro, depicts an enslaved Mina (the term applied to Nagôs in Rio; figure 4.9). The sitter's cheeks display three horizontal incisions: markings associated with the Kingdom of Oyo, and indicating that the sitter may have been involved in the empire's collapse in the 1830s, leading to his arrival in Brazil as a captive when still a child. According to Samuel Johnson, those from Egbaland received two or three vertical scarifications on their cheeks: an important political distinction between these two rival polities that may have persisted in Brazil.

The subtleties of this visual language so critical to the articulations of political life in Yorùbáland was recognizable, but apparently unknown, to José's accusers. As such, this visual record works to ensure that José, as now described and reproduced in Bahia's colonial legal documents, would no longer escape the vision of his master and city officials, as he had done on the night of January 24–25 when he left his home to meet up with Francisco and Carlos. In this way, the act of recording José's appearance mimics Article 19 of the 1842 Hispano-Cuban Slave Code that decreed, as Lugo-Ortiz and Rosenthal describe it, that enslaved persons could only

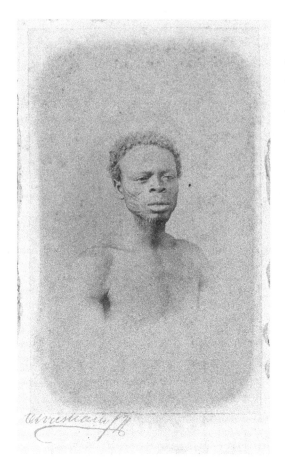

4.9

Christiano Júnior, *Escravo Mina*, 1864. Albumen print, Rio de Janeiro. Museu Histórico Nacional, Rio de Janeiro, Brazil.

leave the plantation with a written paper that included both testimony to the license as well as an "ekphrastic act of verbal portraiture" that recorded the "visual particularities" of the bearer, thereby forcing them to literally carry a kind of regulatory surveillance on their person.[105] So at the moment José was put on trial for his ownership of "entirely strange" objects, objects whose religious and protective function was dependent on the fact that their contents would be visible only to God, José's prosecutors worked to ensure that José, like the now-rebellious objects he owned, would always remain visible: to his master, to the police, to the those who put him on trial, and to the archive that now houses his trial record.

Rosana Paulino's 1994 installation *Parede da Memória* ("Wall of Memory") also works through the political possibilities at the intersection of

4.10 Rosana Paulino, *Parede da Memória*, 1994 (detail). Mixed media installation on cloth. Image courtesy of the Pinacoteca do Estado de São Paulo, São Paulo, Brazil.

the patuá and the portrait (figure 4.10). Paulino's work often engages the social and identity politics of race, class, and gender in Brazilian urban society.[106] In *Parede da Memória*, she constructs a wall composed of numerous patuás, each decorated with a photocopied portrait. While I have so far emphasized the historical currency of patuás among Africans in Bahia around 1835, their evolution continues in Brazil's modern urban centers, where patuás function as personal apotropaic pouches linked to specific orixás in Candomblé. But Paulino's installation replaces the sewn names of orixás that typically decorate contemporary patuás with black-and-white photographic portraits of members of Paulino's family. Foregrounding sewing to highlight Black women's invisible labor in this effort, the installation pays homage to Paulino's ancestors while also counteracting the social marginalization and exclusion suffered by Black Brazilians in Paulino's hometown of São Paulo. Reproducing these faces over and over until they can no longer be ignored by the city's elite, the patuá-portraits double as apotropaic assemblages, working to protect this section of society while rendering its power clear and present in the face of economic and social policies that work to marginalize and occlude Black Brazilians from public life. Yet while Paulino's installation seeks to reclaim the patuá

as portrait to enact positive social change in contemporary Brazil's racially stratified urban centers, it is precisely this union that José's objects worked to avoid. If the visual reproduction of the enslaved body calls attention to the aesthetic conditions on which slavery was predicated, and if José's body was reproduced as a visual object as an aspect of his trial, then perhaps the use of the patuá during the Revolt of the Malês was not so much to either render invisible or highly visible the very enslavement the rebels fought against, but was utilized strategically as one object that, unlike his person, he could submit to in order to outrun surveillance by elites and police forces. Browne might refer to this strategy as one of "dark sousveillance," a term encompassing a series of techniques by which Black people have historically worked to render themselves out of sight as well as a careful observation of the surveillance technologies and techniques of those in power in order to reproduce and undermine them, for example, by "forging slave passes and freedom papers or passing as free."[107]

Unquestionably, the Malê Revolt's participants invested in patuás because of their long political and cultural efficacy in West Africa, and they counted on the continuation of such efficacy in Bahia. Their use demonstrates how these visually benign objects challenged the relationship between "optic" forms of seeing and the performance of surveilling authority. In this way, patuás and the papers they contained reframed debates about Blackness' objecthood, and the rebelliousness it embodied, in the eyes of governors, police forces, and Salvador's wider populace. José's amulets, in other words, interrogated the very terms on which elites defined how an object's form facilitated its function inside systems of social hierarchy, aesthetic pleasure, and economic exchange: systems closely linked to regimes of racial surveillance that intensified in the wake of the revolt. The responses of indecipherability, banality, and interpretive confusion they generated from elites thus explored breakdowns and fissures in the system of racial surveillance that enslaved Africans in Brazil navigated anew.

"Insignificant Things"

The day following the Revolt of the Malês, police arrested Lobão, a free Nagô man, on suspicion of participating in the rebellion. Like José, Torquato, and others brought before judges in the days following the revolt, Lobão was charged with possession of "objects which were suspected to

be the same as those which were found on the blacks participating in the Insurrection."[108] These included:

> His Patuás, or pouches of leather . . . [that] were opened by cutting them at the seams with a penknife, where were found various fragments of insignificant things, like a bit of powder wrapped in cotton, and others with tiny bits of garbage and little packages with seashells inside. Wrapped in one of the leather packages was a small paper written with Arabic letters.[109]

Note the palpable cognitive dissonance of these classifications: "tiny bits of garbage," and "insignificant things." The patuás worn by leaders and participants during the revolt, filled with carefully selected sacred substances and holy writings, imbued these pouches with the power to protect their owners from bodily harm and ensure the success of the Malês' revolutionary aspirations on the night of January 24–25: in sum, the power to undermine the aesthetic conditions of slavery, and to overthrow the slavery economy. And yet in the presence of authorities who sought out these items with such fervor, the trial scribe notes that when finally confronted with the very "evidence" they sought, judges discarded—and disregarded—the activating internal contents of the pouches.

While Lobão's trial judge discounted the objects, writings, and substances contained inside his patuás, Salvador's district attorney and prosecutor, Angelo Muniz da Silva Ferraz, insisted on the revolutionary political implications of African aesthetics in Bahia. In a speech at the trial of Domingos, an enslaved Hausa man implicated in the revolt, Ferraz argued that the threat posed by the rebellion to the nascent Brazilian state was not only in the potentially violent overthrow of the province's slavery economy, but in the aesthetic opposition presented by Arabic script, Malê religious paraphernalia, and in turn, the physical and spiritual protection it afforded the revolt's participants:

> [The prosecution] will prove . . . the authors of this insurrection worked in steadfast secrecy. . . . [They] imbued their followers with the principles of the religion of their country, and the tools of reading and writing the Arabic language. At the same time [they distributed] written papers with characters in this language, special rings, vestments, and caps in their style, not only as a means to recognize each other, but as a shield whose impenetrability, prepared by God, assured them of their ability to overcome the obstacles that opposed their purposes without the risk of danger. [The

prosecution] will prove with the help and guidance of free Africans, they traced in their hideouts the most horrible plans, which had they succeeded would have brought about the extinction of whites and pardos, the destruction of the Constitution and the Government, the loss of our properties and the burning of our public Edifices, the profaning of our images, the burning of our Temples, and all the monuments of our splendor and glory.[110]

While during Lobão's trial his judge declared the contents of his patuás to be "insignificant things," Ferraz, even while emphasizing the apotropaic efficacy of writing—as opposed to the substances and ritual practices that activated these writings—argued that these pieces of garbage held the ability to destroy Brazilian society. For Ferraz, Brazil articulated its history and imperial authority through a carefully constructed system of signs. In turn, the power imbued in the patuás, and the fervor with which authorities sought them out, shows how tightly the Revolt of the Malês' bound aesthetic rebellion with the overthrow of the Bahian slavocracy. Note Ferraz's concerns, then: not only for the physical violence that would be wreaked against Brazilian citizens, but for the destruction of monuments, images, temples, and public edifices; in sum, the visual culture of empire.

Yet Ferraz's stark contrast between the Brazilian state and Malê religious objects, especially Arabic written papers, demonstrates the precariousness of imperial visuality and the rebellious aesthetics that undermined it. Indeed, most of the more than thirty recorded revolts and conspiracies led by enslaved people in Bahia during the first half of the nineteenth century were led by predominantly Muslim Hausas, while most participants in the Malê Revolt were Muslim, generally Nagô.[111] Yet in general, enslavers afforded West African Muslims in Brazil higher status than Africans from elsewhere on the continent's Atlantic coast. As Michael A. Gomez notes, the ability of African Muslims to read and write—in other words, their use of Arabic—resulted in the perceived higher intelligence of African Muslims than nonliterate Central and Western Africans. As such, many Malês were assigned to "more prestigious or less backbreaking tasks that either used their existing skills or provided training in such skills. . . . As culture-bearers and corporeal exemplars, African Muslims disproportionately endured relatively less inhumane treatment in slavery than did their non-Muslim coworkers."[112] As such, for Gomez, "the reasons for their frequent rebellions are therefore not necessarily self-evident."[113]

At the same time, Nicholas Mirzoeff suggests that elites' perceived rebelliousness of enslaved Muslims may result from their higher social

position, especially as tied to the literacy capacities they possessed. Michael Tadman uses the term "key slaves" to describe the enslaved who gained higher authority on plantations, especially as overseers, in the antebellum southern United States.[114] If the structures of colonial visuality and oversight contained the potential for rebellion from the inside then, as Mirzoeff argues, it is no surprise that such key slaves, in Tadman's terms, would frequently lead rebellions. Entrusted with positions of power and oversight in the context of the plantation, they functioned as extensions, though not necessarily surrogates, of the overseer's authority.[115] As such, their frequent rebellions would be in keeping with the larger structure of my argument: that colonial oversight, the aesthetic conditions of slavery, and the systematic visualization of power throughout slave societies could easily turn against itself.

If the structures of oversight had acknowledged the potential counteraesthetics within them, when opening these rebellious patuás, they did not find what they expected. In the aftermath of the revolt, police arrested far more Hausas than were known to have participated. Hausas, the city's predominantly Muslim African ethnic group, made frequent and perhaps greater use of Arabic writing and patuás than Nagôs in general, and so they quickly garnered the suspicion of block inspectors.[116] Yet when judges opened their patuás, these literate Muslims used "insignificant" pieces of "garbage." These objects, these sacred substances, continued to be used in general by Africans, I argue, because they worked outside of the structures of colonial visuality, and in turn sought to flee the aesthetic conditions of slavery.

Thirty Malê patuá papers remain in storage at the State of Bahia Public Archive in Salvador. The incantations and writings on them cover both Qur'anic and non-Qur'anic texts, with the markings on these sacred pages ranging, as Gomez has summarized, "in degree of command from polished to novitiate, with the various grammatical errors an indication of both the nominal nature of the embrace of Islam by some and the overall difficulties of sustaining the Islamic sciences in a place such as Bahia."[117] One document, belonging to Francisco Lisboa, seems to indicate the "nominal nature" of Arabic writing suggested by Gomez (figure 4.11). Rolf Reichert translates fourteen of the text's seventeen lines simply as "unintelligible," while the opening first and concluding two lines invoke praise to God.[118] Juliane Müller, by contrast, sees select Arabic words such as *jahd* (effort), *ḥusām* (sword), and *allāh* (God) interspersed in the text, yet she notes "it is not possible to establish a syntactic and semantic relationship between

4.11 Document found inside of a patuá belonging to Francisco Lisboa; seized by police in 1835. Arquivo Público do Estado da Bahia, Salvador, Bahia, Brazil; Documentos Malês, Maço 2850. Image courtesy of the Arquivo Público do Estado da Bahia.

the Arabic words in most of the text, since they appear isolated within a textual fabric dominated by enigmatic terms that do not seem to be of Arabic origin."[119] These lines, then, appear not meant for humans; they appear not as sacred writing, but as the evocation of sacred text.

While Francisco Lisboa's page still visually alludes to lines of text, even if illegible, another document confiscated from an enslaved man named Lubê blends text and image in a graphic narrative (figure 4.12). Its many folds testifying to its once-presence inside a patuá, the center features yet another version of the Star of Solomon that has emerged as a stock piece in popular apotropaic arsenals in Brazil, Iberia, and Africa. The document's author surrounds the star with the name of the prophet Muhammad— written four times—while above the star is a Hausa invocation written in Maghribi script.[120] Oscillating between languages, visual forms, and narrative direction, the inscriptions inside patuás/bolsas de mandinga do not need to be coherent as a textual narrative, for as Nikolay Dobronravin summarizes, the "Islamic knowledge" embodied in these amulets "was not easily adaptable to 'modern (in fact, European/Christian) objectives' and functional literacy."[121] The text here plays off, and against, a set of magical signs and symbols that works to convey messages intelligible only to the world of the spirits, only to God. While this seems to be at odds with typical Islamic insistence on the Qur'an's incorruptible nature, textual ephemerality and visual ambiguity here emerge as preconditions of ritual and political efficacy, and thus as potent aesthetic choices in bolsas de mandinga and patuás in the Black Atlantic world. As such, the bolsa de mandinga/patuá did not so much incorporate the seeming magical ability of texts to "speak" as they reimagined and reemphasized text as an anticolonial aesthetic system with its own set of apotropaic properties. Through bolsas de mandinga in Portugal, Africa, and Brazil, we saw how, through the careful selection of internal contents placed in active association with each other, these objects worked toward bodily protection for the enslaved. The Malês requested this same kind of protection during their revolt in Bahia, where patuás and their ritual contents protected Malês not only from the potential of physical violence, but also the violence of spirits, and the violence of the slavery system they sought to overthrow.

One can argue, on strong ground, that the Revolt of the Malês was unsuccessful, and that the patuás failed to protect those who wore them. The leaders of the revolt were captured and publicly flogged, its participants put on trial and punished with further sentences and whippings, and Africans throughout the city were forced to send their cultural practices

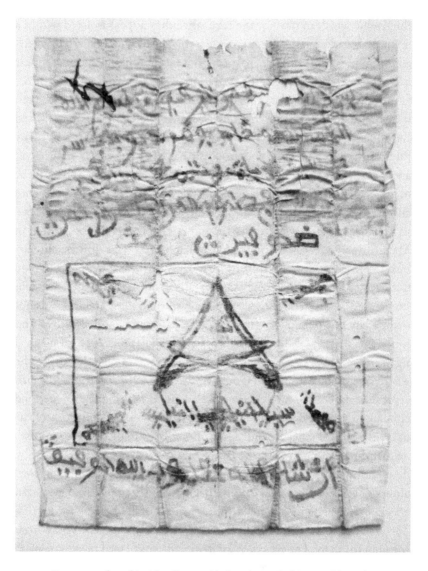

4.12 Document found inside of a patuá belonging to Lubê, seized by police in 1835. Arquivo Público do Estado da Bahia, Salvador, Bahia, Brazil; Documentos Malês, Maço 2848. Image courtesy of the Arquivo Público do Estado da Bahia.

underground. Following the revolt, Salvador entered a period in which residents feared, and suppressed, African cultural expression and its perceived role in the rebellion. Through at least April of 1835, little diminished the zeal with which city officials took to searching Africans' homes and belongings. For the rebellion's detractors, African clothing, religious objects, and Arabic writing remained concretely linked to the possibility of further African-led revolts. The discovery of such objects during police house searches resulted in the prosecution of the Africans who owned them, whether enslaved or free. Salvador's residents often fanned the flames of the repression, turning in Africans they suspected, regardless of their participation in the revolt. As a result, Africans themselves grew fearful of the consequences of outwardly visible cultural expression. Many Africans ceased religious ceremonies altogether, lest their native languages and religious paraphernalia be mistaken as Malê. In turn, Malês eschewed the rings, garments, and patuás that were the public currency and indicators of Malê affiliation in Bahia: indeed, Nikolay Dobronravin speculates that the postrevolt criminalization of Arabic contributed to its decline in Bahia through the end of the nineteenth century.[122] In sum: after the revolt, enslaved and free Africans lived in a far more repressive cultural climate than they did in the days before.

Yet as Ferraz's speech suggests, the Malê Revolt effectively reimagined the aesthetic conditions of slavery through the articulation of a distinct anticolonial aesthetic. As such, while in one sense patuás—and, indeed, all bolsas de mandinga produced and used by Africans subjected to the Portuguese Inquisition—failed to protect the bodies of those who put faith in their protective powers, the careful construction of these objects facilitated spaces to process the contradictions of diaspora, migration, and violence that eventually manifested as visions of an anticolonial future. Authorities' fierce repression of Africans' cultural practices following the rebellion confirms the agency of these revolutionary aesthetics in the context of rebellions of the enslaved.[123] As such, to overthrow Bahia's slavocracy was to also work to overthrow the aesthetic-symbolic structures through which that system articulated its authority.

Epilogue

In a book arguing for the key role of visually innocuous and occluded objects in discourses of race and power in Atlantic slavery, it may seem strange to conclude with a vision as clearly revolting (at least to white landowners) as Manuel López López's 1806 engraving, *Desalines* (figure E.1). Born into slavery in Saint-Domingue in 1758 and later serving as an officer in the French army, Jean-Jacques Dessalines emerged as one of the leaders of the insurrections now collectively known as the Haitian Revolution, declaring himself Emperor of Haiti on September 2, 1804.[1] Inserted into the second edition of Jean-Louis Dubroca's biography of Dessalines printed in Mexico City—a book designed as part of a French propaganda campaign to vilify Dessalines's government by portraying it as excessively authoritarian and cruel—*Desalines* rehearses a set of tropes designed to explicitly manifest the white plantocracy's greatest fear: that the slave has become the master by violent force. Mirroring the sartorial trappings of elite French colonists, in his left hand Dessalines holds up the decapitated the head of a white woman. Her symmetrical face and white skin implicitly tie classical civilization to whiteness, while the blood dripping from her neck testifies to its destruction. In his right, Dessalines holds up a sword in a gesture of victory and attack, its blade unsoiled from the violence of the revolution. While the sword's pristine condition asks whether Dessalines is personally responsible for the violence wreaked on the woman's body, her physical death is not necessarily separable from the loss of the vision of empire: her closed eyes incapable of surveying the artful labor of slavery whose reproduction was also the reproduction of imperial power.[2]

"The Haitian Revolution," writes Michel-Rolph Trouillot, "entered history with the peculiar characteristic of being unthinkable even as it

E.1

Desalines. Plate following page 72 in Dubroca, *Vida de J. J. Desalines.* Image courtesy of the John Carter Brown Library, Providence, Rhode Island.

happened."[3] As revolts spread from northern Saint-Domingue across the colony, as plantations were razed and landowners were massacred, enslaved Africans created a world so inapprehensible only months before as to be a "non-event."[4] The nonevent encompasses the benign and the apocalyptic: a representational black hole unable to be rendered even as it happened. How then, to paraphrase Trouillot, does one visualize an impossible vision?[5]

If Dessalines helped to inaugurate an impossible world, *Desalines* provides a fearsome image that also rehearses and rehashes existing visual structures of power: French colonial dress, the concentration of political power into a single emperor, and the occupation of the colonial landscape as the consolidation of authority. The choice to include a woman's head as the vanquished here works toward this reading. As Neil Hertz has argued, in the 1790s, following the French Revolution, Medusa's head emerged as a symbol of the male ruling class' fear of losing its own political authority— either to women or to disenfranchised classes eager for territorial and political power. In this way, the woman's long locks emerge as a way to process this fear: for at the same time, as Hertz suggests, imagining such

a political threat in terms of a woman's decapitation also serves as an apo-tropaic counter that seemingly reconfirmed the structures of white mas-culine political and cultural authority even as specific political revolutions succeeded in reducing that power.[6]

If López sought to represent the impossible through the rehearsal of es-tablished tropes that both defiled and confirmed white masculine political authority, I suggest that rehearsing these tropes highlights what remains obscured in such a clearly revolting vision. From the old French *rehercier*, "to go over again," "rehearse" derives from the term for a rake, used literally to turn over soil and ground. In turn, the visual similarity of such rakes to funerary candle holders gave rise to the term "hearse." In the rehearsal of the visual tropes of slave rebellion, the performativity of the visual de-rives from the cultivation of landscape and the spectacle (and specter) of death and the invisible. To rehearse the tropes of political authority, then, is to bring them forth to publicly, even spectacularly, put them to rest; to turn them over on the ground to cultivate what lies beneath; to imagine new worlds through the repurposing of the old, and the revisitation of the obscure.

A few months after Dessalines's installation as emperor, an ombuds-man in Rio de Janeiro discovered a group of free Black militiamen wear-ing medallions displaying his portrait.[7] For the ombudsman, the sight of Black Brazilians displaying support for the overthrow of a slavery regime in Saint-Domingue manifested that same possibility in Brazil's capital. In-deed, the militiamen in question "were employed as troops" assigned to "skillfully handle the artillery" for the city's defenses, and as such possessed the ability to turn Rio's structures of protection against the very society they were meant to serve, as Dessalines did in Haiti.[8] As a result, the om-budsman immediately ordered the portraits "removed from the chests" of the soldiers.[9]

The names and ranks of the militiamen do not appear in the ombuds-man's report, nor do records of any punishments they may have suffered. Instead, the text presents a vision of potential revolt stamped out by eliminating the revolutionary potential of Dessalines's image from Brazil. But what caused the militiamen to disseminate this image of the Haitian emperor so widely, and what did the ombudsman so fear in its persistence from Haiti to Brazil? Owing to an absence of description in the report, one can only speculate as to what portrait of Dessalines was used in the medallions: whether it was a full-body image or a classical bust; whether it was drawn on paper, painted as oil on metal, struck like a coin, or a carved

like a cameo.[10] In turn, we do not know how Dessalines's portrait came to be so quickly known in Rio de Janeiro's free Black communities, especially given the relative scarcity of known contacts between Haiti and Brazil following the revolution.[11] Yet the absence of details of the medallions' origins and medium serve to focus on the specter of Dessalines that looms so large in the report, even given its small physical size on the chest of the Black militiamen.

The ombudsman's reaction to quickly eliminate Dessalines's image was, in a sense, very much in keeping with the fears of a slave rebellion domino effect that spread through the hemisphere's plantation economies following Haiti's 1804 independence from France. Throughout Brazil, the violent overthrow of Saint-Domingue's plantation economy created a cultural climate in which images and references to Haiti were not only feared in general, but particularly suspicious when associated with free and enslaved Africans and Black crioulos.[12] This became even more pronounced following Brazil's independence in 1822, when government officials thought the enslaved would find the separation of Brazil's ties to Portugal as an opportunity to overthrow the new imperial government in Rio de Janeiro. In 1824 in Sergipe, for example, a man witnessed a group of revolutionaries paying homage to Haiti at a private dinner. Distressed by the events, he sent the following to the Governor of Arms of Sergipe on June 26:

ALERT. A small spark makes a great fire. The fire has already been lit. At a dinner in [the municipality of] Laranjeiras . . . were made three toasts: first, to the extinction of the kingdom . . . second to [the destruction] of all that is white in Brazil . . . third to equality of blood and of rights. The brother of another boy spoke many compliments to the King of Haiti, and because he was not well understood, he spoke more clearly: Saint-Domingue, the great Saint-Domingue . . . Alert. Alert. Respond before it is too late.[13]

Around the same time of this small "fire," an anonymous official sent a secret letter to Emperor João VI, speaking to the fear the letter-writer had for the ramifications of the Haitian Revolution, and the countercivilizational values of Black people in Brazil:

If one continues to speak of human rights, of equality, it will end by uttering the fatal word: freedom, a terrible word which has much more force in a country of slaves than in any other. So, the whole revolution will end up in Brazil with an uprising of slaves, breaking their shackles, burning the cities,

the fields, and the plantations, massacring the whites, and making in this magnificent empire of Brazil a deplorable replica of the shining colony of Saint-Domingue. Nothing is exaggerated as just outlined. Everything, unfortunately, is very much true.[14]

"The whole revolution will end up in Brazil," he fears. This revolution, he states, will bring a landscape of violence wreaked on bodies as much as the trappings of imperial authority, where the violent death of "the whites" is not separable from the burning of plantations and the symbols of imperial authority manifested in public architecture. Here the letter-writer similarly paints "the revolution" as a complete destruction of the symbolic structures of Brazil's slavery system, just as Ferraz would later do in his 1835 speech regarding the Revolt of the Malês.

Historians continue to look to the destruction of Saint-Domingue's colonial slavery system and the eventual establishment of an independent Haiti to think through some of the key questions and paradoxes at the heart of ideas of humanity, rights, nation, memory, and diaspora. Yet I question the extent to which we continue to return to Haiti for inspiration, bolstered by its figuring as the only "successful" revolt against slavery in the Americas. "Too often," writes Robin D. G. Kelley, "our standards for evaluating social movements pivot around whether or not they 'succeeded' in realizing their visions rather than on the merits or power of the visions themselves . . . yet it is precisely those alternative visions and dreams that inspire new generations to continue to struggle for change."[15] Our continued focus on Haiti as a singular exemplar of a successful rebellion against slavery is in many ways deserved. But I wonder if such a focus comes at the expense of looking and thinking with the revolutionary imaginings of anticolonial futures that were persistent and palpable foundations of so many other seemingly "unsuccessful" rebellions.[16] Who decides, then, what constitutes a politically successful revolt? Is it about the immediate recognition of a singular event that overturns the government or the state? Or might change also emerge slowly from the struggle, from the everyday work of fabricating one's survival by assembling and caring for the fragments of a broken world?

Let us return, then, to *Desalines* and its "rehearsal" of certain visual tropes that clearly represent both the destruction and persistence of extant structures of power. If the great white fear of the revolution was intelligible for whites only through preestablished and rehearsed systems of representation, then the revolting visions they encountered were revolting to them

only because they were also, in a sense, quite palatable. As studies on the visual culture of slave rebellion continue to emerge, I am asking that we remain uneasy about focusing on visions that may seem so clearly revolting. Lopez's *Desalines* and the medallions seized by the ombudsman are less counterrevolutionary visions derived from the new worlds imagined by the enslaved than they are rehearsals of the fears held deep in colonial authority: a revolution articulated through a seeming switch of places. *Desalines* continues as a plantation overseer, continues to display the trappings of French authority: the slaves as masters, and the masters as subjugated slaves, but the structures of power intact.

Instead, I ask that we rehearse the tropes of slave rebellion to find what lies yet untilled, yet not buried, yet not performed, under and around the clear and present. As I have argued throughout this book, the truly revolting visions were ones that escaped the systems of representation already directed in the reproduction of colonial power. My focus has been on that which commanded the attention of mandingueiros and patuá-makers across the Atlantic world: seemingly benign, unseen, and quotidian aesthetic practices. While the immediate political aspirations of such revolts remained unrealized, the visions of other worlds they enacted worked to unmake, and unsettle, the key ambivalences of colonial visual culture. In this sense, "the whole revolution" had already ended up in Brazil. We have seen how the bolsa de mandinga and the patuá confounded the aesthetic conditions of slavery as well as its legal articulation while forcing city officials to accept, even capitulate to, their powers. It is through these overlooked moments, at the edge of seemingly unsuccessful political revolts, that I argue we can work through the future antislavery visions emerging from enslaved Africans themselves. The ombudsman should not fear the figure of Dessalines. In the absence of evidence, I prefer to imagine the lockets as containing an image of Dessalines not dissimilar from Lopez's *Desalines*. If *Desalines*'s revolt was through its palatability, perhaps utilizing the portrait of the emperor distracted the ombudsman from the truly revolting vision, one constructed not in the portrait but *through* the medallions.

We can return, then, to the image that opened this book: Jacques Viegas's bolsa de mandinga, bound to the inquisitorial papers that archived and imprisoned him (figure I.1). Reading Jacques's voice in the scores of handwritten folios that surround this object, there is no sense that he utilized it explicitly to contest the power of the Catholic Church, or to begin a political revolt, or to make a conscious argument about his own exile into

the Atlantic traffic in objects and lives. For Jacques, its use was pragmatic and personal. He needed to protect himself from anyone who would see him harm, and possessed with an object to this end, he saw an opportunity to boast of its powers and gain material wealth while doing so. By contrast, for the militiamen that day in Rio de Janeiro, those medallions materialized their affiliation with a newly independent Black state. In confiscating the lockets, the ombudsman sought to remove potential inspiration for a revolt. But the medallions' ability to articulate a transnational Black antislavery movement means the letter-writers needed not worry about "the revolution" arriving in Brazil from Haiti. Even without Dessalines's image, it was already there, rehearsed out of sight.

Taking the militiamen's medallions and Jacques's amulet as exemplars of the discourse of mandinga this book has traced, in the end there may be little in terms of form or function to connect them. In the Sahel, in Dahomey, in Angola, in Brazil, and in Portugal, people used a range of talismans to protect themselves as often as they sought to dominate or control others. If anything, the sheer diversity of their contents, approaches, and responses attests to the experiences of dislocation, material exchange, and social status that similarly testify to the diversity of Africans' life experiences, and African-inspired art forms, that characterize Black Atlantic cultural production.

But filled with blank paper, hair, cotton, and small stones, the contents of Jacques Viegas's mandinga continue to resist efforts at interpretation: as they did for inquisitors, and as they continue to do for contemporary authors trying to make sense of Jacques's life. For this reason, Jacques's amulet and life story all but disappeared in the final two chapters of this book. The narrative instead turned to many other bolsas de mandinga utilizing clear visual references: coins and drawings, flora and fauna, text and gunpowder, scraps of inquisitorial bureaucracy, and verses from the sacred texts of Islam and Christianity. The significance and legibility of these materials, clearly brought together because their mandingueiros and feiticeiros spent a lifetime closely attending to the structures and social ills of Atlantic slavery and mercantilism, allowed for informed speculation on their historical context. These presented a fragmented but clear vision of the world never meant to be glimpsed through inquisitorial or authoritarian archives, not only because of the criticism it posed, but because it was never meant for them, nor, it seems, for anyone reading them today.

Perhaps, then, if this book contains any through-line, it is that the political agency of the visual is not necessarily separable from its seeming obscurity,

and from the potential of the insignificant to continue to imagine other possible worlds. Whoever made Jacques Viegas's bolsa de mandinga created, if even for a moment, a world still desperately needed: where violence would not come to the enslaved, where danger could not "mark"—to return to Hortense Spillers—the lives of Africans transported to foreign locales. This, then, is my insistence on the political potency of the "insignificant." These small objects, these incoherent texts, even when ripped from their pouches, seemingly could not be processed inside an interpretive system not made for them. And *Insignificant Things* makes no claim to a correct analysis of the pouches' contents, in the hope that future researchers will build on the conclusions here or find new ways to ethically engage the objects at their core. For in opening these bolsas de mandinga, in opening these patuás, we continue to not find the powerful objects or explicit images perhaps expected from amulets with the power to protect the lives of the most vulnerable. Unnoticed and innocuous, impenetrable, and thus confounding to regimes of surveillance, these substances retreat from aesthetic conditions of enslavement. In such an oppressive symbolic system, one where public visibility of the body was implicitly tied to violence, the contents of bolsas de mandinga emerge not only as inheritors of a Black Atlantic aesthetics descended from the dynamism of Africans' religious systems and broad engagement with the materials of Atlantic exchange, but also as substances that were constantly repurposed as strategic, pragmatic methods of survival.

Notes

Introduction

1 See R. F. Thompson, *Flash of the Spirit*, xiii; Gilroy, *Black Atlantic*; and Matory, *Black Atlantic Religion*.

2 ANTT-IL, Cadernos do Promotor, No. 72, Livro 266, f. 77–91; ANTT-IL, Cadernos do Promotor, No. 108, Livro 300, f. 48r–50A.

3 ANTT-IL, Processo 15628; ANTT-IE, Processo 7759. On this latter trial, see Sweet, *Domingos Álvares*.

4 ANTT-IL, Processo 2355, f. 9r–10v.

5 ANTT-IL, Processo 2355, f. 10v.

6 K. Thompson, "Sidelong Glance," 30.

7 Lovejoy, *Transformations in Slavery*, 81. See also Green, *Fistful of Shells*, 286.

8 Costa et al., *Economic History of Portugal*, 166.

9 Lopes and Marques, "Outro lado da moeda," 7. See also Law, "Gold Trade of Whydah." For a discussion of the impact of Brazilian gold trading on the Gold Coast, see Smallwood, *Saltwater Slavery*, 9–32.

10 Soares, *People of Faith*, 47–49.

11 Soares, *People of Faith*, 49.

12 Higgins, *"Licentious Liberty,"* 3.

13 TASTD, "SlaveVoyages: Trans-Atlantic Slave Trade—Estimates," https://www.slavevoyages.org/assessment/estimates, accessed March 27, 2022.

14 Tavim, "Educating the Infidels within," 457; Mota, "Wolof and Mandinga Muslims," 10.

15 Cook, *Forbidden Passages*, 122.

16 Tavim, "Educating the Infidels within," 457; Mota, "Wolof and Mandinga Muslims," 1.

17 ANTT-IL, Processo 3932. On this case, see Khwali, "Mouriscos e escrita."

18 Cook, *Forbidden Passages*, 126–27. Cases concerning African-associated amulets also appear Spanish Inquisition cases from the Americas, especially Cartagena; see Guerrero-Mosquera, "Bolsas mandingas en Cartagena."

19 Gschwend, *"Olisipo, Emporium Nobilissimum,"* 142.

20 Recent work suggests that far from being prestige goods, so-called Afro-Portuguese ivories, particularly spoons, were found homes across the social spectrum. See Gomes, Casimiro, and Manso, "Afro-Portuguese Ivories."

21 For a discussion of this painting that largely parallels my own conclusions, see Nagel, "Hell Is for White People."

22 As quoted in Souza, *Devil and the Land*, 84.

23 Souza, *Devil and the Land*, 87.

24 Sweet, *Recreating Africa*, 144–52.

25 Cagle, "Imperial Tensions, Colonial Contours," 227.

26 In 1561, the Portuguese crown established a fourth overseas tribunal in Goa whose jurisdiction extended from the Cape of Good Hope to all Portuguese territories in Asia. In 1621, the Spanish King Felipe IV, reigning as Filipe III in Portugal, ordered the creation of a fifth tribunal in Brazil, but it never materialized. The Portuguese Holy Office—still independently administered during the 1580–1640 Iberian Union between the Portuguese and Spanish crowns—preferred to maintain peninsular control over inquisitorial activity in the colony rather than cede their power to another tribunal. See Marcocci and Paiva, *História da Inquisição Portuguesa*, 220–21, 305–7.

27 As quoted in Siqueira, *Inquisição Portuguesa*, 237.

28 Documentation on these types of crimes or accusations is limited prior to the establishment of the Inquisition. See Moreno, "Feitiçaria em Portugal no século XV."

29 Marcocci and Paiva, *História da Inquisição Portuguesa*, 317.

30 ANTT-IL, Processo 11767, f. 27r.

31 ANTT-IL, Correspondência Recebida de Comissários, Livro 922. As cited in Calainho, *Metrópole das mandingas*, 97.

32 ANTT-IL, Livro de Registro de Correspondência Expedida, Livro 20, f. 3v.

33 As cited in Mott, *Bahia*, 32, 35. The original trial record is ANTT-IL, Processo 597, f. 1–4.

34 Mott, *Bahia*, 36–37, 39.

35 On this case, see Corrêa, *Feitiço Caboclo*.

36 ANTT-IL, Processo 6982, f. 43r.

37 ANTT-IL, Processo 6982, f. 43v.

38 Santos, "Bolsas de mandinga," 109.

39 Calainho, *Metrópole das mandingas*, Appendix I, Table 4 (unpaginated). See also Paiva, *Bruxaria e superstição*, 208.

40 Bucciferro, "Forced Hand," 306.

41 *AAPEB* 53 (1996): 112.

42 Jay, *Force Fields*, 114–33.

43 For early mentions of African-associated amulets in the secondary literature, see Bastide, *African Religions of Brazil*, 144; and N. Rodrigues, *Africanos no Brasil*, 92–96.

44 Souza, *Devil and the Land*, 130.

45 Calainho, *Metrópole das mandingas*, 70. See also Calainho, "Mandingueiros negros no mundo," 18, 26–27.

46 Santos, "Bolsas de mandinga," 21, 22.

47 See for example Souza, *Devil and the Land*, 130–41; and Calainho, *Metrópole das mandingas*, 77.

48 Dider Lahon, for example, sees strands of Yorùbá cosmology and West African Vodun practices through mandingas' Catholic veneer. See Lahon, "Inquisição, pacto com o demónio."

49 Drewal, "Mami Wata and Santa Marta," 209.

50 Calainho (*Metrópole das mandingas*, 183) suggests that the amulets spread from the Mande to other Bantu and African groups before leaving the continent during the slave trade. But I suggest a much more complex process of dissemination based not on object movement, but on discursive transformation. Though Calainho has taken care to note that *mandinga* did not equate to mandinga users, she stops short of a discursive explanation for their use, instead assuming the objects were disseminated from a Mande homeland. In turn, V. S. Santos does broadly discuss the relationship between the Saharan gold trade, the expansion of the Mali Empire, and Portuguese interest in the coast during the rise of the Atlantic slave trade; in this context "religion was a strategy of mediation and negotiation" ("Bolsas de mandinga," 38), but does not fully elucidate how amulets operated as strategies of protection this nexus.

51 Paiva, *Bruxaria e superstição*, 113–14.

52 Rarey, "Assemblage, Occlusion, and the Art"; Fromont, "Paper, Ink, Vodun."

53 Mota, *Portugueses e Muçulmanos*; Green, *Fistful of Shells*.

54 Sweet, *Recreating Africa*, 181–83.

55 Harding, *Refuge in Thunder*, 30–31.

56 Sansi, "Sorcery and Fetishism," 24–25.

57 Gilroy, *Black Atlantic*, 4.

58 For a discussion of Gilroy's impact in African diaspora art history in the United States, see K. Thompson, "Sidelong Glance." See also Patterson and Kelley, "Unfinished Migrations," 12–13; and Barson and Gorschlüter, *Afro Modern*.

59 Scholarship on the visual culture of slavery is vast. I present here a few representative selections published since 2000: Araujo, *Public Memory of Slavery*; Copeland, *Bound to Appear*; Finley, *Committed to Memory*; Kriz, *Slavery, Sugar, and the Culture*; and Wood, *Blind Memory*.

60 Brown, *The Repeating Body*, 12.

61 Verger, *Trade Relations*.

62 See also Matory, *Black Atlantic Religion*.

63 Matory, *Black Atlantic Religion*, 1.

64 Fischer, "Atlantic Ontologies."

65 J. M. Johnson, *Wicked Flesh*, 5; Hartman, "Venus in Two Acts," 5.

66 Blier, "Art of Assemblage."

67 Doris, *Vigilant Things*, 34.

68 Fromont, *Art of Conversion*, 70.

69 Bahia was a captaincy under Portuguese rule until 1822, and then a province in the Brazilian Empire between 1822 and 1889.

70 An earlier version of the image of the fruit-seller is discussed in chapter 2.

71 Buono, "History, Achronicity, and the Materiality," 25–26.

72 Doris, *Vigilant Things*, 16.

73 Copeland, "In the Wake of the Negress," 481. See also Mirzoeff, *The Right to Look*; Browne, *Dark Matters*; and K. Thompson, *Shine*.

74 Herskovits, *Myth of the Negro Past*.

75 Herskovits, "The Negro in Bahia," 395. On Herskovits's methodology, see Matory, "The Homeward Ship," 96–100.

76 R. F. Thompson, *Aesthetic of the Cool*, 24.

77 Matory, "The Homeward Ship," 97.

78 Helton et al., "Question of Recovery," 5.

79 Gikandi, "Rethinking the Archive of Enslavement," 86.

80 Burns, *Dwelling in the Archive*, 26.

81 Helton et al., "Question of Recovery," 4. See, for example, Hartman, *Scenes of Subjection*; Hartman, *Lose Your Mother*; Hartman, "Venus in Two Acts"; Sharpe, *In the Wake*; and Sexton, "Afro-Pessimism." For historical scholarship prioritizing the framework of archival lack, see most importantly Morgan, *Laboring Women*; and Smallwood, *Saltwater Slavery*.

82 Spillers, "Mama's Baby, Papa's Maybe."

83 Fusco, "Bodies That Were Not Ours," 5.

84 Hartman, "Venus in Two Acts," 11.

85 Aidoo, *Slavery Unseen*, 7.

86 Mott, *Bahia*, 31.

87 Sharpe, *In the Wake*, 10.

88 Smallwood, *Saltwater Slavery*, 8. See also Morgan, *Laboring Women*, 199.

89 See Huerta, *The Unintended*.

90 Khayyat et al., "Pieces of Us," 269.

Chapter 1: Labels

1 ANTT-IL, Processo 2355, f. 42r.

2 ANTT-IL, Processo 2355, f. 14r.

3 ANTT-IL, Cadernos do Promotor, No. 72, Livro 266, f. 291v.

4 Fanon, *Black Skin, White Masks*, 82. See also Sexton and Copeland, "Raw Life"; and Moten, "Case of Blackness."

5 Sisòkò, *Epic of Son-Jara*, 104n20, 104n21. See also Levtzion, *Ancient Ghana and Mali*, 54. *Mali* itself is a Fula (rather than Mande) language term for Manden; see Delafosse, *Langue mandingue*, 9. Throughout this chapter, *mandinga* (not capitalized) will refer to amulets labeled in the records with

this term, while *Mandinga* (capitalized) will reference the ethnonym in cases where the Portuguese spelling is necessary. When referring generally to the people or cultural practices, I use *Mandinka*.

6 See also Fromont, "Paper, Ink, Vodun," 6.

7 As quoted in Dayan, *Haiti, History, and the Gods*, 252.

8 The contested etymology of *gris-gris* is revealing. It first appears in French author André Thevet's 1558 discussion of forest spirits in French Antarctique, then a settlement south of Rio de Janeiro. Thevet (*Singularitez de la France antarctique*, 64v) noted that the people of "Guinea and of Canada" have many visions of spirits that "in their language they call . . . *Grigri*." Johannes Wier (*Praestigiis Daemonum*, 92) adopted the same definition in a 1563 text arguing that those claiming to be witches were suffering from delusions. Gwendolyn Midlo Hall (*Africans in Colonial Louisiana*, 163) derives the word from the Bamana-language term *gerregerys*. By contrast, Thomas Winterbottom—likely basing his thoughts on Richard Jobson's 1623 orthographic rendering—argued that "Gree-gree" was a term "of European introduction, adopted by the [Bullom, Temne, and Susu] natives through complaisance" (Winterbottom, *Account of the Native Africans*, 99n). As a result, "We cannot be sure," Rosalind C. Morris argues, "whether . . . the Africans [heard] gregories as *gru-gru/gris-gris*" or whether "Europeans [misheard] *gris-gris* as gregories" (Morris, "After de Brosses," 143).

9 Rubin, "Accumulation," 19.

10 Pietz, "Problem of the Fetish, I." See also Pietz, "Problem of the Fetish, II," and Pietz, "Problem of the Fetish, IIIa."

11 Pietz, "Problem of the Fetish, I," 5, 7.

12 Pietz, "Problem of the Fetish, I," 7.

13 Spillers, "Mama's Baby, Papa's Maybe," 73.

14 On the connotations and definitions of *Mina*, see Law, "Ethnicities of Enslaved Africans"; and Soares, "From Gbe to Yoruba."

15 On meta-ethnic identities in Brazil, see Parés, *Formation of Candomblé*; Soares, *People of Faith*; and Sweet, "Mistaken Identities?"

16 Levtzion, *Ancient Ghana and Mali*, 53.

17 On the early history and political-social structures of the Mali Empire, see Niane, "Mali and the Second Mandingo Expansion."

18 Brooks, "Climate and History in West Africa," 149–50.

19 Hopkins and Levtzion, *Corpus of Early Arabic Sources*, 272. *Jizya* is a permanent tax levied on non-Muslims in an Islamic state. Mansa Musa's hesitancy to levy the tax in this instance suggests the critical position that these non-Muslims played in the gold trade.

20 Green, *Rise of the Trans-Atlantic Slave Trade*, 283.

21 On the definition of *dyula*, see Dalby, "Distribution and Nomenclature of the Manding," 5; Hunwick, *Timbuktu and the Songhay Empire*, xxvii; and Launay, *Traders without Trade*, 1. As Launay (*Traders without Trade*, 2)

notes, *Wangara* remains in use in present-day Ghana to refer to Muslims who speak Mande languages; in Mande-speaking areas, *dyula* had begun to replace Wangara as a term for itinerant traders by the early 1600s.

22 Suware's lifespan is debated between the thirteenth or the fifteenth–sixteenth centuries; see Sanneh, *Beyond Jihad*, 80–83; and Robinson, *Muslim Societies in West African*, 55–59. While Sanneh and Robinson both discuss Suware's preaching in the context of a Muslim in a non-Muslim society, Toby Green (*Fistful of Shells*, 49) discusses its emergence from brokering productive trade relations between elite Muslims and the non-Muslims who generally controlled gold production in the region during the period of Mali's expansion.

23 Austen, "Sources of Gold," 63; Green, *Fistful of Shells*, 41.

24 Green, *Fistful of Shells*, 49. On "accommodationist Islam," see Levtzion, "Eighteenth Century," 21.

25 Farias, "Islam in the West African Sahel," 110.

26 Hunwick (*Islam in Africa*, 15) notes that by the late twentieth century "the making of Qur'anic amulets and the use of Qur'anic verses in healing is approved by almost all Muslim authorities and is considered to have been sanctioned by the Prophet. Some even allow the use of material not derived from the Qur'an and even in languages other than Arabic and all such amulets may be worn by non-Muslims (and even by animals) provided the text is wrapped up and hidden from view."

27 Technically, a talisman can be any object imbued with protective powers. Given their ubiquity and diversity, I do not have space here to sufficiently treat the variety of amulets used throughout the Islamic world.

28 Bravmann, *Islam and Tribal Art*, 88.

29 Bravmann, *Islam and Tribal Art*, 88.

30 See Prussin, *Hatumere*.

31 Nobili, "Written Word," 251.

32 Curtis, *Call of Bilal*, 5.

33 On the definition of *siḥr* in the Qur'an, see Hamès, "Notion de magie."

34 Hamès, "L'usage talismanique du Coran," 83.

35 Nobili, "Written Word," 252.

36 Dupuis, *Journal of a Residence*, 142.

37 On the use of amulets in the Asante state, see Owusu-Ansah, "Islamic Influence in a Forest Kingdom."

38 Hopkins and Levtzion, *Corpus of Early Arabic Sources*, 265.

39 LaGamma, "Sahelian Diasporas," 153.

40 Hunwick, *Sharī'a in Songhay*, 89.

41 Green, *Fistful of Shells*, 51. Operating in tandem with Serer, Fulani, and Hausa traders, Wolof horse importers may have been the first sub-Saharan Africans to sell humans to Europeans. See Alencastro, *Trato dos Viventes*, 47.

42 LaGamma, "Sahelian Diasporas," 153. Through at least the late twentieth century, *nyamakalaw* were still responsible for producing these leather amulet cases in Mande-language regions; see B. E. Frank, "Soninke *garankéw*."

43 Hunwick, *Timbuktu and the Songhay Empire*, 312.

44 MacDonald et al., "'Pays Dô' and the Origins," 73.

45 On the use of amulet-laden Islamic vestments in West African warfare, see also V. S. Santos, "Bolsas de mandinga," 43–45.

46 Bowdich, *Mission from Cape Coast Castle*, 271.

47 Green, *Fistful of Shells*, 55.

48 MacDonald et al., "'Pays Dô' and the Origins," 75.

49 Though scholars often interpret the raised arms on Dogon sculptures as a gesture of supplication or a prayer for rain, Huib Blom (*Dogon*, 270) cautions against interpreting any "archaeological artifact" (Dogon or otherwise) "out of context" since "only the owners of these statuettes may explain their use."

50 Pietz, "Problem of the Fetish, I," 7.

51 See also Mota, "História Atlântica da islamização," 201.

52 Ly-Tall, "Decline of the Mali Empire," 172, 174.

53 Rodney, *History of the Upper Guinea Coast*, 14.

54 Green, *Rise of the Trans-Atlantic Slave Trade*, 17.

55 On Manuel I's forced conversion of Jews in the Portuguese Empire, see Monteiro, *Historia da Santa Inquisição*, 249.

56 Green, *Rise of the Trans-Atlantic Slave Trade*, 18.

57 Shaw, *Memories of the Slave Trade*, 53.

58 Green, *Rise of the Trans-Atlantic Slave Trade*, 283.

59 Havik, *Silences and Soundbites*, 150.

60 Hair, *Interim Translation of Manual Alvares*, II/4: 4.

61 Fernandes, *Manuscrito de "Valentim Fernandes*," p231, f. 338r.

62 Barros, "Extracts from the 'Decadas da India,'" 140.

63 As quoted in Alencastro, *Trato dos Viventes*, 47.

64 Green, *Rise of the Trans-Atlantic Slave Trade*, 52–54. During this period, most Mandinka traders began turning their attention to the more lucrative kolanut trade further south as the gold trade in Senegambia and the Sahel gradually gave way to human trafficking. See Ly-Tall, "Decline of the Mali Empire," 186.

65 Rodney, "Upper Guinea and the Significance," 335. See also V. S. Santos, "Bolsas de mandinga," 41.

66 Pereira, *Esmeraldo de Situ Orbis*, 50.

67 Massing, "Mane, the Decline of Mali," 25.

68 Green, *Rise of the Trans-Atlantic Slave Trade*, 52.

69 Hair, *Interim and Makeshift Edition*, 63. See also Horta, "Evidence for a Luso-African Identity," 117. Almada's allusion to Mandinka identity as bound with cultural and economic secrecy parallels the fierce secrecy with

which dyula guarded Sahelian gold deposits, even from Muslim bureaucrats and elites. This secrecy gave rise to a series of fantastical tales in Portuguese-language accounts about the origin of the gold traded into Senegambia. Duarte Pacheco Pereira fancifully described the mysterious origins of gold from the Sahel, mined by "Dogface" people and eventually exchanged for gold to Bamana and related peoples, before being traded to Mandinka intermediaries before making its way to the coast; see Pereira, *Esmeraldo de Situ Orbis*, 51. It is likely that these stories were not simply guesses by Pereira, but rather were relayed from dyula he encountered in order to discourage outsiders from going to the gold deposits they protected. See Austen, "Sources of Gold," 63.

70 Parés, *Formation of Candomblé*, 1.

71 Havik, *Silences and Soundbites*, 149.

72 Monod et al., *Description de la côte occidentale*, 9. These amulets were closely linked to the cultural capital associated with paper and writing in the context of Islamic expansion in Senegambia during this period: see Mota, "'Sobre o *Alcorão*'"; and Mota, "Wolof and Mandinga Muslims."

73 ANTT, Cartório dos Jesuitas, Maço 68, Doc. 119.

74 Guerreiro, *Relação Anual das Coizas*, 243. *Nómina* (Latin for "names") as a term for amulets derives from the early Christian practice of inscribing (especially through abbreviation) sacred terms and names (*nomina sacra*) on papers, objects, or buildings for amuletic purposes. Through the early seventeenth century, *nómina* was a common term for amulets in Iberia, where it especially referred to written papers kept inside amulets. See Skemer, *Binding Words*, 231n123 and 231n124; and V. S. Santos, "Bolsas de mandinga," 46. For the relationship between *bexerins* and *serigne*, see Mota, "Wolof and Mandinga Muslims," 9.

75 Jobson, *Golden Trade*, 63. See also Schaffer, *Djinns, Stars, and Warriors*, 7. *Marabout* is today used in what Amber B. Gemmeke (*Marabout Women in Dakar*, 7, 11) appropriately describes as a "bewildering variety of circum-stances," but mainly as an honorific title. Jobson may be employing the term circularly here, as occasionally it can refer to "producers of amulets."

76 Villaut, *Relation des costes d'Afrique*, 56–57.

77 Froger, *Relation of a voyage*, 14.

78 Mota and Hair, *André Donelha*, 160.

79 Skemer, *Binding Words*.

80 See Mark, "European Perceptions of Black Africans."

81 Skemer, *Binding Words*, 231n123 and 231n124.

82 Jobson, *Golden Trade*, 63, 64. Thomas Winterbottom made a parallel—if not repetitive—analysis in the late eighteenth century, arguing that the "dress of the pagan African is never thought complete unless a variety of . . . amulets be superadded . . . the wearer often appears much incumbered with the load." See Winterbottom, *Account of the Native Africans*, 99.

83 Jannequin, *Voyage de Lybie*, 120. In the early nineteenth century, British chron-
 icler Hugh Murray morphed Jannequin's description into a fanciful exaggera-
 tion, asserting that Jannequin claimed that Mandinka cavalry were encumbered
 with so many amulets they were "often unable to mount on horseback without
 assistance." See Murray, *Historical Account of Discoveries*, 224.

84 In 1845 the British missionary Samuel Walker visited a house that "was
 hung around with an abundance of greegrees; and, among others, a Por-
 tuguese greegree, or a crucifix. Surely papists do not know how nearly they
 approach to African savages, in their confidence in relics, and such lying
 vanities." Though Walker's description is based on his implicit criticism of
 Catholics as idolaters, the continued parallel use of a Catholic crucifix and
 talismanic pouches recalls Donelha's suspicion of Gaspar Vaz in the 1620s.
 See Walker, *Missions in Western Africa*, 415.

85 Hair, *Interim Translation of Manual Alvares*, II/25: 1.

86 Mota and Hair, *André Donelha*, 148. Donelha had known Vaz originally as
 enslaved to his neighbor on the island of Santiago in Cape Verde.

87 Mota and Hair, *André Donelha*, 148.

88 My interpretation of Gaspar Vaz's story here differs from that of Vanicléia
 Silva Santos ("Bolsas de mandinga," 73), who argues that Vaz "syncretically
 combined" Muslim, Christian, and traditional "religious symbols due to his
 position as an 'intermediary.'" I argue it is more productive to character-
 ize Vaz's strategy as one of strategic revelation depending on audience, as
 opposed to syncretic combination.

89 This is not to suggest that residents of seventeenth-century Upper Guinea
 and Senegambia, in the words of Vanicléia Silva Santos ("Bolsas de mand-
 inga," 79), possessed "a plasticity to incorporate new aspects (*novidades*)."
 Indeed, I am here pushing against formulations of cultural identity that
 presume an inherent receptibility to "outside" influences, instead arguing that
 all identity claims and positions are both socially contingent and strategic.

90 Horta, "Evidence for a Luso-African Identity," 113.

91 Einarsdóttir, *Tired of Weeping*, 13. Also on *grumetes*, see Mark, *"Portuguese"*
 Style, 57.

92 ANTT-IL, Processo 2079, f. 185r. Though all translations I provide are my
 own, the trial transcript has been translated into English and published as
 Green et al., *African Voices from the Inquisition*. This same text (xix–lxvii)
 also contains a thorough analysis of the trial's historical context and his-
 toriographic implications, rightfully characterizing it as an unprecedented
 document. Also on this trial see Calainho, *Metrópole das mandingas*, 88;
 Sweet, *Recreating Africa*, 181; Havik, "Walking the Tightrope"; and
 V. S. Santos, "Mulheres africanas nas redes."

93 In Portuguese-language accounts from Atlantic Africa and Brazil during the
 seventeenth century, parda (masc. pardo) could refer to someone of visibly
 apparent multiracial ancestry; see Curto and Lovejoy, "Introduction," 12.

But the term also functioned to disassociate Black Africans from slave status, especially given the "emergence of a free population of African origin" in Brazil and Portugal; see Mattos, "'Pretos' and 'Pardos,'" 52.

94 Havik, *Silences and Soundbites*, 149–50.

95 Havik, *Silences and Soundbites*, 149.

96 Havik, *Silences and Soundbites*, 149.

97 See also Havik, "Gendering the Black Atlantic," 341. In Portuguese Guinea and Cape Verde, *jacabousse* and *jambacosse* designated (typically non-Muslim) diviners and amulet-makers; see Calainho, *Metrópole das mandingas*, 90; and V. S. Santos, "Bolsas de mandinga," 64–65. In the Spanish Caribbean, however, *jambacosse* became synonymous with *Mandinga* generally. See Gómez, *Experiential Caribbean*, 85.

98 ANTT-IL, Processo 2079, f. 9r. *China* has an unclear definition and origin. Peter Mark (*"Portuguese" Style*, 152n30) derives it from the Jola "word *'bekin'* which . . . refers to a spirit force or the shrine that such forces inhabit." By contrast, Philip J. Havik (*Silences and Soundbites*, 154n313) argues that china is derived from "the Bañun *'hatichina'* or *hatichira*," which, according to Valentim Fernandes, referred to a type of ancestral wooden shrine. On chinas and their definitions in early seventeenth-century Upper Guinea, see also V. S. Santos, "Bolsas de mandinga," 48; and Carreira, "Símbolos, ritualistas e ritualismos," 506, 508.

99 Hair, "Sources on Early Sierra Leone (7)," 63.

100 As quoted in Mark, *"Portuguese" Style*, 16–17.

101 ANTT-IL, Processo 2079, f. 9r.

102 ANTT-IL, Processo 2079, f. 151r.

103 ANTT-IL, Processo 2079, f. 28r, f. 53r.

104 ANTT-IL, Processo 2079, f. 151r–152r. This practice, in reference to pregnancy, remains common in early twenty-first-century Senegambia. Dara Seybold relays the experience of a woman in Senegal who eventually decided to use "rope-like leather cords about two centimeters in diameter and half a meter in length" tied around her waist as a talismanic response to her infertility; see Seybold, "Choosing Therapies," 540–41. This individual abandoned these talismans for a time, finding them "ineffective and expensive" (543). A 1982 survey of women in the Sine-Saloum region of Senegal also found that 60 percent of respondents were familiar with "charms (gris-gris)" as a method of contraception; see Goldberg et al., "Fertility and Family Planning," 119.

105 ANTT-IL, Processo 2079, f. 152v.

106 ANTT-IL, Processo 2079, f. 153r.

107 ANTT-IL, Processo 2079, f. 152v.

108 ANTT-IL, Processo 2079, f. 152v.

109 ANTT-IL, Processo 2079, f. 151v.

110 ANTT-IL, Processo 2079, f. 152v.

111 Hawthorne, *From Africa to Brazil*, 228.

112 ANTT-IL, Processo 2079, f. 158r–158v.

113 ANTT-IL, Processo 2079, f. 160r–160v.

114 ANTT-IL, Processo 2079, f. 160v.

115 ANTT-IL, Processo 2079, f. 161v.

116 Online Etymological Dictionary, "Sorcery," https://www.etymonline.com/word/sorcery, accessed September 23, 2021.

117 ANTT-IL, Processo 5477, f. 7v. On this case, see Pantoja, "Inquisição, degredo e mestiçagem." The case is also discussed in Hawthorne, *From Africa to Brazil*, 241n140; Thornton, "Central Africa in the Era," 99; and V. S. Santos, "Bolsas de mandinga," 113, 125.

118 Heywood, *Njinga of Angola*, 134–35.

119 ANTT-IL Processo 5477, f. 44v.

120 ANTT-IL Processo 5477, f. 80v.

121 ANTT-IL Processo 5477, f. 44v.

122 Souza, *Devil and the Land*, 133–35.

123 ANTT-IL, Processo 5477, f. 9r.

124 Sansi, "Sorcery and Fetishism," 24.

125 Kananoja, "Healers, Idolaters, and Good Christians," 445.

126 See Fromont, *Art of Conversion*.

127 Heywood, "Portuguese into African," 99, 101.

128 Candido, *An African Slaving Port*, 114–15. Candido notes a 1722 case in Benguela of a Black, locally born Portuguese official who sought the consultation of an Mbundu healer and medium.

129 As quoted in Couto, *Os Capitães-Mores em Angola*, 124n48.

130 Pantoja, "Inquisição, degredo e mestiçagem," 130.

131 ANTT-IL, Processo 5477, f. 9r. See also Pantoja, "Inquisição, degredo e mestiçagem."

132 ANTT-IL, Processo 14148, f. 3r–3v.

133 Kananoja, *Healing Knowledge in Atlantic Africa*, 36.

134 ANTT-IL, Processo 14150, f. 7r. For an analysis of the denunciations against Chaves and Tango, see Kananoja, *Healing Knowledge in Atlantic Africa*, 35–42.

135 ANTT-IL, Cadernos do Promotor, No. 66, Livro 260, f. 44v.

136 ANTT-IL, Processo 3670, f. 4r.

137 BNP, Cod. 863, *Collecção de Listas impressas, e manuscriptos, dos Autos da Fé, publicos, e particulares, celebrados pela Inquisição de Lisboa, corrigida, e annotada, por Antonio Joaquim Moreira* (Lisbon, 1863), f. 313r.

138 Souza, *Devil and the Land*, 134; Sansi, "Sorcery and Fetishism in the Modern Atlantic," 23.

139 ANTT-IL, Processo 5477, f. 45r.

140 For a nuanced overview of historical definitions of feitiçaria and its problematic translations, see Bethencourt, *Imaginário da magia*. Bethencourt

(57) also notes that Bluteau (*Vocabluario Portuguez*, Vol. 4, 63–64) gives "primacy to the knowledge of hidden things among the motivations of feiticeiras."

141 Parés, *Formation of Candomblé*, 78.

142 Bluteau, *Vocabluario Portuguez*, Vol. 5, 286.

143 TASTD, "SlaveVoyages: Trans-Atlantic Slave Trade—Estimates," https://www.slavevoyages.org/assessment/estimates, accessed March 27, 2022.

144 V. S. Santos ("Madingueiro não é *Mandinga*") corrects earlier speculations that bolsas de mandinga in Brazil and Portugal were produced by Mandinkas.

145 Feijó, *Orthographia*, 388.

146 Bluteau, *Diccionario da Lingua Portugueza*, 51.

147 ANTT-IL, Processo 2355, f. 1r.

148 ANTT-IL, Processo 2355, f. 19v.

149 ANTT-IL, Processo 2355, f. 19r–19v.

150 ANTT-IL, Processo 2355, f. 19v.

151 ANTT-IL, Processo 2355, f. 24v.

152 Akinjogbin, *Dahomey and Its Neighbours*, 37.

153 Law, *Ouidah*, 29, 30.

154 Akinjogbin, *Dahomey and Its Neighbours*, 34, 36.

155 Law, *Slave Coast of West Africa*, 226–27. See also Kea, "Firearms and Warfare," 194.

156 Law, *Ouidah*, 30.

157 Phillips, "Journal of a Voyage," 200.

158 ANTT-IL, Processo 2355, f. 24v.

159 AHU, São Tomé, Caixa 4, doc. 367.

160 On this ship's journey, see Jones, *Brandenburg Sources*, 180–98.

161 Seibert, "São Tome and Príncipe," 62.

162 Jones, *Brandenburg Sources*, 198.

163 Verger, *Trade Relations*, 3–4, 11; Parés, *Formation of Candomblé*, 5.

164 Soares, "'Nação' que se tem," 307. As Soares notes in this same article (306), in the eighteenth century, many Africans from the Bight of Benin arrived in Bahia and re-embarked to Rio de Janeiro and Minas Gerais.

165 Rodney, "Upper Guinea and the Significance," 335. For a detailed overview of the *Mandinga* ethnonym among enslaved persons in the Americas as tied to political shifts and processes of enslavement in Upper Guinea, see Wheat, *Atlantic Africa*, 32–42.

166 Palmié, "Ethnogenetic Processes," 347.

167 Adderley, *"New Negroes from Africa,"* 100.

168 Antonil, *Cultura, e opulencia*, 23.

169 ANTT-IL, Cadernos do Promotor 110, Livro 302, f. 190–94.

170 Gagliardi and Biro, "Beyond Single Stories," 2.

171 Kasfir, "One Tribe, One Style?"

172 See, for example, Bertolossi, "Corpo Fechado"; and Hawthorne, *From Africa to Brazil*, 242. Calainho (*Metrópole das mandingas*, 172) first noted that

mandinga does "not reflect an ethnic homogeneity among a certain group" but rather "the fruit of a process of cultural, social, and religious disarticulation established starting with the slave trade."

173 Amselle, *Mestizo Logics*, 11. See also Gagliardi, *Senufo Unbound*.
174 B. S. Hall, *History of Race*, 23.
175 Sweet, "Quiet Violence of Ethnogenesis."
176 Smallwood, *Saltwater Slavery*, 184.

Chapter 2: Contents

1 ANTT-IL, Processo 2355, f. 7r–7v.
2 Pietz, "Problem of the Fetish, I," 7.
3 Matory, *Fetish Revisited*, xix.
4 Matory, *Fetish Revisited*, 258.
5 Taussig, *Devil and Commodity Fetishism*, xvi.
6 AUC, *Devassa do arcediagado de Vouga de 1698*, III/D, 1, 4, 5, 38, f. 267. As cited in Paiva, *Práticas e Crenças Mágicas*, 124.
7 ANTT-IL, Maço 27, No. 41.
8 Buono, "Crafts of Color." See also Buono, "'Treasures Are the Feathers.'"
9 ANTT-IL, Processo 10181, f. 1v. See also Souza, *Devil and the Land*, 130. For another bolsa case from Brazil containing human remains, see ANTT-IL, Cadernos do Promotor, No. 113, Livro 305, f. 251.
10 ANTT-IL, Maço 27, No. 20, f. 6r. See also Souza, *Devil and the Land*, 132.
11 AHN, Inquisición 1023, f. 402r–403r. As cited in Gómez, *Experiential Caribbean*, 140. According to Gómez, "In 1689, eleven witnesses ('seven white and four black') declared that through the use of 'magic' he was able to survive the close range of impact of a 'cannon bullet' that hit him in the chest." See Gómez, "Transatlantic Meanings," 137. On this case, see also Guerrero-Mosquera, "Bolsas mandingas en Cartagena," 86–89.
12 "Lienzo corporal" refers to the sacred linen used to cover the Eucharistic host and wine during Catholic Masses.
13 "A supposedly miraculous type of bread associated with the Catholic saint Nicolas de Tolentino." Gómez, "Transatlantic Meanings," 137.
14 AHN, Inquisición 1023, f. 400r. This is my own translation from the Spanish text as transcribed in Gómez Zuluaga, "Bodies of Encounter," 131n142. Gómez's *Experiential Caribbean*, the book based on that dissertation, does not reproduce the original Spanish text.
15 Gómez, *Experiential Caribbean*, 140–41.
16 Collier, *Media Primitivism*, 18.
17 Pietz, "Problem of the Fetish, II," 24.
18 Collier, *Media Primitivism*, 8, 9. See also Matory, *Fetish Revisited*.
19 Findlen, *Possessing Nature*, 22.

20 Yaya, "Wonders of America," 173, 174.

21 Delbourgo, "Slavery in the Cabinet," 4.

22 Collier, *Media Primitivism*, 8. See also Delbourgo, "Slavery in the Cabinet," 3.

23 Pietz, "Problem of the Fetish, II," 24.

24 Pietz, "Problem of the Fetish, I," 6.

25 Pietz, "Problem of the Fetish, II," 42.

26 Gott, "Native Gold, Precious Beads," 49.

27 Nooter, "Secrecy," 56. Aimée Bessire makes a similar point in her analysis of Sukuma protective objects in early twenty-first-century Tanzania; see Bessire, "Power of Ephemera," 21.

28 Rubin, "Accumulation." See also Doris, *Vigilant Things*, 16; and Strother, "From Performative Utterance."

29 On donso, see McNaughton, "Shirts That Mande Hunters Wear."

30 Ferrarini, "Shirts of the Donso Hunters," 85.

31 Ferrarini, "Shirts of the Donso Hunters," 85.

32 Matory, *Fetish Revisited*, 259.

33 Kananoja, *Healing Knowledge in Atlantic Africa*, 12.

34 Kananoja, *Healing Knowledge in Atlantic Africa*, 31. See also Figueiredo, "Política, Escravatura e Feitiçaria," 644.

35 Bethencourt, *Imaginário da magia*, 59; Paiva, *Práticas e Crenças Mágicas*, 108–16; Kananoja, *Healing Knowledge in Atlantic Africa*, 31.

36 Pietz, "Problem of the Fetish, I," 7. Pietz distinguishes between fetish and feitiço: where the former is defined by its "irreducible materiality," the feitiço was, by contrast: "quasi-personal powers and material objects that were capable of being influenced both through acts of worship" (Pietz, "Problem of the Fetish II," 23). Nevertheless, Pietz's framing of the "irreducible materiality" of the fetish risks discounting, as Alessandra Brivio (*Vodu in Africa*, 49) notes, the critical "immaterial" aspects that inform its discursive power. Though Brivio's observation concerns West African Vodun specifically, I employ it here to reference the wide range of immaterial forces referenced by accused feiticeiros in the Portuguese Empire. For a similar point in relation to Kongo religiosities, especially in *minkisi* spirit containers, see MacGaffey, "African Objects and the Idea," 125–27.

37 Sansi, "Sorcery and Fetishism," 21.

38 Bluteau, *Vocabulario Portuguez*, Vol. 4, 63, 64–65. See also Bethencourt, *Imaginário da magia*, 57.

39 Bethencourt, *Imaginário da magia*, 72.

40 Thornton, "Cannibals, Witches, and Slave Traders," 277, 293. See also Calainho, *Metrópole das mandingas*, 166–67. For this history's manifestations in late twentieth-century Sierra Leone, see Shaw, "Production of Witchcraft."

41 As quoted in Ly-Tall, "Decline of the Mali Empire," 178.

42 Fromont, "Paper, Ink, Vodun," 37. Calainho (*Metrópole das mandingas*, 166–67) also discusses enslavement in Africa as a punishment for perceived

crimes and anti-social behavior but does not explicitly cite it as a motivation for mandinga-production or procurement.

43 Walker, *Missions in Western Africa*, 333.

44 Little, "Political Function of the Poro," 349. As an important counterpoint to the history discussed in this section, historian Adeleye Ijagbemi suggests that oral histories may intentionally overemphasize the historical role of displacement and warfare in the formation; of power associations see Ijagbemi, "'Rothoron' (The North-East)," 46.

45 Shaw, *Memories of the Slave Trade*, 60.

46 Keefer, "Poro, Witchcraft and Red Water," 5–8.

47 See, for example, Camara, "Hunter in the Mande Imagination."

48 Michael C. Carlos Museum, Emory University, "Hunter's Shirt, Donson Dlokiw." Jan Jansen ("Framing Divination," 123n21) provocatively translates *dibi* as "darkness."

49 Marees, *Description et récit historial*, 3.

50 Villaut, *Relation des costes d'Afrique*, 262.

51 De Brosses, "Worship of Fetish Gods," 44.

52 De Brosses, "Worship of Fetish Gods," 46. Noting this, Pietz rightly situates amulets, at least those used in West Africa, also as material exemplars of the fetish; see Pietz, "Problem of the Fetish, II," 38–40.

53 De Brosses, "Worship of Fetish Gods," 48.

54 Corry, *Observations Upon the Windward Coast*, 61.

55 Corry, *Observations Upon the Windward Coast*, 61.

56 Barbot, *Description of the Coasts*, 312.

57 Phillips, "Journal of a Voyage," 224.

58 Genge, "Survival of Images?," 31–32.

59 Genge, "Survival of Images?," 31–32.

60 Matory (*Fetish Revisited*, xix) notes the persistence of this even today, as Afro-Atlantic religions "reconfigure interfamilial, interclass, interethnic, interracial, and intergender relationships through the liturgical assembly, re-valuation, and care of material things, many of which have been imported from Europe or by Europeans."

61 A. C. Silva, "A Memória Histórica." The original document is housed at the AIHGB, DL 310,79. Mendes had no personal experience in Dahomey. Rather, by his own account, he had learned the Fon language to communicate with those enslaved on his sugar plantation. He also interviewed the Dahomean ambassador to Brazil, and while in Portugal met and conversed with another long-term resident of Dahomey.

62 A. C. Silva, "A Memória Histórica," 261–62, 262n5.

63 Matory, *Fetish Revisited*, xix.

64 Lima et al., "Weaving the Second Skin," 104.

65 Bethencourt, *Imaginário da magia*, 73.

66 Bethencourt, *Imaginário da magia*, 74.

67 This image is one of forty-three watercolor paintings bound together at the FBN under the title *Figurinhos de Brancos e Negros dos Uzos do Rio de Janeiro e Serro do Frio* (Figures of Whites and Blacks [illustrating] the Customs of Rio de Janeiro and Serro do Frio). The plates are reproduced in color in Julião, *Riscos Illuminados*. In the preface to this edition, Lygia Cunha dates Julião's watercolors to after 1776, based on an analysis of an allegory in one of the plates; see Julião, *Riscos Illuminados*, ix–xi. However, in a 1949 manuscript attached to the originals, J. W. Rodrigues dates the paintings to "before 1770," meaning there is quite divergent disagreement on exactly when they were produced. On Julião's work, see V. P. G. Silva, "Figurinhas de brancos e negros."

68 Julião likely intended this image to represent an enslaved West African-born woman. Julião incorporated a slightly adapted version of this image labeled *preta Mina da Bahia* ["Black [enslaved African] Mina Woman of Bahia"] in the lower register of his 1779 collage panorama, *Elevation and façade showing in naval prospect the city of Salvador*, now held at the GEAEM in Lisbon and discussed in this book's introduction. On this image see Lara, "Customs and Costumes," 137.

69 In 1734, an anonymous Portuguese author published a devotional book to the "Sacred Heart of Jesus" motif; see Anonymous, *Devoção Do Santissimo Coração*. As the Holy Office had to control the publication of all books in the empire, Fr. Thomás de Sampayo wrote in his license for the book that "In it I found nothing that is opposed to our holy faith or good customs" (unpaginated; six pages before 1).

70 Bethencourt, *Imaginário da magia*, 73.

71 At her 1734 trial in Lisbon, Marcelina Maria, a twenty-six-year-old enslaved woman born in Rio de Janeiro, testified that João da Costa, a Black domestic servant (*criado*) of Francisco I, brother of King João V, had enslaved to him a man named Domingos who was "a famous mandingueiro." ANTT-IL, Processo 631, f. 6r.

72 Soares, *People of Faith*, 122.

73 *Constituiçoens Syndoaes do Bispado do Lamego*, 405.

74 ANTT-IL, Processo 11767, f. 27r. For a summary of this case, see Mott, "Vida mística e erotica."

75 ANTT-IC, Processo 1630, f. 3r.

76 ANTT-IC, Processo 1630, f. 7r.

77 ANTT-IC, Processo 1630, f. 3r.

78 ANTT-IC, Processo 1630, f. 17r.

79 ANTT-IC, Processo 1630, f. 8v.

80 ANTT-IC, Processo 1630, f. 3r. As one example, Luis testified that he heard the enslaved José da Costa say that an enslaved man named Sebastião sold a mandinga to a man named António Criansa. Criansa marched in the Coimbra auto-da-fé of October 8, 1730.

81 ANTT-IC, Processo 1630, f. 11r.

82 ANTT-IC, Processo 1630, f. 11r.

83 ANTT-IC, Processo 1630, f. 9r.

84 ANTT-IC, Processo 1630, f. 7r.

85 ANTT-IC, Processo 1630, f. 18r.

86 ANTT-IL, Processo 11767, f. 33v and f. 40r. José Francisco Pereira's partner, José Francisco Pedroso (ANTT-IL, Processo 11774, f. 24r), also testified that José Francisco Pereira sold a bolsa de mandinga to a white man in Rio de Janeiro for 2,400 *réis* (plural of *real*, the base unit). During the reign of João V (1706–1750), one-half moeda de ouro was equivalent to 2,400 réis; three cruzados novos was equivalent to 1,200 réis; one quartinho was 1,000 réis; and sixteen tostões was 1,280 réis. Recall that in 1704, Jacques Viegas had purchased his own bolsa de mandinga in Lisbon from Manuel for two patacas, which equaled just 640 réis. Jacques was also accused of bartering mandingas: he sold one to a white man for a knife and a bottle of wine; see ANTT-IL, Processo 2355, f. 15v; and Calainho, "Mandingueiros negros no mundo atlântico," 22.

87 Of course, a rise in the prices of bolsas de mandinga may also have been related to an increase in wages, prices, and the money supply overall in Lisbon during the first half of the eighteenth century; see Serrão, "Extensive Growth," 138–40.

88 See also ANTT-IL, Processos 3670 and 9972.

89 ANTT-IL, Processo 11767, f. 56v, f. 57r.

90 ANTT-IL, Processo 254, f. 65r. Mascarenhas may have learned this technique from José Francisco Pereira, as the pair had worked together as mandingueiros in Lisbon over a decade prior.

91 Sweet, *Recreating Africa*, 203.

92 ANTT-IL, Cadernos do Promotor, No. 108, Livro 300, f. 48r-50A.

93 ANTT-IC, Processo 1630, f. 10v.

94 Lapa, *Livro da Visitação do Santo Ofício*, 215.

95 Lapa, *Livro da Visitação do Santo Ofício*, 215. Anselmo was imprisoned in Lisbon in September 1768 but released six weeks later due to lack of evidence. See ANTT-IL, Processo 213.

96 ANTT-IL, Processo 11767, f. 17r–17v.

97 ANTT-IL, Processo 11767, f. 16v.

98 ANTT-IL, Processo 11767, f. 17r–17v.

99 José Francisco Pedroso, also a *natural* of Ouidah, was enslaved to the brother of José Francisco Pereira's enslaver.

100 On the use of coins as amulets in Portugal, see Vasconcellos, "Amuletos"; and Vasconcellos, "Signification religieuse, en Lusitanie." See also Fromont, "Paper, Ink, Vodun," 9.

101 See also Fromont, "Paper, Ink, Vodun," 23.

102 Berliner, "Arma Christi"; and Gayk, "Early Modern Afterlives."

103 Calainho, *Metrópole das mandingas*, 111.

104 Lahon, "Inquisição, pacto com o demónio," 35.

105 V. S. Santos, "Bolsas de mandinga," 200, 202. See also Fromont, *Art of Conversion*; and Thornton, "Afro-Christian Syncretism." In general, Thornton notes, scholarly work on this topic has focused "largely on the degree to which the basic cosmology of Kongo dominated the syncretism, thus making it in some ways more Kongo and less Christian. Some, such as James Sweet [*Recreating Africa*, 104–13], have expanded the question to argue that Kongo religion changed so little that it is probably best not to call them just Christians, but perhaps bireligious, emphasizing the maintenance of a core Kongo cosmology." For Thornton's argument on the persistence of Kongo Catholicism in the formation of African diasporic religions in the Americas, see Thornton, "Kingdom of Kongo and Palo Mayombe."

106 Sweet, *Domingos Álvares*, 61.

107 Dean and Leibsohn, "Hybridity and Its Discontents," 6.

108 Daniel Buono Calainho's careful work has shown that mandinga- and amulet-associated cases made up nearly one third of all Portuguese Inquisition cases involving persons of African descent between 1600 and 1774 (Calainho, *Metrópole das mandingas*, 96). In his analysis of 690 surviving cases of "illicit magical practices" processed in Coimbra, Lisbon, and Évora in this same period, José Pedro Paiva found that 8 percent of defendants (55 in total) were accused of feiticaria, "the majority for using bolsas de mandinga" (Paiva, *Bruxaria e superstição*, 204). My own research suggests this number may be as high as 12 percent of all defendants, as here I examine additional cases where terms other than *mandinga* were used to describe pouch-form amulets.

109 Dean and Leibsohn, "Hybridity and Its Discontents," 6.

110 J. C. Monroe, *Precolonial State in West Africa*, 222–23.

111 Law, "A Neglected Account," 321; Piqué and Rainer, *Palace Sculptures of Abomey*, 9.

112 European traders debated Agaja's political and personal reasons for participating in the slave trade during his own lifetime, and his motivation remains the subject of research. See Henige and Johnson, "Agaja and the Slave Trade"; Law, "King Agaja of Dahomey"; and Polhemus, "Dialogue with King Agaja."

113 Bay, *Asen, Ancestors, and Vodun*, 17.

114 Bay, *Asen, Ancestors, and Vodun*, 161; Rush, "Ephemerality and the 'Unfinished.'"

115 Blier, "Art of Assemblage."

116 Parés, *O Rei, O Pai*, 303.

117 Parés, *O Rei, O Pai*, 163–64; Rush, "Ephemerality and the 'Unfinished,'" 62.

118 Carson, *Making an Atlantic World*, 41.

119 Bay, *Asen, Ancestors, and Vodun*, 22.

120 Fromont, "Paper, Ink, Vodun"; Lahon, "Inquisição, pacto com o demónio"; and Rarey, "Assemblage, Occlusion, and the Art."

121 Fromont, "Paper, Ink, Vodun," 12.

122 Blier (*African Vodun*, 244, 293) provides both translations of this term.

123 On the translation of *bocio* as "empowered cadaver," see Blier, *African Vodun*, 100.

124 Adandé, "*Bocio*: From Nothingness," 182.

125 No known bocio survive from prior to the twentieth century.

126 Blier, *African Vodun*, 1.

127 On asen, see Bay, *Asen, Ancestors, and Vodun*.

128 On the various types of bo, see Herskovits, *Dahomey*, Vol. 2, 256–88; and Blier, *African Vodun*, 101–5.

129 Fromont, "Paper, Ink, Vodun," 31.

130 Parés, *O Rei, O Pai*, 303, 306; Bay, "Protection, Political Exile," 52. Bay also smartly cautions against solely linking the development and use of *bo* to the rise of the slave trade; see Bay, "Protection, Political Exile, and the Atlantic Slave-Trade," 50–52.

131 Daniels, "Undressing of Two Sacred Healing Bundles," 423.

132 Blier, *African Vodun*, 289.

133 Blier, *African Vodun*, 293.

134 Sweet, *Domingos Álvares*, 243n45.

135 It is possible that José Francisco had some exposure to Christianity in West Africa. Edna G. Bay relates a description of a royal asen held in the collection of the Musée Historique d'Abomey in Benin, which depicts a Catholic chapel established in Dahomey during Agaja's reign. See Bay, *Asen, Ancestors, and Vodun*, 39, 40.

136 Rowe, *Black Saints in Early Modern*, 2. See also Iyanaga, "Why Saints Love Samba," 143.

137 ANTT-IL, Cadernos do Promotor 86, Livro 279, f. 171–73. Lidiane Vicentina dos Santos infers that given the described similarities and proximity of these two men, they were either taught to make the orations by this same sailor or exchanged their teachings with each other. See L. V. Santos, "'Terra Inficcionada,'" 97.

138 ANTT-IL, Processo 6982, f. 11v–12r.

139 ANTT-IL, Processo 254, f. 64v. My translation of this critical paragraph matches that in Fromont, "Paper, Ink, Vodun," 19. Mascarenhas's story also notes the depth of the transatlantic mandingueiro network the Inquisition worked to uncover by the 1740s. Ventura—Mascarenhas's supposed teacher in Rio de Janeiro in the mid-1730s—had assisted José Francisco Pereira in his production of amulets in Lisbon in 1730.

140 See Fromont, "Paper, Ink, Vodun."

141 See also Sweet, *Recreating Africa*, 185–86.

142 ANTT-IL, Processo 11774, f. 22v.

143 Soares, *People of Faith*, 241. If the record books were extant, it may have been possible to retrace some of the details José Francisco Pedroso provided, including the identity of his padrinho, Manuel da Cunha Barbosa.

144 Soares, *People of Faith*, 81.

145 A. L. Monroe, "Kongo Symbols, Catholic Celebrations," 206.

146 *Constituições Primeiras do Arcebispado*, 4; Russell-Wood, "Black and Mulatto Brotherhoods," 570.

147 A. C. Rodrigues, *Igreja e Inquisição no Brasil*.

148 See, for example, Borges, *Escravos e libertos nas irmandades*; A. J. M. Oliveira, *Devoção negra*; Reginaldo, *Rosários dos Angolas*; Soares, *People of Faith*; and Valerio, "Architects of their own humanity."

149 ANTT-IL, Processo 11767, f. 26r.

150 Pietz, "Problem of the Fetish, II," 37.

151 ANTT-IL, Processo 11774, f. 23v.

152 ANTT-IL, Processo 11774, f. 41v.

153 ANTT-IL, Processo 11767, f. 17v.

154 Araujo, "Dahomey, Portugal, and Bahia," 2, 4.

155 Kea, "Firearms and Warfare," 194.

156 As quoted in Thornton, *Warfare in Atlantic Africa*, 82. A French observer later saw Agaja personally distributing gunpowder to Dahomean troops at the beginning of a military campaign; see Robin Law, *Slave Coast of West Africa*, 272.

157 The continued use of gunpowder for graphic and ground writing in contemporary Kongo-associated ritual practices in Cuba and Brazil suggests the need for further investigations of the connections between African-inspired religiosities and the material history of the slave trade. See Martínez-Ruíz, *Kongo Graphic Writing*, 74.

158 It was common practice in Hueda and Dahomey to welcome European traders with firearm salutes; see Norris, "Journey to the Court of Bossa Ahadee," 119–20. I thank Ana Lucia Araujo for directing me to this reference.

159 For the case of Luiza Pinta, an Angolan healer who used "abutua root" as a curative treatment in Minas Gerais, see Mott, "Feiticeiros de Angola na Inquisição," 12. For Pinto's original case, see ANTT-IL, Processo 252.

160 Harms, *Diligent*, 257–60.

161 Williams, *Capitalism and Slavery*, 63.

162 Kowalski, "Julien Sinzogan et la traite," 250n7. See also Daget, *Traite des noirs*, 92–93; and Harms, *Diligent*, 256–57.

163 Gruzinski, *Mestizo Mind*, 19.

164 Palmié, *Wizards and Scientists*, 62.

165 Palmié, *Wizards and Scientists*, 62.

166 ANTT-IL, Processo 6982, f. 10v.

167 ANTT-IL, Processo 6982, f. 10v–11r. On *cartas de marear*, see Rosario, *Carta de Marear Delineada*; and M. Pimentel, *Arte Practica de Navegar*, 68–69. Pimentel's text is largely based on the work of his father: see L. S. Pimentel, *Arte pratica de navegar*.

168 Correia, "Arte de navegar."
169 M. Pimentel, *Arte Practica de Navegar*, 231.
170 Russo, *Untranslatable Image*, 3.
171 Russo, *Untranslatable Image*, 3.
172 Russo, *Untranslatable Image*, 7.
173 Collier, *Media Primitivism*, 16.

Chapter 3: Markings

A shortened version of chapter 3 appears as "Leave No Mark: Blackness and Inscription in the Inquisitorial Archive," in *Black Modernisms in the Transatlantic World*, edited by Steven Nelson and Huey Copeland (New Haven, CT: Yale University Press, 2023).

1 Spillers, "Mama's Baby, Papa's Maybe," 67.
2 Bryant, *Rivers of Gold*, 52.
3 Spillers, "Mama's Baby, Papa's Maybe," 67.
4 *Comissários* were mid-level bureaucrats responsible for processing denunciation letters received from across the empire. They would forward cases to prosecutors if they felt the denunciations warranted further investigation. Comissários could choose to take no action on a case for a series of reasons, including that the described crimes were not important enough to pursue, or because they lacked identifying information.
5 ANTT-IL, Correspondência Recebida de Comissários, Livro 922, f. 378r.
6 ANTT-IL, Correspondência Recebida de Comissários, Livro 922, f. 378r.
7 ANTT-IL, Cadernos do Promotor, No. 72, Livro 266, f. 77–91.
8 ANTT-IL, Cadernos do Promotor, No. 72, Livro 266, f. 291r–291v.
9 ANTT-IL, Correspondência Recebida de Comissários, Livro 922, f. 626r.
10 ANTT-IL, Correspondência Recebida de Comissários, Livro 922, f. 626r.
11 ANTT-IL, Processo 2355.
12 ANTT-IC, Processo 1630, f. 7v.
13 ANTT-IL, Correspondência Recebida de Comissários, Livro 922, f. 378r. To my knowledge São Boaventura's letter is the only extant reference to this decree. This is not surprising, as copies of the decrees were not preserved in inquisitorial archives.
14 ANTT-IL, Maço 61, No. 2, "Editais Para Denúncia de Quem Practicou o Crime de Heresia e Apostasia," 1653.
15 For a detailed description and interpretation of the Inquisition's system for distributing editais and other notices, see A. C. Rodrigues, *Igreja e Inquisição*, 261–83.
16 Lapa, *Livro da Visitação do Santo Ofício*, 125.
17 ANTT-IL, Maço 63, No. 22, "Editais do Conselho Geral do Santo Ofício e Certidões, Declarações de Publicação de Editais no Brasil," f. 3r

18 A. C. Rodrigues, *Igreja e Inquisição*, 271.

19 ANTT-IL, Maço 27, No. 41, f. IV.

20 ANTT-IL, Processo 5477.

21 ANTT-IL, Cadernos do Promotor, No. 113, Livro 305, f. 251r.

22 ANTT-IL, Maço 27, No. 20.

23 For a longer analysis of Luis de Lima's transatlantic connections and the mandinga-network in which he participated, see Sweet, "Slaves, Convicts, and Exiles."

24 ANTT-IC, Processo 1630, f. 13r.

25 Cartas de tocar are yet to be the subject of a monographic study. For the sparse scholarship on them, see Lahon, "Inquisição, pacto com o demônio," 27; Paiva, *Bruxaria e superstição*, 114; and Souza, *Devil and the Land*, 143–44. Souza and Paiva also discuss their relationship to bolsas de mandinga. In turn, Souza (318) suggests that cartas de tocar were "probably specific only to colonial Brazil," but the number of examples referenced here from Portugal attests to their wider circulation.

26 Bouza, *Corre manuscrito*, 93–108.

27 ANTT-IL, Processo 1964, f. 7v, 11v. On the definition of *cabra* as "the name the Portuguese give to some Indians," see Bluteau, *Vocabulario Portuguez*, Vol. 2, Letter C, 21.

28 ANTT-IL, Processo 1964, f. 11v.

29 Previous discussions of cartas de tocar often temper the original trial language, discussing something akin to "romantic pursuits." But the language used in Luis's testimony clearly describes sexual domination and assault.

30 ANTT-IC, Processo 1630, f. 17r.

31 ANTT-IC, Processo 1630, f. 17v.

32 ANTT-IC, Processo 1630, f. 10r–10v.

33 As cited in Souza, *Devil and the Land*, 143–44.

34 ANTT-IE, Processo 3641, folio not numbered (Confession session). As cited in Paiva, *Bruxaria e superstição*, 114.

35 ANTT-IL, Maço 27, No. 20, f. 9r. See also Souza, *Devil and the Land*, 144.

36 ANTT-IL, Cadernos do Promotor 109, Livro 277, f. 86. Taveira attested that he declared the contents of the bag to be sinful and burned them prior to his deposition.

37 Healy, "Anxious and Fatal Contacts," 22.

38 Luna and Klein, "Slave Economy and Society," 4.

39 Sweet, *Recreating Africa*, 51.

40 Sweet, *Recreating Africa*, 51.

41 Aidoo, *Slavery Unseen*, 4.

42 Aidoo, *Slavery Unseen*, 3.

43 Aidoo, *Slavery Unseen*, 4.

44 Lapa, *Livro da Visitação do Santo Ofício*, 130. For a summary and analysis of this case, see M. O. A. Oliveira, "Olhares Inquisitoriais na Amazônia Portuguesa," 105–8.

45 Lapa, *Livro da Visitação do Santo Ofício*, 130.

46 Lapa, *Livro da Visitação do Santo Ofício*, 130.

47 ANTT-IL, Processo 1894, f. 112.

48 ANTT-IL, Processo 1894, f. 112.

49 Lapa, *Livro da Visitação do Santo Ofício*, 130.

50 Lapa, *Livro da Visitação do Santo Ofício*, 130.

51 ACMSP, Processos-crimes, Feitiçaria, Pascoal José de Moura, Porto Feliz, 1765. As cited in Schleumer, "Recriando Áfricas," 2.

52 ANTT-IL, Processo 9352, f. 4r.

53 Daniela Buono Calainho, noting the frequent invocation of mandinga amulets as agents of sexual dominance and protection in fights, frames them as "fundamentally masculine" objects; see Calainho, "Mandingueiros negros no mundo atlântico," 17. However, my concern is how the intertwined uses of mandingas and cartas de tocar worked, in the eyes of the Inquisition, to *produce* the image of a kind of unrestrained Black masculinity.

54 Lyotard, *Discourse, Figure*.

55 ANTT-IL, Processo 11767, f. 12r; and ANTT-IL, Processo 11774, f. 33v.

56 Abreu, "Reading in Colonial Brazil," 13. Only one book was published in Brazil prior to 1808: a 24-page pamphlet celebrating the arrival of Antônio do Desterro Malheiros, newly installed in the diocese of Rio de Janeiro, in 1747. See Cunha, *Relação da entrada que fez*. A provision issued in July of 1747 prohibited all printing in Brazil without royal authorization.

57 For an outline of white abolitionists and pro-slavery apologist debates over literacy and slavery in the mid-nineteenth-century United States, see Hager, *Word by Word*, 25–53.

58 Conrad, "Preface," xviii. Reliable data on literacy rates among the enslaved in Brazil prior to this census are notoriously difficult to uncover. For a recent study focusing on educational attainment by enslaved and free Blacks in the nineteenth century, see Bastos, "A educação dos escravos e libertos." Christianni Cardoso Morais has also analyzed signatures from wills and other legal documents from mid-eighteenth-century Minas Gerais to form a speculative and wider analysis of literacy for enslaved and free Black people in Brazil; see Morais, "Ler e escrever."

59 Hager, *Word by Word*, 31.

60 ANTT-IL, Processo 2137.

61 Guedes's race is not mentioned in the trial text.

62 ANTT-IL, Processo 11767, f. 9v.

63 Sweet, *Recreating Africa*, 186.

64 Gronniosaw, "A Narrative of the Most Remarkable Particulars," 11–12.

65 For a summary and analysis of the shifting interpretations of the Caravaca cross in seventeenth-century Iberia, see García-Arenal and Mediano, *Orient in Spain*, 215–19.

66 ANTT-IL, Processo 18003. For a detailed analysis of this case, see Rangel, "Feituras da Proteção no Recôncavo."

67 ANTT-IL, Processo 1078.

68 ANTT-IL, Processo 218.

69 ANTT-IL, Processo 6693.

70 ANTT-IL, Processo 9738.

71 ANTT-IL, Cadernos do Promotor, No. 79, Livro 272, f. 397r.

72 Sharpe, *In the Wake*, 30.

73 Fromont, "Paper, Ink, Vodun," 23.

74 Pereira, *Compendio narrativo do peregrino*, 123.

75 Frago, *Alfabetização na sociedade*, 42.

76 Wissenbach, "Cartas, procurações, escapulários," 109. The association between written papers and the possibility of enslavement (either through its authorization or protection from it) also manifested in eighteenth-century Senegambia, where claiming a Muslim identity often protected one from enslavement. See Schaffer, *Djinns, Stars, and Warriors*, 7; and Green, *Fistful of Shells*, 262.

77 ANTT-IL, Maço 27, No. 41, f. 1r.

78 ANTT-IL, Maço 27, No. 41, f. 1r.

79 Souza, *Devil and the Land*, 126.

80 ANTT-IC, Processo 1630, f. 19v–20r.

81 ANTT-IL, Processo 9972. On this case, see also Souza, *Devil and the Land*, 134; and Sweet, *Recreating Africa*, 183.

82 ANTT-IL, Cadernos do Promotor, No. 51, Livro 248, f. 283–85v.

83 BNP, Cod. 864, *Collecção de Listas impressas, e manuscriptos, dos Autos da Fé, publicos, e particulares, celebrados pela Inquisição de Evora, corrigida, e annotada, por Antonio Joaquim Moreira* (Lisbon, 1863), f. 302v.

84 ANTT-IL, Processo 6982, f. 9r–10v.

85 ANTT-IL, Maço 27, No. 20, f. 6r.

86 Rarey, "Counterwitnessing the Visual Culture."

87 ANTT-IL, Cadernos do Promotor, No. 51, Livro 248, f. 283–85v. One tostão was equivalent to 100 réis.

88 While Rama confirmed the veracity of Manuel's object in Lisbon, other mandinga trials explicitly discuss the performativity of mandingueiros' sale techniques. Research by Lexie Cook ("Before the Fetish") notes that Patrício de Andrade, whose 1690 case (ANTT-IL, Processo 3670) is discussed briefly in chapter 1, asserted he used a trick knife in his public performances to convince onlookers of the effectiveness of mandingas. Such an assertion also functioned as a defense at his trial. Cook's work in this area will open new avenues for considering the mutual imbrications of performance, Blackness, and bodily autonomy in this context.

89 The politics of water acquisition at the fountain reveal an intriguing cross-section about how race, gender, and class intersected in Lisbon's use of public utilities. Free and enslaved Black men, mulatos, and Indians, for ex-

ample, had to use the first spot, while the second was reserved for "Moors" as well as free people who also had access to the first spout. The third and fourth were reserved exclusively for white men; the fifth for Black, mulata, and Indian women; and the sixth exclusively for white women. See AML, Chancelaria da Cidade, Livro 7, f. 149.

90 This estimate comes from Richard Twiss, an English traveler to Lisbon in the 1770s, who observed that "about one fifth of the inhabitants of Lisbon consists of blacks, mulattoes, or of some intermediate tint of black and white." See Twiss, *Travels through Portugal and Spain*, 2. James H. Sweet is the first, to my knowledge, to try to parse out the populations of enslaved and free Black persons in Lisbon from this estimate; see Sweet, "Hidden Histories of African Lisbon," 236–37. Sweet's estimates are extrapolations from research on Portugal's and Lisbon's Black and enslaved population in the 1550s; see Fonseca, *Escravos no sul de Portugal*, 25; and Saunders, *Social History of Black Slaves and Freedmen in Portugal*, 50–58.

91 ANTT-IL, Maço 27, No. 41, f. 1r.

92 ANTT-IL, Maço 27, No. 41, f. 1v.

93 ANTT-IL, Livro 155, f. 566–67. As cited in Bethencourt, "*Auto da Fé*," 159n21.

94 A series of first-person accounts of Lisbon's autos-da-fé survive, most concerning the fate of Jews condemned by the Inquisition. See, for example, Lachs, "English Account of an Auto da Fe"; and Oppenheim, "Newspaper Account of an Auto da Fe."

95 Saraiva, *Marrano Factory*, 114.

96 Saraiva, *Marrano Factory*, 113.

97 Saraiva, *Marrano Factory*, 114.

98 Oppenheim, "Newspaper Account of an Auto da Fe," 181. This text's author got the details on the accused from the published auto-da-fé list, for their description repeats it nearly verbatim (see ANTT-, Tribunal do Santo Ofício, Conselho Geral, liv. 435, f. 282v.). For Manuel Lopes de Carvalho's trial, during which he declared that Christianity relied on Jewish teachings and advocated for the circumcision of Christian children, see ANTT-IL, Processo 9255. By focusing on Carvalho's dramatic public execution, the author exemplifies an increasingly common trend in foreign eyewitness accounts and produced images seeking to focus on individual subjects condemned by the Inquisition to create sympathy for them as part of a larger strategy and longer process over the seventeenth and early eighteenth centuries during which the "Inquisition became the material for an ideal 'anti-image' of the church." (Bethencourt, "*Auto da Fé*," 168.)

99 Sweet, *Domingos Álvares*, 185.

100 On Picart's Inquisition images, see Calafat, "Gallican and Jansenist Roots."

101 Recent scholarship confirms the watershed significance of *Cérémonies et coutumes* upon its publication, particularly in its use of comparative visual

imagery and text to argue for universal human qualities that underlie all religious systems and ritual practices. On the significance and influence of Picart's engravings to this end, see Hunt and Jacob, "Introduction"; and Hunt et al., *Book That Changed Europe*.

102 Sweet, "Hidden Histories of African Lisbon," 239.

103 Sweet, *Domingos Álvares*, 155.

104 ANTT, Tribunal do Santo Ofício, Conselho Geral, liv. 435, f. 290r.

105 ANTT-IL, Processo 502.

106 ANTT-IL, Processo 502.

107 ANTT-IC, Processo 1630, f. 11r.

108 ANTT-IE, Processo 7759, f. 15v.

109 ANTT-IL, Processo 15628, f. 2r.

110 Intriguingly, amulets used in West Africa also could turn their users invisible to avoid detection by authorities. John Augustus Otonba Payne, writing in early 1890s Lagos, records the use of *aferi* or "vanishing charms" that "enable a burglar . . . to disappear and elude the police" (Payne, *Table of Principal Events*, 27). I thank Lisa Earl Castillo for locating this reference.

111 See, for example, Harding, *Refuge in Thunder*, 24–27; Souza, *Devil and the Land*, 135–41; Sweet, *Recreating Africa*, 181–85.

112 Sansi, "Sorcery and Fetishism," 24.

113 On the "degrading hypervisibility" of enslaved subjects, see Hartman, *Lose Your Mother*, 36; on slavery and Blackness' "invisibility," see K. Thompson, *Shine*. For an exploration of that tension as it operates with respect to slavery and portraiture, see Lugo-Ortiz and Rosenthal, "Introduction."

114 Copeland, "Glenn Ligon and other Runaway Subjects," 85.

115 Lima et al., "Weaving the Second Skin," 108.

116 ANTT-IL, Processo 224, f. 7v.

117 Sharpe, *In the Wake*, 69. For the poems Sharpe describes, see Philip, *Zong!*

118 A. C. Rodrigues, "Deciphering Scarification in West Africa." See also A. Rodrigues, "African Body Marks, Stereotypes."

119 ANTT-IL, Correspondência Recebida de Comissários, Livro 922, f. 378r.

120 Hartman, "Venus in Two Acts," 2.

121 Hartman, "Venus in Two Acts," 5.

122 Hartman, "Venus in Two Acts," 14.

Chapter 4: Revolts

A small section of chapter 4 appeared in my essay "Counterwitnessing the Visual Culture of Brazilian Slavery," in *African Heritage and Memories of Slavery in Brazil and the South Atlantic World*, edited by Ana Lucia Araujo (Amherst, NY: Cambria Press, 2015).

1 A "Freguesia" is a secondary local administrative unit in Portugal and its former colonies.

2 *AAPEB* 53 (1996): 79. José had been enslaved to two different men since arriving in Brazil. The first was a free Black man named André, and the second a French merchant named Gey de Carter, to whom José was enslaved at the time of his trial.

3 For the most thorough history of the Malê Revolt and the insurrections leading up to it in the first three decades of the nineteenth century in Bahia, see Reis, *Rebelião Escrava no Brasil*.

4 Reis, *Rebelião Escrava no Brasil*, 427.

5 Reis, *Rebelião Escrava no Brasil*, 432–33.

6 *AAPEB* 53 (1996): 78.

7 In Yorùbá, *anjonu* broadly references a range of spiritual forces that facilitate skills, talents, or modes of protection. In some areas they are related to Hausa spirits called *isköki* (the plural of *iska*, literally "the wind"). These spirits became consolidated with Muslim *jinn* (Hausa: *aljannu*, from which "anjonu" derives) and then incorporated into Yorùbá worship, then making their way to Bahia with the heavy Yorùbá and Hausa presence in traffic in enslaved Africans to Bahia in the first decades of the nineteenth century. See Reis, *Rebelião Escrava no Brasil*, 192–93; and Chappel, "Joshua Adelakun of Mede," 96n5.

8 Reis, *Rebelião Escrava no Brasil*, 213, 231.

9 *AAPEB* 53 (1996): 80–81, 86.

10 APEB, Insurreições de escravos, Maço 2850, fol. 6v. See also Reis, *Rebelião Escrava no Brasil*, 428.

11 Reis, *Rebelião Escrava no Brasil*, 433

12 For one of the earliest descriptions and summaries of the confiscated objects, see N. Rodrigues, *Africanos no Brasil*, 92. For an analysis of the papers Rodrigues describes, see Müller, "Manuscritos Afro-Islâmicos."

13 APEB, Insurreições de escravos, Maço 2846, f. 4v–5. As cited in Reis, *Rebelião Escrava no Brasil*, 432.

14 Reichert, "Os Documentos Árabes," 174.

15 Reichert, "Os Documentos Árabes," 174. The translation from Reichert's Portuguese to English is my own.

16 On this folding ritual, see Reis, *Rebelião Escrava no Brasil*, 183. On a group of spirits known in Senegal and potentially referenced in the amuletic papers used by the revolt's participants, see Müller, "Manuscritos Afro-Islâmicos," 96.

17 As transcribed in Reichert, "Os Documentos Árabes," 170.

18 Dobronravin, "West African Ajami," 159–61.

19 *AAPEB* 54 (1996): 46.

20 *AAPEB* 54 (1996): 38.

21 *AAPEB* 53 (1996): 99. This equation between Arabic script and indecipherability in the context of revolt was not confined to Brazil. During the Saint-Domingue

revolution, one French colonel recalled often finding written papers "in the bags, or *macoutes* of the few negroes we killed. . . . Those writings were not understood by anyone. It was Arabic." See Malenfant, *Des colonies*, 212.

22 N. Rodrigues, *Africanos no Brasil*, 77. For a transcription in contemporary Brazilian Portuguese of the Count of Ponte's original letter, see Moura, *Diciónario da Escravidão Negra*, 211–13.

23 By the early nineteenth century, Brazilians—and possibly even Dahomeans enslaved in Brazil—were using the terms *mandinga* and *patuá* interchangeably; see A. C. Silva, "A Memória Histórica," 262. A 1913 Portuguese dictionary makes the transition to the term *patuá* explicit, defining it both as a Tupi word referring to a "leather *or* cloth bag, which is carried on the shoulder" as well as a "type of amulet, consisting of a sack of leather, containing snake heads and other things, to which are attributed miraculous qualities, and which the credulous carry about the neck to rid them of harm." See Figueiredo, *Novo Diccionário da Língua Portuguesa*, 1497–98.

24 For an overview of the talismanic writing and amulets used by enslaved Muslims in this context, see Diouf, *Servants of Allah*, 183–90.

25 Lamiral, *L'Affrique et le peuple*, 253.

26 Lamiral, *L'Affrique et le peuple*, 254–55.

27 Porteus, "The Gri-Gri Case."

28 Hegel, *Philosophy of History*, 96.

29 Moten, *In the Break*, 1.

30 Moten, *In the Break*, 1.

31 Moten, *In the Break*, 1.

32 Mitchell, *What Do Pictures Want?*, 28.

33 As cited in Fick, *Making of Haiti*, 111.

34 Palmié, *Wizards and Scientists*, 62.

35 Dubois, *Avengers of the New World*, 77, 105; James, *Black Jacobins*, 68–84.

36 Childs, *1812 Aponte Rebellion*, 156.

37 Palmié, *Wizards and Scientists*, 94.

38 "Digital Aponte: The 'Book of Paintings,'" http://aponte.hosting.nyu.edu/book-of-paintings/, accessed November 17, 2020.

39 Palmié, *Wizards and Scientists*, 83.

40 Mercer, *Travel and See*, 227.

41 Mercer, *Travel and See*, 244.

42 As quoted in Bastide, *African Religions of Brazil*, 106.

43 As quoted in Bastide, *African Religions of Brazil*, 106.

44 See, for example, Binger, *Du Niger au Golfe*, 321. See also Diouf, *Servants of Allah*, 184.

45 Matory, *Sex and the Empire*, 8.

46 Matory, *Sex and the Empire*, 8.

47 Matory, *Sex and the Empire*, 8.

48 Barcia, *West African Warfare*, 25–26. See also Smith, *Kingdoms of the Yoruba*, 69.

49 Lovejoy, *Transformations in Slavery*, 145.

50 Lovejoy, *Transformations in Slavery*, 147.

51 Lovejoy, *Transformations in Slavery*, 145; Barcia, *West African Warfare*, 31; and Gailey, *Lugard and the Abeokuta Uprising*, 2.

52 On the wars in the Kingdom of Egba, see Reis, *Rebelião Escrava no Brasil*, 338.

53 S. Johnson, *History of the Yorubas*, 136.

54 S. Johnson, *History of the Yorubas*, 266.

55 S. Johnson, *History of the Yorubas*, 288.

56 Akinyẹle, *Akinyẹle's Outline History*, Vol. 3, 79.

57 Reis, *Rebelião Escrava no Brasil*, 24. On the Black population of Salvador in the mid-1830s, see also Reis, "African Nations," 64–67.

58 Reis, *Rebelião Escrava no Brasil*, 177.

59 Reis, *Rebelião Escrava no Brasil*, 177.

60 On African participation in Catholic brotherhoods in Salvador in the nineteenth century, see Reis, *Death Is a Festival*, 39–65.

61 Reis, *Rebelião Escrava no Brasil*, 81–82.

62 Reis, *Rebelião Escrava no Brasil*, 82.

63 Reis, *Rebelião Escrava no Brasil*, 92.

64 Castillo and Parés, "Marcelina da Silva," 4.

65 Reis, *Rebelião Escrava no Brasil*, 460, 466–67.

66 FPV, Notas avulsas sobre insurreições de escravos, 267. As cited in Castillo and Parés, "Mareclina da Silva," 6.

67 FPV, Notas avulsas sobre insurreições de escravos, 267. As cited in Castillo and Parés, "Mareclina da Silva," 7.

68 FPV, Notas avulsas sobre insurreições de escravos, 268. As cited in Castillo and Parés, "Mareclina da Silva," 7.

69 FPV, Notas avulsas sobre insurreições de escravos, 267. As cited in Castillo and Parés, "Mareclina da Silva," 7.

70 FPV, Notas avulsas sobre insurreições de escravos, 268. As cited in Castillo and Parés, "Mareclina da Silva," 7.

71 FPV, Notas avulsas sobre insurreições de escravos, 267. As cited in Castillo and Parés, "Mareclina da Silva," 6.

72 FPV, Notas avulsas sobre insurreições de escravos, 267. As cited in Castillo and Parés, "Mareclina da Silva," 6.

73 FPV, Notas avulsas sobre insurreições de escravos, 267. As cited in Castillo and Parés, "Mareclina da Silva," 7.

74 Ewbank, *Life in Brazil*, 131.

75 Ewbank, *Life in Brazil*, 132.

76 Z. L. Frank, *Dutra's World*, 27; Reis, "African Nations," 69.

77 The Brazilian system wherein escravos de ganho could purchase their freedom expanded the slavery economy. Since enslavers set the price of one's freedom, they could charge above-market rates for it. Thus, enslavers

could use the profit from an escravo de ganho's manumission purchase to purchase more enslaved laborers.

78 Ewbank, *Life in Brazil*, 246. Ewbank also implied that all enslaved persons possessed amulets, even if he could not see them outwardly on their person.

79 Balangandā is onomatopoetic, referring to the clanging sound the objects created as their wearer moved. On pencas de balangandās, see Farelli, *Balangandās e figas da Bahia*; Cunha and Milz, *Joias de Crioula*; and S. T. V. da Silva, *Joias Crioulas*, 27–29.

80 Chenault, "Bound in Beauty," 145. On amulets and other forms of jewelry specifically associated with Candomblé, see Lody, *Joias de axé*.

81 Lara, "Signs of Color," 206. See also Lara, *Fragmentos setecentistas*, 94–100.

82 Lara, "Signs of Color," 207.

83 Lara, "Signs of Color," 207.

84 Lara, "Signs of Color," 208.

85 Lara, "Signs of Color," 209.

86 Chenault, "Bound in Beauty," 143.

87 See Araujo, "Gender, Sex, and Power," 487.

88 Trindade, "Arte Colonial," 174, 182.

89 Lara, "Signs of Color," 218.

90 Buono, "Historicity, Achronicity, and the Materiality," 25–26.

91 Browne, *Dark Matters*.

92 Mirzoeff, *Right to Look*, 50.

93 Costa, *Rochas e histórias*, 135.

94 For a catalog inventory and description of all the pelourinhos of colonial Brazil, including analyses of maps and drawings of them, see Salema, *Pelourinhos do Brasil*. For a catalog of the pelourinhos throughout the entire Portuguese Empire, see Chaves, *Pelourinhos do Ultramar Português*.

95 Today, the entire historic center of Salvador, commonly referred to as "The Pelourinho," is still named for this post. Multiple initiates in Candomblé houses throughout the city have either explicitly or implicitly informed me they refuse to walk in this area because of the pain it generates for them.

96 Costa, *Rochas e histórias*, 135.

97 Schwartz, *Sovereignty and Society*, 236.

98 See Rarey, "Counterwitnessing." On "theaters of power," see Lara, *Fragmentos setecentistas*, 29–78. Lara convincingly outlines how the very distribution of colonial subjects in urban space was in fact a distribution of power relations throughout the city, and in turn, cities functioned already as an arena for the reproduction of imperial authority.

99 See Rarey, "Counterwitnessing," 81–83.

100 Lugo-Ortiz and Rosenthal, "Introduction," 6.

101 Hartman, *Scenes of Subjection*, 36.

102 Lugo-Ortiz and Rosenthal, "Introduction," 6.

103 *AAPEB* 53 (1996): 77–92.

104 Reis and Mamigonian, "Nagô and Mina," 82.

105 Lugo-Ortiz and Rosenthal, "Introduction," 7. The original text is from Article 19 of the "Reglamento de Esclavos: Código Negro Hispano-Cubano," as reproduced in Ortiz, *Negros Esclavos*, 444–45. Article 19 of the code is translated into English in Paquette, *Sugar Is Made with Blood*, 269.

106 Cleveland, *Black Art in Brazil*, 128–31.

107 Browne, *Dark Matters*, 21–22.

108 *AAPEB* 53 (1996): 111.

109 *AAPEB* 53 (1996): 112.

110 APEB, Insurreições de escravos, maço 2849, f. 26–27. As translated from a transcription in Reis, *Rebelião Escrava no Brasil*, 442–43.

111 Reis, "Candomblé and Slave Resistance," 58–59; Reis and Mamigonian, "Nagô and Mina," 94–96. Reis and Mamigonian note that while many of the involved Nagôs were Muslims, the Nagô leaders of the revolt failed to enlist the help of many Hausas, who were the predominant Muslim ethnic group in the city. As such, a crossing of ethnic and religious affiliation bound the rebels together. Some of Bahia revolts were led by practitioners of Yorùbá religion. While we have already seen the permeability and adaptability of religious identities in nineteenth-century Bahia, Reis does suggest that some of these revolts were "possibly inspired by warrior [orishas], such as Ogun, the [orisha] of iron and war, who became increasingly popular in Yorubaland at the most intense phase of the Bahian slave trade from that region in the 1820s through the 1840s." Manuel Barcia (*West African Warfare*) supports this conclusion. On the expansion of the cult of Ogun in Oyo, during what he calls the "Age of Ogun," see Matory, *Sex and the Empire*, 13–22. On the expansion of Ogun devotion more generally, see Barnes and Ben-Amos, "Ogun, the Empire Builder"; and Peel, "A Comparative Analysis of Ogun."

112 Gomez, *Black Crescent*, 84, 97.

113 Gomez, *Black Crescent*, 97.

114 Tadman, *Speculators and Slaves*, xxi–xxii.

115 Mirzoeff, *Right to Look*, 55–56.

116 Reis and Mamigonian, "Nagô and Mina," 94–95.

117 Gomez, *Black Crescent*, 107. See also Diouf, *Servants of Allah*, 178–83.

118 Reichert, *Documentos Árabes,* Documento No. 30.

119 Müller, "Manuscritos Afro-Islâmicos," 95.

120 Müller, Juliane. "Manuscritos Afro-Islâmicos," 87; Dobronravin, "West African Ajami," 166. Dobronravin (166) suggests that other amuletic papers in this group should contain African languages used by their makers—such as Yorùbá—but so far none other than Hausa have been identified.

121 Dobronravin, "West African Ajami," 169.

122 Dobronravin, "West African Ajami," 162.

123 Reis, *Rebelião Escrava no Brasil*, 443–44.

Epilogue

1 Geggus, "Preface," x.

2 See Casid, *Sowing Empire*.

3 Trouillot, *Silencing the Past*, 73.

4 Trouillot, *Silencing the Past*, 70–107.

5 Trouillot, *Silencing the Past*, 73. Trouillot asks, "How does one write a history of the impossible?"

6 Hertz, "Medusa's Head."

7 AHU, Brasil, Papeis avulsos, Caixa 2 (1799–1824), Doc. 295. As transcribed in Mott, "A Revolução dos Negros," 5. See also Mott, "A Escravatura."

8 AHU, Brasil, Papeis avulsos, Caixa 2 (1799–1824), Doc. 295. As transcribed in Mott, "A Revolução dos Negros," 5.

9 AHU, Brasil, Papeis avulsos, Caixa 2 (1799–1824), Doc. 295. As transcribed in Mott, "A Revolução dos Negros," 5.

10 Mott, "A Revolução dos Negros." 5.

11 Mott, "A Revolução dos Negros." 5.

12 See Nascimento, "'São Domingos.'"

13 ANRJ, IG 105, Ministério da Guerra, Sergipe, Correspondencia do Presidente da Provincia, f. 119. As cited in Nascimento, "São Domingos," 126.

14 AHU, Brazil Diversos, Caixa 2 (1799–1824), Doc. 295. As transcribed in Mott, "A Revolução dos Negros," 6–7. See also Mott, "Documento Inédito para a História."

15 Kelley, *Freedom Dreams*, ix.

16 In this vein, Ana Lucia Araujo has traced the reemergence of images of, and monuments to, "slave and free black fighters" and "iconic rebels" across the Americas in the 1960s, which had replaced an earlier focus on submissive or docile enslaved figures. Collectively, she cites the emergence of this new imagery in the context of political fights against US imperialism and European colonization: a point that underscores the ongoing utility of the past in public memory. See Araujo, *Shadows of the Slave Past*, 180.

Bibliography

Abbreviations

AAPEB	*Anais do Arquivo Público do Estado da Bahia*
ACMSP	Arquivo da Cúria Metropolitana de São Paulo, São Paulo
AHN	Archivo Histórico Nacional de España, Madrid
AHU	Arquivo Histórico Ultramarino, Lisbon
AIGHB	Arquivo do Instituto Histórico e Geográfico Brasileiro, Rio de Janeiro
AML	Arquivo Municipal de Lisboa, Lisbon
ANRJ	Arquivo Nacional, Rio de Janeiro
ANTT-IC	Arquivo Nacional da Torre do Tombo, Lisbon–Inquisição de Coimbra
ANTT-IE	Arquivo Nacional da Torre do Tombo, Lisbon–Inquisição de Évora
ANTT-IL	Arquivo Nacional da Torre do Tombo, Lisbon–Inquisição de Lisboa
APEB	Arquivo Público do Estado da Bahia, Salvador
AUC	Arquivo da Universidade de Coimbra, Coimbra
BNP	Biblioteca Nacional de Portugal, Lisbon
FBN	Fundação Biblioteca Nacional, Rio de Janeiro
FPV	Fundação Pierre Verger, Salvador
GEAEM	Gabinete de Estudos Arqueológicos e da Engenharia Militar, Lisbon
SCMBA	Santa Casa de Misericórdia da Bahia, Salvador
TASTD	Trans-Atlantic Slave Trade Database

Primary Sources

Anonymous. *Devoção Do Santissimo Coração de Jesus.* Coimbra: Antonio Simoens Ferreyra, 1734.

Antonil, André João. *Cultura, e opulencia do Brasil por suas drogas, e minas.* Lisbon: Officina Real Deslandesiana, 1711.

Barbot, Jean. *A Description of the Coasts of North and South-Guinea.* London: A. & J. Churchill, 1732.

Barros, João de. "Extracts from the 'Decadas da India' of João de Barros." In *The Voyages of Cadamosto and Other Documents on Western Africa in the Second Half of the Fifteenth Century.* Translated and edited by G. R. Crone, 103–48. London: Hakluyt Society, 1937.

Bernard, Jean Frederic. *Cérémonies et coutumes religieuses de tous les peoples du monde*, Vol. 2. Amsterdam: J. F. Bernard, 1723.

Binger, Louis Gustave. *Du Niger au Golfe de Guinée par le pays de Kong et le Mossi*, Vol. 1. Paris: Imprimiere Lahure, 1892.

Bluteau, Raphael. *Diccionario da Lingua Portugueza*, Vol. 2, *L–Z*. Edited and expanded by Antonio Moraes Silva. Lisbon: Simão Thaddeo Ferreira, 1789.

Bluteau, Raphael. *Vocabulario Portuguez, e Latino*, Vol. 2, *B–C*. Coimbra: Collegio das Artes da Companhia de Jesu, 1712.

Bluteau, Raphael. *Vocabluario Portuguez, e Latino*, Vol. 4, *F–J*. Coimbra: Real Collegio das Artes da Companhia de Jesu, 1713.

Bluteau, Raphael. *Vocabluario Portuguez, e Latino*, Vol. 5, *K–N*. Lisbon: Pascoal da Sylva, 1716.

Bowdich, Thomas. *Mission from Cape Coast Castle to Ashantee*. London: John Murray, 1819.

Constituições Primeiras do Arcebispado da Bahia. São Paulo: Typographia 2 de Dezembro, 1853.

Constituiçõens Syndoaes do Bispado do Lamego, Feitas pelo Illustrissimo, & Reverendissimo Senhor D. Miguel de Portugal, Publicadas, e Aceitas no Synodo, que o dito Senhor celebrou em o anno de 1639. Lisbon: Miguel Deslandes, 1683.

Corry, Joseph. *Observations Upon the Windward Coast of Africa*. London: W. Bulmer and Co., 1807.

Cunha, Luís Antonio Rosada da. *Relação da entrada que fez o excellentissimo, e reverendissimo senhor D. Fr. Antonio do Desterro Malheyro*. Rio de Janeiro: Antonio Isidoro da Fonseca, 1747.

de Brosses, Charles. "On the Worship of Fetish Gods: Or, A Parallel of Ancient Religion of Egypt with the Present Religion of Nigritia." Translated by Daniel H. Leonard. In *The Returns of Fetishism: Charles de Brosses and the Afterlives of an Idea*, edited by Rosalind C. Morris and Daniel H. Leonard, 44–132. Chicago: University of Chicago Press, 2017.

de Marees, Pieter. *Description et récit historial du riche royaume d'or de Guinea, aultrement nommé, la coste de l'or de Mina, gisante en certain endroict d'Africque*. Amsterdam: Comille Claesson, 1605.

Dubroca, Jean-Louis. *Vida de J. J. Dessalines, Gefe de los Negros de Santo Domingo; con notas muy circunstanciadas sobre el origen, caracter y atrocidades de los principales gefes de aquellos rebeldes desde el principio de la insurreccion en 1791*. Mexico City: D. Mariano de Zúñiga y Ontiveros, 1806.

Dupuis, Joseph. *Journal of a Residence in Ashantee*. London: Henry Colburn, 1824.

Ewbank, Thomas. *Life in Brazil; or, A Journal of a Visit to the Land of the Cocoa and the Palm*. New York: Harper & Brothers, 1856.

Feijó, João de Morais Madureira. *Orthographia, ou Arte de Escrever, e Pronunciar com acerto a Lingua Portugueza*. Lisbon: Miguel Rodrigues, 1734.

Fernandes, Valentim. *O Manuscrito de "Valentim Fernandes." Oferecido à Academia por Joaquim Bensaúde. Leitura e revisão das Provas pelo académico titular fundador António Baião*. Lisbon: Editorial Atica, 1940.

Figueiredo, Cândido de. *Novo Diccionário da Língua Portuguesa*. Lisbon: Livraria Clássica Editora, 1913.

Froger, François. *A relation of a voyage made in the years 1695, 1696, 1697 on the coasts of Africa, streights of Magellan, Brasil, Cayenna, and the Antilles*. London: M. Gillyflower, W. Freeman, M. Wotton, J. Walthoe, and R. Parker, 1698.

Green, Toby, Philip Havik, and F. Ribeiro da Silva, eds. *African Voices from the Inquisition, Vol. 1: The Trial of Crispina Peres of Cacheu, Guinea-Bissau (1646–1668)*. Oxford: Oxford University Press, 2021.

Gronniosaw, James Albert Ukawsaw. "A Narrative of the Most Remarkable Particulars in the Life of James Albert Ukawsaw Gronniosaw, an African Prince, As related by Himself." In *Slave Narratives*, edited by William Andrews and Henry Louis Gates, Jr., 1–34. New York: Library of America, 2000.

Guerreiro, Fernão. *Relação Anual das Coizas que Fizeram a os Padres da Companhia de Jesus nas suas Missões nos Anos de 1600 a 1609*. Vol. 3, *1607 a 1609*. Edited by Artur Viegas. Coimbra: Imprensa da Universidade, 1942.

Hair, P. E. H. *An Interim and Makeshift Edition of Andre Alvares de Almada's Brief Treatise on the Rivers of Guinea, being an English translation of a variorum text of Tratado breve dos Rios de Guiné (c. 1594), organized by Avelino Teixeira da Mota, together with an incomplete annotation*. Liverpool: Department of History, University of Liverpool, 1984.

Hair, P. E. H. *An Interim Translation of Manual Alvares S. J., Etiopia Menor e Descripcao Geografica da Provincia da Serra Leoa [c. 1615] ("Ethiopia Minor and a geographical account of the Province of Sierra Leone")*. Liverpool: Department of History, University of Liverpool, 1990.

Hair, P. E. H. "Sources on Early Sierra Leone (7): Barreira Letter of 9.3.1607." *Africana Research Bulletin* 6, no. 2 (1976): 45–70.

Hopkins, J. F. P., and Nehemia Levtzion, eds. *Corpus of Early Arabic Sources for West African History*. Princeton, NJ: Markus Wiener Publishers, 2000.

Hunwick, John O. *Timbuktu and the Songhay Empire: Al-Saʻdī's Taʼrīkh al-sūdān down to 1613 and other contemporary documents*. Leiden: Brill, 2003.

Hunwick, John O., ed. *Sharīʻa in Songhay: The Replies of al-Maghīlī to the Questions of Askia al-Ḥājj Muḥammad*. Oxford: Oxford University Press, 1985.

Jannequin, Claude. *Voyage de Lybie au royaume de Sénégal, le long du Niger*. Paris: Charles Roüillard, 1639.

Jobson, Richard. *The Golden Trade: Or, A Discovery of the River of Gambra, and the Golden Trade of the Aethiopians*. London: Nicholas Okes, 1623.

Jones, Adam, ed. *Brandenburg Sources for West African History 1680–1700*. Stuttgart: Franz Steiner Verlag Wiesbaden, 1985.

Julião, Carlos. *Riscos Illuminados de Figurinhos Brancos e Negros dos Uzos do Rio de Janeiro e Serro do Frio*. Rio de Janeiro: Biblioteca Nacional, 1960.

Labat, R. Pere. *Voyage du chevalier des Marchais en Guinée, isles voisines, et a Cayenne, fait en 1725, 1726, & 1727*, Vol 2. Paris: Chez Saugrain, 1730.

Lachs, Phyllis S. "An English Account of an Auto da Fe: Lisbon, 1669." *Jewish Quarterly Review* 57, no. 4 (1967): 319–26.

Lamiral, Dominique Harcourt. *L'Affrique et le peuple affriquain, considérés sous tous leurs rapports avec notre commerce & nos colonies*. Paris: Dessenne, 1789.

Lapa, José Roberto do Amaral, ed. *Livro da Visitação do Santo Ofício da Inquisição ao Estado do Grão-Para 1763–1769*. Petrópolis: Vozes, 1978.

Malenfant, Colonel. *Des colonies, et particulièrement de celle de Saint-Domingue*. Paris: Chez Audibert, 1814.

Monod, Théodore, Raymond Mauny, and A. Teixeira de Mota. *Description de la côte occidentale d'Afrique (Sénégal au Cap de Monte, Archipels) par Valentim Fernandes (1506–1510)*. Bissau: Centro de Estudos da Guiné Portuguesa, 1951.

Monteiro, Fr. Pedro. *Historia da Santa Inquisição do Reyno de Portugal e suas Conquistas*, Part 1, Vol. 2. Lisbon: Regia Officina Sylviana, e da Academia Real, 1749.

Mota, A. T. da, and P. E. H. Hair, eds. *André Donelha: Descrição da Serra Leoa e dos rios da Guiné do Cabo Verde (1625)*. Lisbon: Junta de Investigações Científicas do Ultramar, 1977.

Murray, Hugh. *Historical Account of Discoveries and Travels in Africa, From the Earliest Ages to the Present Time*, 2nd ed., Vol. 1. Edinburgh: Archibald Constable and Company, 1818.

Norris, Robert. "A Journey to the Court of Bossa Ahadee, King of Dahomy, In the Year 1772." In Archibald Dalzel, *The History of Dahomy: An Inland Kingdom of Africa*, 106–49. London: T. Spilsbury and Son, 1793.

Oppenheim, Samuel. "A Newspaper Account of an Auto da Fe in Lisbon in 1726, in which a Jew, a Native of Bahia, South America, was Burnt." *Publications of the American Jewish Historical Society* 22 (1914): 180–82.

Payne, John Augustus Otonba. *Table of Principal Events in Yoruba History, with Certain Other Matters of General Interest, Compiled Principally for Use in the Courts Within the British Colony of Lagos, West Africa*. Lagos: Andrew M. Thomas, 1893.

Pereira, Duarte Pacheco. *Esmeraldo de Situ Orbis*. Lisbon: Imprensa Nacional, 1892.

Pereira, Nuno Marques. *Compendio narrativo do peregrino da America: Em que se tratam varios discursos espirituaes, e moraes, com muitas advertencias, e documentos contra os abusos, que se achaõ introduzidos pela malicia diabolica no Estado do Brasil*. Lisbon: Manoel Fernandes da Costa, 1728.

Phillips, Thomas. "A Journal of a Voyage Made in the Hannibal of London, Ann. 1693, 1694, from England to Cape Monseradoe in Africa." In *Collection of Voyages and Travels*, Vol. 6, organized by Awnsham Churchill and John Churchill, 173–239. London: Astley, Schwabe, 1732.

Pimentel, Luis Serrão. *Arte pratica de navegar e regimento de piloto*. Lisbon: Antonio Craesbeeck, 1681.

Pimentel, Manoel. *Arte Practica de Navegar, & Roteiro: Das Viagens, & costas maritimas do Brasil, Guine, Angola, Indias e Ilhas Orientales, e Occidentales*. Lisbon: Bernardo da Costa de Carvalho, 1699.

Rosario, Fr. Antonio do. *Carta de Marear Delineada*. Lisbon: Felipe de Sousa Villela, 1717.

Rugendas, Johann Moritz. *Voyage pittoresque dans le Brésil*. Paris: Engelmann & cie., 1835.

Silva, Alberto da Costa e. "A Memória Histórica sobre os Costumes Particulares dos Povos Africanos, com Relação Primitiva ao Reino da Guiné, e nele com Respeito ao Rei da Daomé, de Luis Antônio de Oliveira Mendes." *Afro-Ásia* 28 (2002): 251–92.

Tardieu, Amédée. *Sénégambie et Guinée*. Paris: Fermin Didot Frères, 1847.

Thevet, André. *Les singularitez de la France antarctique, autrement nommée amerique: & de plusieurs terres & isles decouvertes de nostre temps*. Paris: Maurice de la Porte, 1558.

Twiss, Richard. *Travels through Portugal and Spain in 1772 and 1773*. London: Printed for the author, 1775.

Villaut, Nicolas. *Relation des costes d'Afrique appelées Guinée*. Paris: Chez Denis Thierry, 1669.

Walker, Samuel Abraham. *Missions in Western Africa, Among the Soosoos, Bulloms, &c*. Dublin: William Curry, Jun. and Co., 1845.

Wier, Johannes. *De Praestigiis Daemonum, et Incantationibus, ac Veneficiis*, Book 5. Basel: Oporinus, 1563.

Winterbottom, Thomas. *An Account of the Native Africans in the Neighborhood of Sierra Leone*, Vol. 1. London: C. Wittingham, 1803.

Secondary Sources

Abreu, Márcia. "Reading in Colonial Brazil." In *Books and Periodicals in Brazil, 1768–1930: A Transatlantic Perspective*, edited by Ana Cláudia Suriani da Silva and Sandra Guardini Vasconcelos, 13–34. New York: Modern Humanities Research Association and Routledge, 2014.

Adandé, Joseph C. E. "*Bocio*: From Nothingness to Liminality and Minimality." In *Art History and Fetishism Abroad: Global Shiftings in Media and Methods*, edited by Gabriele Genge and Angela Stercken, 177–88. Bielefeld: transcript Verlag, 2014.

Adderley, Rosanne Marion. *"New Negroes from Africa": Slave Trade Abolition and Free African Settlement in the Nineteenth-Century Caribbean*. Bloomington: Indiana University Press, 2006.

Aidoo, Lamonte. *Slavery Unseen: Sex, Power, and Violence in Brazilian History*. Durham, NC: Duke University Press, 2018.

Akinjogbin, I. A. *Dahomey and Its Neighbours 1708–1818*. Cambridge: Cambridge University Press, 1967.

Akinyẹle, Isaac Babalola. *Akinyẹle's Outline History of Ibadan*, Vol. 3. Ibadan: Caxton Press (West Africa), 1900.

Alencastro, Luiz Felipe de. *O Trato dos Viventes: Formação do Brasil no Atlântico Sul, Séculos XVI e XVII*. São Paulo: Companhia das Letras, 2000.

Amselle, Jean-Loup. *Mestizo Logics: Anthropology of Identity in Africa and Elsewhere*. Translated by Claudia Royal. Stanford, CA: Stanford University Press, 1998.

Araujo, Ana Lucia. "Dahomey, Portugal, and Bahia: King Adandozan and the Atlantic Slave Trade." *Slavery & Abolition* 33, no. 1 (2012): 1–19.

Araujo, Ana Lucia. "Gender, Sex, and Power: Images of Enslaved Women's Bodies." In *Sex, Power, and Slavery*, edited by Gwyn Campbell and Elizabeth Elbourne, 469–99. Athens: Ohio University Press, 2014.

Araujo, Ana Lucia. *Public Memory of Slavery: Victims and Perpetrators in the South Atlantic*. Amherst, NY: Cambria Press, 2010.

Araujo, Ana Lucia. *Shadows of the Slave Past: Memory, Heritage, and Slavery*. New York: Routledge, 2014.

Austen, Ralph A. "The Sources of Gold: Narratives, Technology, and Visual Culture from the Mande and Akan Worlds." In *Caravans of Gold, Fragments in Time: Art, Culture, and Exchange across Medieval Saharan Africa*, edited by Kathleen Bickford Berzock, 63–74. Evanston, IL: Block Museum of Art, Northwestern University, 2019.

Barcia, Manuel. *West African Warfare in Bahia and Cuba: Soldier Slaves in the Atlantic World, 1807–1844*. Oxford: Oxford University Press, 2013.

Barnes, Sandra T., and Paula Girshick Ben-Amos. "Ogun, the Empire Builder." In *Africa's Ogun: Old World and New*, edited by Sandra T. Barnes, 39–64. Bloomington: Indiana University Press, 1997.

Barson, Tanya, and Peter Gorschlüter, eds. *Afro Modern: Journeys through the Black Atlantic*. Liverpool: Tate Liverpool, 2010.

Bastide, Roger. *The African Religions of Brazil: Toward a Sociology of the Interpenetration of Civilizations*. Translated by Helen Sebba. Baltimore: Johns Hopkins University Press, 1978.

Bastos, Maria Helena Camara. "A educação dos escravos e libertos no Brasil: Vestígios esparsos do domínio do ler, escrever e contar (Séculos XVI a XIX)." *Cadernos de História da Educação*, 15, no. 2 (2016): 743–68.

Bay, Edna G. *Asen, Ancestors, and Vodun: Tracing Change in African Art*. Urbana: University of Illinois Press, 2008.

Bay, Edna G. "Protection, Political Exile, and the Atlantic Slave-Trade: History and Collective Memory in Dahomey." In *Rethinking the African Diaspora: The Making of a Black Atlantic World in the Bight of Benin and Brazil*, edited by Kristin Mann and Edna G. Bay, 42–60. New York: Routledge, 2001.

Berliner, Rudolf. "Arma Christi." *Münchner Jahrbuch der Bildenden Kunst* 6 (1955): 35–153.

Bertolossi, Leonardo Carvalho. "Corpo Fechado: Tradição fetichista, as bolsas de mandinga ofereciam proteção contra males do corpo e do espírito e se popularizaram na Colônia." *Revista de Hisória*, December 9, 2017.

Bessire, Aimée. "The Power of Ephemera: Permanence and Decay in Protective Power Objects." *African Arts* 42, no. 3 (2009): 16–27.

Bethencourt, Francisco. "The *Auto da Fé*: Ritual and Imagery." *Journal of the Warburg and Courtauld Institutes* 55 (1992): 155–68.

Bethencourt, Francisco. *O imaginário da magia: Feiticeiras, adivinhos e curandeiros em Portugal no século XVI*. São Paulo: Companhia das Letras, 2004.

Blier, Suzanne Preston. *African Vodun: Art, Psychology, and Power*. Chicago: University of Chicago Press, 1995.

Blier, Suzanne Preston. "The Art of Assemblage: Aesthetic Expression and Social Experience in Danhomè." RES: *Anthropology and Aesthetics* 45 (2004): 186–210.

Blom, Huib. *Dogon: Images and Traditions*. Brussels: Momentum Publications, 2010.

Borges, Celia Maia. *Escravos e libertos nas irmandades do Rosário: Devoção e solidariedade em Minas Gerais; séculos XVIII e XIX*. Juiz da Fora: Editora UFJF, 2005.

Bouza, Fernando, *Corre manuscrito: Una historia cultural del Siglo de Oro*. Madrid: Marcial Pons, 2001.

Bravmann, René A. *Islam and Tribal Art in West Africa*. Cambridge: Cambridge University Press, 1974.

Brivio, Alessandra. *Il vodu in Africa: Metamorfosi di un culto*. Rome: Viella, 2012.

Brooks, George E. "Climate and History in West Africa." In *Transformations in Africa: Essays on Africa's Later Past*, edited by Graham Connah, 139–59. London: Leicester University Press, 1998.

Brown, Kimberly Juanita. *The Repeating Body: Slavery's Visual Resonance in the Contemporary*. Durham, NC: Duke University Press, 2015.

Browne, Simone. *Dark Matters: On the Surveillance of Blackness*. Durham, NC: Duke University Press 2015.

Bryant, Sherwin. *Rivers of Gold, Lives of Bondage: Governing through Slavery in Colonial Quito*. Chapel Hill: University of North Carolina Press, 2014.

Bucciferro, Justin E. "A Forced Hand: Natives, Africans, and the Population of Brazil, 1545–1850." *Revista de História Económica: Journal of Iberian and Latin American Economic History* 31, no. 2 (2013): 285–317.

Buono, Amy. "Crafts of Color: Tupi *Tapirage* in Early Colonial Brazil." In *The Materiality of Color: The Production, Circulation, and Application of Dyes and Pigments, 1400–1800*, edited by Andrea Freeser, Maureen Daly Goggin, and Beth Fowkes Tobin, 235–46. Burlington, VT: Ashgate, 2012.

Buono, Amy J. "History, Achronicity, and the Materiality of Cultures in Colonial Brazil." *Getty Research Journal* 7 (2015): 19–34.

Buono, Amy J. "'Their Treasures are the Feathers of Birds': Tupinambá Feather-work and the Image of America." In *Images Take Flight: Feather Art in Mexico and Europe (1400–1700)*, edited by Alessandra Russo, Gerhard Wolf, and Diana Fane, 179–89. Munich: Hirmer Verlag, 2015.

Burns, Antoinette. *Dwelling in the Archive: Women Writing House, Home, and History in Late Colonial India*. Oxford: Oxford University Press, 2006.

Cagle, Hugh. "Imperial Tensions, Colonial Contours: Jesuits, Slavery, and Race within and beyond the Portuguese Atlantic." In *The Routledge Hispanic Studies Companion to Colonial Latin America and the Caribbean (1492–1898)*, edited by Yolanda Martínez-San Miguel and Santa Arias, 215–30. New York: Routledge, 2021.

Calafat, Guillaume. "The Gallican and Jansenist Roots of Jean Frederic Bernard and Bernard Picart's Vision of the Inquisition." In *Bernard Picart and the First Global Vision of Religion*, edited by Lynn Hunt, Margaret Jacob, and Wijnand Mijnhardt, 291–312. Los Angeles: Getty Research Institute, 2010.

Calainho, Daniela Buono. "Mandingueiros negros no mundo atlântico moderno." *Trashumante: Revista Americana de Historia Social* 16 (2020): 10–32.

Calainho, Daniela Buono. *Metrópole das mandingas: Religiosidade negra e inquisição portuguesa no antigo regime*. Rio de Janeiro: Editora Garamond, 2008.

Candido, Mariana P. *An African Slaving Port and the Atlantic World: Benguela and Its Hinterland*. Cambridge: Cambridge University Press, 2013.

Camara, Brahima. "The Hunter in the Mande Imagination." *Mande Studies* 10 (2008): 121–32.

Carreira, António. "Símbolos, ritualistas e ritualismos ânimo-feiticistas na Guiné Portuguesa." *Boletim Cultural da Guiné Portuguesa* 14, no. 63 (1961): 505–41.

Carson, James Taylor. *Making an Atlantic World: Circles, Paths, and Stories from the Colonial South*. Knoxville: University of Tennessee Press, 2007.

Casid, Jill H. *Sowing Empire: Landscape and Colonization*. Minneapolis: University of Minnesota Press, 2005.

Castillo, Lisa Earl, and Luis Nicolau Parés. "Marcelina da Silva: A Nineteenth-Century *Candomblé* Priestess in Bahia." *Slavery & Abolition* 31, no. 1 (2010): 1–27.

Chappel, T. H. J. "Joshua Adelakun of Mede." *African Arts* 38, no. 1 (2005): 74–96.

Chaves, Luís. *Pelourinhos do ultramar português*. Lisbon: Divisão de Publicações e Biblioteca Agência Geral das Colónias, 1948.

Chenault, Sarah K. "Bound in Beauty: Creole Jewelry in Bahia." In *Axé Bahia: The Power of Art in an Afro-Brazilian Metropolis*, edited by Patrick A. Polk, Roberto Conduru, Sabrina Gledhill, and Randal Johnson, 142–45. Los Angeles: Fowler Museum at UCLA, 2018.

Childs, Matt D. *The 1812 Aponte Rebellion in Cuba and the Struggle against Atlantic Slavery*. Chapel Hill: University of North Carolina Press, 2006.

Cleveland, Kimberly. *Black Art in Brazil: Expressions of Identity.* Gainesville: University Press of Florida, 2013.

Collier, Delinda. *Media Primitivism: Technological Art in Africa.* Durham, NC: Duke University Press, 2020.

Conrad, Robert Edgar. "Preface." In *Children of God's Fire: A Documentary History of Black Slavery in Brazil,* edited by Robert Edgar Conrad, xv–xxvi. University Park: Pennsylvania State University Press, 1984.

Cook, Karoline P. *Forbidden Passages: Muslims and Moriscos in Colonial Spanish America.* Philadelphia: University of Pennsylvania Press, 2016.

Cook, Lexie. "Before the Fetish: Artifice and Trade in Early Modern Guinea." PhD diss., Columbia University, 2022.

Copeland, Huey. *Bound to Appear: Art, Slavery, and the Site of Blackness in Multicultural America.* Chicago: University of Chicago Press, 2011.

Copeland, Huey. "Glenn Ligon and Other Runaway Subjects." *Representations* 113, no. 1 (2011): 73–110.

Copeland, Huey. "In the Wake of the Negress." In *Modern Women: Women Artists at the Museum of Modern Art,* edited by Cornelia Butler and Alexandra Schwartz, 480–97. New York: Museum of Modern Art, 2011.

Corrêa, Luís Rafael Araújo. *Feitiço Caboclo: Um Índio Mandingueiro Condenado Pela Inquisição.* Jundiaí: Paco Editorial, 2018.

Correia, Carlos Alberto Calinas. "A arte de navegar de Manoel Pimentel: As edições de 1699 e 1712." MA thesis, Universidade de Lisboa, 2010.

Costa, Antônio Gilberto. *Rochas e histórias do patrimônio cultural do Brasil e de Minas.* Rio de Janeiro: Bem-Te-Vi, 2009.

Costa, Leonor Freire, Pedro Lains, and Susana Münch Miranda. *An Economic History of Portugal, 1143–2010.* Cambridge: Cambridge University Press, 2016.

Couto, Carlos. *Os Capitães-Mores em Angola no Século XVIII.* Luanda: Instituto de Investigação Científica de Angola, 1972.

Cunha, Laura, and Thomas Milz. *Joias de Crioula.* São Paulo: Editora Terceiro Nome, 2011.

Curtis, Edward E., IV. *The Call of Bilal: Islam in the African Diaspora.* Chapel Hill: University of North Carolina Press, 2014.

Curto, José C., and Paul E. Lovejoy. "Introduction: Enslaving Connections and the Changing Cultures of Africa and Brazil during the Era of Slavery." In *Enslaving Connections: Changing Cultures of Africa and Brazil during the Era of Slavery,* edited by José C. Curto and Paul E. Lovejoy, 11–18. Amherst, NY: Humanity Books, 2004.

Daget, Serge. *La traite des noirs: Bastilles négrières et velléités abolitionnistes.* Rennes: Ouest-France Université, 1990.

Dalby, David. "Distribution and Nomenclature of the Manding People and Their Language." In *Papers on the Manding,* edited by Carleton T. Hodge, 1–13. Bloomington: Indiana University, 1971.

Daniels, Kyrah Malika. "The Undressing of Two Sacred Healing Bundles: Curative Arts of the Black Atlantic in Haiti and Ancient Kongo." *Journal of Africana Religions* 1, no. 3 (2013): 416–29.

Dayan, Joan. *Haiti, History, and the Gods.* Berkeley: University of California Press, 1995.

Dean, Carolyn, and Dana Leibsohn. "Hybridity and Its Discontents: Considering Visual Culture in Colonial Spanish America." *Colonial Latin American Review* 12, no. 1 (2003): 5–35.

Delafosse, Maurice. *La langue mandingue et ses diaclects (Malinke, Bambara, Dioula)*, Vol. 1. Paris: Librarie Orientaliste Paul Geunther, 1929.

Delbourgo, James. "Slavery in the Cabinet of Curiosities: Hans Sloane's Atlantic World." London: British Museum, 2007. https://www.britishmuseum.org /PDF/Delbourgo%20essay.pdf.

Digital Aponte, "Digital Aponte: The 'Book of Paintings.'" Accessed November 17, 2020. http://aponte.hosting.nyu.edu/book-of-paintings/.

Diouf, Sylviane A. *Servants of Allah: African Muslims Enslaved in the Americas*, 15th anniversary ed. New York: NYU Press, 2013.

Dobronravin, Nikolay. "West African Ajami in the New World (Hausa, Fulfulde, Mande Languages)." In *The Arabic Script in Africa: Studies in the Use of a Writing System*, edited by Meikal Mumin and Kees Versteegh, 159–72. Leiden: Brill, 2014.

Doris, David. *Vigilant Things: On Thieves, Anti-aesthetics, and the Strange Fates of Ordinary Objects in Southwestern Nigeria.* Seattle: University of Washington Press, 2011.

Drewal, Henry John. "Mami Wata and Santa Marta: Imag(in)ing Selves and Others in Africa and the Americas." In *Images and Empires: Visuality in Colonial and Postcolonial Africa*, edited by Paul S. Landau and Deborah D. Kaspin, 193–211. Berkeley: University of California Press, 2002.

Dubois, Laurent. *Avengers of the New World: The Story of the Haitian Revolution.* Cambridge, MA: Harvard University Press, 2004.

Einarsdóttir, Jónína. *Tired of Weeping: Mother Love, Child Death, and Poverty in Guinea-Bissau*, 2nd ed. Madison: University of Wisconsin Press, 2004.

Fanon, Frantz. *Black Skin, White Masks.* Translated by Charles Lam Markham. London: Pluto Press, 2008.

Farelli, Maria Helena. *Balangandãs e figas da Bahia: O poder mágico dos amuletos.* Rio de Janeiro: Editora Pallas, 1981.

Farias, Paulo F. de Moraes. "Islam in the West African Sahel." In *Sahel: Art and Empires on the Shores of the Sahara*, edited by Alisa LaGamma, 108–37. New York: The Metropolitan Museum of Art, 2020.

Ferrarini, Lorenzo. "The Shirts of the Donso Hunters: Materiality and Power between Concealment and Visual Display." *African Studies Review* 62, no. 1 (2019): 76–98.

Fick, Carolyn E. *The Making of Haiti: The Saint-Domingue Revolution from Below.* Knoxville: University of Tennessee Press, 1990.

Figueiredo, João de Castro Maia Veiga de. "Política, Escravatura e Feitiçaria em Angola (séculos XVIII e XIX)." PhD diss., Universidade de Coimbra, 2015.

Findlen, Paula. *Possessing Nature: Museums, Collecting, and Scientific Culture in Early Modern Italy.* Berkeley: University of California Press, 1994.

Finley, Cheryl. *Committed to Memory: The Art of the Slave Ship Icon.* Princeton, NJ: Princeton University Press, 2018.

Fischer, Sibylle. "Atlantic Ontologies: On Violence and Being Human." *e-Misférica* 12, no. 1 (2015). https://hemisphericinstitute.org/en/emisferica-121-caribbean-rasanblaj/12-1- essays/e-121-essay-fischer-atlantic-ontologies.html.

Fonseca, Jorge. *Escravos no sul de Portugal: Séculos XVI–XVII.* Lisbon: Editora Vulgata, 2002.

Frago, Antonio Viñao. *Alfabetização na sociedade e na história.* Porto Alegre: Artes Medicas, 1993.

Frank, Barbara E. "Soninke *garankéw* and Bamana-Malinke *jeliw*: Mande Leatherworkers, Identity, and the Diaspora." In *Status and Identity in West Africa: Nyamakalaw of Mande*, edited by David C. Conrad and Barbara E. Frank, 133–52. Bloomington: Indiana University Press, 1995.

Frank, Zephyr L. *Dutra's World: Wealth and Family in Nineteenth-Century Rio de Janeiro.* Albuquerque: University of New Mexico Press, 2004.

Fromont, Cécile. *The Art of Conversion: Christian Visual Culture in the Kingdom of Kongo.* Chapel Hill: University of North Carolina Press, 2014.

Fromont, Cécile. "Paper, Ink, Vodun, and the Inquisition: Tracing Power, Slavery, and Witchcraft in the Early Modern Portuguese Atlantic." *Journal of the American Academy of Religion* 88, no. 2 (2020): 1–45.

Fusco, Coco. *The Bodies That Were Not Ours and Other Writings.* London: Routledge, 2001.

Gagliardi, Susan Elizabeth. *Senufo Unbound: Dynamics of Art and Identity in West Africa.* Cleveland: The Cleveland Museum of Art, 2015.

Gagliardi, Susan Elizabeth, and Yaëlle Biro. "Beyond Single Stories: Addressing Dynamism, Specificity, and Agency in Arts of Africa." *African Arts* 52, no. 4 (2019): 1–6.

Gailey, Harry A. *Lugard and the Abeokuta Uprising: The Demise of Egba Independence.* London: Routledge, 2013.

García-Arenal, Mercedes, and Fernando Rodríguez Mediano. *The Orient in Spain: Converted Muslims, the Forged Lead Books of Granada, and the Rise of Orientalism.* Translated by Consuelo López-Morillas. Leiden: Brill, 2013.

Gayk, Shannon. "Early Modern Afterlives of the *Arma Christi*." In *The Arma Christi in Medieval and Early Modern Material Culture: Objects, Representations, and Devotional Practice*, edited by Lisa H. Cooper and Andrea Denny-Brown, 273–307. Burlington, VT: Ashgate, 2014.

Geggus, David P. "Preface." In *The Impact of the Haitian Revolution in the Atlantic World*, edited by David P. Geggus, ix–xviii. Columbia: University of South Carolina Press, 2001.

Gemmeke, Amber B. *Marabout Women in Dakar: Creating Trust in a Rural Urban Space*. Zurich: LIT Verlag, 2008.

Genge, Gabriele. "Survival of Images? Fetish and the Concept of the Image between West Africa and Europe." In *Art History and Fetishism Abroad: Global Shiftings in Media and Methods*, edited by Gabriele Genge and Angela Stercken, 29–56. Bielefeld: transcript Verlag, 2014.

Gikandi, Simon. "Rethinking the Archive of Enslavement." *Early American Literature* 50, no. 1 (2015): 81–102.

Gilroy, Paul. *The Black Atlantic: Modernity and Double Consciousness*. Cambridge, MA: Harvard University Press, 1993.

Goldberg, Howard I., Fara G. M'Bodji, and Jay S. Friedman. "Fertility and Family Planning in One Region of Senegal." *International Family Planning Perspectives* 12, no. 4 (1986): 116–22.

Gomes, Mário Varela, Tánia Manuel Casimiro, and Claudia Rodrigues Manso. "Afro-Portuguese Ivories from Sierra Leone and Nigeria (Yoruba and Benin Kingdoms) in Archaeological Contexts from Southern Portugal." *African Arts* 53, no. 4 (2020): 24–37.

Gomez, Michael A. *Black Crescent: The Experience and Legacy of Black Muslims in the Americas*. New York: Cambridge University Press, 2005.

Gómez, Pablo F. *The Experiential Caribbean: Creating Knowledge and Healing in the Early Modern Atlantic*. Chapel Hill: University of North Carolina Press, 2017.

Gómez, Pablo F. "Transatlantic Meanings: African Rituals and Material Culture in the Early Modern Spanish Caribbean." In *Materialities of Ritual in the Black Atlantic*, edited by Akinwumi Ogundiran and Paula Saunders, 125–42. Bloomington: Indiana University Press, 2014.

Gómez Zuluaga, Pablo Fernando. "Bodies of Encounter: Health, Illness and Death in the Early Modern African-Spanish Caribbean." PhD diss., Vanderbilt University, 2010.

Gott, Suzanne. "Native Gold, Precious Beads, and the Dynamics of Concealed Power in Akan Beliefs and Practices." *Etnofoor* 25, no. 1 (2013): 48–77.

Green, Toby. *A Fistful of Shells: West Africa from the Rise of the Slave Trade to the Age of Revolution*. Chicago: University of Chicago Press, 2019.

Green, Toby. *The Rise of the Trans-Atlantic Slave Trade in Western Africa, 1300–1589*. Cambridge: Cambridge University Press, 2011.

Gruzinski, Serge. *The Mestizo Mind: The Intellectual Dynamics of Colonization and Globalization*. Translated by Deke Dusinberre. New York: Routledge, 2002.

Gschwend, Annemarie Jordan. "*Olisipo, Emporium Nobilissimum:* Global Consumption in Renaissance Lisbon." In *The Global City on the Streets of Renaissance Lisbon*, edited by Annemarie Jordan Gschwend and K. J. P. Lowe, 140–61. London: Paul Holberton Publishing, 2015.

Guerrero-Mosquera, Andrea. "Bolsas mandingas en Cartagena de Indias durante el siglo XVII." *Memorias: Revista Digital de Historia y Arqueología desde el Caribe colombiano* 43 (2021): 69–93.

Hager, Christopher. *Word by Word: Emancipation and the Act of Writing*. Cambridge, MA: Harvard University Press, 2013.

Hall, Bruce S. *A History of Race in Muslim West Africa, 1600–1960*. Cambridge: Cambridge University Press, 2011.

Hall, Gwendolyn Midlo. *Africans in Colonial Louisiana: The Development of Afro-Creole Culture in the Eighteenth Century*. Baton Rouge: Louisiana State University Press, 1992.

Hamès, Constant. "La notion de magie dans le Coran." In *Coran et talismans: Textes et pratiques magiques en milieu musulman*, edited by Constant Hamès, 17–47. Paris: Éditions Karthala, 2007.

Hamès, Constant. "L'usage talismanique du Coran." *Revue de l'histoire des religions* 218, no. 1 (2001): 83–95.

Harding, Rachel E. *A Refuge in Thunder: Candomblé and Alternative Spaces of Blackness*. Bloomington: Indiana University Press, 2000.

Harms, Robert. *The Diligent: A Voyage through the Worlds of the Slave Trade*. New York: Basic Books, 2002.

Hartman, Saidiya. *Lose Your Mother: A Journey along the Atlantic Slave Route*. New York: Farrar, Straus and Giroux, 2007.

Hartman, Saidiya. *Scenes of Subjection: Terror, Slavery, and Self-Making in Nineteenth-Century America*. New York: Oxford University Press, 1997.

Hartman, Saidiya. "Venus in Two Acts." *Small Axe* 12, no. 2 (2008): 1–14.

Havik, Philip J. "Gendering the Black Atlantic: Women's Agency in Coastal Trade Settlements in the Guinea Bissau Region." In *Women in Port: Gendering Communities, Economies, and Social Networks in Atlantic Port Cities, 1500–1800*, edited by Douglas Catterall and Jodi Campbell, 315–56. Leiden: Brill, 2012.

Havik, Philip J. *Silences and Soundbites: The Gendered Dynamics of Trade and Brokerage in the Pre-colonial Guinea Bissau Region*. Münster: LIT Verlag, 2004.

Havik, Philip J. "Walking the Tightrope: Female Agency, Religious Practice, and the Portuguese Inquisition on the Upper Guinea Coast (Seventeenth Century)." In *Bridging the Early Modern Atlantic World: People, Products, and Practices on the Move*, edited by Caroline A. Williams, 173–91. Burlington, VT: Ashgate, 2009.

Hawthorne, Walter. *From Africa to Brazil: Culture, Identity, and an Atlantic Slave Trade, 1600–1830*. New York: Cambridge University Press, 2010.

Healy, Margaret. "Anxious and Fatal Contacts: Taming the Contagious Touch." In *Sensible Flesh: On Touch in Early Modern Culture*, edited by Elizabeth D. Harvey, 22–38. Philadelphia: University of Pennsylvania Press, 2003.

Hegel, G. W. F. *The Philosophy of History*. Translated by J. Sibree. New York: Dover Publications, 1956.

Helton, Laura, Justin Leroy, Max Mishler, Samantha Seeley, and Shauna Sweeney. "The Question of Recovery: An Introduction." *Social Text* 33, no. 4 (2015): 1–18.

Henige, David, and Marion Johnson. "Agaja and the Slave Trade: Another Look at the Evidence." *History in Africa* 3 (1976): 57–67.

Herskovits, Melville J. *Dahomey: An Ancient West African Kingdom*, Vol. 2. Evanston, IL: Northwestern University Press, 1967.

Herskovits, Melville J. *The Myth of the Negro Past*. Boston: Beacon Press, 1941.

Herskovits, Melville J. "The Negro in Bahia, Brazil: A Problem in Method." *American Sociological Review* 8, no. 4 (1943): 394–404.

Hertz, Neil. "Medusa's Head: Male Hysteria under Political Pressure." *Representations* 4 (1983): 27–54.

Heywood, Linda M. *Njinga of Angola: Africa's Warrior Queen*. Cambridge, MA: Harvard University Press, 2017.

Heywood, Linda M. "Portuguese into African: The Eighteenth-Century Central African Background to Atlantic Creole Cultures." In *Central Africans and Cultural Transformations in the American Diaspora*, edited by Linda M. Heywood, 91–114. Cambridge: Cambridge University Press, 2002.

Higgins, Kathleen J. *"Licentious Liberty" in a Brazilian Gold-Mining Region: Slavery, Gender, and Social Control in Eighteenth-Century Sabará, Minas Gerais*. University Park: Pennsylvania State University Press, 1999.

Horta, José da Silva. "Evidence for a Luso-African Identity in 'Portuguese' Accounts on 'Guinea of Cape Verde' (Sixteenth–Seventeenth Centuries)." *History in Africa* 27 (2000): 99–130.

Huerta, Monica. *The Unintended: Photography, Property, and the Aesthetics of Racial Capitalism*. New York: NYU Press, forthcoming 2024.

Hunt, Lynn, and Margaret Jacob. "Introduction." In *Bernard Picart and the First Global Vision of Religion*, edited by Lynn Hunt, Margaret Jacob, and Wijnand Mijnhardt, 1–13. Los Angeles: Getty Research Institute, 2010.

Hunt, Lynn, Margaret Jacob, and Wijnand Mijnhardt. *The Book That Changed Europe: Picart and Bernard's Religious Ceremonies of the World*. Cambridge, MA: Harvard University Press, 2010.

Hunwick, John O. *Islam in Africa: Friend or Foe; An Inaugural Lecture Delivered at the University of Ghana, Legon, on Wednesday, 10th December, 1975*. Accra: Ghana Universities Press, 1976.

Ijagbemi, Adeleye. "'Rothoron' (The North-East) in Temne Tradition and History: An Essay in Ethno-History." *Journal of the Historical Society of Nigeria* 8, no. 4 (1977): 31–47.

Iyanaga, Michael. "Why Saints Love Samba: A Historical Perspective on Black Agency and the Rearticulation of Catholicism in Bahia, Brazil." *Black Music Research Journal* 35, no. 1 (2015): 119–47.

James, C. L. R. *The Black Jacobins: Toussaint L'Ouverture and the San Domingo Revolution*, 2nd ed. New York: Vintage Books, 1989.

Jansen, Jan. "Framing Divination: A Mande Divination Expert and the Occult Economy." *Africa: Journal of the International African Institute* 79, no. 1 (2009): 110–27.

Jay, Martin. *Force Fields: Between Intellectual History and Cultural Critique*. New York: Routledge, 1993.

Johnson, Jessica Marie. *Wicked Flesh: Black Women, Intimacy, and Freedom in the Atlantic World*. Philadelphia: University of Pennsylvania Press, 2020.

Johnson, Samuel. *The History of the Yorubas: From the Earliest Times to the Beginning of the British Protectorate*. London: George Routledge & Sons, 1921.

Kananoja, Kalle. "Healers, Idolaters, and Good Christians: A Case Study of Creolization and Popular Religion in Mid-Eighteenth-Century Angola." *International Journal of African Historical Studies* 43, no. 3 (2010): 443–65.

Kananoja, Kalle. *Healing Knowledge in Atlantic Africa: Medical Encounters, 1500–1850*. Cambridge: Cambridge University Press, 2021.

Kasfir, Sidney Littlefield. "One Tribe, One Style? Paradigms in the Historiography of African Art." *History in Africa* 11 (1984): 163–93.

Kea, R. A. "Firearms and Warfare on the Gold and Slave Coasts from the Sixteenth to the Nineteenth Centuries." *Journal of African History* 12, no. 2 (1971): 185–213.

Keefer, Katrina. "Poro, Witchcraft and Red Water in Early Colonial Sierra Leone: G. R. Nylander's Ethnography and Systems of Authority on the Bullom Shore." *Canadian Journal of African Studies / Revue canadienne des études africaines* 55, no. 1 (2021): 1–17.

Kelley, Robin D. G. *Freedom Dreams: The Black Radical Imagination*. Boston: Beacon Press, 2002.

Khayyat, Munira, Yasmine Khayyat, and Rola Khayyat. "Pieces of Us: The Intimate at Imperial Archive." *Journal of Middle East Women's Studies* 14, no. 3 (2018): 268–91.

Khwali, Abdallah. "Mouriscos e escrita: Cartas em árabe de cativos marroquinos." In *In the Iberian Peninsula and Beyond: A History of Jews and Muslims (15th–17th Centuries)*, Vol. 1, edited by José Alberto R. Silva Tavim, Maria Filomena Lopes de Barros, and Lúcia Liba Mucznik, 196–210. Newcastle-upon-Tyne: Cambridge Scholars Publishing, 2015.

Kowalski, Brigitte. "Julien Sinzogan et la traite négrière." In *Figures d'esclaves: Presences, paroles, representations*, edited by Éric Saunier, 237–54. Mont-Saint-Aignan: Presses universitaires de Rouen et du Havre, 2012.

Kriz, Kay Dian. *Slavery, Sugar, and the Culture of Refinement*. New Haven, CT: Yale University Press, 2008.

LaGamma, Alisa. "Sahelian Diasporas: Migrations from Ancient Ghana and Mali." In *Sahel: Art and Empires on the Shores of the Sahara*, edited by Alisa LaGamma, 146–93. New York: The Metropolitan Museum of Art, 2020.

Lahon, Didier. "Inquisição, pacto com o demónio, e 'magia' africana em Lisboa no século XVIII." *Topoi* 5, no. 8 (2004): 9–70.

Lara, Silvia Hunold. "Customs and Costumes: Carlos Julião and the Image of Black Slaves in Late Eighteenth-Century Brazil." *Slavery & Abolition* 23, no. 2 (2002): 123–46.

Lara, Silvia Hunold. *Fragmentos setecentistas: Escravidão, cultura, e poder na América portuguesa*. São Paulo: Companhia das Letras, 2007.

Lara, Silvia Hunold. "The Signs of Color: Women's Dress and Racial Relations in Salvador and Rio de Janeiro, ca. 1750–1815." *Colonial Latin American Review* 6, no. 2 (1997): 205–24.

Launay, Robert. *Traders without Trade: Responses to Change in Two Dyula Communities*. Cambridge: Cambridge University Press, 1982.

Law, Robin. "Ethnicities of Enslaved Africans in the Diaspora: On the Meanings of 'Mina' (Again)." *History in Africa* 32 (2005): 247–67.

Law, Robin. "The Gold Trade of Whydah in the Seventeenth and Eighteenth Centuries." In *West African Economic and Social History: Essays in Memory of Marion Johnson*, edited by David P. Henige and T. C. McCaskie, 105–18. Madison: African Studies Program, University of Wisconsin–Madison, 1990.

Law, Robin. "King Agaja of Dahomey, the Slave Trade, and the Question of West African Plantations: The Embassy of Bulfinch Lambe and Adomo* Tomo to England, 1726–32." *Journal of Imperial and Commonwealth History* 19, no. 2 (1991): 137–63.

Law, Robin. "A Neglected Account of the Dahomian Conquest of Whydah (1727): The 'Relation de la Guerre de Juda' of the Sieur Ringard of Nantes." *History in Africa* 15 (1988): 321–38.

Law, Robin. *Ouidah: The Social History of a West African Trading 'Port', 1727–1892*. Athens: Ohio University Press, 2004.

Law, Robin. *The Slave Coast of West Africa, 1550–1750: The Impact of the Slave Trade on an African Society*. New York: Oxford University Press, 1991.

Le Herissé, Auguste. *L'ancien royaume du Dahomey, moeurs, religion, histoire*. Paris: E. Larose, 1911.

Levtzion, Nehemia. *Ancient Ghana and Mali*. London: Metheun, 1973.

Levtzion, Nehemia. "The Eighteenth Century: Background to Islamic Revolutions in West Africa." In *Eighteenth Century Renewal and Reform in Islam*, edited by Nehemia Levtzion and John O. Voll, 21–38. Syracuse, NY: Syracuse University Press, 1987.

Lima, Tania Andrade, Marcos André Torres de Souza, and Glaucia Malerba Sene. "Weaving the Second Skin: Protection against Evil among the Valongo Slaves in Nineteenth-Century Rio de Janeiro." *Journal of African Diaspora Archaeology & Heritage* 3, no. 2 (2014): 103–36.

Little, Kenneth. "The Political Function of the Poro, Part 1." *Africa: Journal of the International African Institute* 35, no. 4 (1965): 349–65.

Lody, Raul. *Joias de axé: Fios-de-contas e outros adornos do corpo a joalheira afro-brasileira*. Rio de Janeiro: Bertrand Brasil, 2001.

Lopes, Gustavo Acioli and Leonardo Marques. "O outro lado da moeda: Estimativas e impactos de ouro do Brasil no tráfico transatlântico de escravos (Costa da Mina, c. 1700–1750)." cLio: *Revista de Pesquisa Histórica* 37 (2019): 5–38.

Lovejoy, Paul E. *Transformations in Slavery: A History of Slavery in Africa*, 2nd ed. Cambridge: Cambridge University Press, 2000.

Lugo-Ortiz, Agnes, and Angela Rosenthal. "Introduction." In *Slave Portraiture in the Atlantic World*, edited by Agnes Lugo-Ortiz and Angela Rosenthal, 1–38. New York: Cambridge University Press, 2013.

Luna, Francisco Vidal, and Herbert S. Klein. "Slave Economy and Society in Minas Gerais and São Paulo, Brazil in 1830." *Journal of Latin American Studies* 36, no. 1 (2004): 1–28.

Lyotard, Jean-François. *Discourse, Figure*. Translated by Antony Hudek and Mary Lydon. Minneapolis: University of Minnesota Press, 2010.

Ly-Tall, M. "The Decline of the Mali Empire." In *Africa from the Twelfth to the Sixteenth Century (General History of Africa, Volume IV)*, edited by D. T. Niane, 172–86. Paris: UNESCO, 1984.

MacDonald, Kevin C., Nikolas Gestrich, Seydou Camara, and Daouda Keita. "The 'Pays Dô' and the Origins of the Empire of Mali." In *Landscapes, Sources and Intellectual Projects of the West African Past: Essays in Honor of Paulo Fernando de Moraes Farias*, edited by Toby Green and Benedetta Rossi, 63–87. Leiden: Brill, 2018.

MacGaffey, Wyatt. "African Objects and the Idea of the Fetish." *RES: Anthropology and Aesthetics* 25 (1994): 123–31.

Marcocci, Giuseppe, and José Pedro Paiva. *História da Inquisição Portuguesa (1536–1821)*, 2nd ed. Lisbon: A Esfera dos Livros, 2016.

Mark, Peter. "European Perceptions of Black Africans in the Renaissance." In Ezio Bassani and William B. Fagg, *Africa and the Renaissance: Art in Ivory*, 21–33. New York: The Center for African Art and Prestel-Verlag, 1989.

Mark, Peter. *"Portuguese" Style and Luso-African Identity: Precolonial Senegambia, Sixteenth- Nineteenth Centuries*. Bloomington: Indiana University Press, 2002.

Martínez-Ruíz, Bárbaro. *Kongo Graphic Writing and Other Narratives of the Sign*. Philadelphia: Temple University Press, 2013.

Massing, Andreas W. "The Mane, the Decline of Mali, and Mandinka Expansion towards the South Windward Coast." *Cahiers d'Études africaines* 25, no. 97 (1985): 21–55.

Mattos, Hebe. "'Pretos' and 'Pardos' between the Cross and the Sword: Racial Categories in Seventeenth-Century Brazil." *European Review of Latin American and Caribbean Studies / Revista Europea de Estudios Latinoamericanos y del Caribe* 80 (2006): 43–55.

Matory, J. Lorand. *Black Atlantic Religion: Tradition, Transnationalism, and Matriarchy in the Afro-Brazilian Candomblé*. Princeton, NJ: Princeton University Press, 2005.

Matory, J. Lorand. *The Fetish Revisited: Marx, Freud, and the Gods Black People Make*. Durham, NC: Duke University Press, 2018.

Matory, J. Lorand. "The Homeward Ship: Analytic Tropes as Maps of and for African-Diaspora Cultural History." In *Transforming Ethnographic Knowledge*, edited by Kamari Maxine Clarke and Rebecca Hardin, 93–112. Madison: University of Wisconsin Press, 2012.

Matory, J. Lorand. *Sex and the Empire That Is No More: Gender and the Politics of Metaphor in Oyo-Yoruba Religion.* New York: Berghahn Books, 2005.

McNaughton, Patrick. "The Shirts That Mande Hunters Wear." *African Arts* 15, no. 3 (1982): 54–58, 91.

Mercer, Kobena. *Travel and See: Black Diaspora Art Practices since the 1980s.* Durham, NC: Duke University Press, 2016.

Michael C. Carlos Museum. "Hunter's Shirt, Donson Dlokiw." Emory University. Accessed January 26, 2022. https://collections.carlos.emory.edu/objects /18535/hunters-shirt-donson-dlokiw.

Mirzoeff, Nicholas. *The Right to Look: A Counterhistory of Visuality.* Durham, NC: Duke University Press, 2011.

Mitchell, W. J. T. *What Do Pictures Want? The Lives and Loves of Images.* Chicago: University of Chicago Press, 2005.

Monroe, Alicia L. "Kongo Symbols, Catholic Celebrations: Adornment and Spiritual Power in Nineteenth-Century Religious Festivals in São Paulo, Brazil." *Journal of Africana Religions* 8, no. 2 (2020): 202–31.

Monroe, J. Cameron. *The Precolonial State in West Africa: Building Power in Dahomey.* New York: Cambridge University Press, 2014.

Morais, Christianni Cardoso. "Ler e escrever: Habilidades de escravos e forros? Comarca do Rio das Mortes, Minas Gerais, 1731–1850." *Revista Brasileira de Educação* 12, no. 36 (2007): 493–504.

Moreno, Humberto Baquero. "A feitiçaria em Portugal no século XV." *Anais da Academia Portuguesa de História*, II série, Vol. 39 (1984): 21–41.

Morgan, Jennifer L. *Laboring Women: Reproduction and Gender in New World Slavery.* Philadelphia: University of Pennsylvania Press, 2004.

Morris, Rosalind C. "After de Brosses: Fetishism, Translation, Comparativism, Critique." In Rosalind C. Morris and Daniel H. Leonard, *The Returns of Fetishism: Charles de Brosses and the Afterlives of an Idea*, 133–319. Chicago: University of Chicago Press, 2017.

Mota, Thiago Henrique. "História Atlântica da islamização na África Ocidental: Senegâmbia, séculos XVI e XVII." PhD diss., Universidade Federal de Minas Gerais, 2018.

Mota, Thiago Henrique. *Portugueses e Muçulmanos na Senegâmbia: História e Representações do Islã na África (c. 1570–1625).* Curitiba: Editora Prismas, 2016.

Mota, Thiago Henrique. "'Sobre o *Alcorão* e por Maomé': Islã, produção intelectual e capital cultural na Senegâmbia (séculos XVI e XVII)." In *Estudos sobre África Ocidental: Dinâmicas culturais, diálogos atlânticos*, organized by Raissa Brescia dos Reis, Taciana Almeida Garrido de Resende, and Thiago Henrique Mota, 35–69. Curitiba: Editora Prismas, 2016.

Mota, Thiago H. "Wolof and Mandinga Muslims in the Early Atlantic World: African Background, Missionary Disputes, and Social Expansion of Islam before the Fula *Jihads*." *Atlantic Studies*, forthcoming.

Moten, Fred. *In the Break: The Aesthetics of the Black Radical Tradition*. Minneapolis: University of Minnesota Press, 2003.

Moten, Fred. "The Case of Blackness." *Criticism* 50, no. 2 (2008): 177–218.

Mott, Luiz. *Bahia: Inquisição e Sociedade*. Salvador: Editora da Universidade Federal da Bahia, 2010.

Mott, Luiz. "Feiticeiros de Angola na Inquisição Portuguesa." *Mneme: Revista de Humanidades* 11, no. 29 (2011): 1–22.

Mott, Luiz R. "A vida mística e erótica do escravo José Francisco Pereira, 1705–1736." *Revista Tempo Brasileiro* 92/93 (1988): 85–104.

Mott, Luiz R. B. "Um Documento Inédito para a História da Independência." In *1822: Dimensões*, edited by Carlos Guilherme Motta, 466–83. São Paulo: Editora Perspectiva, 1972.

Mott, Luiz R. B. "A Escravatura: A propósito de uma Representação a El-Rei sobre a escravatura no Brasil." *Revista do Instituto de Estudos Brasileiros* 14 (1973): 127–36.

Mott, Luiz R. B. "A Revolução dos Negros do Haiti e do Brasil." *Mensário do Arquivo Nacional* 13, no. 1 (1982): 3–10.

Moura, Clóvis. *Diciónario da Escravidão Negra no Brasil*. São Paulo: Editora da Universidade de São Paulo, 2004.

Müller, Juliane. "Manuscritos Afro-Islâmicos do Brasil Oitocentista: Os Amuletos Árabes da Coleção Nina Rodrigues." *Afro-Ásia* 61 (2020): 78–117.

Nagel, Alexander. "Hell Is for White People." *Cabinet Kiosk*, June 10, 2020. http://www.cabinetmagazine.org/kiosk/nagel_alexander_10_june_2020.php.

Nascimento, Washington Santos. "'São Domingos, o grande São Domingos': Repercussões e representações da Revolução Haitiana no Brasil escravista (1791–1840)." *Dimensões* 21 (2008): 125–42.

Niane, D. T. "Mali and the Second Mandingo Expansion." In *Africa from the Twelfth to the Sixteenth Century (General History of Africa, Volume IV)*, edited by D. T. Niane, 117–71. Paris: UNESCO, 1984.

Nobili, Mauro. "The Written Word: Islamic Literacy and Arabic Manuscripts in West Africa." In *Caravans of Gold, Fragments in Time: Art, Culture, and Exchange across Medieval Saharan Africa*, edited by Kathleen Bickford Berzock, 241–53. Evanston, IL: Block Museum of Art, Northwestern University, 2019.

Nooter, Mary H. "Secrecy: African Art That Conceals and Reveals." *African Arts* 26, no. 1 (1993): 54–69, 102.

Oliveira, Anderson José Machado de. *Devoção negra: Santos pretos e catequese no Brasil colonial*. Rio de Janeiro: FAPERJ Quartet, 2008.

Oliveira, Maria Olinda Andrade de. "Olhares Inquisitoriais na Amazônia Portuguesa: O Tribunal do Santo Ofício e o disciplimento dos costumes (XVII–XIX)." PhD diss., Universidade Federal do Amazonas, 2010.

Online Etymological Dictionary. "Sorcery." Accessed September 23, 2021. https://www.etymonline.com/word/sorcery.

Ortiz, Fernando. *Los Negros Esclavos*. Havana: Ciencias Sociales, 1987.

Owusu-Ansah, David. "Islamic Influence in a Forest Kingdom: The Role of Protective Amulets in Early 19th Century Asante." *Transafrican Journal of History* 12 (1983): 100–33.

Paiva, José Pedro. *Bruxaria e superstição num pais "sem caça às bruxas," 1600–1774*. Lisbon: Notícias Editorial, 1997.

Paiva, José Pedro. *Práticas e Crenças Mágicas: O medo e a necessidade dos mágicos na diocese de Coimbra (1650–1740)*. Coimbra: Livraria Minerva, 1992.

Palmié, Stephan. "Ethnogenetic Processes and Cultural Transfer." In *Slavery in the Americas*, edited by Wolfgang Binder, 335–64. Würzburg: Königshausen and Neumann, 1993.

Palmié, Stephan. *Wizards and Scientists: Explorations in Afro-Cuban Modernity and Tradition*. Durham, NC: Duke University Press, 2002.

Pantoja, Selma. "Inquisição, degredo e mestiçagem em Angola no século XVIII." *Revista Portuguesa de Ciência das Religiões* 5/6 (2004): 117–36.

Paquette, Robert. *Sugar Is Made with Blood: The Conspiracy of La Escalera and the Conflict between Empires over Slavery in Cuba*. Middletown, CT: Wesleyan University Press, 1988.

Parés, Luis Nicolau. *The Formation of Candomblé: Vodun History and Ritual in Brazil*. Translated by Richard Vernon. Chapel Hill: University of North Carolina Press, 2013.

Parés, Luis Nicolau. *O Rei, O Pai, e a Morte: A Religião Vodum na Antiga Costa dos Escravos na África Ocidental*. São Paulo: Companhia das Letras, 2016.

Patterson, Tiffany Ruby, and Robin D. G. Kelley. "Unfinished Migrations: Reflections on the African Diaspora and the Making of the Modern World." *African Studies Review* 43, no. 1 (2000): 11–45.

Peel, J. D. Y. "A Comparative Analysis of Ogun in Precolonial Yorubaland." In *Africa's Ogun: Old World and New*, edited by Sandra T. Barnes, 263–89. Bloomington: Indiana University Press, 1997.

Philip, M. NourbeSe. *Zong! As told to the author by Setaey Adamu Boateng*. Toronto: The Mercury Press, 2008.

Pietz, William. "The Problem of the Fetish, I." *RES: Anthropology and Aesthetics* 9 (1985): 5–17.

Pietz, William. "The Problem of the Fetish, II: The Origin of the Fetish." *RES: Anthropology and Aesthetics* 13 (1987): 23–45.

Pietz, William. "The Problem of the Fetish, IIIa: Bosman's Guinea and the Enlightenment Theory of Fetishism." *RES: Anthropology and Aesthetics* 16 (1988): 105–24.

Piqué, Francesca, and Leslie H. Rainer. *Palace Sculptures of Abomey: History Told on Walls*. Los Angeles: The Getty Conservation Institute and the J. Paul Getty Museum, 1999.

Polhemus, Neal. "A Dialogue with King Agaja: William Snelgrave's 1727 Ardra Diary and the Contours of Dahomian-European Commercial Exchange." *History in Africa* 43 (2016): 29–62.

Porteus, Laura L. "The Gri-Gri Case: A Criminal Trial during the Spanish Regime, 1773." *Louisiana Historical Quarterly* 17, no. 1 (1934): 48–63.

Prussin, Labelle. *Hatumere: Islamic Design in West Africa.* Berkeley: University of California Press, 1986.

Rangel, Felipe Augusto Barreto. "Feituras da Proteção no Recôncavo Setecentista." *Afro-Ásia* 54 (2016): 227–60.

Rarey, Matthew Francis. "Assemblage, Occlusion, and the Art of Survival in the Black Atlantic." *African Arts* 51, no. 4 (2018): 20–33.

Rarey, Matthew Francis. "Counterwitnessing the Visual Culture of Brazilian Slavery." In *African Heritage and Memories of Slavery in Brazil and the South Atlantic World,* edited by Ana Lucia Araujo, 71–108. Amherst, NY: Cambria Press, 2015.

Reginaldo, Lucilene. *Os Rosários dos Angolas: Irmandades de africanos e crioulos na Bahia setecentista.* São Paulo: Editora Alameda, 2011.

Reichert, Rolf. "Os Documentos Árabes do Arquivo do Estado da Bahia, 1.ª Série: Textos Corânicos." *Afro-Ásia* 2–3 (1966): 169–76.

Reichert, Rolf. *Os Documentos Árabes do Arquivo do Estado da Bahia.* Salvador: Centro de Estudos Afro-Orientais, Universidade Federal da Bahia, 1979.

Reis, João José. "African Nations in Nineteenth-Century Salvador, Bahia." In *The Black Urban Atlantic in the Age of the Slave Trade,* edited by Jorge Cañizares-Esguerra, Matt D. Childs, and James Sidbury, 63–82. Philadelphia: University of Pennsylvania Press, 2013.

Reis, João José. "Candomblé and Slave Resistance in Nineteenth-Century Bahia." In *Sorcery in the Black Atlantic,* edited by Luis Nicolau Parés and Roger Sansi, 55–74. Chicago: University of Chicago Press, 2011.

Reis, João José. *Death Is a Festival: Funeral Rites and Rebellion in Nineteenth-Century Brazil.* Translated by H. Sabrina Gledhill. Chapel Hill: University of North Carolina Press, 2003.

Reis, João José. *Rebelião Escrava no Brasil: A História do Levante dos Malês em 1835,* revised and expanded ed. São Paulo: Companhia das Letras, 2003.

Reis, João José, and Beatriz Gallotti Mamigonian. "Nagô and Mina: The Yoruba Diaspora in Brazil." In *The Yoruba Diaspora in the Atlantic World,* edited by Toyin Falola and Matt D. Childs, 77–110. Bloomington: Indiana University Press, 2004.

Robinson, David. *Muslim Societies in West African History.* Cambridge: Cambridge University Press, 2004.

Rodney, Walter. *A History of the Upper Guinea Coast.* New York: Monthly Review Press, 1982.

Rodney, Walter. "Upper Guinea and the Significance of Origins of Africans Enslaved in the New World." *Journal of Negro History* 54, no. 4 (1969): 327–45.

Rodrigues, Aldair. "African Body Marks, Stereotypes, and Racialization in Eighteenth-Century Brazil." *Slavery & Abolition* 42, no. 2 (2021): 315–44.

Rodrigues, Aldair Carlos. "Deciphering Scarification in West Africa and Brazil during the Eighteenth Century." Public lecture given at the Program of African Studies, Northwestern University, Evanston, Illinois, February 20, 2019.

Rodrigues, Aldair Carlos. *Igreja e Inquisição no Brasil: Agentes, carreiras, e mecanismos de promoção social—século XVIII*. São Paulo: Alameda, 2014.

Rodrigues, Nina. *Os Africanos no Brasil*. São Paulo: Companhia Editora Nacional, 1935.

Rowe, Erin Kathleen. *Black Saints in Early Modern Global Catholicism*. Cambridge: Cambridge University Press, 2019.

Rubin, Arnold. "Accumulation: Power and Display in African Sculpture." In *Arts of Africa, Oceania, and the Americas: Selected Readings*, edited by Janet Catherine Berlo and Lee Anne Wilson, 4–21. New York: Prentice Hall, 1993.

Rush, Dana. "Ephemerality and the 'Unfinished' in Vodun Aesthetics." *African Arts* 43, no. 3 (2010): 60–75.

Russell-Wood, A. J. R. "Black and Mulatto Brotherhoods in Colonial Brazil: A Study of Collective Behavior." *Hispanic American Historical Review* 54, no. 4 (1974): 567–602.

Russo, Alessandra. *The Untranslatable Image: A Mestizo History of the Arts in New Spain, 1500–1600*. Austin: University of Texas Press, 2014.

Salema, Vasco da Costa. *Pelourinhos do Brasil*. Lisbon: Editora da Sociedade Histórica da Independência de Portugal, 1992.

Sanneh, Lamin. *Beyond Jihad: The Pacifist Tradition in West African Islam*. Oxford: Oxford University Press, 2016.

Sansi, Roger. "Sorcery and Fetishism in the Modern Atlantic." In *Sorcery in the Black Atlantic*, edited by Luis Nicolau Parés and Roger Sansi, 19–39. Chicago: University of Chicago Press, 2011.

Santos, Lidiane Vicentina dos. "'Terra Inficcionada': As Prácticas Mágico-Religiosas Indígenas e a Inquisição na Amazônia Portuguesa Setecentista." PhD diss., Universidade Federal de São João del Rei, 2016.

Santos, Vanicléia Silva. "As bolsas de mandinga no espaço Atlântico." PhD diss., Universidade de São Paulo, 2008.

Santos, Vanicléia Silva. "Mandingueiro não é *Mandinga*: o debate entre nação, etnias e outras denominações atribuídas aos africanos no contexto do tráfico de escravos." In *África e Brasil no Mundo Moderno*, edited by Eduardo França Paiva and Vanicléia Silva Santos, 11–27. São Paulo: Annablume, 2012.

Santos, Vanicléia Silva. "Mulheres africanas nas redes dos agentes da Inquisição de Lisboa: O caso de Crispina Peres, em Cacheu, século XVII." *Politeia: História e Sociedade* 20, no. 1 (2021): 67–95.

Saraiva, António José. *The Marrano Factory: The Portuguese Inquisition and Its New Christians, 1536–1765*. Translated by H. P. Salomon and I. S. D. Sassoon. Leiden: Brill, 2001.

Saunders, A. C. de C. M. *A Social History of Black Slaves and Freedmen in Portugal.* Cambridge: Cambridge University Press, 1982.

Schaffer, Matthew. *Djinns, Stars, and Warriors: Mandinka Legends from Pakao, Senegal.* Leiden: Brill, 2003.

Schleumer, Fabiana. "Recriando Áfricas: Presença negra em São Paulo colonial." *Histórica: Revista Electrônica do Arquivo Publico do Estado de São Paulo* 46 (2011): 1–10.

Schwartz, Stuart B. *Sovereignty and Society in Colonial Brazil: The High Court of Bahia and Its Judges, 1609–1751.* Berkeley: University of California Press, 1973.

Seibert, Gerhard. "São Tome and Príncipe: The First Planation Economy in the Tropics." In *Commercial Agriculture, the Slave Trade, and Slavery in Atlantic Africa*, edited by Robin Law, Suzanne Schwarz, and Silke Strickrodt, 54–78. Woodbridge, UK: James Currey, 2013.

Serrão, José Vicente. "Extensive Growth and Market Expansion, 1703–1820." In *An Agrarian History of Portugal, 1000–2000: Economic Development on the European Frontier*, edited by Dulce Freire and Pedro Lains, 132–71. Leiden: Brill, 2016.

Sexton, Jared. "Afro-Pessimism: The Unclear Word." *Rhizomes* 29 (2016). https://doi.org/10.20415/rhiz/029.e02.

Sexton, Jared, and Huey Copeland. "Raw Life: An Introduction." *Qui Parle* 13, no. 2 (2003): 53–62.

Seybold, Dara. "Choosing Therapies: A Senegalese Woman's Experience with Infertility." *Health Care for Women International* 23, no. 6–7 (2002): 540–59.

Sharpe, Christina. *In the Wake: On Blackness and Being.* Durham, NC: Duke University Press, 2016.

Shaw, Rosalind. *Memories of the Slave Trade: Ritual and the Historical Imagination in Sierra Leone.* Chicago: University of Chicago Press, 2002.

Shaw, Rosalind. "The Production of Witchcraft/Witchcraft as Production: Memory, Modernity, and the Slave Trade in Sierra Leone." *American Ethnologist* 24, no. 4 (1997): 856–76.

Silva, Simone Trindade Vicente da. *Joias Crioulas: Coleção Museu Carlos Costa Pinto.* São Paulo: Instituto Victor Brecheret, 2012.

Silva, Valéria Piccoli Gabriel da. "Figurinhas de brancos e negros: Carlos Julião e o mundo colonial Português." PhD diss., Universidade de São Paulo, 2010.

Siqueira, Sônia A. *A Inquisição Portuguesa e a sociedade colonial.* São Paulo: Editora Ática, 1978.

Sisòkò, Fa-Digi. *The Epic of Son-Jara: A West African Tradition*, edited by John William Johnson. Bloomington: Indiana University Press, 1992.

Skemer, Don C. *Binding Words: Textual Amulets in the Middle Ages.* University Park: Pennsylvania State University Press, 2010.

Smallwood, Stephanie E. *Saltwater Slavery: A Middle Passage from Africa to American Diaspora.* Cambridge, MA: Harvard University Press, 2007.

Smith, Robert Sydney. *The Kingdoms of the Yoruba*, 3rd ed. Madison: University of Wisconsin Press, 1988.

Soares, Mariza de Carvalho. "From Gbe to Yoruba: Ethnic Change and the Mina Nation in Rio de Janeiro." In *The Yoruba Diaspora in the Atlantic World*, edited by Toyin Falola and Matt D. Childs, 231–47. Bloomington: Indiana University Press, 2004.

Soares, Mariza de Carvalho. "A 'nação' que se tem e a 'terra' de onde se vem: Categorias de inserção social de africanos no Império português, século XVIII." *Estudos Afro-Asiáticos* 26, no. 2 (2004): 303–30.

Soares, Mariza de Carvalho. *People of Faith: Slavery and African Catholics in Eighteenth-Century Rio de Janeiro*. Translated by Jerry D. Metz. Durham, NC: Duke University Press, 2011.

Souza, Laura de Mello e. *The Devil and the Land of the Holy Cross: Witchcraft, Slavery, and Popular Religion in Colonial Brazil*. Translated by Diane Grosklaus Whitty. Austin: University of Texas Press, 2003.

Spillers, Hortense J. "Mama's Baby, Papa's Maybe: An American Grammar Book." *Diacritics* 17, no. 2 (1987): 64–81.

Strother, Zoe S. "From Performative Utterance to Performative Object: Pende Theories of Speech, Blood Sacrifice, and Power Objects." RES: *Anthropology and Aesthetics* 37 (2000): 49–71.

Sweet, James H. *Domingos Álvares, African Healing, and the Intellectual History of the Atlantic World*. Chapel Hill: University of North Carolina Press, 2011.

Sweet, James H. "The Hidden Histories of African Lisbon." In *The Black Urban Atlantic in the Age of the Slave Trade*, edited by Jorge Cañizares-Esguerra, Matt D. Childs, and James Sidbury, 233–47. Philadelphia: University of Pennsylvania Press, 2013.

Sweet, James H. "Mistaken Identities? Olaudah Equiano, Domingos Álvares, and the Methodological Challenges of Studying the African Diaspora." *American Historical Review* 114, no. 2 (2009): 279–306.

Sweet, James H. "The Quiet Violence of Ethnogenesis." *William and Mary Quarterly* 68, no. 2 (2011): 209–14.

Sweet, James H. *Recreating Africa: Culture, Kinship, and Religion in the African-Portuguese World, 1441–1770*. Chapel Hill: University of North Carolina Press, 2003.

Sweet, James H. "Slaves, Convicts, and Exiles: African Travellers in the Portuguese Atlantic World, 1720–1750." In *Bridging the Early Modern Atlantic World: People, Products, and Practices on the Move*, edited by Caroline A. Williams, 193–202. Burlington, VT: Ashgate, 2009.

Tadman, Michael. *Speculators and Slaves: Masters, Traders, and Slaves in the Old South*. Madison: University of Wisconsin Press, 1989.

Taussig, Michael. *The Devil and Commodity Fetishism in South America*, 30th anniversary ed. Chapel Hill: University of North Carolina Press, 2010.

Tavim, José Alberto Rodrigues da Silva. "Educating the Infidels within: Some Remarks on the College of the Catechumens of Lisbon (XVI–XVII Centuries)." *Annali della Scuola Normale Superiore di Pisa. Classe di Lettere e Filosofia* Serie 5, Vol. 1, no. 2 (2009): 445–72.

Thompson, Krista. *Shine: The Visual Economy of Light in African Diasporic Aesthetic Practice*. Durham, NC: Duke University Press, 2015.

Thompson, Krista. "A Sidelong Glance: The Practice of African Diaspora Art History in the United States." *Art Journal* 70, no. 3 (2011): 7–31.

Thompson, Robert Farris. *Aesthetic of the Cool: Afro-Atlantic Art and Music*. New York: Periscope Publishing, 2011.

Thompson, Robert Farris. *Flash of the Spirit: African and Afro-American Art and Philosophy*. New York: Random House, 1983.

Thornton, John. "Cannibals, Witches, and Slave Traders in the Atlantic World." *William and Mary Quarterly* 60, no. 2 (2003): 273–94.

Thornton, John. "The Kingdom of Kongo and Palo Mayombe: Reflections on an African-American Religion." *Slavery & Abolition* 37, no. 1 (2016): 1–22.

Thornton, John K. "Afro-Christian Syncretism in the Kingdom of Kongo." *Journal of African History* 54, no. 1 (2013): 53–77.

Thornton, John K. "Central Africa in the Era of the Slave Trade." In *Slaves, Subjects, and Subversives: Blacks in Colonial Latin America*, edited by Jane Landers and Barry Robinson, 83–110. Albuquerque: University of New Mexico Press, 2006.

Thornton, John K. *Warfare in Atlantic Africa, 1500–1800*. London: UCL Press, 1999.

Trindade, Jaelson Bitran. "Arte Colonial: Corporação e Escravidão." In *A Mão Afro-Brasileira: Significado da Contribuição Artística e Histórica*, 2nd ed., Vol. 1, organized by Emanoel Araujo, 161–83. São Paulo: Imprensa Oficial do Estado de São Paulo / Museu AfroBrasil, 2010.

Trouillot, Michel-Rolph. *Silencing the Past: Power and the Production of History*. Boston: Beacon Press, 1995.

Valerio, Miguel A. "Architects of Their Own Humanity: Race, Devotion, and Artistic Agency in Afro-Brazilian Confraternal Churches in Eighteenth-Century Salvador and Ouro Preto." *Colonial Latin American Review* 30, no. 2 (2021): 238–71.

Vasconcellos, José Leite de. "Amuletos." *O Archeologo Português* 5 (1900): 287–89.

Vasconcellos, José Leite de. "Signification religieuse, en Lusitanie, de quelques monnaies porceés d'un trou." *O Archeologo Português* 10 (1905): 169–76.

Verger, Pierre. *Trade Relations between the Bight of Benin and Bahia from the 17th to 19th Century*. Translated by Evelyn Crawford. Ibadan: Ibadan University Press, 1976.

Walcott, Derek. "The Antilles: Fragments of Epic Memory." Nobel Lecture, Stockholm, Sweden, December 7, 1992. https://www.nobelprize.org/prizes/literature/1992/walcott/lecture/.

Wheat, David. *Atlantic Africa and the Spanish Caribbean, 1570–1640*. Chapel Hill: University of North Carolina Press, 2016.

Williams, Eric. *Capitalism and Slavery*, 3rd ed. Chapel Hill: University of North Carolina Press, 2021.

Wissenbach, Maria Cristina Cortez. "Cartas, procurações, escapulários e patuás: Os múltiplos significados da escrita entre escravos e forros na sociedade oitocentista brasileira." *Revista Brasileira de História da Educação* 2, no. 2 (2002): 103–22.

Wood, Marcus. *Blind Memory: Visual Representations of Slavery in England and America, 1780–1865*. New York: Routledge, 2000.

Yaya, Isabel. "Wonders of America: The Curiosity Cabinet as a Site of Representation and Knowledge." *Journal of the History of Collections* 20, no. 2 (2008): 173–88.

Index

Bahia, Brazil, 7, 12, 220n69; Black middle class, 191; in context of African political history, 184–85; depicted in collage, *21*, 21–22; Olho de Peixe, 156; Revolt of the Malês (1835), 14, 27. *See also* Revolt of the Malês (Bahia, 1835); Salvador (Bahia, Brazil)

Bahia, Francisco (denounced), 134

balangandãs (penca de balangandãs), *189*, *190*, 190–92, *192*, 246n79

Barbot, Jean, 86–87, *87*

Barra, Pierrot, *19*, 19–20

Barreira, Balthazar (Jesuit priest), 46, 51–52

Barros, Manuel de (enslaved man), 156, 167

Bay, Edna G., 105, 106

Benguela, Angola, 56

Bernard, Jean Frederic (publisher), 153

Berry, William, 60, *61*

Bethencourt, Francisco, 83

bexerins (Muslim trader clerics), 46

Bight of Benin, 18, 83, 163, 228n164; and embarkations of enslaved persons, 64, 183–84; *Mina* as term for those captured and sold in, 28

Biro, Yaëlle, 69

The Black Atlantic: Modernity and Double Consciousness (Gilroy), 17–19

Black Atlantic world, 2; agency and rebellion located in amulets of, 177–83; context circa 1700, 7–14; in context of patuás, 176; feitiçaria, discourse of, 29; labels used by Africans, 34–35; navigating, 120–23; ship in motion as chronotope for, 17–18; transatlantic networks of mandingueiros, 94–95, 129–30, 235n139; visual tradition of, 23. *See also* Africa; art history of Black Atlantic

Blackness: as "absence of consciousness," 178; Africanness not equated with, 13; as series of othered subject positions, 25, 139

Black Sorcerer (Debret), 144, *145*

Black street vendor, painting of, 89–91, *90*

Blier, Suzanne, 20, 105, 106, 107

Bluteau, Raphael, 59–60, 83

"Bo" (healer), 106

bo (assemblages), 106–9, *107*, *108*

Boat (Barra), *19*, 19–20

bocio (figures), 106–9, *107*, *108*, 235n123

bodies: as "fleshy envelope," 134; marking of, 124; objectification of in slavery, 31,

54, 178; perceived capacity of to tolerate violence and pain, 147–48; performance of inviolacy by, 124–25; as permeable, 89, 91, *92*, 107, 137; scarification, 89, 124, 129, 160, 162–63, 197; as texts, 159–60. *See also* enslaved people

"bodyguard" amulets (*guarda di kurpu*), 33, 53

bolsa de mandinga, as term, 5, 57–58. *See also* mandingas (bolsas de mandinga)

bolsas. *See* amulets; contents of amulets; contents of mandinga pouches; mandingas (bolsas de mandinga); patuás (packets)

Bouza, Fernando, 130–31

Branco, João de Siqueira Castelo (accused white man), 76

Brant Pontes, Felisberto Caldeira, 185–86

Bravmann, René, 36

Brazil: African ethnic groups, encounters between, 15, 33–34, 134; cultural dialogues with West Africa, 18; depicted as land of torments, 9–10, *9–10*; independence (1822), 211; Inquisition's most significant focus on, 12; Minas Gerais gold rush, 7, 12; racial-sexual imbalances, 134; religious diversity, 10–11; shifting ethnic identities in, 66. *See also* Bahia, Brazil; Salvador (Bahia, Brazil)

breves (Catholic orations), 15, 29, 58, 76, 77, 88, 93, 95, 131, 159

Brivo, Alessandra, 230n36

Brown, Kimberly Juanita, 18

Browne, Simone, 193, 200

bruxaria ("witchcraft"), 59

Bryant, Sherwin, 124

Buono, Amy J., 22

Buré (Upper Niger valley), 35

burials (*bangué*), 163–64, *165*

Burkina Faso, 80

Burns, Antoinette, 24

cabildos de nación (mutual aid organizations, Cuba), 66, 67

"cabinet of curiosities" (*Wunderkammer* or *Kunstkammer*), 2, 234n108, 239n53

Candido, Mariana, 56

Candomblé, 67, 185–87, 197

Caravaca Cross, 142–43

Declaration of the Rights of Man, 179

Delbourgo, James, 79

denunciations, 11–13, 125, 136, 237n4; duty to denounce, 11; generic formal descriptors given to apotropaic objects, 57; of "new Christians," 91; of performed inviolacy, 146–50; self-denunciation, 12; for using amulets as protection from intimate violence, 124–25; of women, 51

Desalines (López), 208, *209*, 212–13

Dessalines, Jean-Jacques, 208–14, *209*

Devil: accusations of pacts with, 4, 57–58, 72–74, 136–37

The Devil and the Land of the Holy Cross (Mello e Souza), 15

dictionary, Portuguese-language, 59–60, 83

djambakós (healers), 51, 226n97

Dobronravin, Nikolay, 207

Dogon peoples, 41–42, *42*, *43*, 223n49

Donelha, André, 46–48, 50

donso (Mande hunters), 80–81, *81*, *82*, 84–85

Doris, David, 20, 22

Drewal, Henry John, 15

Duarte, Luís (accused of Islamism), 8

Dubroca, Jean-Louis, 208

Dupuis, Joseph, 38

dyula (or Wangara) gold traders, 35–38, 222n21, 223–24n69

editais (inquisitorial decrees), 12, 126–27

Egba (federation of Yorùbá kingdoms), 183–84, 187, 197

ekphrastic descriptions: of contents of mandinga pouches, 28, 73, 76–78; of people, 198

Elevation and facade showing in naval prospect the city of Salvador (Julião), *21*, 21–22, 232n68

Elmina Castle (trading outpost), 66, 70

enslaved people: archive of, 127–29; escravas de ganho (wage-earning women), *189*, 189–90, 196–97, 245–46n77; at forefront of early modern collecting practices, 28–29; fugitivity from slavery, 94, 156, 167; "hypervisibility" and "invisibility" of, 29, 129, 158, 167, 196, 242n113; "key slaves," 169; *Mina* as self-identifying term, 27–28; negative population growth rate, 134; representations of, 18; "slave" as

visualized concept, 196; status of as act of archival inscription, 124. *See also* bodies

enslavers: gris-gris used for violence against, 177–78; mandinagas used for protection from, 146–47, 154, 177; wealth of displayed by enslaved women's finery, 191

equestrian images, *39*, *40*

Escobar, Crescencio de (mameluco), 135–37

escravas de ganho (wage-earning enslaved women), *189*, 189–90, 196–97, 245–46n77

Espírito Santo, Brazil, 12

ethnic identities, 6, 66–67

ethnogenesis, violence of, 69–71

ethnonyms: African, 28, 31, 34, 62; used to classify laborers, 67–68

Eucharistic hosts, 95, 143–44

Ewbank, Thomas, 187–90, *188*, 192, 193, 246n78

exorcism rituals, 12

Exordium (al-Fātiḥah), 173

exploitation, as manifestation of witchcraft, 83–84

Fanon, Frantz, 31, 108

Farias, Paulo F. de Moraes, 36

Feijó, João de Morais Madureira, 59

feitiçaria. *See* fetishism or sorcery (feitiçaria)

feiticeiros (operators of power objects or feitiços), 59–60, 68, 83–84, 149, 158, 214, 230n36. *See also* mandingueiros

feitiço. *See* fetish (*feitiço*)

Felipe IV (Felipe III), 218n26

Fernandes, Valentim (Lisbon-based printer), 45

Ferrarini, Lorenzo, 80

Ferraz, Angelo Muniz da Silva (district attorney of Salvador), 201–2, 207, 212

fetish (feitiço), 11, 28, 32–34; Africans' bodies as, 78; and debate over value, 88–98; illegibility of, 58; mandinga associated with, 59, 62, 74, 78; materiality of, 33, 230n36; problems of cross-cultural translation, 42–43; talismans and discourse of, 42–43; terminology of230n36, 28, 33–34, 46, 230n36; West African discourse of, 79–80, 94; witchcraft as etymological origin of term, 33. *See also* mandingas (bolsas de mandinga)

Maghribi script, *174*, 175, 205

Makandal, François, 33

makandal (amulet), 33

Malê Revolt. *See* Revolt of the Malês (Bahia, 1835)

Malerische Reise in Brasilien (Rugendas), 163

Malês: accused of revolt, 174, 201; fashion items among, 172, 207; suppression of after revolt, 207; as term for African-born Muslims, 171. *See also* patuás (packets); Revolt of the Malês (Bahia, 1835)

Mali Empire, 35–40, 184, 219n50, 221n19; decline of, 44; as Manden (or Manding), 32; Soninke diaspora, *39*, 39–40, *41*; Timbuktu, 40, 45; Tinntam village, figure from, 41–42, *42*

"Mama's Baby, Papa's Maybe" (Spillers), 24–25

Mande cultural sphere, 36, 39–40, 80–81, *81*, 84–85, 219n50

Mandinga-ness, effort to define, 28

mandingas (bolsas de mandinga), 1–4, *2*, *3*; aesthetic logics adopted by, 20–21; African origin assumed for all, 70; anti- or counterslavery practice, debate over, 158; as bolsa de mandinga ("Mandinga pouch"), 5; cast-off materials and ephemera in, 20; Catholic characteristics of, 15, 17, 58, 59, 88–91, *90*; as challenges to Portuguese authority, 29, 58, 74, 99, 149–50, 154–58; connected with Brazil, 12; consecrated to spirits, 57; construction and public visibility of, 124; "cords," 52–53, 226n104; definitional boundaries exceeded by, 58–59; as descriptive of function, not form, 91–92; detritus of cultural trauma in, 108; discursive of, 16, 31–32, 219n50; diverse clientele for, 13–16, 91; Eucharistic hosts connected with, 143–44; exchange value of, 4, 85, 119–20, 191; indecipherability and visual banality as core aesthetic strategies, 3, 5–6, 22–23, 50, 75, 91, 180–81, 200, 213; independent spaces created by, 25, 75, 192–93; insignificance attributed to, 14, 58, 73–74, 77, 85, 200–206; linked to fugitivity, 94, 156, 167; linked to resistance, 4, 17, 26, 94, 156, 158, 167, 178; market for, 75, 78, 91, 94–95, 98, 114, 186–87, 240n88; material dimensions of, 5, 9, 14, 16–17, 62; non-African elements in, 99–102, *100*, *101*, *117*; power of confirmed by confiscation of, 147, 154; revolutionary possibilities contained inside, 29–30; rise in demand for, 94–95; shifting racial and cultural dynamics in use of, 55–57; and sorcerous work of classification, 54–62; survival, role in, 5, 26; as term, 6, 57, 220–21n5, 228–29n172; as transcultural objects, 16–17, 19, 70, 127; transoceanic circulation of, 1, 5–6, 25, 27–28, 32, 46–57, 59, 75–79, 89. *See also* altar stones (pedras d'ara); amulets; contents of mandinga pouches; fetish (feitiço); patuás (packets); protection from intimate personal violence; touch cards (cartas de tocar); written materials

mandingueiros ("mandinga-makers"), 5, *29*, 56; independent spaces created by, 75; social status of, 17; transatlantic networks of, 94–95, 129–30, 235n139; use of altar stones by, 95–96. *See also* feiticeiros (operators of power objects or feitiços); João, Manuel (mandingueiro); Lima, Luis de (enslaved mandingueiro); mandingueiro); Mascarenhas, António (mandingueiro); Morais, Vicente de (Mbundu soldier); Pedroso, José Francisco (mandingueiro); Pereira, José Francisco (mandingueiro)

Mandinka identity, 28, 32, 43–46, 50–53, 60, 66, 70, 221n5; imperial perceptions of, 45, 59–60, *61*; Portuguese-language accounts of, 44–45; strategic claiming of, 66, 68; on Upper Guinea Coast, ca. 1500–1668, 44–54

Mandinka/Mandinga, as ethnonym, 28, 54, 62

Mansa Musa (ruler of Mali), 35, 221n19

Manuel (enslaved man in Lisbon), 3, 32, 147–49

Manuel I, 44

manumission, 145

manumission cylinders, 191

marabouts, 46, 224n74

Marees, Pieter de, 85

Margaret of Austria, 91

markings: branding, 163–64; recontextualization of, 131; relationship between

writings and markings of violence, 29; scarification, 89, 124, 129, 160, 162–63, 197; transfer between archival and corporeal, 129. *See also* archive; classification; labels; touch cards (*cartas de tocar*)

Marques Pereira, Nuno, 9–10

Martín, Juan (accused by Inquisition), 8

Martins, Francisco de Souza (President of Bahia province), 171, 172

Martins, Francisco Gonçalves (Chief of Police, Salvador), 171

Mascarenhas, António (mandingueiro), 95, 111, 233n90, 235n139

masculinity: Black, 139, 177, 239n53; white ruling class, 209–12

material exchange, 14, 16–17; transformation of, 87–88; transoceanic networks of, 8–9, 25, 29, 94–95, 129–30, 235n139

materiality of fetish, 33, 230n36

materials: cast-off, *19*, 19–20; context of, 5–6; as dimension of mandingas, 5, 9, 14, 16–17; literal binding of amulet into inquisitorial record, 26–27, 29; new, incorporated into amulets, 47, 49, *49*; used for balangandãs, 190; and visual culture of slavery, 18–19

Matory, J. Lorand, 19, 74, 80–81, 88–89

Maurício, Joseph (priest), 143

Mbundu soldiers (kilambas), 55

medals, 89–92, *90*, 99; Arma Christi, 110, *111*

Medusa's head symbol, *209*, 209–10

Melo, João da Gama (Governor of Bahia), 176

Mendes, Luís Antônio Oliveira de (Bahian-born sugar planter), 87–88, 231n61

Menezes, Dona Francisca Maria de (widow), *96*, 96–98, *98*

Mercer, Kobena, 181

metaphysical interpretations, discounting of, 78–79

Metrópole das mandingas (Calainho), 15

Mexico, conquest of, 122

Middle Passage, 23, 70

militiamen, free Black, 210–11, 213

Mina Coast ("Slave Coast"), 7, 66

Mina people, 27–28, 162, *163*; Mina as label applied by slavery system, 66; naturalization of term by enslaved persons, 62; photograph of, 197, *198*

Minas Gerais (Brazil), 7–8; gold rush, 7, 12

Mirzoeff, Nicholas, 193, 202

missionaries, Portuguese, 113

Mitchell, W. J. T., 178–79

modernity: early modern collecting practices, 28–29; originating metaphors of captivity and mutilation, 25; transformative role of papers in, 129

Morais, Vicente de (Mbundu soldier; mandingueiro), 27, 55–58

Morici, Francisco José dos Santos, 197

Mota, Thiago Henrique, 16–17

Moten, Fred, 178

Mott, Luiz, 25

Moura, Pascual José de (painter), 136–37

Müller, Juliane, 203–4

Muslims: allo writing boards, 181–83, *182*; enslaved, in Oyo, 184; Hausas, 175, 202–3, 247nn111,120; leather amulets used by, 46; literacy of African, 202–3; Maghribi script used by, 175; *Malê* as term for African-born in Brazil, 171, 185; Mandinka, 45–46; in Portugal, 8; in Senegambia, 240n76; trader clerics (bexerins), 46; West African, 173–75. *See also* Islam

Muta Kalombo (spirit), 57

Muxima (Portuguese garrison, Angola), 27, 55

Nafana family royal compound (Banda, west-central Ghana), 36–37

Nagô, as term for Yorùbá in Brazil, 171, 197, 202, 247n111

National and Colonial Assemblies, 179

nautical chart (carta de marear), 1, 110

New Spain, 122

New York Gazette, 152

Nigeria, *38*

Nómina (amulet), 46, 224n74

Nooter, Mary, 80

Novais, José Pinto, 173

nyamakalaw (leatherworkers and blacksmiths), 40, 223n42

objectification, 31–32; of human bodies, 34, 54, 178

objects: "dispossessive force" of, 178; rebelliousness of, 172, 176, 183, 185, 200–202; resistance by, 178

Salvador (Bahia, Brazil), 20–21, *21*; amuletic economy, 187–88; block inspectors, 172; enslaved Africans, numbers of, 185; Largo do Pelourinho (Praça José de Alencar), 194, *194*; State of Bahia Public Archive, 173, 203; suppression of African cultural expression after rebellion, 207. *See also* Bahia, Brazil

Sansi, Roger, 17, 56, 83

Santa Casa de Misericórdia of Bahia, 163–64, *165*

Santos, Vanicléia Silva, 15, 219n50, 225nn88, 89

Santo Tomás, Alberto de (Dominican priest), 12

São Boaventura João de, 124–26, *128*, 166, 237n13

São João Baptista, Church of (São Tomé), 62, *65*

São Jorge (ship), 64–65

São Tomé, 62, 64, *65*

Saraiva, António José, 152

sartorial practices, 50, 186–87, 189, *189*, 224n82; of Black women, *189*, 190–91, *191*

Savalou peoples, 162

Savi, fort at (Hueda), 114, *115*

scapulars, 89–92, *90*, *92*, 110, 132, *133*

scarification, 89, 124, 129, 160, 162–63, 197

Science Museum (London), 37

"scopic regimes of modernity," 15

Sea Islands, 24

Senegal, 176

Senegambia, 16, 27, 35, 240n76

Sergipe, Brazil, 211

Sexton, Jared, 24, 25

Sharpe, Christina, 24, 25, 26, 144, 161

ship in motion, as chronotope for Black Atlantic world, 17–18

shipping routes, 56, 121

ships, slave trade, 104, *104*, *153*, 153–54; bolsas used to stop wind, 2, 156–57; nau (three- or four-masted ship), 121; registers, 24, 64, 167, 193. *See also* slave trade

"shrine franchising," 41–42

Sierra Leone, 45, 83

Sierra Leone National Museum, 48

signification and valuation, system of, 14–15

silence, 23–27; secrecy terms of sentences, 169, *170*

Silva, Andre de (soldier), 57

Silva, Domingos da (Candomblé practitioner), 186–87

Silva, Francisco de Campos da (cristão novo), 137, *138*

Silva, João da (enslaved "natural of Angola"), 156–58, *157*, *159*, 163–64, 167

Siqueira, João de (white man), 147

Skemer, Don C., 46–47

slavery: aesthetic conditions of, 197, 201, 203, 207, 213, 215; African Muslims under, 202–3; dependent on sexual violation of Black subjects, 134–35, 137–39; ethnonyms used to classify laborers, 67–68; *kannumon* as Fon term for, 106; Middle Passage, 23, 70; objectification of human beings, 31, 54, 178; perceived capacity of enslaved to tolerate violence and pain, 147–48; plantation, 23–24, 163, 193; precariousness of, 148; rehearsal of tropes, 208–14; urban landscape, 193–94; as visual condition defined by surveillance, 23, 158–59; visual culture of, 18–19, 23, 158–60, 192; white fears of rebellion against, 210–13. *See also* surveillance

slave ships, registers of, 24, 64, 167, 193

slave trade: and accusations of witchcraft, 83–84; and navigation, 120–21; objects traded for human beings, 87–88, 114, 119; psychological and collective trauma of, 20, 107–9, 121, 123. *See also* ships, slave trade

slave trade, Atlantic, 2, 64, 105, 222n41; between 1690 and 1700, 8; as discourse of classification and redefinition, 34

slave trade, internal African, 6–8, 103, 105; Saharan, 16, 40–41

Smallwood, Stephanie E., 26, 70

Soares, Manuel da Costa (witness), 157

Soares, Mariza de Carvalho, 66, 91, 112

social ills, 83–84

Social Text, 24

Sokoto Caliphate, 184

Soninke diaspora, figure from, *39*, 39–40, *40*

sortis, to sort, 54

Sousa, António de (enslaved man), 76, 145, 146–56

Souza, Laura de Mello e, 10, 15, 55–56, 146, 238n25

"space of correlation," 20

Spain, 6, 142; Spanish Inquisition, 10–11, 47, 77, 217n18

Spillers, Hortense, 24–25, 29, 34, 124, 164, 215; Blackness as series of othered subject positions, 25, 139

spiritual nations, 66–68

spiritual power (nyama), *159*, 160–61, 188, *188*, 205

"Suplice des Condamnez" (Picart), 152–53, *153*

surveillance: aesthetics of, 193, 196, 200; Blackness, the patuá, and the portrait, 193–200; and classification, 193; "dark sousveillance," 200; of enslaved people, 124, 129; global, 1, 11, 127; "oversight," 193; slavery as visual condition defined by, 23, 158–59; undermined by Black people, 6, 200. *See also* slavery

survival, 5, 17–18, 23–27

Suware, al-Hajj Sālim, 36, 222n22

Sweet, James, 17, 70, 95, 108–9, 134, 142, 234n105; on autos-da-fé, 152

syncretism, 15, 76, 95–96, 234n105; shifting racial and cultural dynamics in use of mandingas, 55–57; strategic, 102, 225n88. *See also* religious diversity

Tadman, Michael, 203

talismans, 52, 86, 89, 91–93, *92*, 176–77, 222n27; and discourse of fetish, 42–43; and donso hunters, 80–81, *81*, *82*, 83–85, 84–85; Islamic-associated, 8, 37–39, 47–48, 80; papers as, 8, 30, 36–40, 46–48, 110, 127, 130. *See also* amulets

Tango, Danla á (healer), 57

Tardieu, Amédée, 47–48, *48*

Taussig, Michael, 74

Thompson, Krista, 6, 158

Thompson, Robert Farris, 23

Thornton, John, 83–84, 234n105

Tinntam village (Mali), figure from, 41–42, *42*, *43*

Torquato (enslaved Nagô man), 173, *174*, 176

touch cards (cartas de tocar), 130–39, 156, 238nn25, 29, 239n53; dual performative and materialist logic of, 137; form of, 130–31; included in mandingas, 133; as interplay of protection and violation,

132–36, 139; orations used as, 131–32; power to close off body of user, 132–33; used across racial lines, 135; used for autonomy, 134–35, 139

Trans-Atlantic Slave Trade Database, 64

transculturations, 2, 15–19, 70, 76, 127, 134

transoceanic networks of exchange, 8–10, 25–29, 94–95, 129–30, 235n139; art depicting, *9*, 9–10, *10*; circulation of mandingas in, 1, 5–6, 27–28, 32, 46–57, 59, 75–79, 89; in Lisbon, 8–9, 56–57, 65–66, 149, 152

transplantation, politics of, 22

tropes, rehearsal of, 208–14

Trouillot, Michel-Rolph, 208–9

Tupi people (Brazil), 76

al-'Umarī, 35, 40

Umbanda religion, 144, 164

United States, 141, 203, 248n16

Upper Guinea Coast, 6; Mandinka identity on, 44–54; number of amulets worn, 47–48, *48*; Poro societies, 84

value, debate over, 88–98; Ana Mauricia, painting of, 91, *92*; Bishopric of Lamego, constitutions of (1683), 92–93; Black street vendor, painting of, 89–91, *90*; bodies, as permeable containers, 89, 91, *92*; economic vs. spiritual value of mandingas, 94; exchange value of amulets, 85, 94, 119–20, 191

Vaz, Gaspar (enslaved "cabin-boy"), 50–51, 53, 225n88

Vaz da Cunha, Gerónimo (Viegas denounced by), 31–32, 57, 125

Ventura (enslaved man), 13, 112, 235n139

Verger, Pierre, 18, 66

Viegas, Jacques, 2, 3, 3–5, *4*, 25, 82, 107, 167, 233n86; Black padrinho attested by, 64, 65, 236n143; bolsa of preserved in archive, 1, *2*, *3*, 26–27, 29, 125, 166, 213–14; connotations of survival in amulet of, 26; context of, 7–14; convicted under feitiçaria category, 11; ethnonym used by, 31, 34; exile of, 4, 26; and labor of classification, 62–69; literal binding of amulet into inquisitorial record, 26–27, 29; public display of inviolacy, 31, 125;

Viegas (*continued*)

 self-identification as *Mina*, 27–28, 62, 66, 68; trial record (processo) 2355, 1, *2, 3*, 62, *63*, 72; use of *mandinga* as term by, 31

Villaut, Nicolas, 85

vintém coins, as amulets, 96–98, 113, 116, *119*

violence: archive of intimacy and violation, 129–39; of archive production, 24, 124, 166–69; of ethnogenesis, 69–71; "hyper-visibility" and "invisibility" of enslaved people, 29, 129, 158, 167, 196, 242n113; pelourinhos (public whipping posts), 137, 194–96, *195*, 246nn 94, 95; sexual assault equated with intimacy, 135. *See also* protection from intimate personal violence

visual culture: African, persistence of, 23; fugitivity from, 159; imperial, 21; material of, 18–19; and pencas de balangandãs, 192; of slave rebellion, 213; of slavery, 18, *19*

visual description, political role of, 75

Vodun, 10, 20, 102, 105–6, 185, 230n36

Vodou, lwa of, 19–20, 67–68

West Africa: communal identities in wake of slave trade, 34; cultural dialogues with Brazil, 18; emergence of amulets in prior to slave trade, 15; parallel sense of collective identity among societies, 45; Sahel, 6, 32; smallpox outbreaks, 103. *See also* Sahel, West Africa

West Central Africa, 34, 83

whites: apotropaic objects for white male ruling class, 209–10; fears of Black rebellion, *209*, 209–13; participation in African religiosities, 10, 17, 52, 55, 56; used of touch cards by, 135

"witchcraft," 33, 59, 83–84

Wolof Muslims, 6

women: amulets sold by, 91; Black, control of in slavery system, 135; "cords" used by, 52–53, 226n104; enslaved, challenges to racial order by, 190–91, *191*; escravas de ganho (wage-earning women), 189, 189–90, 196–97, 245–46n77; and Medusa's head symbol, 209, *209*; painted by Rugendas, 163, *163*; touch cards used to attract, 110, 130–36; use of mandingas by, 51–53

written materials, 13, 29–30; allo writing boards, 181–83, *182*; in blood, 99, *101*, 112–13, 116, 120, 131; breves (Catholic orations), 15, 29, 58, 76, 77, 88, 93, 95, 131, 159; and ephemerality of language, 142, 166; folding of as sacred act, 173, 243n16; grammatical structure of, 139–40; graphic writing systems, 129, 164, 236n157; inscription, practices of, 29, 37, 58, 129–30, 136, 224n74; Islamic, 46; letters, 127–29, *128*, 166; literacy as social capital, 131; Maghribi letterforms, 175; multidirectional rearrangement of, 161; mutual constitution of archival papers and human flesh, 124, 129; powers of, 145; Qur'anic, 36, 37–38, 46, 80, 222n26; recontextualization of, 131; significance of for majority illiterate society, 130–31, 141; touch cards as direct response to the proliferation of paper, 137; transcriptions, 136, 141, 169. *See also* mandingas (bolsas de mandinga)

Xangô, orixá of thunder, lightning, and drumming, 187

Yaya, Isabel, 79

Yorùbá people and land, 247n120; anjonu or alijano (wind spirits), 172, 185, 243n7; Egba federation of kingdoms, 183–84, 187; *Nagô*, as term for Yorùbá in Brazil, 171, 197, 202, 247n111; participants in Revolt of the Malês, 29–30; trash assemblages (ààle), 20, 22

Zayd abu Zayd, 142

Zong! (Philip), 161

Printed in the USA
CPSIA information can be obtained
at www.ICGtesting.com
CBHW071911300424
7702CB00004B/10

9 781478 019855